ARCHITECTURE AND STATECRAFT

ARCHITECTURE AND STATECRAFT

Charles of Bourbon's Naples, 1734–1759

 Robin L. Thomas

THE PENNSYLVANIA STATE UNIVERSITY PRESS

UNIVERSITY PARK, PENNSYLVANIA

Library of Congress Cataloging-in-Publication Data

Thomas, Robin L., 1977–
Architecture and statecraft : Charles of Bourbon's Naples,
1734–1759 / Robin L. Thomas.
 p. cm.—(Buildings, landscapes, and societies
series)
Summary: "Examines the crown-sponsored architecture
and urbanism of Naples during the reign of King Charles
of Bourbon (1734–59). Shows how structures and public
spaces helped consolidate royal authority and refashion
the city into a royal capital"—Provided by publisher.
Includes bibliographical references and index.
ISBN 978-0-271-05639-5 (cloth : alk. paper)
1. Architecture and state—Italy—Naples—History—18th
century.
2. Architecture—Italy—Naples—History—18th century.
3. Public buildings—Italy—Naples—Design and
construction—History—18th century.
4. Naples (Italy)—Buildings, structures, etc.
5. Charles III, King of Spain, 1716–1788.
I. Title.
II. Series: Buildings, landscapes, and societies.

NA1121.N3T49 2013
720.1'03094573109033—dc23
2012042510

Frontispiece: Detail, Giovanni Carafa, *Mappa topografica
della città di Napoli e de' suoi contorni*, 1775 (fig. 108).

for my parents

CONTENTS

NAPLES HAS LONG inspired curiosity and devotion. This book is a small contribution to the great commonwealth of learning that is Neapolitan scholarship. It builds upon generations of historical research and therefore owes a great debt to the many authors that came before it. These art historians, along with economic, social, and music historians, made the research of this book ever stimulating and enlightening.

For me, studying Naples was not inevitable. It took the inspiration of two important teachers. Judy Raggi-Moore, with her exhaustive knowledge of Italy's hidden corners, insisted that I enter Naples with an open mind. Sarah McPhee stirred my early curiosity in art history and sparked my interest in baroque architecture.

My research on the subject of the book began when I was a doctoral student at Columbia University. I cannot overstate the guidance that Joseph Connors provided. His catholic interests, keen intellect, and insistence on excellent writing have been, and remain, important models. Hilary Ballon provided significant support, challenging my thinking and recommending further research and better conceptual framing at important junctures. Both scholars' written works served as models of visual and historical rigor.

On a long stroll, I began a conversation with Pablo Vázquez-Gestal about Bourbon Naples. Thankfully, our discussion has yet to end, and Pablo's seemingly encyclopedic knowledge of Neapolitan archives and sources has helped in many ways. Christian Kleinbub, with his keen insights about both images and ideas, has helped me give shape to my thinking on countless occasions. Stephanie Swindle, with a sharp sense of language and a keen editorial eye, read the entire manuscript and helped me in many ways as I prepared the final manuscript. I am very grateful for her love and support.

This book would not have been possible without considerable support. A postdoctoral fellowship at the Bill and Carol Fox Center for Humanistic Inquiry

allowed me to draft large parts of the manuscript. Conversations with the staff and other fellows stimulated me to think in different ways. Keith Anthony, with his boundless curiosity and exceptional gentility, was an excellent sounding board for ideas. An Andrew W. Mellon Fellowship at the Metropolitan Museum of Art permitted me to revise and complete the book. Finally, this book is published with generous support from the George Dewey and Mary J. Krumrine Endowment at Pennsylvania State University.

For help with translations and transcriptions I thank Katherine Liu and Francesca Raggi. Navigating the Neapolitan archives would not have been possible without the assistance of Fausto De Mattia and other people at the city's many institutions, among them the Archivio di Stato, Biblioteca della Società Napoletana di Storia Patria, Archivio Storico Municipale, Museo Nazionale di Capodimonte, Museo Nazionale di San Martino, Istituto Italiano per gli Studi Storici, and Biblioteca Nazionale. For various advice and assistance I thank Ryan Acton, Francesco Benelli, Jesús Escobar, William M. Chace, Jeffrey Collins, Brian Curran, Paola D'Agostino, Madhuri Deasi, Sabina De Cavi, Bianca de Divitiis, Susan Dixon, Wendy Heller, Pierette Kulpa, Susanne Meurer, Giulio Pane, José Luis Sancho, Elizabeth Bradford Smith, Catherine Whistler, and Craig Zabel.

John Wesley wrote, "An ounce of love is worth a pound of knowledge." Indeed, all of the learning that went into writing this book pales in comparison to the love of my family. I thank Karen for her enthusiasm and good humor on our numerous trips through Italy. My parents have supported me without condition, and I never could have achieved any of my goals without them. For their deep wisdom and love I am so very grateful.

ASF	Archivio di Stato, Florence
ASMUN	Archivio Storico Municipale, Naples
ASN	Archivio di Stato, Naples
AST	Archivio di Stato, Turin
ASV	Archivio Segreto Vaticano
BNN	Biblioteca Nazionale di Napoli
BSNSP	Biblioteca della Società Napoletana di Storia Patria
ING	Istituto Nazionale per la Grafica, Rome
ISCAG	Istituto Storico e di Cultura dell'Arma del Genio, Rome

Introduction

CAROLUS REX UTRIUSQUE SICILIAE *(Charles, king of the Two Sicilies)*

In 1714 Iberia was exhausted. The prolonged War of Spanish Succession (1701–14) had ground to an end. Philip V (1683–1746), the first Bourbon ruler of the realm, retained the Spanish Crown but had lost Gibraltar, the Spanish Netherlands, Milan, Sardinia, Sicily, and Naples in the process.[1] In the same year he also lost his wife, Maria Louisa of Savoy. And Philip's own sanity was precarious.

Within the year, Philip welcomed a new consort. Elizabeth Farnese (1692–1766) was the last of the illustrious Italian family that held the duchies of Parma and Piacenza.[2] Philip's minister Cardinal Giulio Alberoni and the powerful Princess of Ursins advised him to marry her. They hoped she could help Spain regain a territorial toehold in Italy. Spirited and willful, Elizabeth brought more than her duchies. The new queen sought an active role in government and did so by maintaining harmonious unity with her husband. They were inseparable in public appearances and private councils. Thus, when Philip's mental condition worsened, Elizabeth provided stable guidance for the ship of state, taking the helm of government during his periodic absences. In 1716 Elizabeth secured the monarchy in another way. She bore a son, Charles, who would become king of the Two Sicilies (1734–59) and eventually king of Spain (1759–88) (fig. 1).

Charles of Bourbon would cobble together the monarchy of the Two Sicilies from two viceroyalties. He would also make a capital out of its metropolis, Naples. This undertaking would require one of the largest and most expensive building programs of the century.[3] The urban architectural program undertaken during his reign is the subject of this book. In telling its history, I aim to show that these structures not only remade Naples but also reshaped the state. Bricks and mortar helped set the foundation for Charles's power and sovereignty, and they legitimized his rule by making the built environment an active agent of statecraft. Similar studies of Henry IV of France, Philip III and Philip IV of Spain, Pope Pius VI, and the Savoy dukes of Turin have shown how rulers used architecture to legitimize and consolidate their power.[4] My goal is to explain how Caroline structures similarly gave political shape to the monarchy of the Two Sicilies.

Circumstances dictated the political uncertainty Charles faced. As offspring of Philip's second wife, he was third in line to succeed to

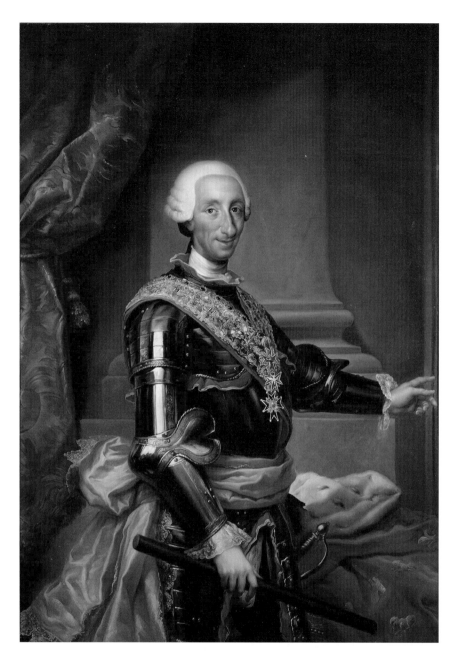

FIGURE 1
Anton Raphael Mengs, *Portrait of Charles III,* 1761. Oil on canvas. Museo del Prado, Madrid.

and the powerful ministers allied with her, Cardinal Alberoni and José Patiño, charted a foreign policy bent upon restoring Spanish control over large parts of Italy.[6] As the Spanish court worked diplomatic channels, Elizabeth groomed Charles to be heir in Parma and Piacenza. By 1730 the queen succeeded in passing the duchies to Charles, as well as in making him hereditary Grand Duke of Tuscany. To secure these titles, the queen hastened her son to Italy, and by 1731 the infante set sail for Livorno to take up residence.[7] Gian Gastone Medici lavishly received Charles as heir apparent in Florence, and the infante was warmly welcomed with elaborate festivals in Parma and Piacenza.[8] Yet his parents were not content with modest fortune. Philip V had given Charles the sword Louis XIV had bestowed upon him when he departed to conquer Spain, and he and Elizabeth filled the infante's retinue with men ready for conquest. She wrote to her son, "Go therefore and conquer; the most beautiful Crown in Italy awaits you."[9]

That lovely Crown was of the two kingdoms of Naples and Sicily. Together they constituted almost all of Italy south of Rome. Ruled over by a succession of Norman, Swabian, Angevin, Aragonese, and Spanish and Austrian Hapsburg dynasties, these territories were the storied and contested jewels of the peninsula. Their riches had dimmed in the course of the seventeenth century as economic activity shifted to northern Europe, but their fertile agricultural lands remained prized possessions. In addition, the Crown carried prestige. Until 1720 Naples and Sicily were the only kingdoms in Italy and were together known simply as "the kingdom."

Succession to this prestigious throne was often contested, and was complicated by titular fealty to the pope. Having held

the Spanish throne. Though he would eventually become king of Spain, this outcome seemed remote in the 1720s. His mother did not want him to be a mere cadet member of the Spanish royal family, and fretted over how to give her son an independent realm.[5] She

suzerain authority at the time of Frederick II (1198–1250), the papacy did not cede its right to approve successors. Pretenders often found sympathetic support in Rome. Plotters were welcomed and sometimes recruited, and popes offered the kingdom as a reward for military support from France, Spain, and the Holy Roman Empire. At the opening of the sixteenth century this political gamesmanship led to a prolonged struggle for control between Spain and France. Spain emerged the victor, and Ferdinand II (reigned 1479–1516 in Sicily and 1504–16 in Naples) made the kingdoms into viceroyalties in 1504. A continuous succession of Spanish viceroys ruled Naples for roughly two centuries thereafter. Yet even during the relatively stable period of viceregal rule, the papacy periodically disputed the investiture of the kingdom.[10] For example, Clement XI (1700–1721) refused to invest Philip V with the title, opening the way for the Austrian Hapsburgs to seize Naples in 1707. Austria maintained the existing apparatus of viceregal government but curbed the independence of viceroys by appointing many court posts from Vienna.[11]

After twenty-five years, Austrian control came to an abrupt end. On 1 February 1733 Augustus II of Poland died, sparking the War of Polish Succession. Armies mobilized to take advantage of the turmoil, and knowing that Emperor Charles VI would have to guard the border to his north, the Spanish sovereign ordered their sons and generals to lead a Hispano-Italian force south in March of 1734.[12] Spanish success was swift. Naples and the mainland soon fell. Sicily followed, and the teenage infante, having received the realm from his father, arrived in Palermo to be crowned king. Within months the two Crowns were combined into that of the Two Sicilies, but since the king was both Charles III of Sicily and Charles VII of Naples, he was simply known as Charles of Bourbon.[13]

Palermo would not be the capital. The honor fell to Naples (fig. 2), which, since the 1280s, had been the political and cultural heart of southern Italy. The House of Anjou first made it the seat of power, drawing Giotto, Simone Martini, Petrarch, and Boccaccio to their court, building new structures, and

FIGURE 2
Alessandro Baratta, *Fidelissimæ Urbis Neapolitanæ*, 1629, with indications of relevant districts by the author. Engraving.

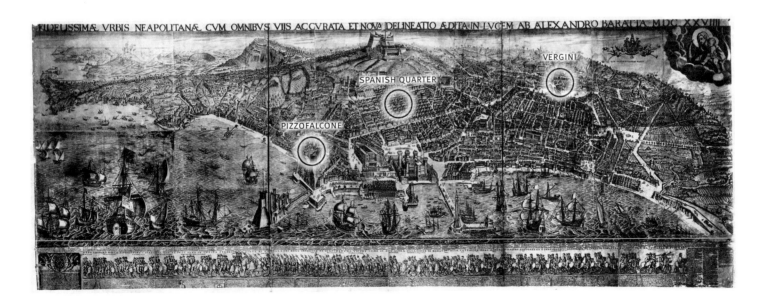

laying out public spaces. Their cultural legacy continued in the fifteenth century under the Aragonese dynasty, which lavished patronage on humanist scholars to create one of the most vibrant courts in Europe. King Alfonso commissioned an edition of Vitruvius, Francesco di Giorgio Martini directed fortification improvements, and Pietro da Milano built the magnificent Aragonese Arch framing the entrance to the Castel Nuovo.

Charles made Naples the seat of a resident king for the first time in almost two hundred years. In its streets people, "know[ing] the great benefit that will result from having a monarch reside here,"[14] proclaimed, "Thank God we are no longer provincials."[15] Yet the city was unready for the role of royal capital, even though the viceroys had not ravaged Naples, as many Bourbon supporters claimed. The city, in fact, had prospered under some charismatic viceroys. Pedro Álvarez of Toledo (1532–1553) proved an energetic ruler, expanding the urban territory, improving the kingdom's defenses, and encouraging a multinational court that reflected the Hapsburg composite monarchy.[16] His legacy continued under the Castro Counts of Lemos (Fernando Ruiz, sixth count, 1599–1601; Francisco Ruiz, eighth count, 1601–3; and Pedro Fernández, seventh count, 1610–16), who erected a large *palazzo reale* as the official residence of the viceroys and the representational *alcázar* of the distant king.[17] Other viceroys, from the Count of Oñate (1648–53) to the civic-minded Duke of Cardona (1666–71), established and renovated important buildings.[18]

Until the middle of the seventeenth century, Naples was loyal to the king, meriting its title of "most faithful." Yet among the realms of the king of Spain, taxation fell hard on Naples and Sicily.[19] Likened to Castile for the ease with which the monarchy could levy taxes and request military contributions, Naples suffered under the heavy toll. Equally problematic, the Spanish left a confusing tangle of local institutions intact, which allowed the nobility, clergy, and civic magistrates to gain considerable power. The Crown also granted fiefdoms within the kingdom to noble families in Rome, Genoa, and Milan in an effort to increase Spanish hegemony in northern Italy.[20] This system of government, complicated by powerful internal and external parties, led to economic abuse and created several social ills. In the countryside aristocrats held vast feudal estates with full legal jurisdiction, but many lived much of the year in Naples or resided outside of the kingdom. Revenue flowed out of the provinces at alarmingly high percentages. Absenteeism combined with taxation policies to make peasant life difficult. To seek opportunity and gain exemption from feudal taxes, the poor migrated to Naples in vast numbers. By the mid–seventeenth century this city was the third most populous in Europe, overwhelmed with a large number of urban poor.

Nobles, churchmen, merchants, and jurists assiduously sought their own ends within the existing social system. Art, architecture, music, learning, and charity thrived. Caravaggio, Jusepe de Ribera, Artemisia Gentileschi, Giovanni Lanfranco, Luca Giordano, and other painters achieved great success in Naples. Its reputation for philosophy and science was bolstered by Giambattista della Porta, Tommaso Campanella, and Giambattista Vico. In music, it reigned supreme. But weak central authority prevented a comprehensive answer to Naples's civic troubles. The results of unchecked local powers and heavy taxation were felt in 1647 when a fisherman named Masaniello led a plebeian revolt that overthrew

the viceroys. Don Juan of Austria quickly restored Spanish power, and attempted to curb local autonomy in the wake of the rebellion. Yet while loyalty to the person of the Hapsburg monarch was restored, the viceregal government increasingly became a target of popular discontent. As in many parts of the Spanish empire, the cry in the streets of Naples was "Long live the king, and death to bad government!"[21] Perceptions of the viceroys' ineptitude only grew after the plague of 1656, which killed tens of thousands of Neapolitans.

Political and economic power could be read in the urban core. Magnificent noble palaces rose along the hill of Pizzofalcone and in the old city center (fig. 2). Convents, filled with members of wealthy noble families, expanded unchecked and absorbed land to create enormous cloisters.[22] Public space in Naples was scarce, and its admired piazzas became overcrowded and chaotic. Municipal magistrates charged with urban planning and construction set down new edicts on building and expansion, but codes could not mask the poor infrastructure, insufficient public works, and aborted attempts to order the capital.[23] At the opening of the eighteenth century aqueducts and roads were in disrepair. Planners defended an edict that forbade expansion beyond the sixteenth-century walls in hope that by limiting space for growth they could discourage migration from the countryside.[24] Instead, the brimming city grew vertically, with buildings rising along its narrow streets like escarpments. Eventually the edict was violated, and districts such as the Vergini developed without oversight or organization. As one contemporary phrased it, Naples was tattered and sick like a man long imprisoned.[25]

Neapolitans greeted the new king with a mixture of hope and apprehension. It was troubling that the teenage sovereign had been reared in a tumultuous court. Philip V suffered from depression, which had significant consequences for the royal family. Court life followed his whim, often shifting to a nocturnal schedule. The king was frequently indisposed, and his advisors and consort insulated him from political life, going so far as to move the royal family to Seville for four years. Overwhelmed by his illness, Philip abdicated in favor of his son Luis I in 1724, only to reassume the throne after the young king's death.

Amidst this tumult Elizabeth maintained order. She was an active and ambitious consort that an admiring Frederick II claimed "would have governed the whole world." He stated: "The pride of a Spartan, the obstinacy of an Englishman, the cunning of an Italian, and the vivacity of a Frenchman, jointly formed the character of this singular woman; who marched audaciously to the accomplishment of her designs; whom nothing could surprise, nothing could impede."[26] These qualities are evident in the way she dominated her husband. During his bouts of mental illness she locked him in his apartments and deprived him of pen and paper lest he attempt to abdicate.[27] In domestic politics, she tenaciously pursued reforms that strengthened the Crown and her personal power. Yet the formidable Castilian aristocracy checked her influence beyond the palace walls and limited many of these policies. It was in foreign affairs that she, Alberoni, and Patiño triumphed. By 1750 her children were all secured with important titles.[28]

Charles was his volatile father's foil.[29] As depicted at middle age (fig. 1), he had a narrow face, lively blue eyes, and a bulbous nose. He typically wore a grin, which made him appear good-spirited and disarmingly informal. Visitors always noted his physical

ugliness but hastened to laud the affable and modest manner revealed by his smile. Obsessed with hunting and fishing, the outdoor activity made him strong and thin but also left him so tan that when observed getting dressed he was described as having an ivory torso with head and hands of porphyry. Ambassadors and courtiers, often physically spent after the king's hunting expeditions, criticized his lack of attention to more important matters.[30] But Charles explained his love of sport by saying it kept the family illness of depression at bay. Close friends, he said, should pity, rather than envy, his love of outdoor exertion.[31] The king hated the formality of court ritual in equal measure to his love of hunting and was thankful to return to his quarters to remove ceremonial garb. Breaking in new clothes was also a burden, and he would often leave more comfortable attire on a table for ready use. Despite these humanizing qualities, Charles was not a people's king. True to the remoteness prescribed by Spanish court etiquette, he maintained distance and privacy.[32]

Fierce loyalty was the quality he manifested most openly. He was deeply devoted to his wife, committed to certain court ministers, and protective of servants. His steadfastness gave others confidence in his word. He was "the most honest king who has ever existed,"[33] according to one account. Yet he was also notoriously difficult to read. When Pope Benedict XIV met him, Charles only gradually revealed his intelligence and good judgment. Benedict wrote, "We discoursed for an hour and a half, touching on various subjects, entering into diverse points, and in this conversation he demonstrated qualities that were hidden a few moments before, that would not be recognized . . . except by one who knows how to distinguish them, given that the king clothes

himself in a heroic modesty."[34] This cloak of modesty could hide aspects of his personality. Sir James Gray, passing along observations made by Spanish ambassador Clemente Aróstegui, reported, "The King of Naples, he said, is of a very reserved Temper; a great Master of Dissimulation, & has an habitual Smile on his Face, contracted by a constant Attention to conceal his Thoughts; Has a good Understanding and a surprising Memory, as his Father had; is unread and unlearned, but retains an exact Knowledge of all that has passed within his own Observation, & is capable of entering into the most minute Detail."[35] Far from unlearned, Charles was multilingual and cultured. His education included history, geometry, military tactics, fortification, Latin, Italian, and French.[36] Though he claimed not to enjoy music, study, or reading, the king liked art. Over the course of his life he patronized Francesco Solimena, Giovanni Paolo Panini, Anton Raphael Mengs, Giambattista Tiepolo, and Francisco de Goya. Under his aegis the university in Naples was reformed, excavations at Herculaneum begun, an art academy founded, and the Royal Porcelain Manufactory at Capodimonte set up.[37]

However, any consideration of the king's role in government and art patronage must take into account his long rule. At the beginning of his reign, roughly from the year he assumed the throne until the death of his father, in 1746, the Spanish court dictated the royal government's policies in Naples. His parents set the political agenda, selected his most important ministers, controlled foreign affairs, and were briefed on every activity at court.[38] After Philip's death (1746) and the conclusion of the War of Austrian Succession (1748), Charles took a more active role. At this point Ambassador Aróstegui observed, "In many

things the king works himself like a minister, and every day passes many hours alone in his study; he has complete confidence in his own judgment and is so obstinate that rarely can one convince him to change his mind. He has a high opinion of his prerogatives and his independence and is convinced that he is the most absolute ruler in Europe."[39] The ambassador's implicit doubt of the king's absolute power resonates with historians' revaluation of absolutism.[40] Established local interests remained resistant to centralized rule, and despite reform efforts they retained a number of privileges. Nor did the king work alone. He depended on collaborations with local authorities and elites and relied upon a circle of ministers and powerful courtiers, some of whom lamented the occasions when he acted on his own judgment.[41] The king's role in shaping policy must therefore be balanced with a fair accounting of contributions by other members of the court.

Common wisdom in Italy held that the quality of a ruler be judged by the competency of his advisors.[42] In Spain, a monarch's principal ministers were even more important. Elizabeth depended upon Alberoni and Patiño, just as Philip III relied on the Duke of Lerma and Philip IV the Count-Duke of Olivares. Before Charles's departure, Elizabeth and Philip assigned him a powerful majordomo that they hoped could fulfill a similar role. Manuel de Benavides y Aragón, the tenth Count of Santiesteban del Puerto (served 1734–38) would shape the infante's court and early government.[43] His aristocratic roots, familiarity with court ceremonial, understanding of the trappings of royal majesty, and knowledge of Spain's international politics made him a natural choice. Named chief majordomo, he would appoint ministers and fill government posts.

Following the Spanish model, Santiesteban established court secretaries of state, though the Neapolitan government had four rather than the three that were typical in Spain. Santiesteban wisely drew the ministers from the king's various territories. The secretary of mercy and justice (*grazia e giustizia*) oversaw the legal system, and Bernardo Tanucci (served 1737–76) held the office for the king's entire reign. Tanucci, a Tuscan jurist, was shrewd, learned, and accomplished in Latin. These qualities served him well as he attempted to bring clarity to the kingdom's byzantine codes. He also fought to broaden the jurisdiction of the royal government, though it set him at odds with existing aristocratic and ecclesiastical privilege.

The secretary of ecclesiastical affairs (*affari ecclesiastici*) was instead a Neapolitan, Gaetano Maria Brancone (served 1737–58). He was responsible for finessing diplomatic relations with Rome, supervising the kingdom's religious institutions, and censuring books. Though Tanucci questioned Brancone's intellectual capacity to handle these tasks, the Neapolitan proved remarkably able. More important to Charles, he was exceptionally loyal.

Commerce, war, and the navy fell under the purview of the secretary of finance (*azienda*). This post was first held by the Sicilian Giovanni Brancaccio (served 1737–53), who was succeeded by another Sicilian, Leopoldo de Gregorio (1753–59). Both men capably oversaw the kingdom's financial health and sought to encourage trade. Their efficiency made them dependable and eventually led to de Gregorio's assumption of the most important duties of the government.

The secretary of state, or first secretary of state, since all of the other ministers were technically termed secretaries of state, had

the most important duties. Responsible for foreign affairs and setting the agenda of the royal council, called the Real Camera di Santa Chiara, the secretary of state was the most powerful of the four. Officeholders changed three times during the king's reign. Charles's first, José Joaquín de Montealegre (served 1734–46), initially deferred to Santiesteban. After the majordomo's return to Spain in 1738, Montealegre headed a vast program of internal reform in consultation with Elizabeth. Enormously energetic, he focused on curbing the power of the nobility and spurring commercial growth. Montealegre was succeeded by Giovanni Fogliani Sforza d'Aragona (served 1746–55), a nobleman from Piacenza who lacked the charisma of his predecessor. Fogliani was a seasoned diplomat who strengthened the kingdom's contacts in Europe. But his measured style and his disagreements with the Neapolitan queen prevented him from matching Montealegre's reforms. After Fogliani's dismissal, in 1755, Bernardo Tanucci assumed the leading role but shared responsibility with Leopoldo de Gregorio. The latter, a shrewd and steely magistrate, had climbed to prominence as the secretary of finance. He shepherded many projects to completion and was scrupulous at checking bills and maintaining timetables for the king's buildings. De Gregorio would follow the king to Madrid, where, as the Marquis of Esquilache, he was principal architect of Charles's reforms in Spain. Together these men waged campaigns silent and public and filled lawbooks with edicts that banned abusive practices and encouraged progress.[44]

The queen was also an active participant in policy decisions.[45] Maria Amalia of Saxony (1724–1760) had a mannish face, a shrill voice, and an impatient character. She was vocal on issues of state, and the king consulted her and listened to her opinions. But he was not beyond good-humored reprimands of her headstrong manner. Exceptionally educated, she also had developed a love of music and porcelain in her native Dresden. Naples became the city she loved the most, and she genuinely loved her husband too. They had eight children, and after she died, in 1760, Charles remained a chaste widower.

The king's enthusiasm united with that of the queen when commissioning buildings. Charles had grown up in the shadow of Hapsburg Spain, where the builder kings Philip II and Philip IV left enormous legacies in brick and stone.[46] He knew the Escorial, San Ildefonso, Aranjuez, the palaces and public spaces of Madrid, and saw many of Spain's cities as his father toured the country. His first letters from Italy brim with enthusiasm about structures. The Medici villas and tombs, the Farnese palaces in Piacenza and Colorno, and the Norman Palace in Palermo all earned his admiration.[47] For her part, Maria Amalia had watched Dresden be remade by George Bähr and Matthäus Daniel Pöppelmann. Her grandfather had constructed the Zwinger palace and commissioned the city's Frauenkirche.[48] It is not surprising that on her way to Naples her retinue stopped to examine cities and their most important buildings.[49] From their letters and the accounts of others, we know that the royal couple had strong opinions on structure, style, and construction. Documents reveal that they examined models, recommended changes, and dictated design features. The architect Luigi Vanvitelli reported his conversations with them, and as the following chapters show, they were very particular about planning. Yet they were less engaged with the tasks of construction and finance and left these important

logistical challenges to court ministers and architects.

Among their projects, they improved roads and aqueducts and built enormous palaces outside of Naples at Caserta and Portici, structures that, despite a substantial scholarly literature, merit greater research. In the capital, the sovereigns commissioned the monumental public buildings that are the focus of this book. Built for more than the mere sake of building, each structure addressed important civic needs. The buildings also shaped the monarchy's relationship with its subjects. For, by providing space for theater, charity, military training, and trade, the royal government united people in spaces that bore the king's imprimatur. Yet the Caroline buildings of Naples should not be viewed as a comprehensive program hatched in a single moment by the royal government. The impetus for each structure was often conditioned by immediate needs, both practical and political. The Teatro di San Carlo (1737) provided the largest venue for opera in Europe and brought the nobility to the court by connecting the theater to the Palazzo Reale. It was the first building the monarchy built, and arose out of the political expediency of drawing the aristocracy to the Crown. The Reale Albergo dei Poveri (begun 1751) was conceived much later in the king's reign, and offered charity to Naples's enormous mendicant population. It also helped the monarchy reduce the influence of ecclesiastical charitable foundations by consolidating activity under Crown supervision. The cavalry barracks at the Ponte della Maddalena (1754–63) was erected at a time when the military was being completely reorganized. Echoing policy changes, it helped outfit the growing army with adequate housing, reinforce rank and order, draw the nobility into military service, and police the capital.

Finally, the Foro Carolino (1759–65) provided shops, residences, and ordered open space, even though the project began as an effort by the city government to erect an equestrian statue to the king. The monarchy depended upon ministers to steer building projects to completion and make them effective instruments of political policy. Montealegre oversaw the San Carlo, Brancone guided the Albergo dei Poveri, and de Gregorio supervised the cavalry barracks. They were responsible for making sure each work site was efficient and each commission sufficiently funded. Each of the following chapters explores how they completed each building and how the structures figured in Caroline political, social, economic, and cultural renewal.

Charles and his ministers were among the most ambitious sponsors of public buildings that satisfied civic needs. In Berlin, Frederick II hatched a contemporaneous ensemble around his Forum Fridericianum, and Peter I of Russia established a number of public buildings in St. Petersburg during the preceding generation. Rome and Turin also joined Naples in building large hospices, hospitals, granaries, archives, and military quarters,[50] and Amsterdam, London, and Paris were at the vanguard of this wave of civic architecture.[51] While the types of buildings erected in the early eighteenth century had roots in previous epochs, such as Medici Florence, Renaissance Venice, Henry IV's Paris, Charles II's London, Christian IV's Copenhagen, and Hapsburg Antwerp and Madrid, they are distinguished by the discourses of Enlightenment reform that accompanied them. With the growth of the bourgeoisie, the boom in newspapers, journals, and books, and increased travel, opinions on building proliferated. It was no longer sufficient merely to commission structures.

To withstand the scrutiny of pamphleteers and the public, buildings had to be tied to social and economic improvement.[52] Many buildings in Naples were, and how they improved civic life is explored in each chapter.

It is informative to compare the frenzy of construction in Naples with the vast undertakings of Philip IV and Louis XIV. The planet king and the sun king were both Charles's ancestors. Both had constructed hospices, public squares, and structures for the military. These buildings, like Buen Retiro and Versailles, were architectural expressions of royal authority. Similarly, they centralized court and civic functions in buildings sponsored by the Crown. Charles was linked with Louis in panegyrics, but one must be cautious not to liken the buildings of the monarchs too closely.[53] Naples's civic infrastructure dictated what types of buildings were needed and considered. They were also built in a severe style that had more in common with Hapsburg architecture in Spain than with Bourbon architecture in France. The *estilo austriaco* of Iberia bore a moral message that had been articulated as early as the reign of Philip II.[54] Spanish majesty would be conveyed not through architectural opulence but through austere authority. The buildings in Naples therefore occupy a fascinating juncture where dynastic stylistic precedent dovetails with renewed focus on the public utility of architecture.

Building for the civic good helped convince foreigners and citizens that the king was an able ruler. This was crucial, since the monarchy was immediately challenged by European powers. In 1737 the king was forced to cede his rights to Parma, Piacenza, and Tuscany. England used gunboat diplomacy to compel the Two Sicilies into action during the War of Austrian Succession (1740–48). And in 1744

Bourbon forces battled the army of Maria Theresa at Velletri in order to preserve Charles's claim on the Two Sicilies. Diplomatic recognition and military might were essential to dynastic stability, making the public spectacles of the Teatro di San Carlo and the efficiency of the cavalry barracks at the Ponte della Maddalena instrumental to the sovereign's power.

Domestically, the royal government faced many thorny subjects whom it had to convince to remain loyal. The court appeased the clergy and nobility by granting rewards. It helped the poor by offering assistance and job training. And the monarchy maintained public order with a modernized military. Throughout, the king and his advisors modified the existing political and social system without overturning it. They gradually centralized power, often in the guise of partnerships. For example, to finance architectural commissions, the royal government turned to local powers for contributions. The construction of the Teatro di San Carlo, Albergo dei Poveri, and Foro Carolino required fundraising from nobles, clergy, and the city government. Their fiscal participation cemented partnerships with the monarchy and made them party to the royal government's improvements of Naples. Yet collaboration required compromise, and each building's history reveals the court's pragmatism, an aspect of royal patronage that has been stressed in analyses of other cities.[55]

To pay for part of construction costs, the kingdom initially received enormous subsidies of American silver via Spain. As the English consul wrote in 1734, "It is certainly for the advantage of this city and kingdom to have a sovereign reside among them, who brings money into the country from Spain and carries none out."[56] Yet good fortune alone could not justify the amount spent on buildings. Instead,

contemporary perspectives on royal architectural patronage help explain how the king was able to build on such a scale.

Royal building had long been deemed the decorous embodiment of majesty and magnificence. Indeed, basing their opinions on the writings of Aristotle, Renaissance theorists applauded architectural projects that were commensurate with a patron's wealth and power.[57] Princely power justified lavish projects, and the Aragonese Arch of the Castel Nuovo in Naples embodied the belief.[58] In Spain, the theory of magnificence was deepened and elaborated in the writings of Jerónimo Castillo de Bovadilla (ca. 1547–ca. 1605).[59] Great buildings, he argued, gave eternal fame to great monarchs by impressing their accomplishments upon future generations. Royal buildings also delivered immediate benefits to society, stimulating economic activity, providing work, and improving civic life. The Spanish school of political economy mirrored its different stylistic values. Italian palaces sought to impress the observer through ornament. In Spain style was calibrated to convey authority rather than riches. The Escorial achieved the same ideological goal as the Aragonese Arch, but through scale, geometry, and austerity.

In the second decade of the eighteenth century, theorists began to focus more on the civic and economic benefits that Castillo de Bovadilla articulated. French discourses, from that of Nicolas Delamare (1707) to many others through the reign of Louis XV, focused attention upon the virtues of royal projects, arguing for their positive effects on national pride to civic welfare. In Naples, royal historiographer Giambattista Vico (1668–1744) felt that magnificent buildings commissioned by enlightened kings had a civilizing effect.[60]

More persuasive eighteenth-century theorists articulated specific economic benefits. As Antonio Genovesi (1712–1769), professor at the University of Naples and first chair of political economy in Europe, defined it: "Public luxury is that which courts of sovereigns display in their public functions, both domestic and foreign, such as public appearances, festivals, buildings, embassies, etc. Public luxury also means that which cities want to distinguish themselves, such as buildings, public houses, piazzas, fountains, festivals, etc."[61] Bernard de Mandeville, Jean-François Melon, and Voltaire shared Genovesi's positive view of public luxury. These theorists also posited that the built environment could stimulate progress, provide jobs, and improve urban life. Alighting on the term "public happiness," or *pubblica felicità*, Ludovico Antonio Muratori (1672–1750) agreed, and expanded their reasoning. He felt that sumptuous public buildings were the best evidence of a healthy state. Look at a city, he said; if the buildings are finely built, so too is the society behind them. Genovesi gave this argument a monarchical twist, stating that a well-built city and a healthy state were inseparable from a robust monarchy.[62] For him, grand sovereigns led thriving nations. Buildings therefore not only burnished the king's image but also reflected the prosperity of all his people.

Bourbon luxury had critics, though. Philosopher Paolo Mattia Doria (1662–1746) felt that surplus spending undermined social cohesion. A similar argument was used by Oliver Goldsmith in his 1770 poem "The Deserted Village":

O luxury! Thou curst by Heaven's decree,
How ill exchanged are things like these for
 thee!

How do thy potions, with insidious joy,
Diffuse their pleasures only to destroy!
Kingdoms by thee, to sickly greatness
 grown,
Boast of a florid vigour not their own:
At every draught more large and large they
 grow,
A bloated mass of rank unwieldy wo;
Till, sapp'd their strength, and every part
 unsound,
Down, down they sink, and spread a ruin
 round.[63]

Goldsmith's appeal would eventually be overwhelmed by Adam Smith's tide of capitalist economic reasoning. Likewise Doria was marginalized and withheld publication of his *Idea per una perfetta repubblica* rather than face royal censure.[64] While a few subsequent historians would take up his criticisms to disparage Charles's reign, their opinions find little resonance in contemporary accounts.[65] The royal government spent lavishly on architecture, but most observers saw such works as part of the kingdom's prosperity. Great buildings rose, the economy grew, and agricultural production increased along with the population.

This cursory survey of the political and economic state of the kingdom reveals its needs and how the royal government aimed to address them. The artistic firmament was entirely different. Naples had a long, rich, and thriving tradition of architecture.[66] After its brilliant florescence under the Angevins, important building activity never ceased. The seventeenth century opened with monuments erected by Domenico Fontana and his son Giulio Cesare, including the Palazzo Reale. The city then became home for the fertile imagination of the Bergamese sculptor and architect Cosimo Fanzago, whose magnificent marble revetments and carvings transformed the interiors of Neapolitan churches into vibrant displays of form and color. At roughly the same time, the archaeological mind of Francesco Antonio Picchiatti revived archaic motifs and recombined them with novel decorative features in the city's churches. In the eighteenth century Domenico Antonio Vaccaro blended elaborate stucco decoration with canonical architectural orders to give Naples its own rococo style. And Ferdinando Sanfelice, himself an aristocrat, became known for crafting magnificent and geometrically complex staircases in the palaces of his peers.

With such a strong tradition and talented pool, Naples's architects must have regarded the potential royal patronage as a boon. Yet the court rarely tapped Neapolitans to design buildings. At first it chose court engineers whose primary virtue was their loyalty.[67] Two of these, Angelo Carasale and Giovanni Antonio Medrano, designed the Teatro di San Carlo. The royal government's faith in them was ill-founded, for they were later imprisoned for embezzlement. The court then engaged Sanfelice to restore the university but, by having the architect continue an existing plan, eliminated any possible creativity.

In the 1740s the Neapolitan court imported talent rather than employ local architects. Perhaps the king, queen, and their ministers mistrusted the latter. Perhaps they imitated the patronage of Philip V, who called Filippo Juvarra from Italy rather than use local architects.[68] Likely they needed practitioners with experience designing the massive structures they would commission. The best of these architects were trained in Rome. Thus in 1751 Luigi Vanvitelli was invited from Rome to plan the Royal Palace at Caserta, the cavalry barracks, and the Foro Carolino, while

Ferdinando Fuga was called to build the Reale Albergo dei Poveri.

Fuga and Vanvitelli were among the most important architects of the century. They had been involved in every major commission in Rome during the preceding decades. Fuga had designed the façade of Santa Maria Maggiore and planned the Palazzo della Consulta. Vanvitelli had remade the convent of Sant'Agostino and completed the Trevi Fountain. Their arrival infused Caroline commissions with Roman influences that earned Naples continental renown. Marked by classical orders and monumental massing and articulation, their buildings broke with the color, ornament, and intricacy of the Neapolitan tradition. Little resembling their surroundings, these buildings stood out in Naples and stylistically foregrounded the king's works. Yet while they cloaked their structures in an ornamental vocabulary learned in Rome, their planning was sometimes conditioned by earlier proposals from local architects or royal engineers. By melding Roman style with Neapolitan circumstances, they proved John Locke's metaphor that "the Commonwealth of Learning is not at this time without Master-Builders, whose mighty Designs . . . will leave lasting Monuments to the Admiration of Posterity."[69]

Posterity, however, has not always been admiring. Naples remains on the margins of architectural history despite its centrality during the early modern period. Moreover, art historians have avoided the Neapolitan buildings of Fuga and Vanvitelli because they complicate stylistic interpretation. The architects shifted between severe and more ornamental manners, leading some to argue their buildings embody budding neoclassicism, while others mark them as the end of the baroque.[70] They thought of themselves as adherents of neither style.

The commission dictated the style, and the architects' minds teemed with different modes of architectural expression that they could summon at the draftsman's table. Such adaptability made them valuable to Charles but makes them slippery for stylistic classification. Indeed, the appreciation of eighteenth-century Italian architecture has been crippled by its defiance of stylistic categories. Recent research has rightly begun to emphasize the virtues of heterogeneity.[71] To understand Fuga's and Vanvitelli's Neapolitan commissions, we must likewise admire their adoption of various styles according to circumstances.

The architects drew their mutable manners from a lifetime of studied examples. They knew the greatest buildings in Italy, both ancient and modern, and often looked beyond the peninsula.[72] They were familiar with designs and buildings in France and Spain. Documents are peppered with references to structures in Prague and statues in Copenhagen. Vanvitelli wrote confidently of buildings in Stockholm and St. Petersburg. They worked in a period of exceptional cosmopolitanism, which Laurence Sterne characterized in his *Sentimental Journey* as "an age so full of light, that there is scarce a country or corner of Europe whose beams are not crossed and interchanged with others—Knowledge in most of its branches, and in most affairs, is like music in an Italian street, whereof those may partake, who pay nothing."[73] Caroline Naples reveals how the period's free interplay of ideas and examples influenced architecture.

In tracing the themes of cosmopolitanism and political legitimization, I hope to arrive at a deeper understanding of the structures themselves. Doing so should plant them firmly in the history of architecture. And by linking the stories of these buildings together, Naples will

reemerge as the dynamic center of architectural innovation that it was under Charles of Bourbon.

The king had a long reign. Not all of it was in Naples. In the autumn of 1759 Charles left for Spain, where the death of his half brother left the throne vacant. Some of his commissions were unfinished, and the king would follow their construction from Madrid. Some remained incomplete, but Naples had been profoundly reshaped, and the dynasty's place was secure. The capital was celebrated in the magnificent map of Giovanni Carafa, the duke of Noja (1775), which is examined in the final chapter of this book. It was also lauded in a new translation of Vitruvius by Bernardo Galiani (1758), who dedicated the volume to the king. These works and others enshrined Charles among Naples's greatest rulers, and despite the limits of his centralizing efforts, contemporaries and historians praised him as one of the most successful reforming monarchs of his generation.

When called to Madrid, Charles took architects and ministers with him. Yet he left many behind in Naples. Vanvitelli and Fuga both remained. In a ceremony on 6 October Charles ceded the throne to his eight-year-old son, Ferdinand, by handing him the sword that had been wielded by two generations of conquering Bourbons. After an evening of farewells, Charles and Maria Amalia rose the following morning and were accompanied by crowds to the harbor.[74] As the fleet fired a welcoming discharge, the sovereigns were rowed out to the flagship that would carry them to Barcelona. It was fittingly christened the *Phoenix.* From its deck they could admire a resurrected capital. We will do the same, but with the king, his consort, and court within our frame of vision so that we can see how remaking a city helped shape a monarchy.

The Teatro di San Carlo

LITERIS ARTIBUS EXCITATIS ORBE PACTO THEATRUM QUO SE POPULUS OBLECTARET *(This theater is dedicated to the learned arts, stirred in the designated ring, so that the people may amuse themselves)*

—Inscription above the portal of the Teatro di San Carlo, 1737

The first royal commission was a theater (fig. 3). Begun in 1737, just a few years after the conquest of southern Italy, it heralded the monarchy's boldness. Completed in an astounding eight months, it was the largest opera house in Europe. And it housed an art that the Neapolitans viewed as proprietarily theirs. Throughout Europe Naples was renowned as "the capital of the music world."[1] By building a new theater and giving it the name San Carlo, the Crown drafted the city's cultural strength into its own efforts to solidify power.

Yet the king did not love opera. In November of 1739 he "talked through one half of the opera and slept through the other."[2] Another opera he termed "L'inclemenza di Tito" for its extreme length.[3] The opera house had little to do with the monarch's tastes, and the king was little involved in the commission. His mother, majordomo, and secretary of state seem to have planned the San Carlo. They did so not merely to harness culture. They also used the San Carlo to draw the nobility to the Crown. Opera houses were the Neapolitan aristocracy's favorite social venue, and by appropriating

that type of structure and connecting it to the palace, the court hoped to exert greater control over the nobility. The San Carlo was therefore a political space, where the most important social and cultural activities in Naples were brought under the purview of the monarchy. The Crown regulated seating, set programming, and established rules for house etiquette. Spectacles delighted but, more importantly, instructed, with plots, arias, and choruses that emphasized the virtues of royal rule and civic harmony. Artfully crafted society and morally inflected art therefore served early and crucially to legitimize Charles's sovereignty.

Though most records of the theater were destroyed in the Second World War, many important sources were transcribed in earlier studies. Some new archival material has been discovered, and many accounts by ambassadors and court officials help deepen the historical record. Yet despite a considerable bibliography, histories of the building remain inexact.[4] This chapter gathers the information together with a more comprehensive survey of contemporary accounts from travelers and court officials to bring clarity to the building's history. But the

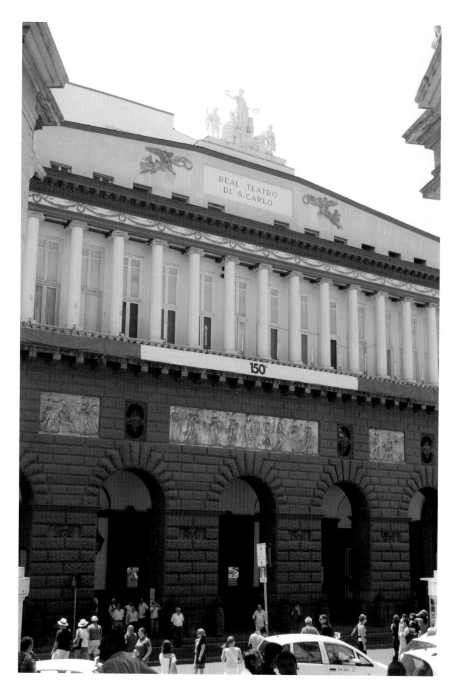

FIGURE 3
Teatro di San Carlo.

houses and adopted the relatively new shape of the horseshoe auditorium. The acoustical consequences of its scale and shape have not been adequately explored. Examination of orchestra size, musical compositions, and singing styles sheds some light on the possible effects of the San Carlo and suggests that the form and size of the theater caused changes in music. The dominance of Neapolitan music in the eighteenth century, I argue, helped lead to the subsequent dominance of the horseshoe.

OPERA IN NAPLES

In the eighteenth century Naples was pre-eminent in music. Concerts in the *sale* of noble palaces, festivals in churches, and performances in theaters were lauded for their compositions, singers, and musicians. Joseph Jérôme de Lalande proclaimed, "Music is, above all, the triumph of the Neapolitans";[5] Pierre Jean Grosley felt that in music "Italy may be compared to a diapason and Naples the octave";[6] and Jean-Jacques Rousseau feverishly counseled, "Run, fly to Naples and listen to the masterpieces of Leo, Durante, Jomelli, and Pergolesi."[7] To these names we could add the singer Farinelli and the composers Vinci, Piccini, and Paisiello. Neapolitan musicians held important posts across the continent and formed the epoxy that held together European music in the galant style.[8] The appellation evokes the life of royal capitals and courts where it was widely popular. It was marked by clear melodies, in contrast to the contrapuntal intricacy of the baroque.

The institutions that produced these musicians and propagated the galant style were a group of charitable foundations affiliated with religious orders.[9] Set up to school foundlings in the mid–sixteenth century, conservatories blossomed during the seventeenth. Under the

question of how the building buttressed the new government is a more important avenue of exploration.

The influence of the plan of the San Carlo is another. It exceeded the scale of all previous

direction of master teachers such as Nicola Porpora and Francesco Durante, their schooling became an essential stepping-stone for aspiring musicians. They also benefited from the expertise of court composers like Alessandro Scarlatti, who taught as part of their duty to the viceroys and often found positions for students in important orchestras. Families from around the kingdom sent young boys to Neapolitan conservatories in hopes that ten years of training would lead to successful careers.

Musicians from the conservatories found patronage in multiple venues, both in Naples and beyond. Some were employed by the city's many religious foundations and confraternities. Others found posts as chamber or chapel musicians for the archbishop or viceroy. Many were regularly contracted for entertainments in the city's noble palaces.[10] However, it was the aristocracy's love of opera that forced performances out of private homes and into theaters, where the most lavish spectacles took place.

By the eighteenth century the opera house had become "the throne of music," where "she [could] display all of the pomp of her enchantments."[11] Naples had four major ones (fig. 4): the Teatro dei Fiorentini, the Teatro della Pace, the Teatro Nuovo, and the Teatro San Bartolomeo. Two of these theaters, the Fiorentini and San Bartolomeo, were located in the traditional "theater district," an area between the port, Via Medina, and Castel Nuovo.[12] The compact Teatro Nuovo was found to the west of these, in the heart of the Spanish Quarter. The most distant was the Teatro della Pace, located in the eastern part of the city, near Castel Capuano.[13]

Three, the Fiorentini, Pace, and Nuovo, staged *commedia per musica*. These full-length comic operas had been pioneered by the Teatro

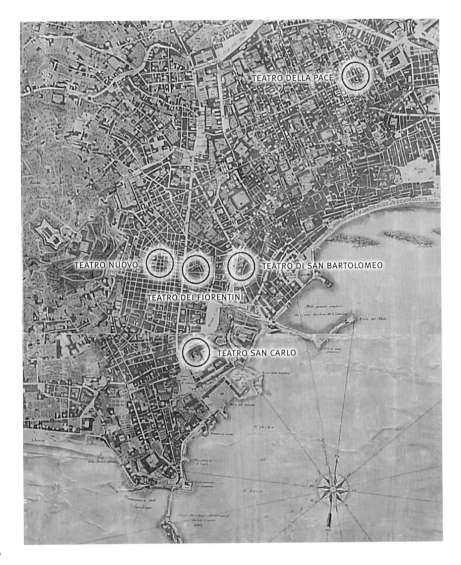

dei Fiorentini in the first decades of the eighteenth century.[14] Composers produced some of their most innovative music for these productions. With lyrics often written in Neapolitan dialect, they were popular with locals, but the dialect confused outsiders. If the confusion on stage did not keep outsiders away, the theaters' locations often did. To reach the Teatro Nuovo, carriages had to climb the narrow streets of one of the city's most densely populated neighborhoods. The area was notorious for

FIGURE 4
Map of Naples with theater locations highlighted by the author. After Giovanni Carafa, duke of Noja, *Mappa topografica della città di Napoli e de' suoi contorni,* 1775 (fig. 108).

prostitution.[15] Yet it was much better than the Teatro della Pace, which the royal government closed in 1749 for having become a bordello.[16]

The oldest of the theaters was the Teatro dei Fiorentini. It had an auditorium shaped like a boxy U and was disproportionately long, with a confusing series of stairs, corridors, and common rooms.[17] The newest, the Teatro Nuovo, was a model of spatial efficiency. Domenico Antonio Vaccaro (1681–1750), an architect, painter, and sculptor, who played the harpsichord and had a comic-opera actress as a sister-in-law, completed it in 1725 (fig. 5).[18] Confronted with a tiny parcel of land, Vaccaro ingeniously tucked a horseshoe hall into it and was lauded for doing so by the court architect

Antonio Canevari.[19] Vaccaro's horseshoe was composed of a half-round perimeter of seating joined to the stage by straight segments. He angled the boxes toward the stage, where a wide proscenium arch permitted unobstructed views. More importantly, a large number of spectators could occupy the ample orchestra seating and tiers of boxes. With a capacious hall and comic-opera programming, the Teatro Nuovo made its owners, Angelo Carasale and Giacinto de Laurentis, successful impresarios.

The exclusive venue for tragic opera, or *dramma per musica,* was the Teatro San Bartolomeo. This was the first theater in the city to stage opera (1654), and its programming shifted ever more toward *dramma per musica* in the eighteenth century.[20] This genre adapted plots from ancient myth or Renaissance epic and was performed in formal Italian. Utmost skill was needed to mold lofty narrative into compact and elegant poetry for singing, and the masterful Pietro Metastasio would ensure his fame by writing many of these opera libretti. The San Bartolomeo was also the largest house in the city, and like all theaters in Naples, it was overseen by the Ospedale degli Incurabili, which had been responsible for its construction. Basing Neapolitan management on that of the *corrales* in Madrid, Philip II had entitled the Incurabili to revenue from theaters in order to support the hospital's charitable mission.[21] The San Bartolomeo also received financial support from the viceroy, making it the de facto court theater. Viceroys attended performances and established certain artistic parameters for the theater.[22] Its auditorium had a flattened proscenium arch framed by Ionic pilasters opening onto a rectangular auditorium.[23] Parterre seating backed the orchestra pit and was ringed by two tiers of boxes and a gallery. Above rose an open colonnade and

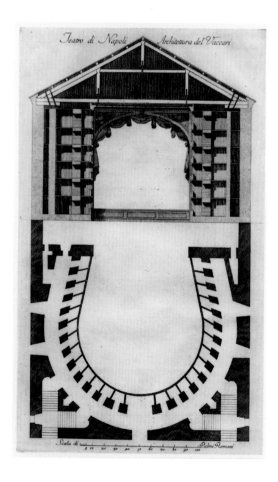

FIGURE 5
Plan and transverse section of the Teatro Nuovo. Engraving. From Cosimo Morelli, *Pianta e spaccato del nuovo teatro d'Imola* (Rome, 1780).

barrel vault fictively rendered on a flat ceiling. Despite its elegance, seeing the stage was difficult, seating cramped, and access by carriage challenging. In 1696 the number of boxes was increased, and Ferdinando Galli-Bibiena (1657–1743) was called to modify the proscenium in 1699. In 1711 the theater burned and was quickly rebuilt. Its postfire appearance is undocumented, but its shortcomings are.

In 1734 the San Bartolomeo was ailing, and a report by government officials called for a change in superintendents and reinstatement of Crown subsidies, which had been suspended during the preceding military struggle. In October of 1735 royal dispatches did both. Prince Bartolomeo Corsini replaced Lelio Carafa as superintendent, and the impresario, Angelo Carasale, was given greater liberty in programming. The confidence placed in Carasale is not surprising. He had already achieved enormous success at the Teatro Nuovo.[24] Yet though the impresario programmed better operas and billed more famous singers, the limitations of the structure undermined success on stage.

Charles praised the decoration and illumination of the San Bartolomeo, but his court recognized its shortcomings.[25] Leading his government was a loyal servant to the king and queen of Spain, Manuel de Benavides y Aragón, the tenth Count of Santiesteban del Puerto.[26] Benavides ranked among the most august Castilian aristocratic families. Under Charles II, his father, Francisco, had served terms as viceroy of Sardinia, Sicily, and Naples. No Hapsburg loyalist, Francisco rushed to support Philip V's claim to the throne and was rewarded with numerous honors. Manuel followed his father's example of faithful service to the Bourbons. He distinguished himself as emissary to the Congress of Cambray in 1720, was appointed to the cabinet of Luis I, and

took on the important role of Charles's tutor. When Charles sailed for Italy, Santiesteban accompanied him and was given the charge to form the infante's court. Santiesteban's aristocratic roots, familiarity with Spanish ceremonial, understanding of the trappings of royal majesty, and knowledge of Spain's international politics made him a natural choice for the task. Named chief majordomo, he would appoint ministers and fill government posts, all in consultation with the queen and Patiño. Punctilious about court etiquette, the count implemented Spanish Bourbon customs and deftly integrated Charles's Iberian, Neapolitan, Tuscan, and Emilian courtiers. Yet he proved as overweening as he was fastidious. Aloof and dissimulating, he was a considerable adversary and an equally frustrating partner. Flattery gained his favor, and praising his father's merits proved particularly effective.

All recognized Santiesteban's omnipresence, his privileged relationship with the Spanish sovereign, and his control over the young king. The majordomo restricted access to Charles and limited the king's participation in councils of state. As the Duke of Newcastle observed in 1734: "[T]he Count of St Stefano [Santiesteban] never leaves the Prince one moment, and seems as if his whole thought and attention was engaged and occupied about his person. None ever speak to him unless the said Prime Minister be present, and the Prince hardly ever answers anything, and never but in general terms."[27] His power at its zenith in 1737, the opera house required Santiesteban's participation and approval. The organization of seating in the opera house and its reinforcement of court hierarchy would seem to confirm his guiding role. And as Pablo Vázquez-Gestal argues, the majordomo began the project in direct consultation with the Spanish court.[28]

Elizabeth dominated decisions in Spain and tried to do the same in Naples. Charles remained tethered to her and wrote his parents often, while she and the Spanish court minister José Patiño controlled Charles's government through Santiesteban. Elizabeth had a clear political philosophy formed under the influence of Cardinal Alberoni and refined as she governed Spain during Philip's illnesses. From what she wrote in 1724 to the Prince of Asturias, Luis, she felt any successful monarch had to bring the nobility to heel.[29]

The Neapolitan nobility, like their Castilian counterparts, were powerful and sometimes thorny allies for monarchs. Roughly divided between feudal and urban aristocratic families, they maintained their baronial jurisdiction and civic privileges through all ruling dynasties.[30] Many monarchs granted concessions in exchange for their loyalty, but appeasement did not prevent rebellion. The barons' revolt against the Aragonese kings is immortalized in the bronze doors of the Castel Nuovo. Some were complicit in the 1647 Revolt of Masaniello, and more were involved in the Macchia revolt against Philip V in 1701.[31] Before Charles arrived in the city, they followed a well-established tradition of riding out of Naples to greet the new ruler. The formal greeting was also an occasion for nobles to secure advantages for their political and financial support.[32] Santiesteban, communicating his plan to Patiño, satisfied them by creating new posts of gentlemen of the king's chamber as Philip V had done in Spain.[33]

Opera would play a similar role in drawing the nobility to the Crown. Elizabeth, in addition to her expertise on government, also claimed an expertise on music. She was talented at playing keyboard instruments, could sing, and helped reintroduce Italian opera in Spain.[34]

Not only did she hire Italian musicians, she had her principal artistic advisor, Annibale Scotti, and the court musician, Farinelli, go to great lengths to spur a taste for Italian opera. The theater of the Caños del Peral (1737) and the Coliseo del Buen Retiro (1738) were renovated, and a troupe of Italian opera musicians were encouraged to stage lavish spectacles within them. In addition to this public effort, Elizabeth also had new theaters built in the palaces of Aranjuez, El Pardo, and San Ildefonso (1735–41).[35] Erected during the same years, the San Carlo seems to have been a part of a similar strategy to use opera in service of the Crown, and may reflect the influence of the Spanish monarchy. Indeed, the king and queen reported successful opera performances to Charles, and he sent libretti and scores to them.[36]

THE NEW THEATER

Spain and Naples were attuned to opera and its social importance. Yet for three years the inadequate San Bartolomeo continued to serve as the court theater, the Crown's purse underwriting its operating debt. On one trip down the narrow streets to the theater, the king's carriage struck a bystander. The area was subject to criminal activity.[37] Rival aristocrats had been known to come to physical blows in its corridors.[38] And it had too few boxes for the court.[39] Adding boxes to the crowded hall seemed impossible, and by September of 1736 the royal government contemplated building a new house. Initially the Crown thought to offer a site and leave construction costs to private investors. Yet in the spring of 1737 the court accepted a greater financial role and purchased the San Bartolomeo for an annual payment of 2,500 ducats.[40]

Though the Crown bought the old house, it did not intend to keep it. The purchase merely

compensated the Incurabili for its impending loss of revenue. Instead, the court considered building a completely new theater that could "correspond to the dignity of the reborn monarchy and the population of one of the metropolises of Europe."[41] The king's councilors therefore needed to look beyond Naples for examples. In Italy, Charles had attended the Teatro Farnese and Teatro Ducale in Parma, the Teatro del Tigrane in Piacenza, and the Teatro della Pergola in Florence, which he considered the most beautiful.[42] Originally designed by Ferdinando Tacca in the 1650s, the Pergola had been stripped of its lavish decoration in 1719, leaving three tiers of boxes surrounding bench seating.[43] Despite the king's preference, it did not become the most important model for the new theater in Naples. Instead, plans of the theaters in Parma, in the hands of Secretary of State Montealegre, assumed this role.[44]

José Joaquín de Montealegre, Marquis of Salas, was more important for the building than Santiesteban and Elizabeth.[45] While they may have had a leading role in hatching the idea, he executed it. He signed the surviving plan and approved expenditures, and it was he, not the king, who oversaw the ceremonial stonelaying.[46] Montealegre was an able administrator and efficiently carried out most of the policies Santiesteban dictated. Eager to reform the kingdom, he also wanted to overhaul its financial and administrative systems by loosening the nobility's grip on land, taxation, banking, and justice and shifting old feudal authority to a new royal administration. Though change would be incremental, Montealegre's abilities as a brilliant courtier would help him to advance reforms. Lively and alert, he had a taste for lavish living. Observers noted his exceptional ambition, his somewhat scheming manner, and his constant energy. All preferred him to his dour superior. Equipped with an excellent memory, he sought to extend his reach into all branches of government. Peers were stunned by the sheer number of activities he oversaw, stating that his was the work of three men. One advisor worried that his good health could not last "if he [did] not leave himself some time to breathe."[47] While breathlessly engaged in administering the nascent royal government, Montealegre perceived the propagandistic power of opera and helped the court harness it.

The theatrical life of the duchies of Parma and Piacenza provided important models for using music in service of the sovereign. Lavish celebrations and festivities greeted Charles in both cities.[48] Entry processions were staged for the infante, and sixteen noblemen performed an equestrian ballet within the grand Teatro Farnese of Parma. Titled *The Arrival of Ascanius in Italy,* the ballet connected Charles to the young Trojan hero, who came to Italy with his father to found a new kingdom. In addition to this exceptional spectacle, which was recorded in a contemporary print, the duchies provided dynastic as well as general models for musical celebration. The important collection of Farnese music texts were shipped to Naples, and the Neapolitan court welcomed a series of set designers who had trained in the duchies.[49] Particular operas also helped cement connections with Parma. On the king's name day in 1736 *Alessandro in India* was performed.[50] It clearly honored Charles's conquest of southern Italy as much as it told the story of the ancient general. It also linked the king to the most famous Farnese warrior, Alessandro Farnese (1545–1592), who had fashioned himself as a new Alexander after he fought in the Netherlandish Wars of the late sixteenth century.

Such references were likely important to Elizabeth. Upon her arrival in Spain, the queen sought to link her new Bourbon family with her Farnese ancestors. She encouraged the publication of Luís Salazar y Castro's history of her family in Spanish.[51] She invited a number of Emilian artists to Madrid and entrusted them with important projects.[52] And well after Charles abandoned Parma for Naples, she fought to ensure that the duchy would pass to her son Philip. Thus a broader program of connecting the Bourbon and Farnese lines underpinned the specific requests for designs of opera houses in Parma.

Of the two houses of Parma, the Farnese and the Ducale, the former was the more architecturally important, while the latter proved better for music. Completed in 1628, Giovan Battista Aleotti's Teatro Farnese remained one of the most magnificent on the peninsula.[53] With a U-shaped auditorium that could hold 3,500, the house was a vast space for spectacles that Duke Ranuccio I (1569–1622) used to consolidate his supremacy over the nobility. Aleotti broke from the tradition of *sale di spettacoli,* or rooms for spectacle, by separating the audience from the stage with a proscenium arch. This separation marked a dramatic change in theater building by creating a boundary between spectator and performance. Within the auditorium the duke sat on a raised platform extended into the orchestra, while the rest of the audience occupied simple risers and a two-tiered Serlian arcade, the bays of which framed the first suggestion of opera boxes. Yet it was the Farnese's location that probably appealed most to planners in Naples. Aleotti's theater occupied the old *salone* of the Palazzo della Pilotta. It forced spectators to enter the ducal palace, proceed up a grand staircase and into a theater adorned with Farnese portraits and heraldry. It is likely that the royal government in Naples hoped to replicate this court-centering architecture.[54]

If the Farnese was the largest house in Italy in 1734, it was not the best suited to viewing customs. Its enormity required vast and expensive spectacles. Mock naval battles and tournaments were set to music and staged to great effect. But the dukes could rarely afford such entertainment. Only nine performances took place in the course of a century, with the celebration of Charles's arrival being the last.[55] More important was the Teatro Ducale (1688), designed by Stefano Lolli for Elizabeth Farnese's opera-loving grandfather, Ranuccio II (1630–1694). The Teatro Ducale was much smaller, with a capacity of about one thousand. Its plan imitated the Farnese, but it had tiers of boxes rather than risers and an arcade. Boxes had become popular for social and economic reasons. Aristocrats wanted more boxes because these semiprivate spaces had become important social venues. Meanwhile, owners of theaters, even princes, welcomed the revenue that came from box leases. Cristoforo Ivanovich, describing their fiscal utility, suggested that a theater needed at least one hundred to be financially successful.[56] Thus, while the Farnese provided a distinguished architectural model, the Ducale fit practical needs. Yet the idea that a court theater should also be a revenue-generating public theater struck some as indecorous. Of the new royal theater in Naples, the Venetian ambassador reported, "One thing, though, is very much to [the theater's] discredit, and that is, as I have come to know, that [the theater] is intended for public use, nor will people be admitted without paying, which among other things does discredit to the dignity of a prince."[57] In this respect the Teatro San Carlo

would be an unusual hybrid. It would function as a space of the court, connected to the palace and a principal representational space of the monarchy. Yet it would also operate as a public theater, dependent upon ticket sales and open to anyone who could afford entry. In this sense an ostensibly royal space was partly financed by the attending public.

Word circulated among ambassadors in Naples that the new theater would be an exact copy of the theater in Parma.[58] Yet Montealegre wanted the new theater built "to the best architecture, symmetry, proportion, and commodity, exceeding all of the other theaters in Italy."[59] Therefore, requests were made for plans and elevations of two recently constructed houses: the Teatro Filarmonico in Verona and the Teatro Argentina in Rome. The Filarmonico had no courtly connections.[60] It was run by an impresario on behalf of an academy. Designed by Francesco Galli-Bibiena (1659–1739), the theater had a bell-shaped auditorium, a form favored by the family of Bolognese stage designers. Bibiena marked off the proscenium arch with Corinthian columns supporting scroll brackets. He then crafted tiers of boxes that sloped down like descending steps as they approached the stage. The lavish and complex interior took over ten years to complete (1715–31). It was considered one of the most elegant of Europe, yet the Caroline court ignored it. Instead, the Teatro Argentina provided greater inspiration (fig. 6). The Marquis Gerolamo Theodoli designed the house in 1731 at the request of the Sforza-Cesarini family.[61] He drew upon Carlo Fontana's Tor di Nona house (1669–71), considered the first horseshoe theater. Yet he pinched the breadth of the hall and connected it to the stage with straight segments. This alteration deepened the auditorium and made it more similar to

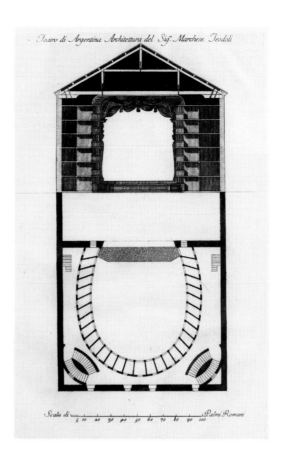

a horseshoe in shape. Theodoli included six tiers of thirty-one boxes, which combined with ample orchestra seating to accommodate a large number of spectators.

The Argentina operated without direct connection to the papacy, but like all opera houses in Rome, it looked to the Vatican for cultural guidance. Under Alexander VIII Ottoboni (1689–91), opera flourished. The papal nephew Cardinal Pietro Ottoboni wrote libretti, hosted Handel, and commissioned Filippo Juvarra to design a small theater for the Palazzo della Cancelleria. Innocent XI Odescalchi (1676–89) and Clement XI Albani (1700–1721) instead restricted theatrical performances. And throughout the period women were banned from the stage.[62] Such limitations

did not allow the Argentina to become culturally preeminent. Its plan, however, was important for the builders of the San Carlo. Though the Teatro Nuovo provided an example of the horseshoe on their soil, the Neapolitans likely looked to the Argentina to predict how the form would work on a larger scale.

While eagerly mining these plans, the designers of the San Carlo indifferently watched as another important theater came to light. As early as 1711 Emmanuel-Maurice de Lorraine, duc d'Elbeuf, extracted colored marbles from excavation shafts of a buried Roman "temple" at Portici. When the king began his suburban palace in the same coastal town, royal engineer Rocque Joaquin de Alcubierre reopened these tunnels to seek new finds. The discoveries were closely monitored by Montealegre and supervising engineer Giovanni Antonio Medrano. Yet only in October of 1738, a year after the Teatro San Carlo was completed, were excavations approved for the site of the "ancient temple." On 12 January 1739 an inscription unmasked this subterranean structure as the theater of Herculaneum.[63] The discovery coincided with multiple publications about the shape of Roman theaters and amphitheaters.[64] Vitruvius's contested description could be compared to more-physical evidence. Antiquarians therefore greeted the discovery with enthusiasm. The royal government and court engineers instead demurred. Neapolitan theaters never sought to imitate ancient examples. Opera needed a comfortable and profitable house rather than a replica of Greece or Rome.

DESIGNING THE HOUSE

Though it remains unclear who decided upon a location adjoining the royal palace, the site of the theater seems never to have been in question. The palace complex was a mixture of older buildings, as seen in a plan from the time of Charles's ascension (fig. 7). At the northwestern corner lay the Palazzo Vicereale. Commissioned in the sixteenth century by Pedro de Toledo, its bastioned corners on the north and west visually reinforced the viceroy's political control over the city. In 1737 it still retained one of these original corners, and under Charles it housed offices of the royal government. In 1602 Domenico Fontana had designed a new Palazzo Reale to the south of the Palazzo Vicereale. His building centered on a large interior courtyard and contained an arcade in its façade to reflect the political stability of the viceroys. It also contained a number of Spanish architectural features and was technically one of the *alcázares reales,* or royal palaces, of the absent monarch.[65] Never completed to the architect's original design, wings were awkwardly joined to the east of the palace during the following decades. These eastern wings fronted the arsenal and bay and extended toward the moat and bastions of the Angevin Castel Nuovo. Royal gardens filled the remaining space, except for a wing of small structures to the north that separated the gardens from the street.

A location in the gardens was selected for the theater. The site would recall that of a small temporary theater built there by Viceroy Oñate in the mid–seventeenth century.[66] And the location was practical for musicians. The palace's royal chapel housed the Real Cappella, the preeminent musical institution in Naples. These musicians principally played in religious services held within the large chapel that Fontana had designed. Like its counterpart in the Alcázar of Madrid, this chapel was central to the palace, both architecturally and musically.[67] Yet it was not the only place where court

FIGURE 7
Plan of the Palazzo Reale,
before 1737. Black ink and pink
wash on paper. Archivio di
Stato, Naples, *sezione disegni,*
cartella X, 1.

musicians performed. Members of the Real
Cappella were also engaged to perform at the
San Bartolomeo and in the court's many public
ceremonies.[68] One important setting for cer-
emonies was the Sala Reale of the palace. This
large rectangular room, the first in the viceroy's
representational apartment, was often trans-
formed into a temporary theater for opera.
In 1767 Ferdinando Fuga made the transfor-
mations permanent by crafting a court theater
within the sala.[69] Given the activities that took
place there, connecting an opera house to the
Real Cappella and Sala Reale held numerous
practical advantages and created an unparal-
leled hub of music in the capital.

While the location was convenient for
musicians, it proved challenging for architects.

The principal obstacle was providing public
access. Streets bordered the palace complex
on only two sides, the north and west. Build-
ings blocked access on both sides, but the
small preexisting wing to the north was less
encumbering than the palaces to the west.
The court therefore chose to locate the theater
there. However, for unclear reasons, the thin
blockade of preexisting buildings would not be
demolished, and connecting the theater to the
street would prove a challenge.

Solving these problems were two engineers
in the roles of architects. "Engineer," follow-
ing Spanish professional organization, was a
high position in Naples. Both civic and royal
architects were called engineers, and until the
1740s the king maintained the existing system

of royal engineers.[70] Notable was the fact that both were military men. Military engineers were educated and valued in Spain and the Two Sicilies. Both nations had long coastlines that had to be defended against raids by North African pirates.[71] Vigilant maintenance and improvement of towers and defenses were essential to safeguard towns and cities lining the coast. Secure defenses required men trained in the latest technology, and for this reason an academy for military engineering was established in Barcelona at the opening of the eighteenth century.

Giovanni Antonio Medrano (1703–ca. 1750), whose signature appears on the only surviving plan of the San Carlo, was a product of that rigorous Spanish training. Sicilian by birth, Medrano studied in Barcelona under the Flemish military architect Jorge Próspero de Verboom.[72] His first work was designing fortresses in Catalonia under Verboom's supervision. In 1729 Philip V called Medrano to Seville to tutor the young princes in the arts of architecture and war. When Charles embarked for Italy, Medrano sailed with him, continuing his role as tutor and assuming new responsibilities as lieutenant and ordinary engineer. Santiesteban approved of the monarch's interest in military architecture and reported to Madrid the positive results of Medrano's instruction.[73]

After Hispano-Italian forces took southern Italy, Medrano designed the obelisk commemorating the decisive Battle of Bitonto, and within a year he was named first engineer of the kingdom. Throughout his career Medrano's hands planned ravelins and restored battlements. Like all engineers, he had a firm grasp of geometry. Yet other than forming the massive walls that would protect against the spread of fire, he seemed unready for the delicate task of crafting an opera house.[74]

His touch would be softened by Angelo Carasale (d. 1742), who had risen from the "vilest condition" of an ironworker.[75] His skill as a maker of armaments had been noted by Viceroy Mihály Frigyes D'Althann (1722–28), who took Carasale under his protection, elevated him to engineer of royal works, and gave him numerous commissions. With new prestige Carasale entered into joint-capital ventures, such as the Teatro Nuovo. He excelled as an impresario, a profession Carlo Goldoni considered the most difficult.[76] Yet he never shook his sooty origins and was characterized by peers as an "uncivil and eccentric personality."[77] They looked down on his taste for gambling, women, and fine carriages, and he tweaked their envy by gaining the confidence of Montealegre. The minister entrusted Carasale with the management of the San Bartolomeo and tapped him to assist with the San Carlo. From the royal government's perspective, Carasale was a successful impresario and an efficient builder. He had gotten the Teatro Nuovo constructed in a quick seven months and was contracted to construct the San Carlo within a similarly brisk time frame based on Medrano's plan.[78]

The original plan (fig. 8), signed with particular flourish in the lower right by Medrano, is dated 22 March 1737. Opposite Medrano's signature is an extended note that Montealegre, in council with the royal minister of finance, Brancaccio, and a new superintendent of theaters, Erasmo Ulloa, approved the plan. Montealegre's signature appears at the bottom left and bears the same date. The dates belie the approval process. A working plan must have been in place prior to final approval, because on 4 March Carasale signed a contract to complete the building by November.[79] The drawing also documents a shift in responsibility away from Santiesteban and toward Montealegre

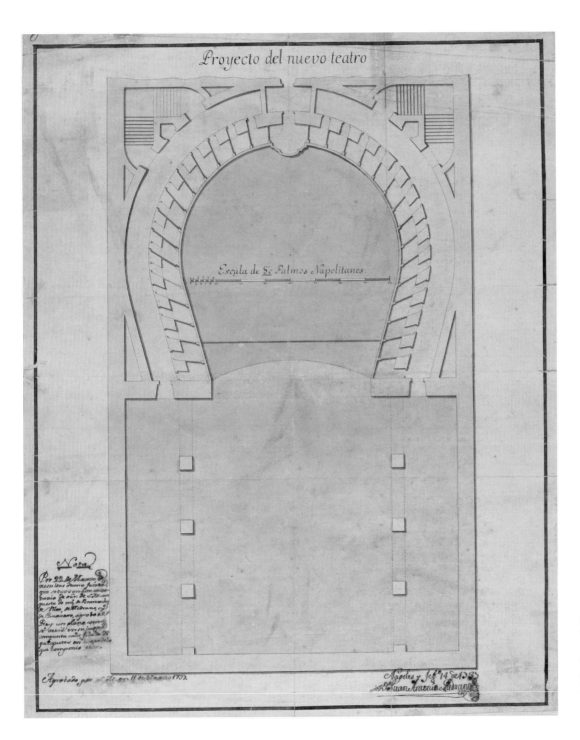

FIGURE 8
Giovanni Antonio Medrano,
plan of the Teatro di San Carlo
(inscribed *Proyecto del nuevo
teatro*), 1737. Black ink and
yellow wash on paper. Archivio
di Stato, Naples, *sezione disegni,*
cartella X, 12.

and other court officials. Indeed, Ulloa had only been appointed superintendent of theaters on 3 March, taking the place of Bartolomeo Corsini, who was named viceroy of Sicily.[80]

The plan, in black ink and yellow wash, presents the theater at the level of the royal box in the second tier. The theater is divided into two equal parts: the stage and the auditorium. Three piers mark off center stage from the wings, and dotted lines between them indicate arches in the intervals. An arch also spans an opening at the back of the stage, as well as the proscenium, which is provided with an apron. Pietro d'Onofri claimed that one could see the royal gardens through the opening at the back of the stage, but slightly later plans show an enclosed room beyond it. This room was used for bringing the king's cavalry on stage and an elephant on one occasion.[81]

The stage is shown at the same level as the second tier, evident from the doorways at either side that connect to the corridors behind the boxes. Yet this was impossible. The stage could not rise fully above the height of the lowest tier of boxes without obstructing the view from them. Thus Medrano mixed levels in the drawing, something also evident in his delineated orchestra pit, a feature well below the second tier of boxes.

Thirty boxes, divided by wooden partitions, flank the royal one, which has a curved parapet extending into the auditorium. Patrons sitting in boxes, which Medrano reduced in number by two when he constructed the theater, accessed them from quarterpace stairs that Medrano tucked in at the corners beyond the auditorium's horseshoe curve. Given that Carasale's Teatro Nuovo was also a horseshoe and had the same quarterpace stairs, he may have suggested that Medrano copy Vaccaro's model (fig. 5).[82] One different feature is the royal box, which has no

access from the within the theater. The room behind it is walled off from the corridor connecting the other boxes and opens to a space beyond the theater. This space is not defined, and the rippled wash at the upper edge of the drawing suggests general uncertainty about that side of the theater because it would abut preexisting buildings and require additional drawings.

The geometry Medrano used to generate the auditorium was simple and had been detailed by Fabrizio Carini Motta in his 1676 treatise, *Trattato sopra la struttura de' teatri e scene*. Carini Motta's treatise does not figure as prominently as it should in histories of theater construction.[83] Unlike Leon Battista Alberti, who had vaguely described his theater in *De re aedificatoria* as "from the hoofprint of a horse,"[84] Carini Motta gave concrete instructions. He used whole-number geometry, clear descriptions, and ample illustrations. First, he established the overall dimensions of the hall and divided it roughly in half with a line that formed the stage boundary. The dimensions of the stage opening were set according to the designer's wishes. Then Carini Motta turned to the auditorium. He based his horseshoe on a large circle that was equal to the width of the hall and tangent to the outer limit of the stage opening. A smaller concentric circle then formed the perimeter of the seating or boxes. The designer then joined this smaller circle to the stage opening with straight lines to create the horseshoe shape. When his pen lifted, the architect was left with a horseshoe hall soundly linked to the stage.[85]

The San Carlo's shell of masonry protected an interior of timber. Wood was valued for its acoustical warmth, and planks from the San Bartolomeo were reused to construct the stage of the San Carlo.[86] The boxes, also made of wood, are illustrated in an elevation drawing now in the Courtauld Institute (fig. 9).[87]

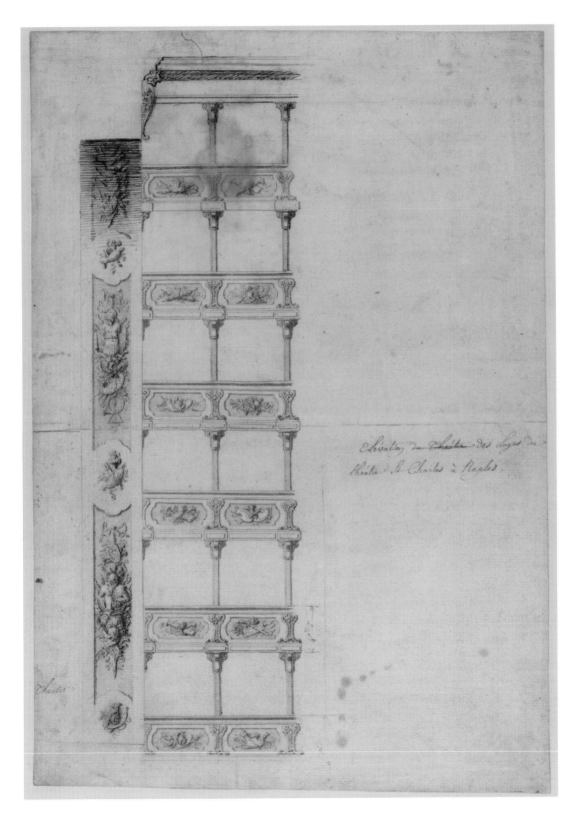

Elévation du Théâtre des Loges du
théâtre St. Charles à Naples

FIGURE 9
Elevation of the boxes of the
Teatro di San Carlo (inscribed
*Elévation des Loges du théatre
St. Charles à Naples*), between
1737 and 1767. Black ink on paper.

The drawing shows them decorated with implements of the arts and separated by thin partitions faced with ornamental brackets. Medrano angled these partitions to offer better views of the stage. The proscenium arch likewise bore symbols of the arts, along with reliefs of military trophies. A contemporary painting of the theater dating from roughly the same time shows it crowded with spectators, with only a few boxes in the fifth ring unoccupied (fig. 10). An architectural ruin that serves as a backdrop for a battle between a man and a centaur dominates the stage. A great crimson-and-ermine-patterned curtain fills the upper part of the arch, which is topped by Fames sounding trumpets and supporting a Bourbon crest.

Royal arms reminded the spectator that the theater was connected to the palace complex. Yet the jagged upper edge of Medrano's plan reveals uncertainty about how to join the theater to it (fig. 8). In the end, Medrano simply placed the theater behind the small wing of rooms to the north, leaving them untouched. Irregular in shape and separated by a thick wall, the rooms could only be accessed from the Palazzo Vicereale, and later plans would label them part of the "old palace" rather than the theater. This intervening structure had consequences for the building's exterior. Antonio Joli's painting from the 1750s shows that the theater (at left) lacked an independent façade (fig. 11).[88] It instead appeared to be a continuation of the bastioned Palazzo Vicereale. This articulation saved costs and did not impinge upon the street. More importantly, the fortified aspect of the old palace helped the monarchy present the opera as an extension of the court.

Such royal overtones were confirmed by the presence of the king, called "the most valuable ornament of our spectacles."[89] His box, opposite the stage, was double the width

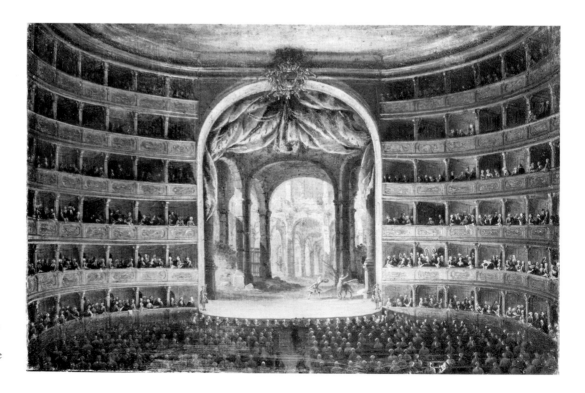

FIGURE 10
Michele Foschini, *Interior of the Teatro di San Carlo,* before 1767. Oil on canvas. Museo Nazionale di San Martino, Naples.

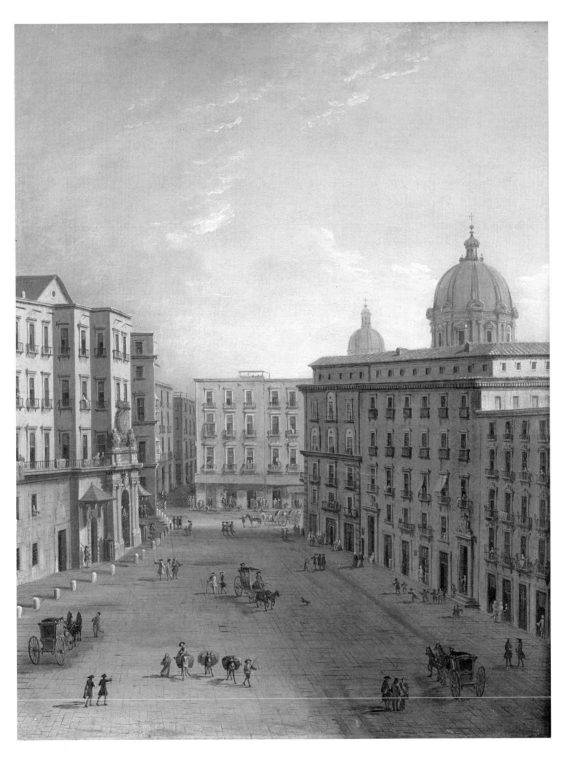

FIGURE 11
Antonio Joli, *Street of the Teatro di San Carlo*, ca. 1756–58. Oil on canvas. Lord Montagu of Beaulieu, Beaulieu.

and height of the others. Larger boxes were typically reserved for royalty. For example, the Old Pretender maintained a box in the Teatro Argentina that was triple the width of the others. At the San Carlo the royal box was so large that contemporaries described it as a "salon."[90] Convenience also marked the king's status. The room behind the royal box is shown as a domed *retrocamera* in a print from 1749 (fig. 12). This arrangement of a box and *retrocamera* created a private and public space for the monarch within the theater, an arrangement analogous to the royal chapel in the Alcázar in Madrid, where a private oratory for the monarch occupied a space at the back.[91] From the theater's *retrocamera* the monarch could retire to the palace via a private corridor that Medrano did not show on his original plan. Though an apocryphal anecdote claimed that Carasale had the corridor built in three hours on opening night, it was completed in advance.[92]

Medrano's quarterpace stairs would not provide access to the exterior. To connect to the street, staircases would be cut through the ground floor of the preexisting part of the old palace. This was not entirely unusual. The *corrales* of Madrid were accessed through stairs that were often cut through existing buildings. A recently published yet undiscussed drawing conserved in the Archivio di Stato (fig. 13), probably by Medrano, reveals the planning involved in creating the steps.[93] With a dotted line the drawing indicates the proposed level of the theater, which is measured as fourteen and a half Neapolitan palms above the level of the street at the point of the old palace façade. This height would be bridged by flights of stairs within an elegant open vestibule. Comparison of this drawing with prints of the vestibule as it was built (fig. 14) reveals that Medrano indicates the center of the vestibule by a vertical dotted line drawn inside the old palace wing, roughly twenty palms from the building's façade. A further twenty-five palms separates this point from another vertical line to the left. This second vertical line lies outside the old palace wing and would correspond to corridors leading to orchestra seating and the quarterpace stairs that led to the boxes. A partly destroyed sheet in the Archivio di Stato of Naples shows the plan of the stairs by Medrano (fig. 15).[94] Two smaller staircases flanked the central one and would be used by nonnoble patrons and the livery. Paired pilasters distinguished the central portal as the entry for the aristocracy and dignitaries (see also fig. 11). As the 1749 print shows (fig. 14), guests passed through the principal door into an open hall. U-shaped flights were accessed from the left and right and led to a small landing where they rejoined, forming a single flight that led into the auditorium.

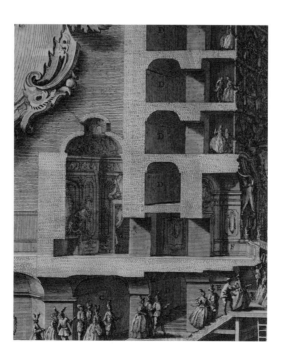

FIGURE 12
Vincenzo Re, *Spaccato del Regio Teatro di S. Carlo adornato per Festa di Ballo* (fig. 17), detail showing the royal box.

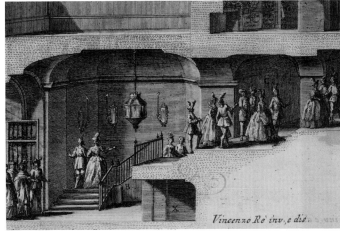

FIGURE 13
Giovanni Antonio Medrano,
section of the Palazzo Vicereale
including the levels of the
street and royal garden, 1737.
Black ink and pink wash on
paper. Archivio di Stato, Naples,
sezione disegni, cartella X, 7.

FIGURE 14
Vincenzo Re, *Spaccato del Regio
Teatro di S. Carlo adornato per
Festa di Ballo* (fig. 17), detail
showing the principal stair.

FIGURE 15
Giovanni Antonio Medrano,
plan of the stairs of the Teatro
di San Carlo, 1737. Black ink and
pink wash on paper. Archivio
di Stato, Naples, *sezione disegni,*
cartella X, 13.

This gradual ascent marked by turns and landings created a parading space for spectators. Contemporaries lauded this progression because it fulfilled aristocrats' desire for spaces where they could display their social importance.[95] Two centuries of Spanish rule had attuned Neapolitan nobles to the communicative power of stairs. The staircase was an important feature of Iberian architecture, and in 1650 Viceroy Oñate helped import these Spanish models to Italy by commissioning a new staircase for the Palazzo Reale based on the one in the Alcázar of Toledo.[96] A taste for staircases subsequently flourished among the Neapolitan nobility. In the 1720s and 1730s the aristocrat-architect Ferdinando Sanfelice remade his peers' residences with magnificent and complex flights that displayed the wealth, power, and social standing of the owners. The San Carlo's regal architecture therefore engaged nobles on terms they understood.

The portal where they entered also bore a royal architectural message (fig. 11). Like

stairs, portals held special significance in Spain and Spanish Naples. In both places they were the principal ornaments of a building's astylar façade. Medrano and Carasale framed an arched entry with paired pilasters backed by rustication. These double pilasters echoed the portals of the Palazzo Reale and Castel Nuovo in Naples as well as the Alcázar of Madrid, which were all flanked by double columns. To make such royal connections clear, the pilasters supported trabeation and an attic zone surmounted by the Bourbon arms. Four stucco statues originally flanked the crest, but these deteriorated and were never replaced.[97] An inscription positioned within the attic zone also commemorated royal patronage. Commenting upon the heraldic importance of the portal, one contemporary stated, "Now even in the act of pleasure one cannot but remember from time to time the illustrious benefactor."[98]

To seal the message of royal patronage the theater opened on the king's name day, 4 November, and was called San Carlo in his honor.[99] Yet the Crown bore less than half of the total costs of the building. Of the projected 70,000 ducats, the king shouldered 32,086. Part of the royal subsidy underwrote an aspect of construction that was in the Crown's best interest. The 20,000 ducats paid to construct the walls would help ensure that a fire in the San Carlo would not spread to the palace. Box sales covered the remaining costs.[100]

Before the theater opened, a sounding was held on 27 October for the king and his ministers. Charles informed his parents, "The theater came out magnificent, and one can hear the voice better than in any other."[101] Minister of Justice Bernardo Tanucci concurred, claiming that the San Carlo surpassed all other houses in Europe.[102] On 4 November 1737 the largest opera house in Europe opened

its doors. Patrons found their way to seats in the orchestra or in their new boxes. When the king entered the hall, they greeted him with applause. He then had Carasale called to his box, where he placed his hand on the builder's shoulder as a sign of royal protection.[103]

The court rewarded Carasale with commissions at Portici, the port of Naples, and the Palazzo Reale. Carasale collaborated with Medrano again on the royal hunting lodge at Capodimonte. But that commission would cost them their careers. In 1740, following rumors of mismanagement, the Princess of Belmonte instigated an inquiry into the project's budget. It uncovered fiscal irregularities and pointed to similar fraud at the San Carlo. Carasale and Medrano were arrested for embezzlement.[104] Despite claims that the rapid construction of the San Carlo confounded a full fiscal accounting and that court intrigue was the true cause for scrutiny, both were imprisoned in the Castel Sant'Elmo, where Carasale died in 1742.

For different reasons Santiesteban's power also swiftly waned. Backed by the queen of Spain, his power seemed unassailable. Yet shortly after the completion of the theater, the court welcomed news of the king's engagement to Maria Amalia of Saxony. Some nobles, including Belmonte, believed that positions in the queen's household could give them political influence beyond the grasp of the omnipresent majordomo. Others directly lobbied Spain for his removal, citing his haughty manner. The king also started to feel oppressed by his constant surveillance. In August of 1738 Elizabeth withdrew her support, and the majordomo returned to Spain.[105]

Belmonte's scheming proved that the nobility could manipulate conditions to crush the ambitions of parvenus and check the authority of royal advisors. Yet her assertion of power

played out against a backdrop of shrinking aristocratic autonomy. Within months, Elizabeth ordered Belmonte removed from court, making an example of her for the nobility.[106] The departure of Santiesteban and the disgrace of Carasale did not open avenues for the local nobility to gain power. Montealegre took the reigns of government and continued a policy of limiting aristocratic influence. Noble power would be curtailed further, and the San Carlo would help restrict aristocratic autonomy.

ASSEMBLING THE NOBILITY

While Medrano's and Carasale's careers ended, the theater's life flowered. Patrons entered the auditorium either directly into the orchestra through a passage beneath the royal box (fig. 14) or up the quarterpace stairs to tiers of boxes. Seats in the orchestra cost a relatively modest 3 *carlini* and could be purchased from a booth in the central entrance vestibule. The orchestra had between fourteen and seventeen rows, which at their broadest point contained twenty-six seats.[107] These seats were "very roomy and commodious, with leather cushions and stuffed backs, each separated from the other by a broad rest for the elbow."[108] The armrests were a unique innovation. Devotees could rent chairs in the first rows for the entire season and could lock their seats when not attending.[109] They could also access their seats at any time during the opera. Coming and going did not bother others, because "the intervals betwixt the rows [were] wide enough to admit a lusty man to walk to his chair, without obliging any body to rise."[110] Standing room around the perimeter raised capacity to six hundred. Such large crowds had to be controlled, and with the auditor of the army overseeing the theater, the royal military guard occupied the eighth row.[111]

The aristocracy sat in boxes, which numbered twenty-eight in the first three tiers and thirty in the upper three.[112] Like a modern condominium, purchase entitled the owner to exclusive use, but one paid subscription fees in addition. Throughout Italy boxes were regarded as inalienable property that could be passed on to descendants provided the owner continued to pay the annual fees.[113] Families could also sell their boxes, but the monarch controlled the exchange of certain ones. All boxes on the level of the royal one were given to important members of the court and aristocracy, and the Crown ensured that foreign ambassadors were given places in the third ring.[114] Members of the court sat in the five nearest the king, but on opening night the only one of the king's four ministers allowed to sit with the monarch was Montealegre.[115] Beyond them, boxes were rewarded to the most important and loyal families of the Neapolitan and Sicilian nobility. Their proximity to the royal box reflected their positions and standing at court. While their rank was evident to a limited audience in the royal apartments, the San Carlo made the hierarchy of court more public and spatially apparent.[116]

Those in the uppermost tiers paid less and were usually petty nobles, jurists, and court dependents. The livery occupied the sixth tier, but we do not know if they paid for tickets. Calibrated fees were crucial to the fiscal health of the theater.[117] The annual budget, which ran 26,000 ducats in the late 1730s, was mostly funded by the king. Subscriptions and single-ticket sales covered some operating expenses, as did fees paid by noble patrons. Yet though dependent on ticket sales, the San Carlo did not operate in a wholly commercial manner. Its four annual performances were given for a predetermined run that was never extended to

meet demand. Therefore, the San Carlo often ran an operating debt, which the Crown covered in addition to its subsidy.[118]

With a capacity of twelve, each box was like a private room. Patrons outfitted their boxes to fit their tastes, furnishing them with chairs and tables and decorating them with mirrors and tapestries. Since the theater was an important social venue for the nobility, they often made and reciprocated visits to one another's boxes.[119] The chatter drifting from them frustrated connoisseurs such as Samuel Sharp, who lamented:

> The *Neapolitan* quality rarely dine or sup with one another, and many of them hardly ever visit, but at the Opera; on this account they seldom absent themselves, though the Opera be played three nights successively, and it be the same Opera, without any change, during ten or twelve weeks. It is customary for Gentlemen to run about from box to box, betwixt the acts, and even in the midst of the performance; but the Ladies, after they are seated, never quit their box the whole evening. It is the fashion to make appointments for such and such nights. A Lady receives visitors in her box one night, and they remain with her the whole Opera; another night she returns the visit in the same manner. In the intervals of the acts, principally betwixt the first and second, the proprietor of the box regales her company with iced fruits and sweet-meats.[120]

Since they served as important venues for socializing, boxes also functioned like small stages for the nobility to display their wealth. On opening night the *Gazetta di Napoli* reported they were "filled with ladies adorned in rich clothing and precious gems and likewise with men in suits of the most sumptuous luxury."[121] Such a scene inspired Pietro Napoli-Signorelli to claim, "The copious light from the boxes, reverberating and multiplied in a thousand ways by the scintillating gems of the many nobles, changes night into most glorious day and the auditorium into an enchanted realm of Circe or Calypso."[122] His language is more than mere rhetorical flourish. With the nobility ranged around the king, the San Carlo contained a microcosm of the Two Sicilies' most powerful subjects.

Assembling this nation of elites was the theater's triumph. By moving into the palace the most important venue for an art the Neapolitan nobility loved, the court ensured that the most powerful were kept close. The architecture of the theater then provided a way for the court to display royal favor in an organized spatial hierarchy. And while attendance at spectacles encouraged display, the court also instituted uniformity across the boxes. None were permitted to decorate either the interior or exterior of their boxes with a crest of any sort.[123] The only coat of arms in the house was that of the king, situated above the stage opening. The theater's architecture resonated with Santiesteban's careful articulation and assignment of positions in the king's household. It also paralleled the court's effort to delineate ranks of nobility and establish a new Order of San Gennaro to reward those most loyal to the monarch.[124] Proximity to the king became a coveted commodity, with nobles aspiring to the most prized seats. They were not beyond asking for promotion. For example:

> Charlotte Gaetani d'Aragona, Princess of Sansevero, appeals very humbly to Your Majesty that the Prince, her husband, had been given the hope of having a box near

his friends in the second ring in order to be in good company, but has heard say at present that he is to be given one on the first level. She therefore places herself in the august security of the Royal Clemency of Your Majesty, to the end that she might be accorded the just satisfaction to her supplication, for which she would never cease to make vows for the most perfect happiness of Your Majesty, etc.[125]

This plea from an august family was denied, but the space of the San Carlo ensured that the monarchy had socially pregnant cells to parcel out.

As other courts had shown, opera attendance also could build harmony within the kingdom. Appearing in public, it was believed, combated the vices that people indulged in private. As Francesco Milizia noted, those present put on their polished manners:

> Each person presents him- or herself in public with the appearance of their best behavior and civility, which in private they do not possess, and they force themselves to appear really as they should be. Outside of the house and in their numerous parties they show off those pompous and tailored clothes that in private they do not wear. As chamber dresses are to gala outfits, so internal morality is to external. Now, this beautiful exterior container, whenever it appears, is very useful to society and to individuals, and it might penetrate into their inmost souls if occasions to live in public were multiplied.[126]

Milizia drew his idea from Alberti, who additionally believed that theaters were useful as places where people could gather and cultivate a collective identity.[127] For both theorists, theater attendance contributed to civic harmony. Public appearance in theaters also matched the aims of seventeenth- and eighteenth-century court society as articulated by Norbert Elias.[128] Both the court and the theater required a public display of refinement, and the vast scale of the San Carlo enforced the politesse of court within one of the largest public venues in the kingdom.

The San Carlo helped build the sovereign's power. Foreign travelers saw the effects of it, and by the 1780s the nobility were so dependent on the monarch that Gaetano Filangieri declared, "They do not know how to live without being warmed by the rays of the throne."[129] The rays of royal favor emanating from the royal box of the San Carlo had penetrated the old aristocratic order and made the theater into a crucial tool for the solidification of royal power. By harnessing the city's cultural life and giving it a new home, the court had appropriated a key avenue of Neapolitan social life. The court then used the house to reorder society and arrange the nobility according to its dictates. In this microcosm of the Two Sicilies, the king occupied the center, and the royal government controlled the rings of aristocrats that surrounded him.

GOVERNING TASTE

To ensure the beneficial effects of gathering the nobility together, the Crown strictly regulated house etiquette. Audience behavior in Italy was infamous. Tumultuous and often crude, spectators interrupted arias, shouting down singers they disliked. They even threw apples. For singers they liked, the audience offered raucous applause and shouts of "Viva!" Luigi Riccoboni disapproved of these boisterous habits and claimed that they had made the

theater into a place of "libertinage and impiety and, until it is reformed, a school of bad morals and corruption."[130]

The San Bartolomeo confirmed many of Riccoboni's criticisms. Nobles were not beyond physical scuffles in its corridors. Yet the royal court was convinced that theater behavior could be reformed. It was likely Santiesteban who drew up the meticulous rules used to govern etiquette in the San Carlo.[131] Clapping was forbidden, and only the king could request an encore. Lower classes, such as the livery, were confined to the upper reaches of the theater, and the Crown did not permit a tavern on the premises. Mounting the stage from the auditorium was prohibited, and those that did so were sentenced to two years in prison without trial. Since the supervisor of theaters was an army official, the rules were enforced. Soldiers were so scrupulous in their duty that when the Duchess of Castropignano clapped on 28 January 1742, the entire house was reminded of the restrictions on applause.[132] In the words of Giambattista Vico, the court "imposed upon the spectators the silence worthy of a school of philosophy."[133]

Solemnity dovetailed with royal artistic mandates. Despite the compositional fertility of comic *intermezzi*, ballets were instead presented between acts.[134] The *intermezzi*, sung in Neapolitan, were popular, and Charles himself enjoyed them and had them performed often in the royal palace.[135] Yet the language and subject matter did not fit the solemnity that the Crown desired for the San Carlo. Ballet inspired a more decorous reaction. Samuel Sharp noted the "dead silence" that descended upon the house when the ballet began.[136] Indeed, ballet proved very popular with local audiences. Neapolitan aristocrats were devoted dancers, as a 1729 treatise by Giambattista

Dufort attests. Therefore, it is not surprising that in 1752 a dance master, Gaetano Grossatesta, became impresario of the San Carlo.[137]

Increasing the gravity of *opera seria* had been the goal of Gian Vincenzo Gravina, who was a Neapolitan author at the forefront of literary and dramatic reform.[138] He felt that tragedy was the most useful drama, arguing that it educated the public in civil government. Other theorists, such as Ludovico Antonio Muratori, Antonio Conti, and Scipione Maffei, shared his view, and their thoughts and writings influenced Cardinal Pietro Ottoboni to stage tragic opera in his theater at the Palazzo Cancelleria.[139] His operas stressed moral themes of the virtuous ruler and his loyal subjects. Like other European courts, Naples adopted this approach by promoting operas that allegorically conveyed lessons of justice and sovereignty.[140] For example, the San Carlo opened with an opera that was pregnant with political significance. Pietro Metastasio had written the libretto of *Achille in Sciro* to celebrate the marriage of Maria Theresa of Austria to Francis of Lorraine in 1736.[141] The Caroline court was the first outside of Vienna to stage the opera, even though relations between the two were strained. In Naples the Crown harnessed the opera's themes for its own allegorically flattering ends. It told the story of Ulysses's discovery of Achilles on Skyros, where the warrior's mother had sent him into hiding dressed as a woman. The opera stressed the cultural refinement that Achilles attained on Skyros, but its drama hinged upon the awakening of his warrior instincts by Ulysses. To spectators, the similarities with Charles were apparent. Though cultured, the young king had been roused to his true duty as a warrior during the conquest of the Two Sicilies. The elevation of martial virtue was coupled with a discourse

on musical taste. Through the character of Achilles, the libretto decries the effeminacy of earlier styles and instructs the listener to follow poetically dignified expression. The words therefore helped Charles justify the types of operas presented. As Martha Feldman has argued, many characters in *opera seria* became proxy mouthpieces for royal governments.[142] Stage protagonists such as Achilles, Ezio, and Titus helped reinforce ideas of sovereignty by imparting lessons of vigor, virtue, clemency, and good taste. Such virtues were intended to mirror the qualities of the ruler and thus justify his or her reign. Vico's metaphor of a school of philosophy is therefore an apt description of opera in the San Carlo. Culture instructed the audience on their duties as loyal subjects. And these opera themes combined with architectural stratification to make the San Carlo into a political space where etiquette, seating, and entertainment were mechanisms for consolidating royal authority.

The political dimension of the San Carlo became a model for others. During the spring of 1737 Frederick II's court architect, Georg Wenzeslaus von Knobelsdorff, was in Naples, to be followed within a few years by the Prussian court composer, Johann Gottlieb Graun. We do not know their observations while in Naples, but it is clear that they helped craft a similar musical culture in Berlin. Knobelsdorff built the Königliche Oper in a horseshoe form, while Frederick and Graun crafted works to fill it. In perhaps the greatest exercise of musical absolutism, Frederick revised arias and wrote libretti in order to make opera into an instrument of his enlightened despotism.[143] Even though Francesco Milizia declared that the Prussian king used opera to "ennoble the sentiments of a multitude of citizens," early audiences were limited to the court and

military officers.[144] Such strategies were shared in Naples, but with the distinction that the San Carlo included those beyond the court.

SHAPING MUSIC

Cultural policies made librettists think of political ethics, but the test facing composers and musicians was greater. The hall was larger than that of any previous opera house, and its horseshoe form relatively new. It therefore presented unique acoustical challenges.

Singers confronted the most daunting hurdles. Usually they determined musical programs, demanding arias that could display their virtuosity. Naples produced the greatest of these vocalists, including the castrati Farinelli and Caffarelli. Temperamental and difficult, they could ask huge fees and dictate what type of music they sang. In 1726 Margherita Gualandi demanded that the composer Johann Adolf Hasse rewrite arias twelve times for her premiere at the Teatro San Bartolomeo. Still unsatisfied, she fled the city the night before the opening performance.[145] Yet the San Carlo limited a singer's vocal acrobatics because the size of the hall required greater stamina and projection. A singer such as Farinelli might be able to rise to the challenge because of his acclaimed ability to sustain notes. But Metastasio would write that the tenor Anton Raff would not be capable, because "that huge volume of air in the Teatro San Carlo [would] swallow up all the inimitable graces and the extraordinary agility that make the singer so admirable when he performs in a room."[146] More blunt, the architect Luigi Vanvitelli said that one had to scream to be heard in the San Carlo.[147] Meeting the demands of space would not be easy, and Metastasio underlined the problem: "[It was advisable for] persons destined to use their voices in such ample

theatres, to begin in very early youth, to render it strong, firm, clear, and vigorous, by an exercise very different from that in present practice. On the contrary, our singers, who can be heard with much less force, have abandoned the ancient laborious school: and instead of fatiguing themselves in rendering their voices firm, robust, and sonorous, study to make them more delicate and flexible."[148] To the poet, a simpler vocal technique melded with ideas of reforming drama. He claimed that the robust voice had a natural and clear sound whose force and directness could penetrate into the human soul to move the listener.[149] Given the court's favor for operas that stressed the heroic, vigorous, and direct communication of virtue, it likely welcomed such changes.

As with singing, the Neapolitan orchestra, considered the best in Europe, also changed.[150] Though it is difficult to reach firm conclusions about how the orchestra played, it is clear that it grew by roughly fifteen players soon after the San Carlo opened.[151] Though not noted by historians, similar growth occurred in Dresden, Turin, Berlin, and Paris after each city opened a large opera house, suggesting that architecture wrought lasting changes on the size of orchestral ensembles.[152] As with voices, larger auditoriums and ensembles required different compositions. In his treatise on playing the flute Johann Joachim Quantz advised: "In a large place, where there is much resonance . . . great speed produces more confusion than pleasure. . . . [Here the musician] must choose concertos written in a majestic style."[153] The simpler melodic sweeps of the galant were better adapted to these spaces than the intricacy of baroque counterpoint. In particular the "simplicity and paucity of notes" that characterized Neapolitan opera were well suited for these acoustical conditions.[154]

The possible changes wrought by the opera house have yet to be charted against the scores of the operas presented. We can only conclude that the acoustics of the theater preoccupied musicians from the start. Giovanni Maria Galli-Bibiena was asked to make adjustments to the San Carlo in 1742. In 1767 Ferdinando Fuga added mirrors, paired columns flanking the proscenium, and boxes between the columns.[155] Some claimed his interventions hurt the acoustics, but in 1770 they did not bother Wolfgang Amadeus Mozart. To younger ears the auditorium was beautiful, and it was the quality of the compositions rather than the sound of the music that was unworthy of the space.[156]

CURTAIN CALLS: THE SAN CARLO IN EUROPE

After 1767 the San Carlo would remain unchanged until the turn of the century. In 1797 Domenico Chelli redecorated the hall in a rococo style. Between 1809 and 1811 Antonio Nicolini redesigned the façade (fig. 3), giving the San Carlo its independent face. He also began to redecorate the interior, but on 13 February 1816 the house burned. Nicolini rebuilt it according to the original plan, and though the audience still sits in the 1737 space, it is his neoclassical auditorium that surrounds the modern spectator.

Rather than trace how the auditorium changed, I shall instead turn to the unexamined question of the San Carlo's influence on the future of opera-house construction. The San Carlo, as one of the largest horseshoe auditoriums, became a target for attack in the twentieth century. Associated with absolutism, it was decried as tyrannical rather than lauded as innovative.[157] In its own time this was not the case.

In Naples, the royal government continued to weld music to the monarchy by building a short-lived opera house at the Royal Palace of Portici and having Luigi Vanvitelli include a permanent theater in the Royal Palace at Caserta.[158] Vanvitelli's small house was a brilliant refinement on the San Carlo. He gave it architectural monumentality by dividing boxes with engaged Corinthian columns. He made a vaulted ceiling and provided gallery seating within the pendentives. Yet he replicated the San Carlo's plan, confirming its symbolic importance for the monarchy.

The dynastic connection was also recognized in Dresden. When Frederick Augustus married Maria Amalia to Charles in 1738, ties between the Saxon court theater and the San Carlo were cemented through sharing scores, composers, and singers. Pöppelmann's theater in the Zwinger predated the San Carlo, but Frederick Augustus had it remodeled in ways that made the two theaters appear similar in shape, manifesting the diplomatic intimacy of the courts.[159]

In the mid–eighteenth century only the Teatro Regio in Turin challenged the San Carlo's renown. The Regio was likewise connected to the royal palace and hitched to the ambitions of the dynasty. The Dukes of Savoy became kings only in 1713 and were anxious to promote their status, politically and architecturally, among the European powers. Begun a year later and equal in size, the Regio was regarded as a rival to the San Carlo.[160] It had an elliptical auditorium rather than a horseshoe. The key difference between the two opera-hall forms is that the horseshoe is based on one circle tangent with the dividing line between the auditorium and stage, while an ellipse is based on two, one tangent with the stage line and the other beyond, creating a longer, more attenuated

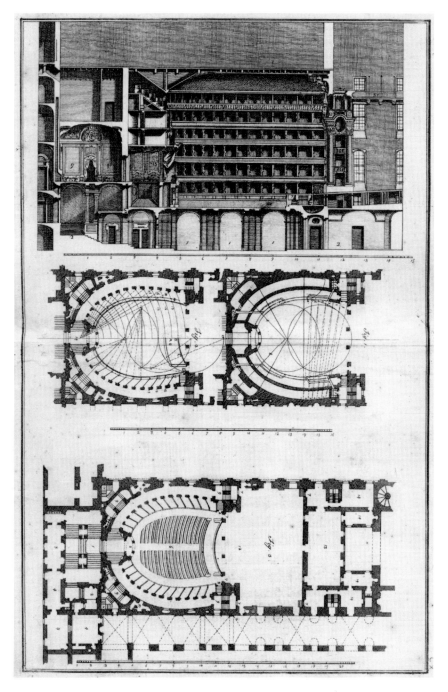

FIGURE 16
Plan of the Teatro Regio of Turin. From Bernardo Antonio Vittone, *Istruzioni diversi concernenti l'officio dell'architetto civile* (Lugano, 1766).

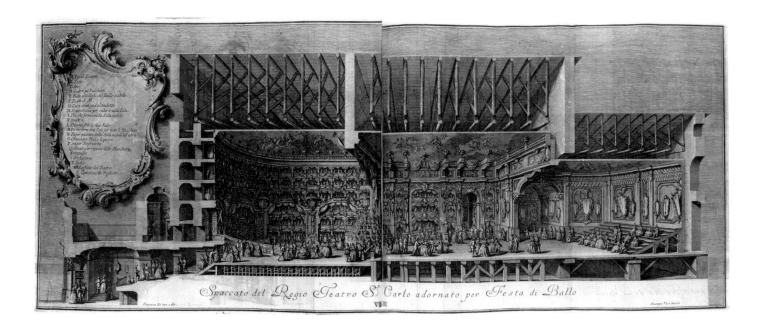

Spaccato del Regio Teatro S. Carlo adornato per Festa di Ballo

FIGURE 17
Vincenzo Re, *Spaccato del Regio Teatro di S. Carlo adornato per Festa di Ballo*. From *Narrazione delle solenni reali feste* (Naples, 1749).

auditorium. This geometry was clearly illustrated by Bernardo Antonio Vittone's diagrams of the theater published in his *Istruzioni diverse* of 1766 (fig. 16). The differences inspired partisan comparisons. Charles Emmanuel II's ambassador in Naples would condescendingly write, "I saw the vast Royal Theater, which, however, is not equal in proportion, good taste, or ornament to that of Your Majesty."[161]

The theaters dueled in print as well. The court publicized the San Carlo by commissioning a book recording the festivities held in celebration of the birth of the king's son. This book, the *Narrazione delle solenni reali feste* (1749), depicted a transformed San Carlo. Mirrors, paintings, ephemeral sculptures, and draperies remade the auditorium and stage into a single lavish ballroom. Though the book presents the theater in its most elaborate pomp, it was only the second publication to reproduce as many images of a single theater, and the only one to identify it so strongly with the dynasty

(fig. 17).[162] Turin answered, yet delays postponed publication of the Teatro Regio until 1761.[163]

With the two houses in print, the ellipse and the horseshoe became the most common types of auditoriums in Europe.[164] Choosing between models entailed cultural considerations as much as architectural ones. The form of the house could communicate the taste of its patrons. The French immediately eyed with envy the opera houses in Naples and Turin. As Charles de Brosses wrote:

Truly we should be ashamed that in all of France we do not have a single [decent] theater, with perhaps the exception of that of the Tuileries, which is uncomfortable and almost never used. The hall of the Opéra, good for the private individual who had it built in his own house to stage his tragedy of *Mirame*, is ridiculous for a city and populace like that of Paris. Know that the theater of Naples is

larger than the entire Opéra of Paris and proportionally wide.[165]

By the time Voltaire echoed these sentiments twenty years later, French architects had begun to travel to Italy to study theaters.[166] The year the San Carlo was inaugurated Gabriel-Pierre-Martin Dumont began to make drawings of opera houses, which he would publish in 1763. Jacques-Germain Soufflot would likewise come, looking for inspiration for the new house in Lyon.[167] After Soufflot opted for the ellipse (1756), the form spread widely in France and was adopted for the Opéra at Versailles (1765–70) and the Opéra in Paris (1770). French favor for the ellipse also emerged in Diderot and d'Alembert's illustrations for the *Encyclopédie,* where Turin's theater was represented with ten plates while the San Carlo garnered only two.

The Querelle des Bouffons could have shaped the French favor for Turin's theater. This vicious debate had been sparked by a performance of Neapolitan Giovanni Battista Pergolesi's *La serva padrona* in 1752.[168] It was a comic opera, and when a troupe of traveling Italian comic actors, or *bouffons* (as they were called by the French), performed it as an *intermezzo* at the Paris Opéra, it sparked controversy. Some considered it indecorous for a theater that featured *tragédie lyrique.* Many others did not, for the opera proved exceptionally popular. A pamphlet war ensued, with some upholding Italian music for its grace, harmonic clarity, and clear expression of the human passions through melody. Defenders of the French tragic tradition instead felt that declamatory recitative and close adherence of poetry and music were nobler. The debate was soon framed in national terms, with supporters of French music connecting it to national traits and values. At the Opéra the tragedians won. The *bouffons* left in 1754, and comic works were not presented for another twenty years. Since most of the works staged by the *bouffons* were by Neapolitan composers, the Gallic camp would not have favored building theaters based on the one in Naples, even if, ironically, it too staged tragic opera. The Regio instead belonged to kings that ruled over Francophone Savoie, and treatises by the chevalier de Chaumont and Pierre Patte buttressed its virtues.[169] With few exceptions the horseshoe was ignored in France.

Italy instead looked to the San Carlo. When the Regio Ducale Teatro of Milan burned in 1776, the archduke vowed to build a theater that could rival any in Europe. From Vienna, Joseph II advised using the Teatro Regio as the model. Yet with the task falling to Giuseppe Piermarini, who had trained in Naples, the auditorium copied the San Carlo.[170] This architectural choice fit the artistic programming of the theater. Most operas performed there were by Neapolitans, making this new Teatro alla Scala into a cultural outpost for the city's music. In Piermarini's book on La Scala (1778), he illustrated the principal halls in Italy (fig. 18), rightly positioning the plan of La Scala next to that of the San Carlo as part of a tightly knit family of horseshoe halls. The one theater that is dissimilar is the Teatro Regio, which Piermarini placed in the upper left corner. Twelve years later Giannantonio Selva's Teatro La Fenice in Venice (completed in 1792) would join the other horseshoe halls.[171] In the nineteenth century the horseshoe spread further. It was the shape preferred for the Royal Italian Opera House at Covent Garden, the Opéra Garnier, and the Academy of Music in Philadelphia.

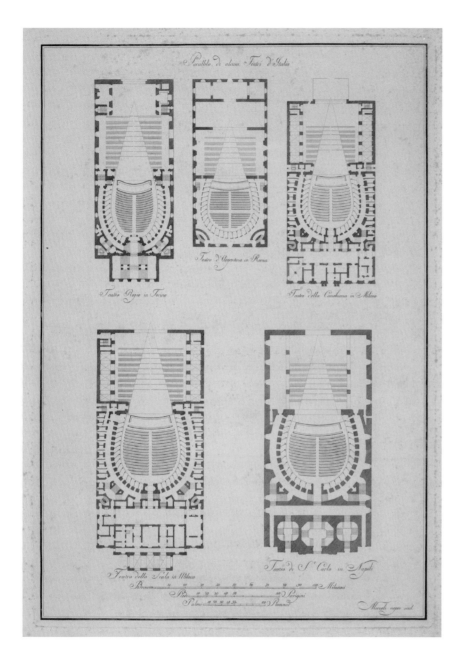

FIGURE 18
Giuseppe Piermarini, *Parallelo di alcuni Teatri d'Italia*. From *Teatro della Scala in Milano* (Milan, 1789).

The horseshoe hall had many practical virtues. It guaranteed relatively clear visibility while maximizing the number of boxes, which was important for revenue. Its deep, wide orchestra could also accommodate a large number of spectators. And unlike the ellipse, it minimized the distance between the boxes and stage. Music also sounded different in a horseshoe hall. Until recently, architectural historians have avoided acoustical judgments of historical structures.[172] Now, however, computer-generated models allow technicians to approximate past acoustical environments with a greater degree of certainty. Yet renovation and restructuring make it difficult to re-create the sound of music in the original San Carlo, and writers of the eighteenth century offer little help. The study of acoustics was imprecise during the period.[173] Many treatises embraced an Aristotelian notion of sound as a mass of air that traveled in circles or Athanasius Kircher's concept of undulating waves.[174] Most Frenchmen followed the Minim father Marin Mersenne, who thought sound congealed around columns of air at the centers of circular-plan spaces.[175] As the chevalier de Chaumont noted, this theory favored the elliptical hall, since the two foci of the ellipse created two coalescing columns within the auditorium. Still others looked to the empiricism of Newton, hoping that his understanding of hydrostatics and hydrodynamics articulated in the *Principia* (1697) could help with acoustics.[176] Although many of Newton's Italian supporters lived in Naples, his ideas did not influence theater building, because theorists had a confused idea of how practical improvements in architecture could enhance sound. For Giannantonio Selva, theories were unimportant. When building La Fenice, he wrote, "I don't think that theories explain why a theater is harmonic." He adopted the horseshoe for practical reasons: "[I]t always came out well."[177]

Well or not, the results were relatively uniform. Reverberation times are the most perceptible qualities of acoustics, and the modern Teatro San Carlo has a reverberation time

of 1.15 seconds.[178] This low lapse allows lyrics to be heard clearly, enhances the playing of a medium-sized orchestra, and is ideal for compositions of the eighteenth century.[179] Other surviving horseshoe auditoriums have similar reverberation times, creating a strikingly uniform listening experience.[180] Given the spread of the horseshoe and the predominance of Neapolitan music, it seems possible that composers, singers, and librettists influenced the choice. For La Fenice it was the music academy that decided on the form, not a panel of architects.[181] And as Jo Mielziner claimed, "[I]n eighteenth-century England . . . the increasing popularity of imported Italian opera . . . led to the dominance of the horseshoe auditorium."[182] The horseshoe therefore spread in tandem with music, guaranteeing audiences and musicians that the halls for which they sang and composed would sound similar regardless of geography. This aural consistency is ironic, because the San Carlo had initially challenged musicians. To understand fully how the San Carlo became the model for so many houses, we should conceive of its effects in two moments: First, though the theater was built to consolidate the monarchy, its scale destabilized music, requiring musicians to adapt to the space. Second, this adapted music encouraged the adoption of the theater's shape elsewhere. Were it built less grandly, or in a different shape, or in a city that was not teeming with musicians, the San Carlo might not have become the model opera house for Europe.

Yet as it happened, the history of theaters in the eighteenth century was largely determined by this chance alignment. Entering the horseshoe auditorium therefore became the most consistent part of any night at the opera. The Royal Opera House, the Palais Garnier, La Scala, La Fenice, and others were the San Carlo adapted and recast in different cities. Their architectural core was the same. And though other halls stretched into ellipses, these houses followed the rough simplicity of the horseshoe. It was the Doric order of opera houses, and its Parthenon was the Teatro San Carlo.

The Reale Albergo dei Poveri

REGIUM TOTIUS REGNI PAUPERUM HOSPITIUM *(Royal hospice for the poor of the entire kingdom)*

—Façade inscription, ca. 1756

If the Teatro di San Carlo was the most influential of Caroline buildings, the Albergo dei Poveri was the most needed (fig. 19). While impossible to quantify until the late nineteenth century, paupers had inundated the capital for centuries, stressing the fragile stability of the overpopulated city.[1] For the royal government, providing for the urban poor would be more complicated than simply offering shelter, food, and clothing. By taking them into custody, the monarchy would unsettle established ecclesiastical and lay charitable organizations dotting the city. Consolidation would face local resistance and create tension with Rome. Therefore, the king's minister of ecclesiastical affairs, Gaetano Maria Brancone, would steer the project by negotiating with church authorities and commissioning Ferdinando Fuga to design the building. Through three sites, five different designs, and multiple fundraising efforts, their planning and amending helped make the Albergo a reality.

Despite its importance, studies of the Albergo dei Poveri remain relatively few. While some historians, such as Andrea Guerra, have brought to light new archival material and offered a thorough discussion of

surviving drawings,[2] my research shows that all previous histories of the design and construction are incomplete. The archives of the papal nuncio in the Vatican Secret Archive and the records of the minister of ecclesiastical affairs in the State Archives in Naples have yielded bountiful information that rewrites the early history of the building. With these documents as aides, the drawings of the Albergo can be assigned new dates, and Fuga's role in its construction can be cast in greater relief.

Most importantly, the structure's role in the consolidation of royal power can be brought to light. Behind the drawings and dispatches lay a broader plan to trim the entangling authority of Rome in the affairs of the Two Sicilies. The financing of the project makes this clear. The message can also be read in Fuga's plans, which overtly and subtly expressed the authority of the king. Architecture could be as persuasive as diplomacy, and by looking at the Albergo with the struggle with Rome in mind, I shall uncover its deeper significance for Naples.

THE POOR IN NAPLES

As early as 1527 Juan de Vives, in his treatise *De subventione pauperum,* linked the urban

underclass to numerous social ills, from theft to disease.[3] The plague, famine, and social unrest that swept through Naples during the seventeenth century bore out his assertions with horrific scenarios. Among the most vivid was the Revolt of Masaniello, which began as a dispute in the marketplace but exploded into a popular uprising against the Spanish viceroys. More violent was the invisible enemy of the plague that struck the tightly packed city in 1656. When it lifted, the citizens could measure its devastation: nearly 250,000 dead by some estimates.[4]

The plague of poverty that aided these convulsions was chronic, and Neapolitans tried to bandage this sore through hospices that provided food, clothes, and shelter. Such charitable institutions had been chartered beginning in the Angevin period. Charles I of Anjou founded the first royal hospital "pro recipiendis pauperibus" at the western edge of the Piazza Mercato in 1270.[5] Though this hospice of Sant'Eligio predated his foundation edict, the collective support of the king, nobles, and court officials set the example of civic welfare for many future Neapolitan poorhouses.

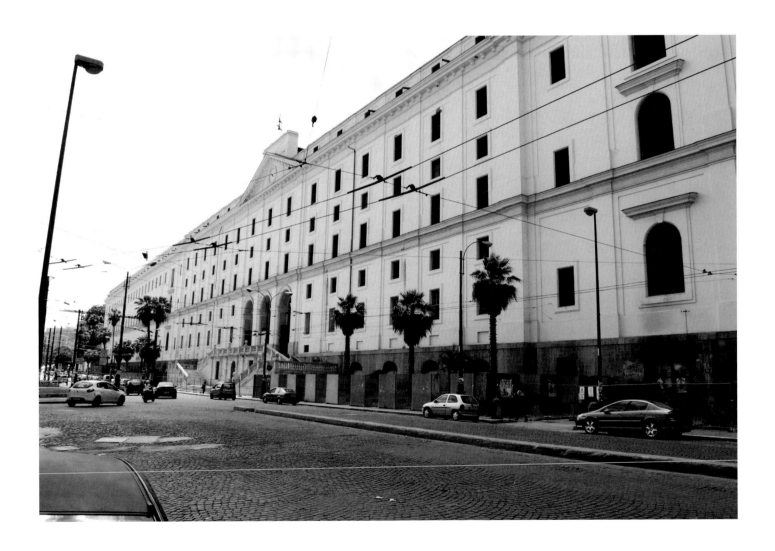

Later hospices, or *luoghi pii,* varied in the types of people that founded them and the objects of their charity.[6] They could be collectively chartered, like the Santa Casa dell'Annunziata and Pio Monte della Misericordia, or initiated by an individual, like Santa Maria del Popolo degli Incurabili. Foundations opened their doors to such specific groups as infants or sailors or flung them wide to accept broader categories of the sick and the poor.

Noble families would often bequeath money and land to charitable foundations, making them financially robust. Soon *luoghi pii* sprouted banking arms to manage their capital.[7] As they amassed wealth, they physically expanded, annexing land adjacent to their founding parcels. And they competed with convents and monasteries in campaigns of aggressive urban encroachment to create large unified blocks in the city. Palaces, homes, and civic buildings were devoured to make way for dormitories, sick wards, and cloisters. Using a term coined by a group of Neapolitan Jesuits, Franco Strazzullo called the absorption of land into unified enclosures *fare l'isola,* literally "making an island."[8] This urban archipelago of religious institutions still confronts the visitor in Naples. High walls close out the city and shelter vast cloisters, courtyards, and religious houses. Their appearance was already noted in the seventeenth century, with one guidebook likening the Annunziata to "a spacious castle."[9] Yet despite their territorial and financial splendor, in times of crisis these *luoghi pii* were overwhelmed.

The ineffectiveness of the *luoghi pii* during the plague of 1656 prompted the viceroys to consider other options for dealing with the poor. Since the burden of urban mendicants was a Pan-European concern, Naples could employ solutions tested in other cities. Forced confinement was the most widely adopted approach. Facing an outbreak of pestilence in 1528, the Venetians had been the first to enclose the poor. Rome followed in 1561 and renewed attempts in the 1580s. Bologna, Brescia, Verona, Vicenza, and Turin had all used buildings for enclosure by the end of the sixteenth century.[10] England advocated more systematic enclosure with a 1576 decree calling for houses of correction to be established in every county, while in German cities the poor were taken into *Zuchthäusern,* or workhouses, where they were instructed in a trade.[11]

Paris faced some of the greatest challenges and pioneered notable solutions. As in other parts of the continent, its beggars were associated with disease. During epidemics the sick were sent beyond the city walls, into tents and huts that were burned when the pestilence passed. Henry IV sought more effective and permanent solutions and founded hospitals for veterans and plague victims. His Hôpital Saint Louis was a palatial edifice, ready to confine the ill should an outbreak occur.[12] Louis XIV followed this example by setting into motion the most comprehensive enclosure system of the era with the creation of the Hôpital Général in 1656. This edict did not found a new structure but rather reorganized existing hospitals and poorhouses under a single administration. By 1676 the Hôpital Général had proved so effective that Louis decreed that one be established in every city of the kingdom.[13]

In Spain the systematic establishment of *albergues* under the aegis of Philip II began at the initiative of Doctor Cristóbal Pérez de Herrera. Pérez de Herrera perceived the social benefits of work and faith and made them integral parts of the lives of mendicants.[14] The architect Diego Sillero began construction

on the *albergue* in Madrid in 1596. Located on the Calle de Atocha, its construction proceeded slowly, particularly after the death of Philip. But Pérez de Herrera published a plan for its arrangement and governance in the *Amparo de pobres* (1598). Men, women, children, the infirm, and women of ill repute were provided with separate dormitories, but a chapel was placed at the center so as to be visible from the dormitories.[15] Most inhabitants came to the *albergue* only at night and were left to roam the city to seek alms during the day. Children were to be schooled so that they would become officials and administrators. Prostitutes were confined and put to work. The sick were given medical care.[16] Pérez de Herrera foresaw numerous social benefits from the operation of his *albergue* and listed them in his book.

As tangible solutions were being tested, other books and pamphlets appeared that discussed the growing problem of paupers. The Valencian Vives initiated a steady flow of Spanish treatises that led up to Pérez de Herrera's foundation. Works by Domingo de Soto (1545), Juan de Medina (1545), and Miguel Giginta (1579) refined a post-Tridentine method for combating mendicancy.[17] They encouraged the foundation of charitable hospices but railed against forced enclosure. They argued that confinement was heretical because begging for alms was an article of faith. In addition to looser control, they proposed complex solutions to mendicancy such as schooling orphans, providing work, and encouraging charity. Likely familiar with Spanish writers, the Neapolitan Giovanni Maria Novario published an exhaustive juridical treatise on mendicancy.[18] His *Tractatus de miserabilium personarum privilegiis* (1623) explored the legal qualification of orphans, the poor, prisoners, and newly converted

Christians to ask for alms and be provided with shelter. Like his Spanish predecessors, he advocated their instruction in Christian piety and urged that all hospices be under ecclesiastical, rather than civic, authority. His goal of religiously guided reform resonated in Counter-Reformation Europe and led to the reprinting of his book in 1637 and 1669.

Given Novario's local advocacy of enclosure among the array of possibilities, the government chose to institute a hospice for the confinement of mendicants. Viceroy Pedro Antonio de Aragón opened it in 1667 within a former Benedictine convent located along the rise of Capodimonte.[19] The structure adjoined the ancient catacombs of San Gennaro, and parts of it had been converted into a hospital as early as 1468. This fifteenth-century hospital was a private foundation, which the viceroy transformed by infusing it with public capital and changing its name to the Ospizio dei Poveri di SS. Pietro e Gennaro extra moenia.

SS. Pietro e Gennaro, commonly referred to as San Gennaro, sat nestled in a ravine at the northern edge of Naples, a location that effectively separated the poor from the rest of the city. Though the preexisting monastery and surrounding hills dictated the building's form, it would be reorganized so that inhabitants could be segregated into five different wings. Approaching SS. Pietro e Gennaro from Naples, the visitor encountered a plain façade marked with sculptures and commemorative inscriptions (fig. 20). A bust of Viceroy Pedro Antonio de Aragón joined full-length statues of San Pietro, San Gennaro, and King Charles II to remind visitors of the temporal and spiritual patrons of the hospice. The portraits also signaled its importance to the monarchy. Funds were withheld from Naples's royal taxes to finance it, it bore one of the few

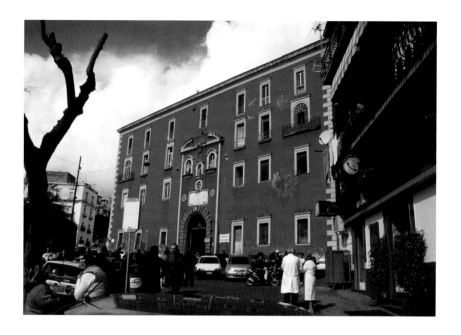

FIGURE 20
Ospizio di SS. Pietro e Gennaro
extra moenia.

sculptures of the king in the city, and the bust of Aragón was the first permanent public portrait of a viceroy.[20] To spread the fame of these patrons and proclaim their progressive social engineering, one of the first books on an established poor hospice in Europe was published on San Gennaro in 1671.[21]

Besides placing Naples at the vanguard of mendicant reform, this building also set some of the standards that the Caroline Albergo dei Poveri would follow. The division of space for groups of inhabitants would be one fundamental similarity, and the location beyond the city walls another. Royal patrons would even be represented near the entry portal. The Ospizio was also an example in a negative sense, presenting financial obligations that the Bourbon monarchy would reject. Due to its conversion from a monastery into a hospital, papal authorization was needed. The pope sanctioned the metamorphosis but required payment of a *quindennio* to Rome.[22] Though it seemed nominal, in 1702 the hospital found itself

liquidating land assets to pay the pope. For the Caroline Albergo dei Poveri, however, obligations to Rome would be explicitly forbidden.

HOUSING THE POOR IN THE EIGHTEENTH CENTURY

From the year that San Gennaro opened to the time that Naples came under Bourbon control, the relationship between the state and the poor had changed dramatically in Europe. Forced enclosure had become common but was not universally accepted. Political discourse explored alternative solutions, which were blisteringly satirized by Jonathan Swift in his "Modest Proposal" (1729). Enclosure still seemed the easiest solution. In France numerous cities had followed the example of Paris by instituting a Hôpital Général. Meanwhile the Hôpital Général of the capital had grown to hold between five thousand and six thousand persons by the end of the seventeenth century. The *Zuchthaus* model was also gaining currency, with ones founded in Dublin, Plymouth, Norwich, Hull, and Exeter near the turn of the century.[23] As Voltaire would proclaim, "Oblige men to work, and you certainly make them honest."[24] Colbert tested the model in France but succeeded only in the provinces, failing to establish effective workhouses in Paris. In Italy, Genoa had woven labor into the lives of the poor when an Albergo dei Poveri was founded there in the 1650s. And work was a component of Rome's Ospizio Generale dei Poveri at the Ripa Grande, founded by Innocent XII in 1693, as well as Turin's Ospizio della Carità (1717).[25]

Italian poorhouses shared a kinship of plan and organization, much of which derived from hospitals. Early modern hospitals had two functional requirements: wards for physical healing and chapels for spiritual healing. Most chapels were simple rectangular halls

open to the public. They attracted bequests for the hospital, which also made them precious repositories for art. The ill rarely attended Mass in the chapel but received the Eucharist directly in their wards. Wards were long rectangular halls with high ceilings. Lined with curtained beds, each ward contained an altar, designed to be visible to all the invalids. Like monastic cloisters, common areas included courtyards or gardens lined with porticos.[26] Wards and courtyards were arranged in various manners, but the most common organization followed the cruciform plan of the Ospedale Maggiore in Milan, begun in 1456. Filarete had arranged its wards around a central chapel hub that was not open to the public. The central location of the chapel permitted simultaneous administration of the sacrament to multiple wards. A separate court for women had wards arranged in a T shape around its chapel and ensured the same liturgical ease. Courtyards lined with porticos surrounded the wards and permitted the circulation of air and access to the outdoors.[27] The cruciform plan spread quickly, to Florence, Mantua, Parma, and other Italian cities. Most importantly, its influence spread to Spain, where it was adopted for the Hospital de la Sangre in Seville (1546–59) and influenced the plan of the Escorial.[28]

Hospices imitated hospitals in plan and organization. Like hospitals, they were usually situated near a water source and away from the center of the city. Yet they hoped to return their inhabitants to society, and space was devoted to training them in a trade and instructing them in the Roman Catholic faith. Rooms were included for work, schools established, and churches built.

To meet the varied demands that these giant hotels for the homeless presented, the best architects were often chosen to build

them. Vincenzo Scamozzi planned San Lazzaro in Venice, Carlo Fontana designed the Ospizio di San Michele in Rome, and Bernardo Antonio Vittone directed the construction of the Ospizi della Carità in Carignano and Casale Monferrato. Adding to the complexity of joining workrooms, dormitories, and kitchens was the demand, stated explicitly to Carlo Fontana, that "a single church serve everyone."[29] This was doubly difficult given that churches had to allow for separate but simultaneous worship for men and women.[30] Early solutions, such as San Lazzaro in Venice, provided separate rooms hidden by grates on either side of a single-aisle church. A roomier method created two naves with separate entrances on either side of a central-altar chapel. This form, with a continuous aisle bisected by the bulge of a high-altar chapel, was selected by Vittone at Casale Monferrato. The central chapel was sometimes opened for public worship, and a third nave could be added to the altar node to offer more space. The third nave was usually joined to the front of the presbytery, creating a T-shaped church like the one of the Albergo dei Poveri in Genoa (fig. 21). There the mendicants occupied the cross of the T while the public remained in the stem, all sharing the same ceremonial focus. Thus the demand for separation of sexes and the opposing pull of public display and absolute confinement made the church a laboratory of architectural innovation.

The eighteenth-century innovations were not simply made in plan. The goals and operation of these foundations also came to be more strongly defined in the literature of the period. The central figure in this discourse was a French Jesuit, André Guevarre.[31] Guevarre breathed life into the moral reasoning of forced enclosure. He saw the gathering of

FIGURE 21
Plan of the Albergo dei Poveri
in Genoa. From Martin Pierre
Gauthier, *Les plus beaux édifices
de la ville de Gênes et ses environs*
(Paris, 1830–32).

he believed "we distinguish, my good Father! betwixt those who wish only to eat the bread of their own labor—and those who eat the bread of other people's, and have no other plan in life, but to get through it in sloth and ignorance."[32] For this reason Guevarre's writings are scrupulous about making sure vagabonds are separated from the reformable, that the sick and infirm are sheltered in other locations, and that the *ospizi* are efficiently administered. His workshop ground up poverty, and he recommended a millstone of tough laws to curb mendicancy.

Guevarre published multiple books on building hospices and banning mendicancy, or rather a single book rewritten for different cities.[33] Within each he republished the foundation edict for the poorhouse of a particular city. He then commenced his authorship with a description of how the poor should be gathered together and how their lives should be ordered in *ospizi*. Leaving architecture to the architects, he simply suggested that the structure be near water and relatively close to the city, and closed the first sections of these treatises with a detailed description of the hospice's administration and governance. Then Guevarre directed his words to an audience of skeptics who might object to a single centralized shelter. Rhetorically framed as a dialogue between the doubtful and himself, Guevarre drew out each potential point of contention and buried it beneath responses peppered with quotes from the Bible and the church fathers. Nor did Guevarre stop with simple justification for the civic utility and religious necessity of the *ospizio*. The dialogue soon targeted private philanthropy, encouraging individuals to donate money to the foundation. By blocking every objection and advertising sites where donations could be made, Guevarre

mendicants in these *alberghi* and hospitals as a means of saving them, spiritually and physically. Thus Christian catechism was one beacon of his argument, while the other was his belief in teaching the mendicants trades. He hoped to transform them into a ready pool of laborers. Yet Guevarre was realistic about the limits of mendicant reform. Like Laurence Sterne,

methodically pushed the reader to contribute funds. Pleading "Times are tough," "I have a large family," or "I will remember the poor in my will" was futile. Guevarre had an answer to each.[34] This masterful argument for support as civic and Christian duty may explain why Guevarre was called to Genoa in 1719 to champion its Albergo dei Poveri.[35] And when the royal government began to finance the Neapolitan Albergo, Guevarre's treatise was in the hands of royal advisors.[36]

THE ALBERGO DEI POVERI IN NAPLES

While solutions to poverty were being tested on paper and in civic and royal councils of Europe, Naples's need for an answer to its urban mendicants grew. The city, which already counted 300,000, had begun to grow at a rapid pace.[37] Many of the new inhabitants were poor and came from rural areas. The court responded to the influx in February of 1736, when Montealegre instituted a council for the policing of Naples. The councilors were to consider the problem of vagrants and beggars and think of "the formation of a place for invalids, where they can be enclosed along with the poor."[38] Montealegre was likely inspired by examples in Spain. Indeed, Philip V had recently reconstructed Madrid's Real Hospicio de San Fernando on plans by Pedro de Ribera (1721–26), giving new life to one of the city's seventeenth-century charitable houses.[39] Yet Spain was not the only example. Montealegre also cited Colbert's efforts in France as a model.[40]

In June the committee received a proposal from a local canon, Emanuele Giraldez, for a *real ospizio* to be built near Naples. Modeling his idea on those of others, Giraldez suggested that the enclosed receive training as craftsmen, sailors, or soldiers. He also suggested that the

kingdom's religious institutions and *luoghi pii* fund the project, a proposal that was taken up with zeal fifteen years later.[41] Yet rather than rush to build a new hospice, the council hoped the *ospizio* of San Gennaro could take up the burden. Unfortunately, the hills that sheltered San Gennaro also limited its expansion, and Montealegre conceded in 1740 that more than one location might be needed.[42]

Solutions would have to wait. In 1740 the War of Austrian Succession erupted as Frederick II of Prussia invaded Silesia. France and Spain joined him, renewing their conflict with the Austrian Hapsburgs, while England, Holland, Sardinia, and Saxony rallied to Maria Theresa's defense. Montealegre, in coordination with Spain, dispatched troops to northern Italy while insisting upon the Two Sicilies' neutrality.[43] England did not accept it, but Montealegre ignored the threat of an English naval attack until August of 1742, when a squadron of thirteen vessels sailed into the bay. The gunboats caught the royal government unaware, trapping the king and his court in the Royal Palace. Charles was advised not to flee Naples lest he alarm the populace. Meanwhile feverish negotiation with the English captain and a subsequent mission to London by Neapolitan diplomat Giovanni Fogliani Sforza d'Aragona eventually led to the fleet's withdrawal. The royal government agreed to recall its troops from Lombardy, angering Spain and France but temporarily saving the vulnerable monarchy. The war would continue for another six years, and the king would personally lead troops into battle in 1744. Montealegre, assailed by military advisors for his naïveté, continued in office only until Philip V's death was imminent. In June of 1746 he was dismissed.

His departure signaled the loosening of bonds between Madrid and Naples. His

successor, Fogliani, owed his career to Elizabeth but was not beholden to her. For the queen retired to La Granja de San Ildefonso after the death of Philip. Fogliani descended from an ancient house of Emilian nobility.[44] He had followed Elizabeth to Spain, served in her court, and earned considerable financial reward. Returning to Italy in Charles's retinue, Fogliani was often dispatched on diplomatic missions: to Florence, Genoa, The Hague, and London. Despite his success in foreign affairs, diplomats questioned his capacity to lead the government. The Sardinian ambassador described him as "a man of tall stature, a long face, blond hair, of few intellectual gifts, not very knowledgeable in court customs, very partial to France, easy to misstep in what he says and then correct himself, just as he is prone to make promises and not keep them; and to sum him up in a few words, a man who takes a long time and is inconclusive in affairs of state."[45] Fogliani lacked the power and charisma of Montealegre, but his weakness probably fit the sovereigns' wishes. Until the 1740s the Neapolitan king and queen allowed their state to be governed from Spain. Now they charted an independent path, guiding the government more directly. Other ministers emerged from behind the shadow of the secretary of state as equal collaborators in royal reforms. Architectural projects received direct royal input and were directed by various ministers within the government.

As the War of Austrian Succession came to an end and a new political landscape dawned, the idea for the poorhouse resurfaced. Discussion now centered on a completely new structure: an Albergo dei Poveri. Today the Italian word *albergo* means a hotel or lodging. Defined more broadly, it can imply a refuge or shelter. It derives from *haribergo,* a medieval Germanic word for military lodging. The Genoese,

first to use it in Italy, associated *alberghi* with urban compounds of allied noble families. In Naples and Palermo the word likely reflected the Spanish usage of *albergue* for its hospices. But Pérez de Herrera's *albergues* were hospices where the poor checked in only at night. In Italy inhabitants were less free, and the use of the word may hearken back to its military roots, suggesting a more regimented life than that of the typical hospice. This would be consistent with the routines of work, prayer, and learning that took place within the *albergo*'s walls.

The idea of a new *albergo* in Naples was encouraged by the founding of one in Sicily. Palermo had begun forcing its poor into a hospice as early as 1733, but only in 1746 was the stone laid for a new Albergo dei Poveri along the road leading to Monreale.[46] This *albergo* was governed by a council of Sicilian nobles who secured approval and 8,060 ducats from the king in 1744. A little-known architect, Orazio Furetto, was given the commission, and despite a counterproposal submitted by his compatriot Giovanni Battista Vaccarini, Furetto weathered criticism with some minor alterations to his designs.

His plan and a perspective view, printed by Antonio Bova ca. 1746–60, proposed a building of two large courtyards (fig. 22). The left one was designated for men and the right for women. Between these square courts Furetto inserted a central core containing the church and its forecourt, administrative offices, and a kitchen. The essential form of the church was a T, the stem of which blossomed into a domed octagon. This octagon was enveloped by a corridor that allowed the poor to reach confessionals without entering the public's space. For Mass, the poor instead occupied two naves on either side of the high altar. These naves were

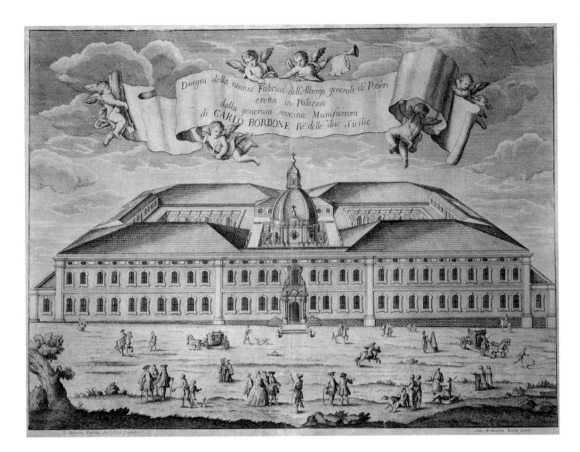

equipped with tiers of balconies so that all of the poor could be accommodated. Despite the inconvenience of balconies and the awkward shuffling between spaces, Furetto projected a building of relative simplicity.

Discussions of an Albergo dei Poveri in Naples began within five years of submission of the initial plans in Palermo. Pietro d'Onofri relates two different incidents that he claims precipitated the project.[47] In one the queen was inspired to found such a house when she received some polished stones made by the poor in the Albergo of Genoa. The role of the queen seems likely given her interest in architecture. Moreover, documents relating to the early stages of the Neapolitan Albergo make reference to a poorhouse in Prague,

a city Maria Amalia had visited and where she likely saw Kilian Ignaz Dientzenhofer's enormous Invalidenhaus under construction.[48] In the other anecdote a charismatic preacher, the Domenican Father Gregorio Maria Rocco, encouraged the king to found it. Rocco had a vast following in Naples.[49] He ministered to the poorest of its inhabitants, giving impromptu sermons in Neapolitan dialect along the narrow streets near the Mercato Grande and the Borgo di Loreto. With his large black walking stick, oversized shoes, and sloppy attire, his humble appearance matched the simple stories that he used to convey his Christian message. He also wanted to improve the lives of the poor and advocated for the illumination of dangerous streets and the custody

of orphans. In addition, two treatises authored by him that are now lost addressed the issue of poor relief and proposed building hospices in Naples.[50]

Onofri oversimplified the project's gestation. As we know, the first discussion of the Albergo took place under Montealegre's aegis in 1736. Yet the author's anecdotes were not pure inventions. The first plan of the Albergo dei Poveri did strongly reflect the Genoese model, and the papal nuncio and civic tribunal did attribute the project to Padre Rocco.[51] The titles of Rocco's treatises suggest more concern with the care and regimen of the poor than architecture. It is clear he favored forced confinement and instruction in Christian piety. Both aims echoed those articulated by Novario a century earlier, and both would be a part of the Albergo dei Poveri in Naples.

In July of 1748 the royal couple had a son and to commemorate the occasion donated 15,000 ducats for the new hospice. Secretary of State Fogliani convened a council to discuss the planning of this "Albergo Generale dei Poveri" and select an appropriate site.[52] Present were three doctors: Francesco Buoncore, Francesco Serao, and Angelo Tirelli. Little is known about Tirelli. Buoncore was the king's personal physician, had traveled with him from Spain, and held a post at the University of Naples.[53] Serao was a professor of medical institutions at the university and was close friends with Francesco Roseti, who had authored a 1744 treatise detailing the need for air and open space when building large hospitals.[54] Serao had also given wise counsel to the king about the salubrious positioning of the Royal Palace at Portici.[55] Two military engineers, Colonel López Varrios and Giovanni Bompiede, joined them on the committee. But the Roman-born architect Antonio Canevari

was the most qualified builder present.[56] Not only had Canevari begun supervising the king's palace at Portici, but he had also worked for the king of Portugal and had extensive experience from an early career in Rome. As architect of the Academy of the Arcadians' Bosco Parrasio, Canevari had even been given the rare charge to select the site as well as design the garden. Such qualification made his opinion particularly valuable. The final member of the committee was the Duke of Cerisano, who would later become the royal ambassador to the Holy See. The committee soon settled on a site called the Borgo di Loreto, to the east of the city.

The council also asked to see designs of other poorhouses in Italy, requesting drawings of those in Rome, Genoa, Turin, and Palermo.[57] The plan of the Albergo in Genoa arrived shortly after 17 August of that year.[58] The design of San Michele in Rome was received from Cardinal Silvio Valenti Gonzaga on 25 August.[59] Meanwhile Furetto traveled from Palermo in October of 1748 to help secure more royal funding for its *albergo* and present its plan to the king.[60] Of the two hospitals of Turin, the plan of the Carità arrived in February of the following year; it is unclear whether one of the Collegio delle Provincie was ever sent.[61] The council pored over these drawings, examining their features and interrogating them and their senders for information.

Looking at the plan of the Albergo of Genoa gives a basic idea of a hospice's components. The centrally positioned church is easy to identify, with its aforementioned T-shaped plan (fig. 21). Harder to discern are the quarters for officials. These suites of small rooms served as the administrative hub of an *albergo* and usually occupied the part closest to the city. In Genoa, they were positioned at the

front. Provisioning the *albergo* was another concern. Large refectories, kitchens, and washrooms were necessary for the numerous inhabitants. These spaces were in the least visible parts of the ground floor, placed near the back of the Genoese structure. Finally there were the workrooms and schools. Fulfilling the mission to instruct, these large rooms occupied the sides of the *albergo* and spaces between the church and refectories. Dormitories, which are not shown the plan of the Genoese building's ground floor, occupied the upper floors, which were likely segregated by sex and age.

Beyond identifying spaces, questions of capacity preoccupied officials in Naples. Their *albergo* was destined to house more people than any of its Italian peers. Already in August 1748 the papal nuncio forecast thousands of people.[62] When the first design for the Albergo was presented to the king, in April of 1749, it proposed accommodating a staggering four thousand, equal to the capacity of the Hôtel des Invalides in Paris.

That first design was submitted by Ferdinando Fuga (fig. 23).[63] He was not alone in seeking the commission. Vaccarini shipped a model from Sicily, probably based on the plans he had made during the design competition in Palermo.[64] The court preferred Fuga's plan, though Luigi Vanvitelli would claim that the Florentine beat out the Sicilian only because of the strong advocacy of Cardinals Colonna and Portocarerro.[65]

Fuga's success was not necessarily attributable entirely to the backing of others. He was one of the most accomplished architects of the period.[66] Born in Florence in 1699, he had apprenticed under Giovanni Battista Foggini before moving to Rome to frequent the Accademia di San Luca and immerse himself in the competitive atmosphere of *concorsi*

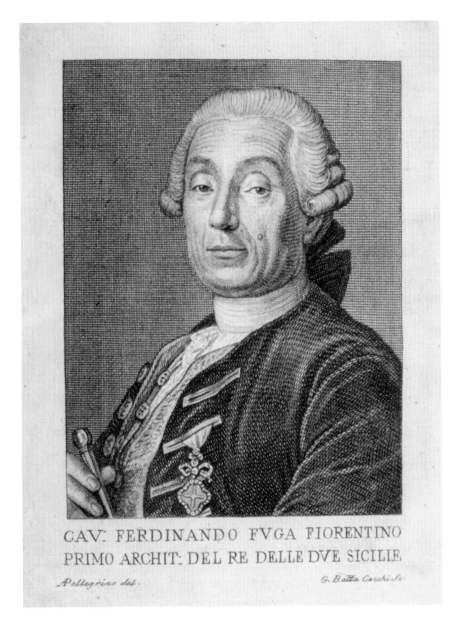

CAV. FERDINANDO FVGA FIORENTINO
PRIMO ARCHIT: DEL RE DELLE DVE SICILIE

Pellegrino del. *G. Batta Cocchi Sc.*

and commissions.[67] During this time, the dawn of his career, Fuga stretched his stylistic versatility and polished his draftsmanship. His first steady patron was the Neapolitan Cardinal Niccolò del Giudice, who commissioned Fuga to design a chapel and portal for his Palazzo Cellamare. Returning to Rome in the 1730s, Fuga rode a wave of Florentine favoritism

FIGURE 23
A. Pellegrino, *Portrait of Ferdinando Fuga.* From Pellegrino Antonio Orlandi, *Abecedario Pittorico dei Professori più illustri in pittura, scultura, e architettura* (Florence, 1788).

ushered in by the election of Clement XII Corsini. He found work completing structures begun by others, including the Manica Lunga of the Quirinal Palace (1731), its Scuderie (1731), and the Carcere delle Donne of the Ospizio di San Michele (1735). After these commissions had tested his adaptability, patrons opened the way for his originality. In the course of a decade Fuga would produce some of Rome's most notable eighteenth-century edifices: the Palazzo della Consulta (begun in 1732), Palazzo Corsini (begun in 1736), and a new façade for Santa Maria Maggiore (1741–43). In these buildings Fuga grafted new structures onto older ones, wove together a single palace from the needs of several constituencies, and met demands for private and public space with equal ease.

Like his drawings, his working method was lucid and direct. As he told it, his mind first registered the function of rooms and then worked out their proper proportions. Ornament came later, and like a careful chef he boiled it down and seasoned it sparingly. Good taste, he found, "is born naturally in the minds of men and is then perfected through good study."[68] He also argued "that the architect refines his designs by comparing them with existing buildings."[69] This studied method, marked by rigorous evaluation and comparison, gave Fuga's projects a polished finish that patrons appreciated.

The Spanish and Neapolitan courts had followed Fuga's rise.[70] One of his first Roman patrons, Cardinal Troiano Acquaviva d'Aragona, was the Spanish ambassador to the papacy. At the death of Filippo Juvarra, the cardinal suggested Fuga succeed him as architect of the Royal Palace of Madrid. Yet Clement XII would not allow Fuga to leave Rome. The architect instead received the post

of Charles's architect in Rome in 1736. In that role he was charged with maintaining Palazzo Farnese and executing ephemeral architecture for royal celebrations.[71] He also made occasional trips to Naples. In 1739 Fuga observed the construction of the new Royal Palace at Portici.[72] His position also placed him in contact with Charles's secretary for ecclesiastical affairs, Gaetano Maria Brancone, overseer of the Albergo project.

Born into a family of Neapolitan civic administrators, Brancone was the only native to hold office as one of the kingdom's four principal secretaries.[73] At his promotion, in 1737, Santiesteban described him as "possessing intelligence, great learning, integrity, and zeal for serving the king."[74] We can be certain of the last quality. Brancone stuck close to Spain under the Austrian viceregency, despite being secretary of the city of Naples from 1720 to 1735. In fact, when Charles arrived in the capital, an eager Secretary Brancone presented him with a list indicating the loyalty of Naples's barons and magistrates. Whether he was intelligent, learned, or honest is moot. Antonio Genovesi described Brancone as "a man of little spirit, of little culture: very devout and of trite ambition."[75] Minister of Justice Bernardo Tanucci was equally unkind, counting him one of the many pedantic jurists that filled the city.[76] These assessments of Brancone's character become important when one considers his responsibilities. He oversaw the Universities of Naples and Catania, granted licenses to print books, and eventually supervised the theaters of the capital. He also took over supervision of the Albergo after Secretary Fogliani convened the initial council. Brancone's oversight proved essential. Funding would require the hard-fought participation of religious institutions, and his support for the

Albergo was unflagging. He crusaded for its completion, scavenged for funds, and sometimes used deceit to push the project ahead. The records of his ministry contain the most complete record of the Albergo's gestation, changing plans, and financing.

Reading Brancone's dispatches corroborates the assertion of the papal nuncio that he called Fuga to Naples. The minister backed the architect from the start and remained in frequent contact with him throughout the design competition. For example, when some grumbled about the projected cost of Fuga's

Albergo, Brancone calmed them by claiming he could reduce the architect's estimate by 200,000 ducats.[77]

Fuga's design of April 1749 was probably a preliminary idea because in August he sent presentation drawings to Naples. "Well adapted, distinct, and clear," these greatly pleased the king.[78] The praise of their precision suggests that these are the drawings now preserved in the Istituto della Grafica in Rome (figs. 24, 25).[79] One presents the plan of the building, and the other sheet shows an elevation of the principal and rear façades

FIGURE 24
Ferdinando Fuga, plan of the Albergo dei Poveri, 1749. Graphite, black ink, and gray and pink wash on paper. Istituto Nazionale per la Grafica, Rome, 13909.

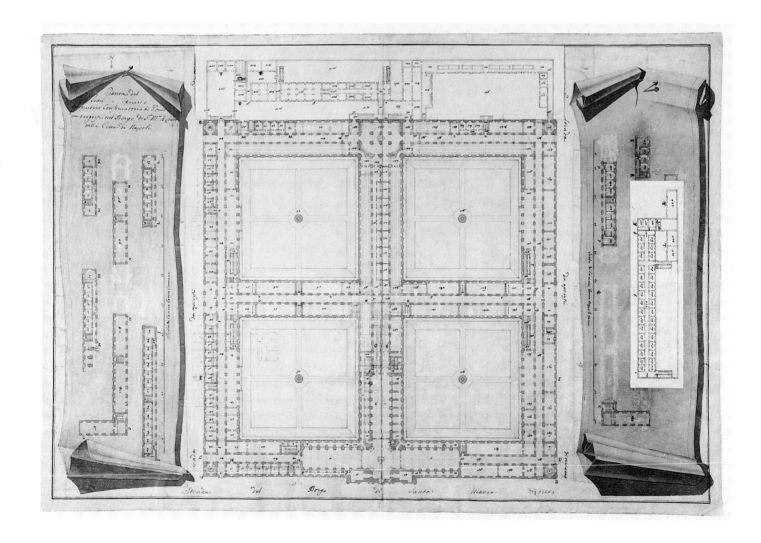

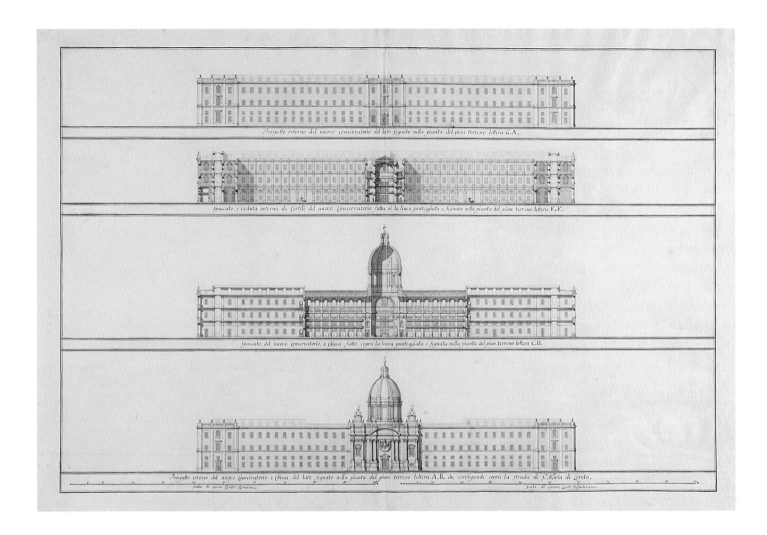

Prospetto esterno del nuovo Conservatorio del lato segnato nella pianta del pian terreno lettera G.A.

Spaccato, e veduta interna de Cortili del nuovo Conservatorio fatta su la linea punteggiata e segnata nella pianta del pian terreno lettera E.F.

Spaccato, del nuovo Conservatorio, e Chiesa fatto sopra la linea punteggiata e segnata nella pianta del pian terreno lettera C.D.

Prospetto esterno del nuovo Conservatorio e Chiesa del lato segnato nella pianta del pian terreno lettera A.B. che corrisponde sopra la strada di S.Maria di Loreto.

FIGURE 25
Ferdinando Fuga, elevations and sections of the Albergo dei Poveri, 1749. Graphite, black ink, and gray and pink wash on paper. Istituto Nazionale per la Grafica, Rome, 13907.

along with two sections. Fuga planned for four courtyards to be joined into a large, almost square building. This cross-shaped arrangement recalled Filarete's Ospedale Maggiore, the Invalides, and the Escorial. Fuga knew the dynastic resonance the latter precedents had for his Spanish Bourbon sovereign and likely knew that the Escorial was inspired by plans of Spanish hospitals.[80] Fuga's plan also shows that he knew the exact location that had been selected in the Borgo di Loreto. A structure at the right side of the drawing, identifiable as the Serraglio delle Ferie, extends toward the

building. This clue places the Albergo between the Porta del Carmine and the Sebeto River on a site occupied by the conservatory of Santa Maria di Loreto (fig. 26).[81]

The location was first and foremost practical. It situated the structure outside the city walls but near the port and the Mercato Grande, where mendicancy was greatest. Symbolically the site linked the Albergo with the nearby hospital of Sant'Eligio, whose regal pedigree was renewed each year when the king viewed the festivities of the Madonna del Carmine from its terrace. And visually the location

was splendid. Near the water's edge at the eastern extreme of the port, the Albergo would have been a prominent landmark for ships sailing into the harbor.[82] A view of the Genoese Albergo was also best enjoyed from the deck of a ship, and both shared a four-courtyard plan. Fuga also adopted the T-shaped church from Genoa but reversed its direction so that the crossing lay at the front of the building.

Though he drew upon examples that the council knew, Fuga made certain his plans were comprehensible by numbering each room and assigning its function in an accompanying key, now lost. Without this key, we can only speculate on how spaces were used. In general, the more public spaces in the building were arranged in the wings closest to the city: the west and south. The largest space was the T-shaped church. To its left suites of small rooms were to serve as offices and quarters for the Albergo's administrators. Similar rooms fill the entire western side of the building, which is broken by a three-bay loggia at its center. This entrance faced the city, and it would probably have greeted residents and nonresidents alike. A symmetrically placed loggia occupied the eastern façade, but this half of the building had a less public role, as most of the rooms were likely destined for instruction and labor. The large rectangular rooms that fill the eastern wing, central east-west arm, and the area to the right of the church would have been where inhabitants learned a trade or received basic education. At this date it is not clear what subjects would have been taught, but they later included grammar, drawing, engraving, music, singing, arithmetic, surgery, shoemaking, sewing, and textile weaving. Between lessons, residents might access the seven-bay loggias positioned along the outer edge of each courtyard and enter the cloistered gardens with

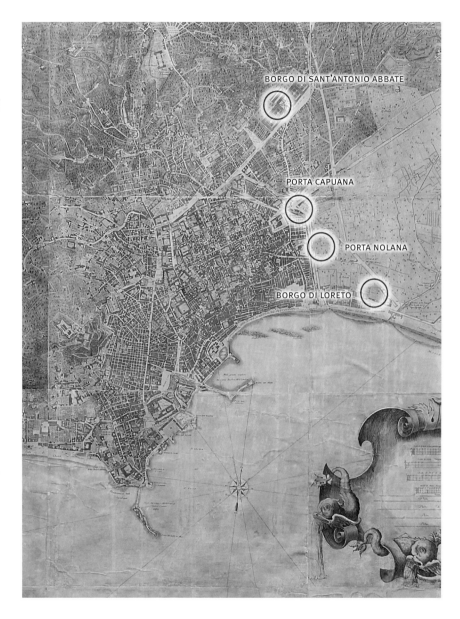

fountains. To eat, inhabitants would have filed toward the back of the building. A large *lavamano*, equipped with fountains at its center and perimeter, is the symmetrical counterpoint to the church crossing. Residents shared the *lavamano* but were presumably divided among four long refectories based on their age and sex (men, women, boys, and girls). In a light-gray wash Fuga showed three rows of common

FIGURE 26
Map of Naples with Albergo dei Poveri locations highlighted by the author. After Giovanni Carafa, duke of Noja, *Mappa topografica della città di Napoli e de' suoi contorni*, 1775 (fig. 108).

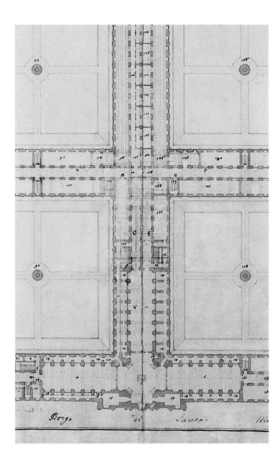

FIGURE 27
Ferdinando Fuga, plan of the
Albergo dei Poveri, 1749 (fig. 24),
detail showing the central nave
of the church.

FIGURE 28
Ferdinando Fuga, elevations
and sections of the Albergo
dei Poveri, 1749 (fig. 25), detail
showing a section through the
lateral naves of the church.

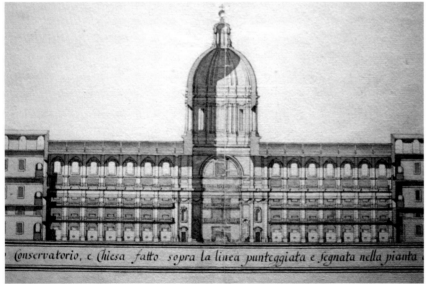

Conservatorio, e Chiesa fatto sopra la linea punteggiata e segnata nella pianta

tables. At the end of each refectory a small table was placed perpendicularly to the others and was perhaps destined for presiding officials. Behind the northern wing of the Albergo extended an irregular service court. Its odd trapezoidal shape, later hidden by a flap, was dictated by the Via dell'Arenaccia, an existing street and drainage channel that forced Fuga to tuck kitchens, washrooms, and ovens into a constrained space.

Dormitories lined the corridors of the upper floors, which can be seen in the section drawing. Large stairways for accessing these floors abutted the inner courtyards, while small spiral ones, perhaps service stairs, were positioned at the corners of the building. Additional access to the outdoors could be found along the roof of the building, where a covered belvedere extended around the building's perimeter. This roof terrace was similar to one at the Ripa Grande, which Fontana had included for drying wool.[83] The feature also had Neapolitan roots in belvederes that afforded cloistered nuns enjoyment of sea breezes and vistas.[84] The Albergo belvedere could offer the poor sweeping views of Vesuvius and the blue waters of the bay.

When attending church, their gaze was instead focused on a single altar. They entered one of three naves extending off of the crossing. The two lateral ones, each six bays long, could contain two separate segments of the enclosed. The single seven-bay one was destined for the other two groups, which were separated by a slender partition in the center (fig. 27). Thin walls also connected all of the piers at the nave's perimeter. These walls permitted priests to circulate behind them while congregants filled the church, and were punctured by narrow slits that served as confessionals (fig. 28).[85] The crannied wall unfortunately restricted the naves' capacity for Mass. Fuga

therefore added three tiers of balconies in the upper reaches of each arm of the church, a feature probably drawn from the Albergo of Palermo. Unlike Furetto, Fuga resolved the opposing pull of confessional intimacy and liturgical openness without requiring two separate spaces for confession and Mass.

While the central altar served the Albergo's inhabitants, Fuga monumentalized the space around it for the public. He placed a dome above that could only be appreciated fully by an outside visitor. In addition, he positioned four subsidiary altars at the bases of the crossing piers to increase its magnificence. The exterior elevation confirms the church's public role. In marked contrast to the austere façade of the wings, the frontispiece of the church stands out (fig. 29). It extends beyond the fabric, stepping into the road to differentiate itself from its humble flanks. Fuga shows it in a

paler hue, suggesting a lighter stone or stucco. He even deferentially lowers the roofline of the wings near it. The two outer bays of the church façade extend the farthest from the structure and are bordered by simple pilaster strips. Corinthian half columns separate these outer bays from the next two, and these recessed bays are in turn separated from the central one by paired columns. Before entering through the single portal, the arriving visitor could look up to admire the large Bourbon escutcheon displayed beneath a fictive drape of fabric. Higher still, Fuga added an attic storey and designed two small *campanili* to visually frame the tall dome. He articulated the drum with paired Corinthian pilasters flanking rectangular windows. The lines of these pilasters are broken by two horizontal bands but picked up again by ribs in the cupola to give the building a strongly vertical thrust.

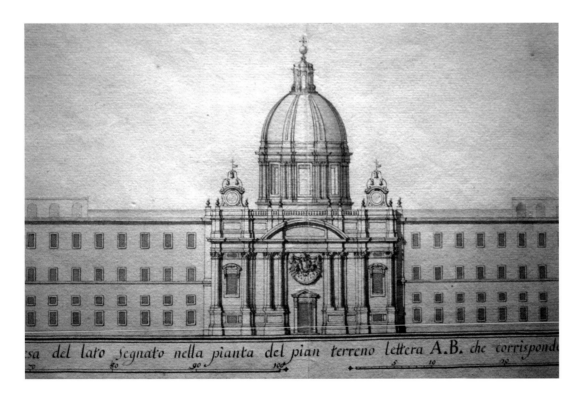

FIGURE 29
Ferdinando Fuga, elevations and sections of the Albergo dei Poveri, 1749 (fig. 25), detail showing the church façade.

With the columns raised on pedestals and the steep dome placed near the front of the edifice, the Albergo's façade would have seemed to teeter over the narrow street before it. This imposing height can be explained only by considering the view from the sea. In contrast to most Neapolitan churches, which faced the dense urban core, Fuga's Albergo was crafted for an audience in the bay, and its height and isolation guaranteed it visual prominence. As it addressed a sea-bound audience, the church also spoke a more international architectural language. Neapolitan church façades, constrained by narrow streets, conventionally stood in low relief with veneers of pilasters closely adhered to the wall. Baroque Rome boasted more plastic façades articulated by free-standing or engaged columns. Indeed, the Albergo's church resembles a miniature St. Peter's.

Among Italian poorhouses this grand representational space was unprecedented. Its roots instead lay in the Escorial and the Dôme des Invalides. The long unarticulated façade of the Escorial is broken in the center by a temple frontispiece. This façade within the façade leads to the forecourt of the domed church, which serves as the monumental heart of the building. In Paris, Jules Hardouin-Mansart foregrounded his cupola, opened the church to the outside, and invited visitors to glimpse the inhabitants on the other side of the altar. The Escorial and Invalides were emblematic of the grandeur and magnificence of their respective monarchs. They intoned power as well as piety and charity, and Fuga's plan evokes a similar message.

The location of the Albergo soon undermined Fuga's precise planning. The area was swampy, and the wide street–cum–drainage channel, the Via dell'Arenaccia, pressed close to the site.[86] Fuga had faced similar problems with his extension of the Ospedale dello Santo Spirito in Rome. There his planned extension was truncated to avoid a turbulent turn in the Tiber River.[87] Fuga had responded to the Arenaccia by compressing the service court, an area on plan he later covered with a flap, and designing a smaller service wing and directing the "new flow" of the drainage bed away from the building. Yet his proposed redirection of the Arenaccia would probably have entailed additional expense and could never have safeguarded the structure against the unpredictable onrush of storm water flowing to the bay.

Surprisingly, the greater concern for the royal government was not how to divert water away from the site but how to get adequate fresh water to it. A diagram of the Acqua Bolla system made in the seventeenth century showed the conservatory of Santa Maria di Loreto at the terminus of one its branches. While sufficient for the conservatory and the nearby cavalry barracks, it was unclear if this low-pressure aqueduct would be sufficient for the construction of the Albergo. Stones had to be washed, and workers and animals needed a clean water supply. The king was very concerned that the water supply be deemed sufficient at the outset. Lack of similar foresight at Capodimonte had led to expensive daily hauling of barrels of water to the work site.[88] A discouraging report by municipal engineer Luca Vechione on the water supply for the Albergo led to new solutions.[89]

Fuga had already compared three sites: the first at the Borgo di Loreto; a second slightly north, near the Porta Nolana; and a third much farther north, in the Borgo di Sant'Antonio Abbate.[90] After the Borgo di Loreto site was judged inadequate, Fuga probably attached the flap to his original drawing,

presenting an option for a service wing unimpeded by the Arenaccia. Of the other two options, the royal government preferred the location outside the Porta Nolana.[91] The site was supplied by a more modern aqueduct, the seventeenth-century Acqua Carmignano.[92] One of its branches passed into ditches below the city's eastern ramparts, and by locating the Albergo near these trenches, water could be directed to it without constructing new channels.

The shift of sites explains why no land was ever purchased in the Borgo di Loreto, a move that also would have required demolishing the conservatory of Santa Maria di Loreto. Instead, all Brancone's records concern the purchase of land outside the Porta Nolana, specifically for the southwest quarter of the Albergo, destined to contain its administrative offices.[93] It was important that these offices be erected first, and Fuga reworked this quadrant of the building on his initial presentation drawing. At the lower left corner he sketched new floor plans that provided five-room suites for the most important officials. He also rethought the center of the building (fig. 30). Graphite revisions show a vaulted room near the crossing and stairs positioned nearby. Fuga likewise marked the central church nave as he contemplated lengthening it. At a certain point he decided on extending it by one bay and confirmed his decision with a hatched line.

From these graphite revisions grew a new plan: a black-wash presentation drawing also in the Istituto della Grafica (fig. 31). This plan again allows us to position the Albergo with precision. A wall, parallel to the left side of the structure, angles to the left just beyond its lower corner. This peculiar feature is identifiable on the duke of Noja map of Naples as the city wall just to the north of the Porta

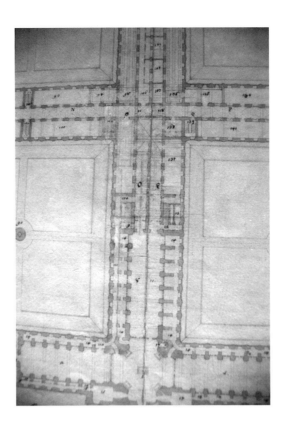

FIGURE 30
Ferdinando Fuga, plan of the Albergo dei Poveri, 1749 (fig. 24), detail showing the graphite revisions of the central nave.

Nolana, situating the Albergo outside of the walls on the north side of a principal road leading into the city.

Most of Fuga's graphite revisions are incorporated in the new plan. The ministers' quarters have been expanded in the lower left quadrant, stairs have been added, and the church lengthened. In addition, Fuga widened the church's central arm. The new bulk did not broaden the nave, which was still constrained by the thin confessional walls on the ground floor. Instead, it deepened the balconies to permit more people to fill the sanctuary. The deeper balconies required easier access, and Fuga inserted two switchback stairs for reaching them. The elaboration of dramatically longer flights mimicked Fuga's thinking at the Palazzo della Consulta, where he had likewise replaced compact stairs with grander ones.[94]

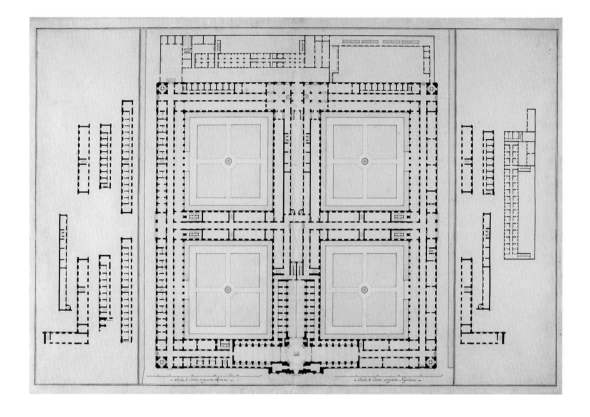

The wider central arm of the Albergo also allowed Fuga to add more open space for light and air. He lengthened the courtyard arcades and inserted light wells in the central arm of the building. Fuga also divided the *lavamano* with a service corridor that provided easier communication between the kitchens and refectories. This split *lavamano* also permitted the segregation of inhabitants, an aspect that would grow more regulated and controlled as planning continued.

Fuga did not label this plan, and no elevation drawing survives. He did, however, propose to make a wooden model, writing to Brancone that it was necessary "for such a magnificent edifice."[95] The king was skeptical and asked how much it would cost and how long it would take to finish. The monarch thought plans on paper sufficient and lauded

Fuga's accomplished draftsmanship. The architect was not seduced by flattery. He persisted, forcing the king to reserve judgment until they spoke in person.[96] When they met, the monarch agreed to Fuga's request.

Though a model of the Albergo in Palermo was displayed for the purpose of public critique, it is unlikely that Fuga would have invited such scrutiny.[97] Nor did the Albergo dei Poveri present curved façades or geometrically complex spaces that a model could realize. More likely, Fuga knew how the complex room arrangements could be clarified with a model, making it a useful tool for explicating the interior. It could also become the principal reference for calculating costs and checking progress.[98] Moreover, Fuga had witnessed the disruption caused by not having a model. When working on San Michele in Rome, Fuga

had appended the Carcere delle Donne to the *ospizio* without the aid of an overall plan. Fontana had never produced a comprehensive drawing, because he believed a wooden model should be made instead.[99] The congregation refused Fontana's request, and Fuga felt the full effect of their decision when he grappled with the *ospizio* without either a drawing or a model.

By December of 1749 the first funds had been sent to Rome for Fuga to make the model. In March of 1750 Brancone assured the architect that he need not worry about any delay or increase in expense so long as the model was completed in the best way possible. Yet in July, with no completion date in sight, the king's reservations resurfaced. In a sharp letter Brancone warned Fuga not to allow the project to cost "any further small sum" and to "finish the model with all possible celerity."[100] Despite this prodding, the model was finished only in November.[101]

When the model arrived in the port of Naples the following January, its journey was not complete. After it was first displayed in the Palazzo Reale, a new location was sought as the groundbreaking approached. With Fuga's approval it was transported down the Via Toledo to the Palazzo dei Regi Studi, which was deemed a convenient place for public display.[102] Rather than exhibit the model for review, as had been done in Palermo, the king probably wanted public attention brought to the building to boost enthusiasm for the project and perhaps inspire donations.

BREAKING GROUND IN SWAMPY SOIL

During the first months of 1751 Brancone rapidly purchased land.[103] Fuga began to direct work on 19 February, and within days a royal foundation edict was published. The edict noted the chaos caused by the poor filling the capital. It lamented the fate of so many sick and disabled among them and offered the promise of royal aid. Yet it threatened the able-bodied beggar with incarceration. Most importantly, it stated that orphans roaming the streets would be educated in a trade and the Christian faith so that they would not slip into a life of vagabondage. Therefore, as the royal edict stated, "we desired to erect in this capital a general Albergo dei Poveri for all sexes and ages and through it to introduce [the poor] to the necessary arts so that this Albergo [would] succeed in the eyes of God and to the benefit of this city and kingdom."[104] The edict established two congregations of governors to oversee the Albergo, one comprising men and the other women. Headed respectively by the king and queen, these councils brought together Neapolitan nobles, members of the clergy, and the principal secretaries of the royal court to guarantee that a broad cross-section of society was invested in the project.

In the same month that the Albergo was begun, the king and queen commissioned another building based on a similar plan. On 17 February, "the king and queen went to Caserta to make designs with Vanvitelli, who [had] been brought [there] by Fogliani to compete with Fuga."[105] The nuncio, eager to report the rivalry, failed to see the architectural similarity when "Vanvitelli was ordered to make a design of a grand palace with four courtyards."[106] This grandiose palace at Caserta would be the largest on the peninsula. It would be lavish. But it is noteworthy that the court conceived both the palace and the more humbly articulated poorhouse in the same moment. Perhaps, in a stroke of architectural propaganda, the government hoped to convey two beacons of royal authority. At the top of the society the king was both ruler and caretaker.

This architectural message proved short-lived. Excavation for the Albergo foundations continued for most of the month. Solid ground had to be found for the great weight of the building to rest upon, or it would certainly sink into the swampy terrain. When twenty-nine *palmi* had been dug without striking solid ground, work stopped, and water filled the excavation trenches.[107] Only Brancone's determination to keep momentum in the sails of the project overrode the temporary failure. A new site had to be selected quickly so that the Albergo would not remain bogged down outside of the Porta Nolana.

While the old site filled with water, Brancone redoubled his efforts. The minister compared the last remaining options, two locations outside the Porta Capuana and one below the church of Santa Maria degli Angeli in the Borgo di Sant'Antonio Abbate (fig. 26).[108] Considering the quality of the air, availability of water, and projected costs of the foundations, he recommended the Sant'Antonio Abbate site. But the location would force major changes to the original plan. On 22 March 1751 Fuga was asked to redesign the Albergo for a narrower tract of land.[109] Brancone meanwhile convened the Deputazione della Salute to approve the site and requested a study of how the Acqua Carmignano could supply the area. All of the land outside the Porta Nolana would have to be resold to the original owners at cost. And all of the poor taken into custody as construction laborers had to be transferred to various domiciles in the Borgo di Sant'Antonio Abbate.[110]

The new location positioned the Albergo farther to the north, near areas that were already inhabited and considered salubrious.[111] Hugging the Via del Campo, it would be the first building to greet travelers arriving from the north. Other royal buildings similarly announced the approach to Naples along the kingdom's thoroughfares. Alfonso I's Poggioreale sat along the Strada di Puglia, and the Royal Palace at Portici straddled the Strada delle Calabrie. However, the prominent site of the Albergo presented significant hurdles. The structure would sit over uneven land, requiring the western end to sink into the hillside and the eastern flank to rise well above it. A retaining wall would need to be built, and large amounts of stone and soil moved. Fuga also had to transform the square footprint of the original plan to fit the strip of land between the Via del Campo and the hills of Capodimonte. The Albergo needed to be oblong, rendering previous designs and the wooden model irrelevant.[112] Royal doubts about the model were confirmed, and Brancone told the rector of the Regi Studi to dispose of it.[113]

To redesign the Albergo, Fuga now turned to his experience with the long, narrow Ospizio di San Michele (fig. 32). He and his Neapolitan patrons could also have been warmed to the idea of an elongated Albergo by Jacques-Germain Soufflot, who visited the city between June and July of 1750, perhaps leaving behind a print of the Hôtel Dieu of Lyon.[114] Even with these catalyzing factors, the architect refashioned his plan with amazing speed. Within two months he had finished "the first outline" of the building, permitting the purchase of land.[115] On 1 June 1751 he came to the capital to present the new design.[116]

Though we lack a drawing bearing this date, all of Fuga's subsequent renderings share basic characteristics that allow us to assume what he presented. The four courtyards would be joined in a longitudinal chain, and a fifth court containing the church, ministers' quarters, and service wing would be inserted at the

center. Building this ministers' wing was again the priority.[117] A large presentation drawing now in the Istituto della Grafica presents this quadrant of the building and probably dates to the late summer of 1751, when work was concentrated there (fig. 33). Looking at this drawing, one is immediately struck by the ingenious church plan. From a common liturgical heart Fuga projected five naves, originating a hub-and-spoke sanctuary. This form allowed more space for the inhabitants, doing away with the shared nave of his first design. By providing a nave for each group, Fuga seems to have followed Libéral Bruant's design for the Salpêtrière chapel in Paris. Yet Bruant's cruciform plan could not anticipate Fuga's radial arrangement of naves. Antoine Desgodetz and Leonhard Christoph Sturm had made hospital designs with a similar hub-and-spoke plan. Yet in both cases the spokes were wards for the infirm.[118]

Faint graphite lines help reveal how Fuga generated this form. Beginning with a circle, he divided it into six equal parts like pieces of a pie. Instead of simply laying out the naves on the axes of these pie cuts, he drew them in two distinct phases. For the lateral naves Fuga projected an X shape within the central courtyard. To allow enough space for stairs that would connect these naves to the upper floors of the Albergo, Fuga could not simply have the arms of the X meet the corners of the courtyard. He therefore divided the depth of the building into three equal parts. The central became the bases of two equilateral triangles, the sides of which constituted the naves' walls and set their width. The apexes of these two triangles are the most worn points on the page,

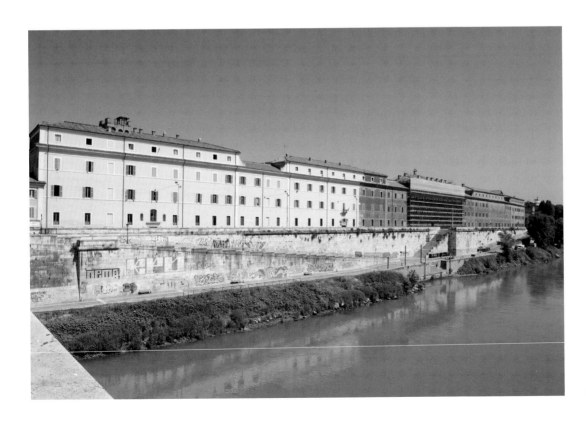

FIGURE 32
Ospizio di San Michele, Rome.

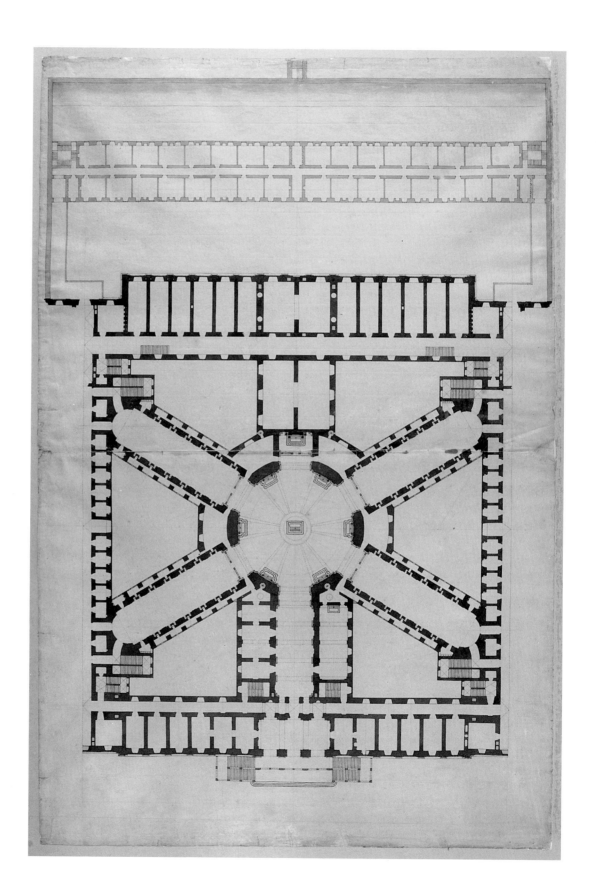

FIGURE 33
Ferdinando Fuga, plan of the
central court of the Albergo
dei Poveri, 1751. Graphite
and blue-gray wash on paper.
Istituto Nazionale per la
Grafica, Rome, 13911.

indicating that they played a crucial role in his planning. Locked together in this manner, the four naves created an X shape that left enough space for stairs to be tucked into each of the four corners of the courtyard. Carlo Fontana's hunting lodge for the Prince of Liechtenstein (ca. 1698), Filippo Juvarra's Palazzina di Caccia at Stupinigi (1729–33), and Germain Boffrand's Malgrange II (1712) all shared the plan. But Fuga's X was destined for paupers rather than princes, and he wrapped the naves in a toothy wall so confessionals could be tucked along the sides. He also positioned an altar where these naves intersected so that all of the inhabitants could see the Mass. As Andrea Guerra has argued, Fuga used a similar process to rethink designs for the church of San Giacomo degli Spagnoli in Rome.[119] With the four naves established, Fuga turned to the fifth one. This nave was centered on a line that bisected the length of the courtyard. Intended for the public, Fuga made it wider than the others by adding a four-bay chapel to the east and a suite of three rooms to the west, both with openings into the second bay of the nave. He did not seamlessly join this nave to the others and left pinched trapezoidal spaces behind the two southern piers of the crossing. Yet its inclusion pulled the dominant axes of the X into a more centripetal space. Fuga reinforced this impression in the crossing. Lozenge-shaped piers faced with altars embraced the cylindrical core and were ringed by an ambulatory with sacristies.[120] Fuga also added a recessed altar opposite the public nave. Its aedicula terminated the public's vista and created a secondary focus beyond the altar in the crossing. To entice the public in to see this view, Fuga added a three-bay entry loggia accessed from the street by a large switchback stair. Above this loggia he placed the ministers' quarters, which he

elaborated in a smaller drawing (fig. 34). Mezzanine floors, like the one shown in the plan, permitted dense stacking of three- and five-room apartments. They additionally ensured that the bureaucrats were housed in the core of the building, near the church and public entrance.

This mezzanine plan also exposes the structural support of the church. Its naves bristled with projecting buttresses that recalled Gothic structures such as Santa Chiara in Naples.[121] A section drawing of the courtyard dated to the same period was published by Gino Chierici in 1931. Though now lost, it shows the debt to Gothic structures more clearly.[122] Fingerlike buttresses clasp the naves in a way that had been unique to Santa Chiara. Not only structural, they symbolically buttressed the Bourbon dynasty by connecting it with the architecture of its Angevin predecessors. Not surprisingly, the monarch selected a chapel adjacent to the

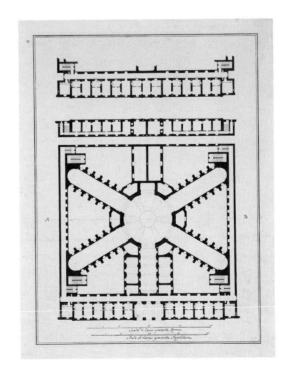

FIGURE 34
Ferdinando Fuga, plan of the mezzanine floor of the Albergo dei Poveri, 1751. Black wash on paper. Istituto Nazionale per la Grafica, Rome, 13910.

Angevin tombs in Santa Chiara for his family's mausoleum. In addition, Fuga would redesign the pavement of its nave, fashioning a large Bourbon crest as the central motif.[123] Yet Fuga did not merely evoke an Angevin structure. He embraced gothic support systems. The architect had employed slender buttresses for the nave of Sant'Appolinare in Rome. And he encased the Albergo dome in a *tiburio*, typical of medieval Lombardy. Only its gently sloping cap emerges, and in the elevation drawing published by Chierici, its cone seems to merge with the fabric like a swelling architectonic Vesuvius.

Fuga's long, sober façade helped give the dome an entrapped appearance. Unarticulated wings extended along most of the building's front, with rows of windows creating a *basso continuo* for periodic treble flourishes of three-bay units with arched windows and pilaster strips.[124] The center gained little more ornamental emphasis. Fuga marked it off with a series of pilaster strips and projected it slightly forward. Two six-bay units formed a humble frame to the central three. At the center the loggia recalled a similar arrangement at the Royal Palace at Portici, renewing the connection between royal palace and poorhouse. Yet the entry is barren of ornament and does not approach the splendor of the previous design.

Theorists would have been pleased. As Marc-Antoine Laugier noted in his 1753 *Essai sur l'architecture:* "Buildings intended to house the poor must retain something of poverty. . . . So much splendor indicates either a superabundant endowment or little economy in the administration. . . . The poor people must be housed like poor people—with much cleanliness and comfort, but with no ostentation!"[125] His thoughts followed similar reasoning by other French theorists who insisted architecture express its *caractère.* They probably would have faulted the first design of the Albergo and certainly would have criticized many of the *luoghi pii* in Naples. Their thoughts, shared in Italy but not articulated in the same way, may explain why conspicuous external magnificence was swapped for inventiveness in plan. Fuga succeeded so well in conveying sobriety on the exterior that when Stendhal entered Naples in 1817, he proclaimed, "first building—Albergo dei Poveri; deeply impressive—no comparison with that over-rated bit of sham baroque, that chocolate-box effect that Rome is pleased to call the Porta del Popolo."[126]

Yet the new design was not universally praised. Vanvitelli disparagingly wrote that Fuga's designs "are not pleasing and put into question whether it will be built."[127] Vanvitelli's appraisal of his rival was always harsh, yet when he reported in the same months that the queen declared, "Vanvitelli *makes things clean*," we hear an implicit indictment of Fuga, who crammed rooms behind the piers of the Albergo crossing.[128] Indeed, Fuga would have to rework the church twice more, but the hub-and-spoke plan remained, becoming the hallmark of the structure.

ORGANIZING THE WORK SITE AND HOUSING THE POOR

Royal agents began purchasing land for the Albergo along the Via del Campo in the spring of 1751. A couple of households of Venetians were displaced, as was the congregation of Santa Maria del Riposo. The land would cost 24,498 ducats and would be paid for through September of the same year.[129] As this patchwork of private land parcels was stitched together, the life of the Albergo was set into motion.

A royal decree issued against vagabonds declared that they would be rounded up and put to work constructing the building. These forced laborers would be joined by slaves and companies of professional masons. A chaplain would be installed to provide spiritual guidance for them, and they would be housed in locations sprinkled around the construction site. Within the year mendicant women would be housed in the nearby Santa Maria della Fede, orphaned girls would be placed at the Santissima Annunziata, and boys at the Immacolata Concezione, all with the understanding that they would be transferred into the Albergo when complete. The sick were taken to the Incurabili, but after some invalids escaped, a better system had to be devised for keeping them in their beds. Similarly the government made certain that vagabonds not working would be locked away in the prisons of the Vicaria.[130]

Fuga meanwhile laid out a system for managing construction. The work site was enormous and complex, with hundreds of workers swarming over the area each day. Contract labor was a mainstay of construction, but it complicated centralized control. For example, the *pipernieri* that worked the Neapolitan *tufo* were allied to various bands, each under its own management.[131] Fuga therefore formulated a set of instructions for the masons, laborers, notaries, accountants, and others that would report to the site each day. These *istruzioni* articulated a series of checks and balances to make the project run smoothly and render it immune from corruption. At the top of the organizational pyramid Fuga placed himself. He delegated all tasks and took final responsibility. He also oversaw workers, assisted when payments were made, and resolved conflicts. From him, tasks cascaded down to *misuratori, soprastanti,* master masons, and *pagatori.* Betraying tacit apprehension about the integrity of these workers, Fuga carefully circumscribed their charges so that arenas of activity did not overlap. He also named a proxy superintendent to make sure competent eyes kept watch while he was away in Rome.[132]

Despite these precautions, problems arose. In August of 1752 pier "number twenty-five" was found unstable, flawed by shoddy craftsmanship. The responsible mason and the actuaries overseeing the funding of the pier were fired for malfeasance.[133] In general, masons took full blame for poor construction, but critics like Giovanni Bottari felt architects were equally culpable.[134] During the eighteenth century the roles of structural engineer and architect began to be more sharply defined. Advancements in science and math tested the limits of architects' technical knowledge, calling for specialists trained in statics. Vanvitelli doubted his own command of calculus and collaborated with a Paduan mathematician to repair cracks in the dome of St. Peter's basilica.[135] Yet he and Fuga continued to perform both roles, a problem that calls into question the placement of blame with respect to pier "number twenty-five."

The Crown's report on the faulty pier also noted a number of poor practices. For example, dirt and rock cleared from the site was to be carted to the "ditches of San Gennaro," a site probably near the eponymous *ospizio.* The intended practice, however, had yielded to more convenient disposal in the Arenaccia. News of this dumping must have incensed the royal government because the dirt would have been washed down the Arenaccia and Sebeto River into the port. The edict ordered the original disposal plan be respected. It also pointed out that since much of the excavated stone was

pozzolana and lapillo, it could be sold to other construction projects, transforming a burdensome expense into fiscal lagniappe. Finally, it concluded that poor practice was a symptom of loose command and requested that Fuga rearticulate the *istruzioni*.[136]

The 1753 *istruzioni* concentrated more authority near the top of the organizational pyramid.[137] Fuga and his substitute were joined by a Roman master mason in a triumvirate of experienced overseers that would guard against incompetence and corruption. They set daily goals for each team and appointed two *misuratori*, "and nobody else," to make vigilant inspections of the foundations. The labor of "poor, forced laborers, and slaves" fell under the purview of the *soprastante*, while court bureaucrats made sure that laborers changed shirts every week and that the injured were transferred to the Santa Maria degli Incurabili. Meanwhile, the Crown asked the governors to take more responsibility for the project so that the Albergo could function independently of the royal government.[138]

As he revised the *istruzioni*, Fuga also tweaked his designs. In a series of drawings approved and signed by Brancone on 23 April 1753, the architect presented the most complete surviving visual record of the planning process. Five plans show four floors and mezzanines (figs. 35, 36), and two sections lay open the principal staircases (figs. 37, 38).[139] Together they display how Fuga fitted each part of the Albergo's life into well-tailored spaces; how his architecture controlled movement through the Albergo with precision; and how divisions, both vertical and horizontal, segregated the inhabitants at all times so that in work, rest, and worship they would be trained like ivies on different trellises.

After a mendicant was given a uniform, he or she would be directed to one quadrant of the building. Males were sent to the west side, while the females were housed in the east. Children occupied the upper floor, and adults were on the first. Each dormitory was a plain vaulted room. Windows, positioned high on the wall, opened to the exterior on one side and faced inner hallways on the other (fig. 39). Each dormitory was ringed by balconies from which food could be lowered into the room when contagion was a threat. These balconies are visible in both the plan and section drawings. Every dormitory had toilets, indicated as small circles, which were canted into open light wells so that outside air could circulate and help sanitation. In addition, there were basins of fresh water at the ends of each hallway, and inhabitants had recourse to outside air from one of two loggias. If an inhabitant became ill, he or she would be taken to an infirmary located within his or her quadrant. An altar was located inside each of these sick wards, which were also equipped with separate kitchens.

Large staircases for accessing the ground floor were situated near the loggias on each level. Fuga made these palatial, with long ramps and small cupolas and lanterns over the landings, which were illuminated from above by open light wells. The poor could descend to the courtyards, refectories, outdoor gardens, and work spaces with ease but could not gain access to the floors of other inhabitants. Fuga's section drawing of the men's staircase clearly shows that it did not ascend to the level of the children (fig. 37), and the young found no door on their descent for sneaking onto the adults' floor. Nor did these groups see each other when proceeding to the church. The section

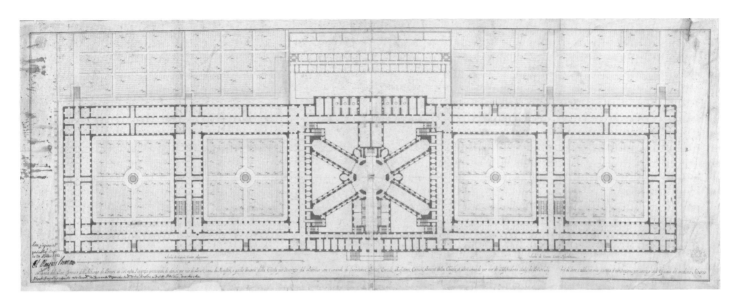

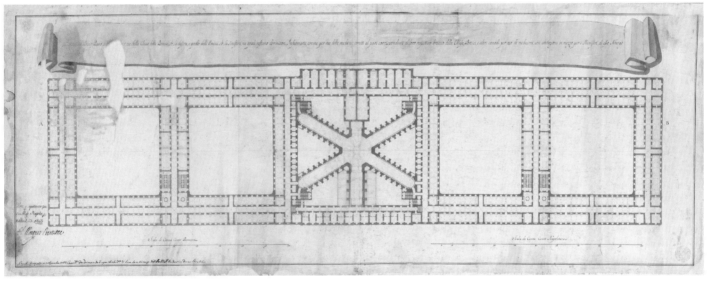

FIGURE 35
Ferdinando Fuga, plan of the ground floor of the Albergo dei Poveri (inscribed *Pianta del Pian Terreno del Albergo de' Poveri in cui resta l'ingresso principale di esso si per uso de' Poveri, come de' Ministri, e quello ancora della Chiesa per servizio del Pubblico con i comodi di Lavoratori, Cortili, Refettori, Carceri, Bracci della Chiesa et altri comodi per uso di chiascheduna classe de' Poveri seg[regati] fra di Loro, e addietro una partita d'abbitazioni per servizio dell'officiali del medesimo Albergo*), 1753. Black ink and pink and yellow wash on paper. Archivio di Stato, Naples, *sezione disegni,* cartella XII, 2.

FIGURE 36
Ferdinando Fuga, plan of the first floor of the Albergo dei Poveri (inscribed *Pianta del Primo Piano del Albergo de' Poveri per uso della classe delle Donne su la destra, e quello delli Omini su la sinistra, ne quali restano Dormitori, Infermarie, Cucine per uso della medesima, coretti al pari corrispondenti al loro respettivo braccio della chiesa, Portici, e altri comodi per uso de' medesimi, con abbitazioni in mezzo per i Ministri di esso Albergo*), 1753. Black ink and pink and yellow wash on paper. Archivio di Stato, Naples, *sezione disegni,* cartella XII, 3.

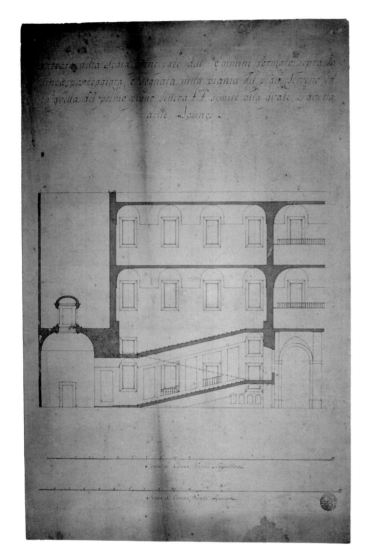

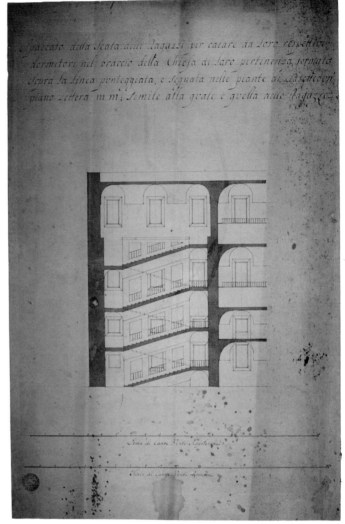

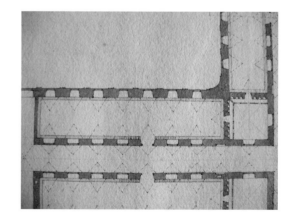

FIGURE 37
Ferdinando Fuga, section of the principal stair for the men (inscribed *Spaccato della scala principale delli Omini*), ca. 1753. Black ink on paper. Biblioteca della Società Napoletana di Storia Patria, Naples, 6.I.4.

FIGURE 38
Ferdinando Fuga, section of the stair for the boys that connects their dormitories to the church (inscribed *Spaccato della scala delli Ragazzi per calare da loro respettiva dormitori nel braccio della Chiesa di loro pertinenza*), ca. 1753. Black ink on paper. Biblioteca della Società Napoletana di Storia Patria, Naples, 6.I.4.

FIGURE 39
Ferdinando Fuga, plan of the first floor of the Albergo dei Poveri, 1753 (fig. 36), detail showing a dormitory.

drawing of the stairs for the boys' nave makes clear that it exclusively served that arm of the church and connected only to their quarter of the building (fig. 38).

Fuga made some small alterations to the church in these 1753 plans (fig. 40). He shaped the crossing into a hexagon by changing the piers from curved to angled ones. This thickening of the piers allowed him to refine the sacristies, whose outer walls had formerly been integral to supporting the dome. He now crafted them into small oval rooms behind the piers. He also revised the public nave, eliminating the suite of rooms to the west and the separate chapel to the east. Six new side chapels now opened directly onto the nave. The church and the ground floor were the only areas inhabitants shared, but Fuga minimized the possibility of encounters between groups. Each courtyard was clearly designated for a specific group because the loggias opening onto them were connected to one of the four principal staircases. Gardens in back of the Albergo were also parceled into four separate sections. And each of the large rooms on the ground floor would have been designated for work or school and equipped with a toilet to prevent mingling in the hallways.

In the instance of a visiting relative, the protocol was similar to that followed by enclosed monks and nuns. *Parlatori* flanking the entrance portico were reserved for outsiders wishing to speak with the enclosed, and Fuga provided benches for these reunions.[140] Unruly inhabitants had no such luxury and were forced into solitary confinement in cells lining the central courtyard. The remaining rooms on the ground floor were for eating. A single service room provided the only connection to the kitchens, which, located at the back, were otherwise sealed off from the rest

of the building. The four refectories were positioned along the two courtyards on either side of the church. Two refectories were located on the north side of the courtyard, while the other two were positioned along the corridors flanking the sides of the church. Taken together they formed two symmetrical L shapes, whose joining angle connected to the service room

FIGURE 41
Ferdinando Fuga, detail of the subterranean water channels of the Albergo dei Poveri, 1753. Black ink and pink and yellow wash on paper. Archivio di Stato, Naples, *sezione disegni,* cartella XII, 1.

refectory anterooms, were farthest from the source, and the fact that Fuga left these rooms dry must indicate that water pressure was insufficient.

Surprisingly, the deficient aqueduct was the Acqua Carmignano, which Fuga had judged satisfactory for supplying the Albergo at the Porta Nolana site. But the Carmignano was showing signs of diminishing pressure. Civic authorities responsible for managing the Carmignano were understandably reluctant to permit the Albergo to tap the channel. The king sought to allay their concerns by promising that his private Acqua Carolina, which ended at Caserta, could be lengthened to reach the capital. Yet only in November of 1753, after Fuga's suite of drawings was complete, was an agreement brokered between the king and the city government.[141] The reinforced Carmignano could now supply the Albergo, yet a skirmish between the city and the architect delayed the construction of conduits. Fuga insisted on designing the channel so that it would not slow progress on the Albergo. The city, accustomed to using its civic engineers, resisted until 1756.

Fuga's final drawing dates to some point after this 1756 settlement because it shows the Albergo abounding with water (fig. 42). Fountains open into basins below windows, at the ends of corridors, and in *lavamani.* Though construction on the water conduits would only be completed in 1765, the drawing probably anticipates the rerouting of the Carmignano and its reinforcement by the Acqua Carolina. Decorated with empty banderoles that would presumably have borne a key, this highly finished drawing may have been intended for publication. Comparing it with earlier renderings, one can see that Fuga again altered the church. He swept away the intricacy of the old

and kitchen in the back. Additionally, each of the four had small anterooms attached. These were designed as *lavamani,* yet while the northern ones were equipped with spouts and basins, the southern ones were not. Examination of the water channels that Fuga showed in his plan of the *sotteranni* (fig. 41) explains this difference. His "underground" parts of the Albergo corresponded to the street level and provided passage from the outside to the service wing and storerooms. Threading beneath them was a network of drains and pipes rendered in a yellow wash. These conduits drew upon a single aqueduct that passed along the northern wall of the building. Areas near the front of the building, such as the two barren

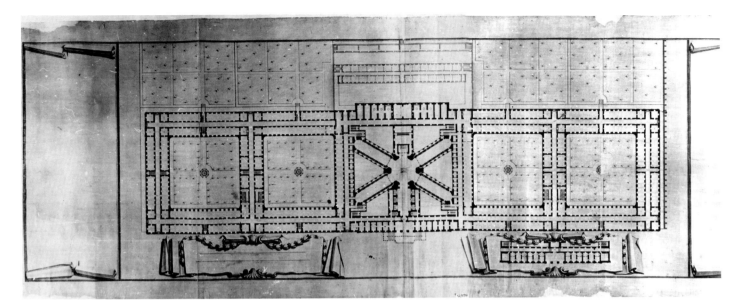

crossing by placing the dome atop six massive piers and consolidating the sacristies into a single room behind the altar. Thicker piers may also have allowed Fuga to rethink the height of the dome, since prints of the 1770s show a high cupola rather than the previous low shell (fig. 43). Raising the exterior profile of the dome would parallel the greater emphasis Fuga placed on the public in this plan. In previous plans a visitor would have traversed one of the Albergo's corridors to pass between the entry loggia and the church. Fuga now made the passage seamless by inserting a round vestibule to connect them. He also widened the public nave and enlarged the rear altar that terminated the public's vista. The architect even nudged the first three steps of the exterior staircase farther into the street to draw visitors inside.

Fuga also adorned the entrance. A revised drawing of the entry loggia (fig. 44) displays sculpted armor at street level to indicate the corps of guards stationed beneath the stair platform.[142] Above the central arch of the

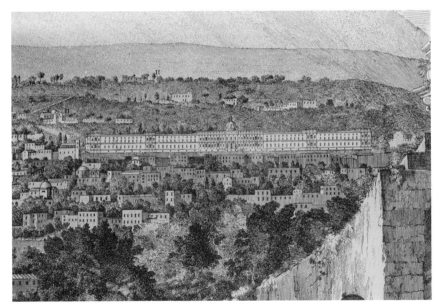

FIGURE 42
Ferdinando Fuga, plan of the Albergo dei Poveri, ca. 1756. Black ink with gray wash on paper. Biblioteca Nazionale, Naples, *carta geografica*, B, 28/67.

FIGURE 43
Giovanni Carafa, duke of Noja, *Mappa topografica della città di Napoli e de' suoi contorni*, 1775 (fig. 108), detail showing the Albergo dei Poveri in a *veduta* of Naples.

loggia winged Fames hold aloft the Bourbon arms and celebrate royal charity, as specified by an inscription on the frieze: "Royal hospice for the poor of the entire kingdom."[143] Inside the loggia Fuga added statues of the royal couple and commemorative inscriptions, and he made detailed renderings of these sculptures on two additional sheets (e.g., fig. 45). Inclusion of the royal couple followed the example of the Ospizio di San Gennaro, where images of the patrons ornamented the façade.[144] Yet unlike those of the earlier hospice, these statues remained in the shadows of the loggia and could only be fully viewed when the visitor passed through its arches. In fact, Fuga created a series of visual enticements. Armor at the ground level preceded the Fames higher up on the façade. The Bourbon arms anticipated a view of the royal simulacra inside the loggia. And one read the inscription before entering the church and seeing the poor. Each stage led to the next, and by reading inscriptions, heraldry, and sculpture, the visitor realized the path was a Bourbon one. To uncover the motivation for Fuga's dynastic route, we must interrogate the Albergo's financial history and political context.

DONATIONS AND DIPLOMACY: STRUGGLES WITH ROME

As one of the largest buildings erected in Europe in the eighteenth century, the Albergo dei Poveri could never depend exclusively on royal bankrolling. The king paid an annual subsidy of 12,000 ducats and looked to the public to provide the balance. To encourage philanthropy, Brancone suggested that individuals be asked by notaries to leave bequests.[145] Private philanthropy was the mainstay of the Albergo's peers, and over the years estate gifts trickled into the Albergo from all strata of society. Yet

this stream of individual bequests could not conceivably fill the Albergo's vast needs.

In 1750 Handel opened the organ at London's Foundling Hospital for the first benefit performance of *The Messiah,* and Brancone proposed opening the coffers of *luoghi pii* and convents to taxation. As the Albergo took in the poor, he argued, it should require the city's charitable institutions to direct their funds to it. According to the papal nuncio, Secretary Brancone conducted his campaign through a screen of "confusion and threats."[146] Some foundations gave funds, then others were ordered to donate or face suppression, since the poor had abandoned their doors for the new hands of the monarchy.[147] Powerful and rich monasteries were the most alluring targets, and Brancone soon secured hefty sums from the Discalced Carmelites of Gaeta and the monks of the Certosa di San Martino.[148] He then boldly asked the Certosa di Padula for 12,000 ducats. Balking at a figure equal to the king's annual subsidy, the Carthusians countered with an offer of 6,000. Brancone refused, and brazenly threatened them with suppression. The astonished Padulan fathers relayed their outrage to the pope, prompting Benedict XIV to proclaim it an "unjust affair."[149] While Rome protested, the government tightened its control over the *certosa,* making clear that "his most Christian majesty is the pope [*papa*] of the Carthusians."[150] They soon gave 10,000 ducats, and with the mightiest of the kingdom's monasteries donating to the Albergo, other foundations soon followed suit.[151] The Jesuits, Dominicans, Benedictines of Monte Cassino, and Carthusians of Chiaramonte all contributed shortly after.[152] This practice of redirecting church monies to royal projects had been practiced by the monarchy in Sicily. In 1742 part of the revenue of the Archbishopric of Monreale had

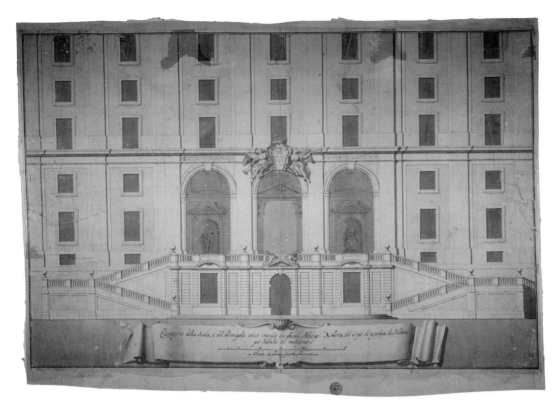

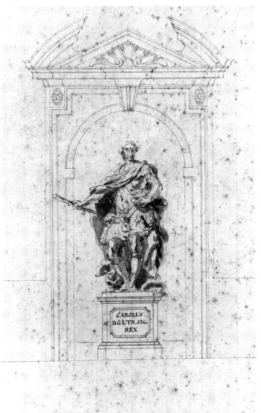

FIGURE 44
Ferdinando Fuga, elevation of the stairs and principal entrance of the Albergo dei Poveri (inscribed *Elevazione della Scala, e del Principale unico ingresso del Reale Albergo*), ca. 1756. Graphite and gray-blue wash on paper. Biblioteca della Società Napoletana di Storia Patria, Naples, 6.I.4.

FIGURE 45
Ferdinando Fuga, *Niche and Figure of Charles Bourbon,* ca. 1756. Black ink, black chalk, and brown wash on paper. Museo Nazionale di San Martino, Naples, 6778.

been redirected to the Albergo of Palermo.[153] Yet though this was the first instance of such funding, in Naples the royal government went much farther.

In fact, Brancone's success with the monasteries emboldened him to press beyond the donation box. With consent of the mother order, he suppressed the withering Augustinian Colorites and transferred their patrimony into the Albergo's chests.[154] Indeed, one of its eleven convents, Santa Maria della Fede, was converted into a temporary shelter for the female paupers until the Albergo was complete. Brancone pressed still deeper. Donations from the Kingdom of Naples had supported the Reverenda Fabbrica of St. Peter's for many centuries, it being the automatic beneficiary of unnamed bequests in the kingdom. Yet absent a legal precedent for such gifts, the minister proposed diverting them to the Albergo.[155] When word reached Rome, the pope countered by sending the nuncio to ask Secretary of State Fogliani to intervene. Fogliani conceded to the appeal, and Brancone contemplated resigning in the wake of the betrayal.[156] These court rifts were disheartening, even for the pontiff, who concluded, "The ministers that surround the king could not be worse."[157] Yet Brancone decided to remain in office even if his daring and inventive fundraising was curbed.

Brancone's mining of ecclesiastical patrimony was symptomatic of a broader political and historical conflict between Naples and Rome. Throughout its history southern Italy had been marked by strife between temporal and spiritual authority. Excommunications and military campaigns were common and had only subsided under the Spanish viceroys. Power in Rome and influence over the papacy became a cornerstone of Spanish policy. As Thomas Dandelet has argued,

Rome became Spanish, and a mortar of mutual benefits cemented the relationship.[158] Spain provided Rome with grain and military protection and rewarded Roman prelates and noble families with titles and revenues from southern Italy. In return, Spain received precedence in many aspects of papal policy. In Naples, the entwining of the papacy and Spain was manifest in the power of ecclesiastical institutions. Church foundations gained enormous influence by bolstering ecclesiastical jurisdiction and expanding their territorial holdings. By the early eighteenth century it was believed that ecclesiastical revenue constituted two-thirds of total land profits in the kingdom.[159] In addition, though they accounted for a mere 2 percent of the population, ecclesiasts in the capital had taken advantage of favorable economics to expand their monasteries and convents in the city center. As they annexed land and competed with each other in size and magnificence, the lay population eked out housing in diminishing space. In the early eighteenth century one commentator viewed the displacing effects of monastic growth as a direct cause of homelessness and mendicancy.[160] These thoughts reflected the growing suspicion of the church by Neapolitan jurists and literati. Their skepticism, mixed with Enlightenment ideas of proper governance, proved explosive. Pietro Giannone's *Istoria civile del Regno di Napoli* (1724) was the boldest criticism of Rome. Giannone argued that meddling popes had thwarted the kingdom's florescence and freedom at every decisive moment in its history. The church abused its privileges and violated civil law with impunity. Wildly successful in northern Europe, the *Istoria civile* was immediately banned in Italy and led to Giannone's arrest, excommunication, and death in prison.[161] The monarchy never aligned

itself with the vociferous attacks of Giannone but did heed calls for reducing the influence of Rome in the affairs of the Two Sicilies.[162] Most importantly, the court followed the suggestion of one pamphleteer and legally halted expansion of ecclesiastical landholding.[163]

Clement XII protested. The pope was not entirely opposed to reform but was unreceptive because of Charles's initial succession to Parma and Piacenza.[164] In 1731 Clement had argued that the duchies were fiefdoms of Rome and should revert to the Papal States absent an heir. Yet Elizabeth Farnese did not consult the pope and negotiated their transference to Charles with other European powers. When the infante arrived in Italy, his court did not acknowledge feudal ties, but Santiesteban tried to allay the pope by appointing papal nephew Bartolomeo Corsini to Charles's retinue. Relations gradually improved, and the pope and royal government negotiated the investiture of the Two Sicilies in 1738.

Yet representatives of the two sides came to an impasse over the question of legal jurisdiction. The issue was reopened after the election of Benedict XIV, in 1740. The new pope proved more accommodating and sent Cardinal Acquaviva, who had represented Charles under Clement XII, to negotiate the issue with Naples. Charles's representatives made high demands and extracted commensurate concessions.[165] A complete stop was put on the establishment of new churches and religious foundations, and a moratorium was placed on the expansion of existing ones. In addition, church lands could now be taxed and were subject to civic legal proceedings. With those demands met, the court reconciled with Rome by reinstating the *chinea,* a ceremonial commemoration of fealty, and donating the Farnese fragments of the *Forma Urbis Romae* to the Capitoline Museum.[166] Yet the 1741 treaty did not guarantee perpetual peace. Conflicts over ecclesiastical jurisdiction, Freemasonry, and the Inquisition soon disturbed relations between Rome and Naples. A visual testament of the awkward friendship was left in two paintings the king commissioned from Giovanni Paolo Pannini in 1746. Documenting the royal visit to Rome after the Battle of Velletri, one depicts an audience with Benedict in the Kaffehaus of the Quirinal Palace (fig. 46),[167] while the other shows Charles approaching the Basilica of St. Peter's (fig. 47). During the Kaffehaus visit Benedict and Charles got along exceptionally well. Noting that Charles was the first sitting king to have visited Rome since Emperor Charles V, the pope lauded the king as pious, virtuous, and modest.[168] The paintings tell a different story. They relegate the pope and the basilica to the wings of the canvases while the king occupies the center. In one, the expectant pontiff is barely visible through a door at the left, while in the other the scale of the Reverenda Fabbrica is reduced. In both Charles is oversized, something noted by contemporaries.[169] This outsized protagonist clearly enjoys a political triumph rather than a diplomatic reconciliation.

Throughout these turbulent years the most vocal proponent of papal authority in Naples was Cardinal Giuseppe Spinelli. Spinelli, a Neapolitan of enviable lineage, had helped broker the investiture of Charles by Clement XII. Though he represented the pope rather than the king, he found favor with the monarchy. Yet once settled in Naples, the archbishop challenged the court by guarding the jurisdiction of his ecclesiastical curia. In response, the king irked the archbishop by meeting with him rarely, favoring the cult of the Immaculate Conception, with its long

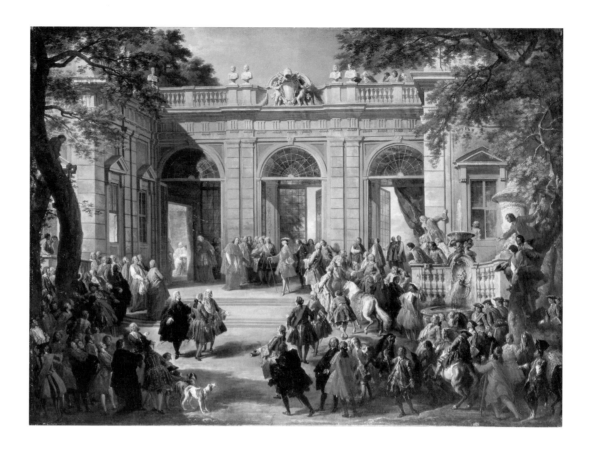

associations with the Spanish sovereigns, and supporting popular preachers like Padre Rocco.[170] Locked out of royal counsel and given a minimal role in the king's spiritual life, Spinelli used architecture to assert his relevance.

Architectural expressions of papal alliance were not unknown in Naples. Francesco Borromini had designed one of the most conspicuous paeans to Urban VIII with his drawings for a baldachin for Santa Maria a Cappella Nuova. This baldachin would have borne a frieze studded with Barberini bees and been surmounted by a giant papal tiara. Though we cannot be certain that Spinelli knew of the model, he made his alliance with the papacy equally clear when he renovated the high altar of the duomo. The architect Paolo Posi was called from Rome to make designs. His project

(1744) transformed the apse of the cathedral into a theatrical *bel composto* representing the Assumption of the Virgin (fig. 48). Gilded clouds and heavenly rays erupt from the glow of a stained-glass window representing the Holy Spirit. Rising up from the altar, Pietro Bracci's sculpture of Mary is borne upon a cushion of marble clouds and seraphim. The ensemble clearly copied Bernini's *Cathedra Petri*. And to complement this homage to the Roman bishop's seat, Spinelli completed an existing decorative scheme for the nave, facing the piers with aediculae sheltering busts of past archbishops of Naples.[171] These successors of San Gennaro pointedly underlined ecclesiastical power and longevity.

Fuga's designs for the Albergo dei Poveri were a royal response to this visual challenge.

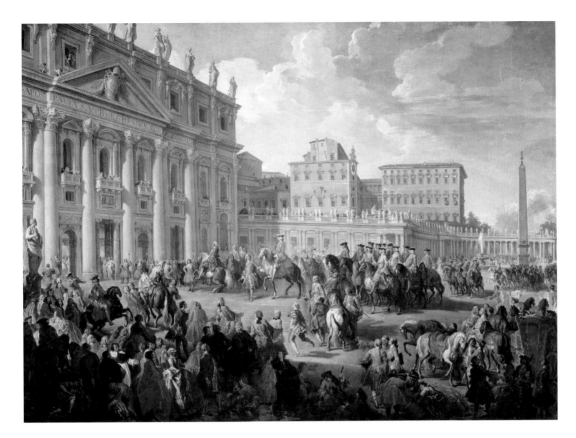

FIGURE 47
Giovanni Paolo Pannini,
*Charles III Visits St. Peter's
Basilica,* 1746. Oil on
canvas. Museo Nazionale di
Capodimonte, Naples.

His first St. Peter's–like façade was not deferential to Rome. The royal escutcheon on its façade instead confirmed that Naples stood under a king rather than the pope. Fuga maintained the Petrine reference in his later designs. The double-altar vista from the public nave of the Albergo's church echoed the baldachin and *Cathedra Petri* arrangement in St. Peter's. Thus, as Spinelli sought to make visual alliances with the basilica, Fuga made subtle references to its features as statements of royal authority. Nor was Naples alone in alluding to St. Peter's to assert royal authority. In Portugal John V recast the basilica as a palace-monastery in Mafra (1717–30), even including a benediction loggia for the Lusitanian monarch.[172]

Like the Portuguese, Charles won this duel with the archbishop. In 1749 a judgment from Spinelli's ecclesiastical curia forced a prelate to recant a previously held position. For many, the ruling smacked of the Inquisition, which had never been completely implemented in Naples by either Spain or Rome during the previous centuries.[173] Public outcry flared up against the archbishop and his authority. In 1749 Spinelli left for Rome, never to return. After his departure Alessio Mazzocchi, who composed the Latin inscription above the entrance to the Albergo, published the *Dissertatio historica de cathedralis ecclesiae neapolitanae* (1751), which debunked the myth of an unbroken succession of bishops of the city, unmooring episcopal authority from its direct connection to San Gennaro. On the street people now ridiculed Spinelli as "better made to be a grand vizier of Constantinople."[174] The Albergo was

he left Naples. He only resigned his seat in 1754, leaving the duomo renovations as the visual testament of his battle with the monarchy.[176]

The struggle with Archbishop Spinelli inevitably embroiled the Albergo dei Poveri. By building it, the monarchy supplanted the church's fragmented custody of the urban underclass in hospices, hospitals, and *luoghi pii*. The court probably believed, as Neapolitan professor of political economy Antonio Genovesi articulated, that piety and charity unaccompanied by the wisdom of the state was ineffective.[177] Indeed, the *luoghi pii* were poorly administered. Many had too many directors. Inside their walls churchmen outnumbered the poor two to one.[178] Private *luoghi pii* therefore fell from the constellation of viable remedies. Very few were founded in the second half of the century despite a large number of petitions requesting the Crown's sanction of new foundations. Constructed "for the poor of the entire kingdom," the Albergo was the replacement for the city's flock of charitable institutions. The court made this clear not only by forcing financial contributions, which continued to grow after 1760, but also by continuing a policy of closing foundations and adding their patrimony to the Albergo's coffers.[179] The wealth of these foundations boosted the Albergo's fiscal fortunes, and their closure helped reshape the city by turning their *isole* into spaces for public use. For example, the Coloritan convent of Santa Maria della Fede was used to house poor women. This reshuffling of land made the Albergo's urban dimension clear. It had replaced some of the city's charitable ecclesiastical foundations and helped release for public use land that had long been exclusively ecclesiastical. Once guarded, *isole* were now reintegrated into civic and public life.

declared outside the jurisdiction of local religious authorities and placed under the authority of the royal chaplain, while its chapel was dedicated to the Spanish monarchy's favored cult of the Immaculate Conception.[175] Spinelli remained cardinal for a number of years after

ALBERGO OR PRISON?

Fuga's plans display rigid architectural control of inhabitants, which might lead one to conclude that the Albergo was like a prison. Though life within its walls was carefully circumscribed, entry into the Albergo was instead mostly voluntary.[180] Roughly one-quarter of the inhabitants were enclosed by civic authorities or public administrators, forced off the street by government decree. Half entered with a recommendation from the king or one of his ministries. These people sought assistance and were not forcibly enclosed. The remainder applied directly to the Albergo administration for admission. The population of the Albergo was therefore overwhelmingly voluntary. Most inhabitants were under thirty years of age and could expect to return to society.[181]

People were attracted to its charity because they would be fed, clothed, and housed. They were also taught a trade. During the eighteenth century the Albergo's schools taught grammar, drawing, engraving, music, singing, arithmetic, surgery, shoemaking, sewing, and textile weaving. An Albergo education would have been an advantage in the urban economy. It is therefore not surprising that half of those enclosed left the Albergo in less than 180 days.[182] Orphans were taken under long-term care, but they too were expected to leave the Albergo when they reached adulthood.

With the death of Brancone in 1756 and the departure of the king in 1759, the Albergo lacked a strong advocate. The regency, under Bernardo Tanucci, felt that Fuga's building was too costly, and in 1764 famine ravaged Naples while "disorder and confusion" reigned at the Albergo.[183] Though it failed at this time of need, Fuga worked on the structure until his death, in 1781. Construction then continued under Mario Gioffredo and Carlo Vanvitelli until 1790.[184]

After the expulsion of the Bourbons in 1799, the subsequent Napoleonic occupation, and the return of Ferdinand IV in 1815, concern for the political stability of the dynasty superseded any thoughts of completing the Albergo. Ideals of educating, housing, and providing work for many thousands drifted into the background. Only the wings fronting the street were completed. The church and the housing blocks were left partly built. The finished parts of the building remain impressive for the modern visitor. The barrel-vaulted corridors convey elegance and order in their austerity. To pass beyond these hallways to the church is to move from polished surface to the raw anatomy of the building. The sanctuary is incomplete, with toothy brick walls outlining its intended plan (fig. 49). Hallways, stairs, and doorways expose the web of tissue intended to connect naves and housing wings. Perpetually exposing Fuga's brilliant plan, the Albergo stands like a half-assembled ocean liner, laying open its vast model of order.

Though never completed, the Albergo influenced many later buildings, both in plan and organization. When Charles assumed the Spanish throne, he devoted considerable attention to reforming the hospices and almshouses in his realms. The monarchy wanted to increase the royal government's control of poor relief and encourage the founding of new or consolidation of existing institutions. All would provide similar services: food, shelter, catechism, and education in a trade. And they would be encouraged to open their doors to broad categories of those in need.

The Viceroyalties of New Spain and Peru witnessed major foundations. Church officials

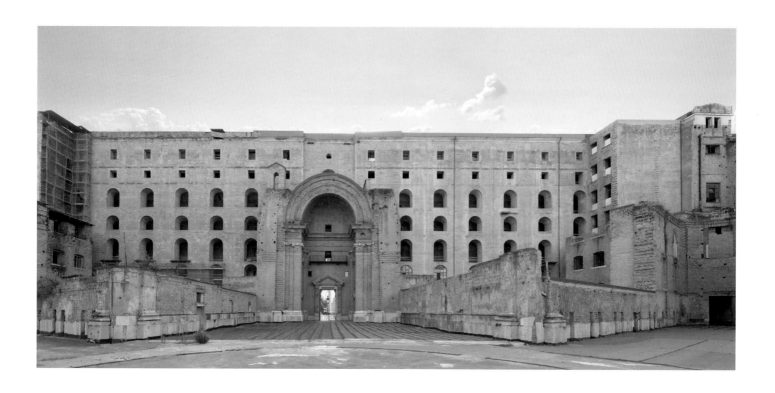

FIGURE 49
Church interior of the Albergo
dei Poveri.

spearheaded establishment of the poorhouse of Mexico City, yet it was chartered only in 1774, after Charles requested changes in its organization. It received financial backing from multiple sectors of society and opened its doors to many groups.[185] The financial role of the Crown was limited, but its involvement in organization and governance was part of the broader effort to control poor relief. In Quito, the poorhouse founded in 1785 marked the rise of secular control over welfare. It depended upon both government and ecclesiastical coffers but gave precedence to royal authority.[186] In both cases the centralization of mendicant care led to the building of large structures. Few closely imitated the Albergo's plan, but the Hospital de Nuestra Señora de Belém in Guadalajara (1787–97) had wards arranged in a star pattern that was very similar in shape to the church in Naples.[187] Ironically, it was founded by religious authorities and had

little connection to the Crown. The history of mendicant reform in the Spanish Americas therefore both reinforces and challenges the image of Bourbon centralization. In some large centers the intervention of the Crown led to social improvement, but most reform in the Americas arose at the local level in response to immediate needs. The Crown sanctioned but did not directly manage medicant relief.

As noted, Spain had a strong tradition of aiding mendicants, and in Madrid the involvement of Bourbon authorities was direct. When Charles commissioned Francesco Sabatini to complete a new Hospital General in Madrid, he followed in the footsteps of previous kings. After the foundation of Pérez de Herrera's *albergue* in the late sixteenth century, the Calle de Atocha became a center of charitable activity. In 1587 Philip II consolidated the city's hospitals under a new administration of the Hospital General. The first building for the new

hospital was erected on the Prado, but in 1603 it moved into the *albergue,* transforming Pérez de Herrera's structure into a house for the sick as well as the poor.[188] Despite multiple expansions in the seventeenth century, the Hospital General proved inadequate by the eighteenth. Ferdinand VI (1746–59) began reforming the hospital by establishing the Real Congregación de Hospitales in 1754. In 1755 he also commissioned a new Hospital General in the location of the old institutions. José de Hermosilla, a former pupil of Fuga's, provided the original plans for a multicourt building with a central church. However, work proceeded slowly, and in 1768 the congregation considered changing plans and architects. They ultimately chose Francesco Sabatini to complete the hospital.[189] Sabatini married Fuga's Albergo plans with the Escorial in his five-court building (fig. 50). The entrance was similar to Fuga's in Naples, with a long astylar façade broken at its center by an entry loggia, stairs, and six pilasters (fig. 51). But as in the Escorial, one then entered a small courtyard dominated by the church. Work on Sabatini's hospital proceeded throughout Charles's reign but diminished after the king's death. Like the Albergo in Naples, the Hospital General of Madrid was never completed, and it now houses the Museo Centro de Arte Reina Sofía.

Plans of the Albergo dei Poveri made their way to the rest of Europe as well. Represented clearly on the duke of Noja map (1775), it was transmitted to courts in England, France, Austria, and Russia. Ironically, the church of the Albergo would resonate with prison design. Jeremy Bentham's scheme for a Panopticon prison was reminiscent of the Albergo (fig. 52), and though Bentham trumpeted his originality, he owed much to John Howard, who had traveled through Europe to study prisons,

Pianta del Pian terreno che resta al Piano della Chiesa del nuovo Ospitale Generale. 9

FIGURE 50
Francesco Sabatini, plan of the ground floor of the Hospital General of Madrid (inscribed *Pianta del Pian terreno che resta al Piano della Chiesa del nuovo Ospitale Generale*), 1777. Black ink and gray wash on paper. Archives Nationales, Paris, NN 23/23.

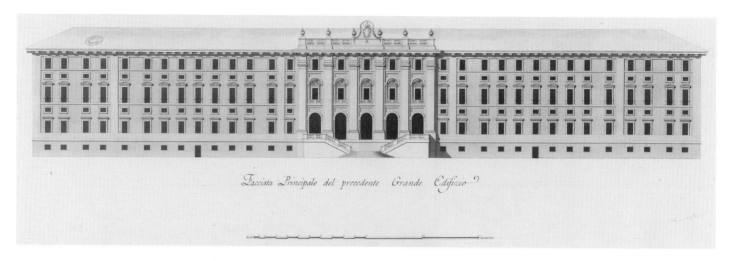

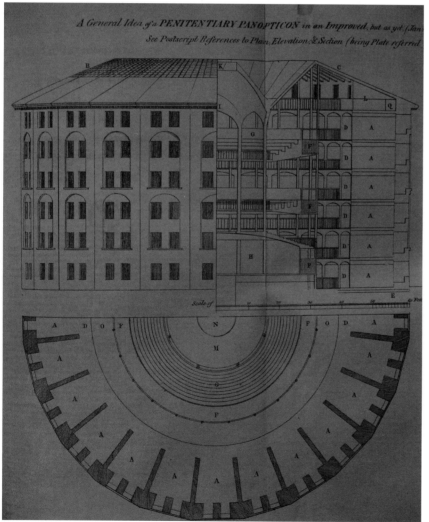

A General Idea of a *PENITENTIARY PANOPTICON* in an Improved, but as yet (Jan...

See Postscript References to Plan, Elevation, & Section (being Plate referred...

FIGURE 51
Francesco Sabatini, principal façade of the Hospital General of Madrid (inscribed *Facciata Principale del precedente Grande Edifizio*), 1777. Black ink and gray wash on paper. Archives Nationales, Paris, NN 23/24.

FIGURE 52
Elevation, section, and plan of the Penitentiary Panopticon. From *The Works of Jeremy Bentham* (Edinburgh, 1843).

poorhouses, and lazarettos in the 1760s.[190] He visited and chronicled Naples, and while his description of the Albergo dei Poveri was brief, his reflections, coupled with the circulation of the duke of Noja map in London, make it likely that Bentham knew the Neapolitan model.[191] In addition, Bentham's collaborator on his Panopticon prison was Robert Adam, who had been in Rome from 1754 until 1757 and likely knew Fuga's plan. Although Adam explicitly gave credit to Bentham, it is possible that the architect helped develop the form of the Panopticon.[192] Regardless of how the Albergo was transmitted, in the 1770s spoke-shaped prisons became common in northern Europe. Within the Two Sicilies prisons would also follow the plan of radial cell blocks connected to a supervisory hub, as occurred at the Ucciardone of Palermo (1835).[193]

Both *albergo* and prison were designed and built to reform the lives of their inhabitants. Charity and incarceration therefore required architecturally similar spaces. Yet the hard divide between prison and poorhouse is still evident in the use and meaning of space. Fuga's designs segregate and control inhabitants to ensure their physical and spiritual salvation.

In his church, the poor peered toward the brightly illuminated altar, which represented one beacon of the Albergo's charity. From its center priests could minister to the poor, hear their confessions, and administer the Eucharist. Bentham's prison uses the Panopticon plan to control as well as reform. Gazes are reversed, with the few in the center keeping watch on those on the periphery. Bentham conceived of the building's center as the metaphorical eye of God, which watched over the imprisoned—its scrutiny inspiring introspection among the convicts. The center is the spiritual eye rather than the spiritual heart. Thus, while the plan of Fuga's radial church anticipates Bentham's Panopticon prison, the use of space must temper any conclusion about their similitude. Still, it is undeniable that the plan of a poorhouse, in the hands of a prison designer, could be easily altered to fit a different function. By merely reversing the gazes at its center, the Albergo's meticulously planned church naves, corridors, dormitories, and workrooms could easily be used to incarcerate. Studying the Albergo therefore helps us understand how a poorhouse could become a prison.

The Cavalry Barracks at the Ponte della Maddalena

INSTAURATA CASTRENSI DISCIPLINA FELICITAS MILITUM ET POPULORUM *(Renewed military discipline is the good fortune of soldiers and the people)*

—Motto from foundation medal, 1754

Charles owed his kingdom to the military. In 1734 a combined force of Italians and Spaniards swept down the peninsula to take Naples and place him on the throne in Palermo. Conquest was not their only task. They would have to defend the realm from invasion, but their presence alone was insufficient, as nations raced to build large armies and wars over succession and empire frequently roiled the continent. If the king were to remain in power, the royal government had to reshape the military into a permanent native force.

In architecture, priorities changed. Barrack hubs afforded greater tactical agility and supplanted fortresses. For the capital, the court wanted a cavalry quarter that would ensure a speedy response to attack and domestic turmoil. By settling on Luigi Vanvitelli as architect, it gave the capital a monument of austere elegance. Among the first of its kind built in Europe, the cavalry barracks at the Ponte della Maddalena has been virtually unstudied (fig. 53).[1] Here I examine the building through new and published archival sources and read its plan as a guide to the social strata of the military, the barracks' distribution of space

reflecting the hierarchy within a regiment. By housing the regiment in accordance with rank, the barracks helped consolidate echelons of command, which could make the cavalry into a more effective fighting force. Such a result made the barracks into another architectural tool for Bourbon statecraft. The barracks also marks the royal government's increasing role in policing Naples. Sited on an area near the city, the Crown's forces helped subdue revolt and deter unrest. Architecturally and functionally they reminded inhabitants of the ultimate power of the monarch.

THE MILITARY INFRASTRUCTURE

To understand Caroline reform, one must survey the kingdom's fortifications before Charles's arrival. A report made in 1734 by Spanish commander José Cavillo de Albornoz, Duke of Montemar, exhaustively examined the defenses of southern Italy. Montemar, who earned his reputation as an audacious commander by retaking Orán for Spain in 1733, was entrusted with the conquest of the Two Sicilies by Philip V the following year.[2] Aware of the obstacles his advance would face, the general

weighed the strength of bastions and the network they formed.[3]

The first component of the defensive infrastructure was a circuit of sixteenth-century watchtowers that used firelit signals or mounted messengers to warn of approaching adversaries.[4] Mostly used to monitor corsair raids, they relayed alarm to fortresses that were the backbone of protection. Encircled by ditches and bristling with bastions and ravelins, these *piazzeforti* were built as part of Charles V and Philip II's comprehensive defense for their Mediterranean kingdoms. In a 1607 treatise Cristóbal de Rojas used the analogy of the city to explain them. Think of border fortresses like city walls, he proposed. Their massive defensive bastions protected the interior of the country as walls did a city, allowing it to thrive.[5] Richelieu's *Testament politique* also advised border fortresses, engagement with which, he believed, would require long sieges that could stall armies and prevent them from reaching the interior.[6] In addition to their defensive purpose, Charles V viewed military installations as mechanisms for subjugating locals and devoted considerable attention and sums to building fortresses in important cities. He employed a team of handsomely compensated military

FIGURE 53
Cavalry barracks at the Ponte della Maddalena.

engineers who were conversant with the most recent developments in military technology.[7] His most valued military engineer, the Valencian Pedro Luis de Escrivá, projected the massive fortress at L'Aquila and the Castel Sant'Elmo above Naples.[8] Both fortresses dominate their respective cities and serve as visible reminders of Spanish military force. With the principal Spanish-controlled cities of the peninsula fortified, Philip II focused more intensively on the frontiers of his empire in Sicily and Lombardy.[9] The fruits of these efforts now confronted Montemar. Naples was protected over land by Gaeta, Capua, and Pescara (fig. 54). From the sea an invader faced Messina, Bari, Brindisi, and Barletta.

During the sixteenth century Naples could have been counted among the best-protected cities in the Mediterranean,[10] but the same could not have been said in the eighteenth. At the southeastern corner of its walls stood

the small coastal fort of the Carmine (see fig. 2). Terminating the wall circuit at the opposite end of the waterfront was the Norman Castel dell'Ovo. Between these two garrisons lay the arsenal, dating from the seventeenth century, and the Castel Nuovo, built by the Angevins and enlarged by subsequent Aragonese and Hapsburg rulers. The strongest fortress, Sant'Elmo, perched above the city and, while unconnected to its walls, was an integral part of Naples's defenses. Yet the large number of castles and forts belied Naples's weakness. Outdated, its fortifications offered little resistance to an eighteenth-century army.

Montemar also enjoyed enormous tactical advantages. For two centuries the kingdom's true security had depended upon keeping armies from reaching its borders altogether. Massive Spanish garrisons in Milan and alliances with northern Italian princes guaranteed that any aggressor would be confronted first in the Po Valley.[11] Austria succeeded in dislodging the Spanish from Milan but could not dismantle the client network that Spain had developed. Bourbon forces were welcomed in Tuscany, Parma, and Piacenza. Spain allied with the king of Sardinia and the Duke of Modena. Moreover, in 1734 the emperor's bellicose northern neighbors would prevent him from deploying substantial troops to Italy. Imperial military planners therefore put their confidence in stone- and earthworks and rapidly reinforced the defenses of fortresses near the border with the Papal States. Immediately before Montemar's invasion, they added bulk to the bastions of Pescara and Capua in particular.[12]

Protecting the Via Appia, the Volturno River, and the plain of the Terra di Lavoro, Capua was the primary bulwark against a northern offensive (fig. 54). In 1734 the

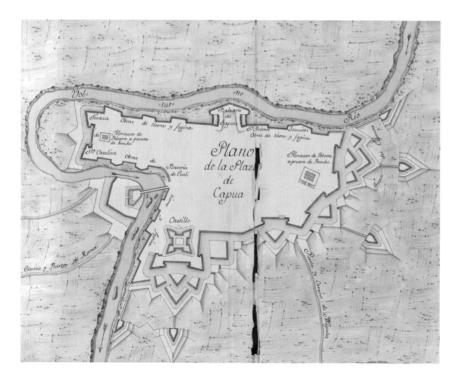

Austrian commander, Count Traun, withdrew from Capua, assured that a small force and its walls could tie down the enemy.[13] Montemar instead circumvented its daunting fortifications and encamped at Aversa.[14] From there he took Naples and gave chase to Traun on the Apulian plain. Victory was clenched at the Adriatic port of Bitonto, not at Capua.[15]

Montemar's tactics foreshadowed shifts in strategy that would make the eighteenth century another period of "military revolution."[16] Field battles replaced sieges. Armies grew more professional and increased in size. And military bureaucracies became ascendant over proprietary nobility. These changes resulted in a diminishing number of decisive battles. "The making of wide and extensive Conquests now-a-days seems to exist only in the theoretic Imaginations of Cabinet Projectors," lamented one contemporary.[17] In Naples Raimondo di Sangro, Prince of Sansevero, was the best of these "professors of the square and compass."[18] Descended from a family of distinguished warriors who had fought at Nördlingen and received the Order of the Golden Fleece, he turned his insatiable curiosity to the military arts.[19] Di Sangro designed fabulous citadels and presented designs of them to Nicola Michetti, architect of Peter the Great. While these drawings and his unfinished *Gran Vocabolario Universale dell'Arte della Guerra* have been lost, his *Pratica più agevole e più utile di esercizj militari per l'infantria* (1747) went through two editions and earned the admiration of Frederick II of Prussia.[20] Another exponent of the military arts was Giovanni Carafa, Duke of Noja, who made models of the Two Sicilies' fortresses in a gesture reminiscent of those Sébastien Le Prestre de Vauban presented to Louis XIV.[21] However, the Prince of Sansevero and the Duke of Noja

were not pioneering innovations. Projecting fortresses had become a gentleman's hobby, and as with Tristram Shandy's Uncle Toby, this "fortification curieuse" was associated with idle amusement.[22]

Montemar had exposed the kingdom's outdated infrastructure by simply bypassing Capua. The new government now rushed to remedy it. Caroline engineers, following the advice of the general and under the direction of Giovanni Antonio Medrano, repaired only the most strategic defenses. A navy was built anew. And Philip left his son half of the invading force until he could build an army.[23] To raise a native force, Montealegre turned to the aristocracy. By tradition, the Neapolitan nobility were great warriors. In the Renaissance their horsemanship and military training were highly regarded. Indeed, the baronial aristocracy fielded regiments for the Crown and led military campaigns. By financing these regiments, they lightened the burden on the royal purse and fulfilled their feudal duties.[24] As Montesquieu articulated in 1748, "For the nobility, honor prescribes nothing more than serving the prince in war."[25] Yet by the late seventeenth century a general decline in Italian aristocrats' participation in campaigns meant honor had to be sweetened with reward. Spain therefore granted numerous Neapolitan aristocrats the Order of Santiago and the Order of the Golden Fleece. Yet despite Madrid's efforts, Neapolitan lords entered the battlefield less often than other vassals.[26] Only when their own interests were threatened, as in the Revolt of Masaniello, did they overwhelmingly support the monarchy with arms. At other times they plotted against it, and Spain thwarted a conspiracy by aristocrats as late as 1701.[27] Fresh memories of baronial rebellion and Elizabeth's distrust of aristocratic intentions

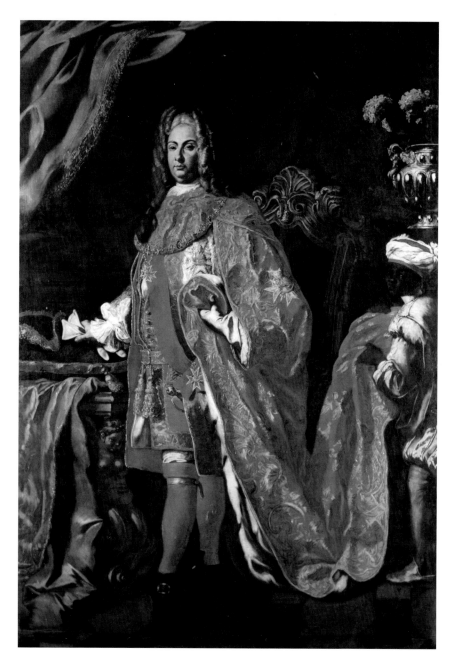

aristocracy was the establishment of a new
heraldic order. The court instituted the Order
of San Gennaro in July of 1738, and Francesco
Solimena's *Portrait of Ferdinando Vincenzo Spi-
nelli, Prince of Tarsia* (ca. 1741) proves its seduc-
tive success (fig. 55).[28] Among the first to be
inducted, Spinelli proudly displays the scarlet
mantle, elaborate collar, and brilliant badge of
the order, each bedecked with Bourbon lilies
and symbols of the saint. The court hoped that
men such as the prince could be relied upon to
raise regiments in Calabria and Apulia. In the
short term they were correct. When regrouped
Austrian forces attacked in 1744, Charles
went into battle with twelve such proprietary
regiments.[29]

The imperial invasion during the War of
Austrian Succession attempted to unseat the
Bourbons before they could consolidate power.
When the two armies met at Velletri, near
Rome, they bombarded each other's positions
for six weeks. Then on 10 August 1744 the Aus-
trians launched a surprise assault. Charles fled
his encampment to rally a counterattack and
turn the tide of battle. Bourbon forces killed
or wounded 2,600 men as they pursued the
retreating Austrians. The victory closed any
question of Charles's legitimacy. It did, how-
ever, open new doubts about the forces of the
Two Sicilies. They were too few, too unprofes-
sional, and too poorly equipped. Moreover,
the nobility could be a liability. Giordano and
Gregorio Grimaldi had sent plans of fortresses
to the enemy and helped draft an Austrian
declaration aimed to convince their peers to
betray the monarch.[30] The king therefore had
to make the army his own.

Reform began swiftly after the victory at
Velletri. Under Fogliani the royal govern-
ment weaned the kingdom from its depen-
dence on Spanish troops and poured greater

led the Neapolitan court to implement a policy
of emolument and control. As seen in the
San Carlo, architecture could establish new
hierarchies by embodying changes in court
favor. Barracks would create similar spatial
control. Yet the earliest tool for attracting the

effort into building a professional, national army. It founded an academy for artillery and allowed the royal military foundry to operate beneath the Palazzo Reale until it could be moved to Torre Annunziata (1753). This new manufactory crafted pistols that visibly confirmed royal control through heraldic decorative motifs and portraits of the sovereign on the pommel caps of more elaborate pieces.[31] As arms production increased, so too did the number of men. The force grew to forty battalions of infantry, eighteen squadrons of cavalry, nine of dragoons, a corps of artillery, and a corps of engineers.[32] This growing army needed housing, and accommodating forces in barracks would be the wisest contribution to the kingdom's infrastructure.

HOUSING THE ARMY

Quartering troops had preoccupied Naples's rulers since the sixteenth century. Viceroy Pedro de Toledo had built an entire district for soldiers, known as the Spanish Quarter (see fig. 2). Their presence in the city was meant to enforce order. Instead, they roamed the surrounding area, creating tension with locals. After eighteen soldiers were murdered in 1547, troops were shifted to areas outside the capital, into fortresses, and in 1666 to a fifteenth-century villa on Pizzofalcone.[33] With few structures built for the purpose of housing soldiers, these remedies were always provisional. By the eighteenth century barracks were more common. Their virtues were outlined by a contemporary Englishman:

> Barracks are built now-a-day in all fortified places, to keep up the discipline, and good order in the garrison: they have been found so useful, that no place is built without them; and experience shews, that those

garrisons which have them, are much more quiet, on account of the conveniency which non-commissioned officers have to visit the quarters every evening, and to see the soldiers shut up in their quarters, which cannot be done when they are lodged amongst the inhabitants, where they have the liberty of going out and in whenever they please; besides, when the governor has a mind to make a detachment, or send out a party, he cannot do it, without the knowledge of the whole town: If any alarm happens, the garrison cannot be assembled without great trouble and loss of time; whereas, when there are barracks, every thing necessary for the good of the service may be done with ease.[34]

Though first constructed in the sixteenth century, it was Vauban who seized upon their benefits.[35] He tucked barracks near the ramparts of his fortresses and felt they helped institute order and prevent desertion. These buildings contained three storeys of dormitories where soldiers shared beds based on rotation of duty. Furnishings were spartan, and Vauban himself often dictated the interior arrangement.[36] The private suites for staff officers had more rooms and amenities. Vauban situated these apartments in pavilions at the ends of the building or near stairs so that officers could keep the troops under watch. Though his single-pile models would be abandoned in favor of U-shaped structures, they helped transform the military into a professional corps.[37]

Philip V commissioned one of the largest barracks on Vauban's model, the Real Cuartel de Guardias de Corps in Madrid (1717). The architect Pedro de Ribera divided the enormous structure into three large courtyards and organized the interior into evenly distributed

dormitories, stables, and officers' quarters.[38] In addition to building barracks, Philip encouraged military innovation.[39] In 1711 he created the Real Cuerpo de Ingenieros and expanded the military academy in Barcelona in order to train this new group of professional army engineers. Under the guidance of his chief military architect, Jorge Próspero de Verboom, he had the kingdom's forts exhaustively analyzed. And in 1737 he set up a Real Junta de Fortificación to carry out repairs. Compared to Spain, Naples lagged behind the latest advances in design and organization. In 1750 Neapolitan soldiers were being housed in civilian areas, sometimes quartered with locals.[40] Barracks could improve relations with citizens and also reinforce chains of command and regimental discipline.

It was the king himself who seems to have initiated the building campaign in Naples, which should not be surprising. Like his father, Charles fought twice for his Crown as generalissimo. He had been schooled in the military arts by Medrano, and excelled in his study of fortification.[41] He had seen many of Spain's forts during the itinerant years of Philip V's court (1729–33), and as he traveled through Italy, he sent designs of fortresses to Spain.[42] He ordered barracks be a part of his palace at Portici, had them added to the Palazzo Reale in Naples, and insisted on a large piazza for military exercises at Caserta.[43]

Turning away from the infrastructure of citadels, the royal government built barracks sited on open plains. This was motivated by the success of *petite guerre* tactics marked by cavalry skirmishes and swift offensives.[44] Placed in Nola, Nocera, Aversa, Capua, and Naples, cavalry barracks would form a ring of bases from which forces could rapidly confront any threat in the territory.[45] And their construction followed the restructuring of the cavalry itself. From company size to horse breeding, it underwent extensive reform to meet contemporary needs.

At the beginning of Charles's reign the cavalry conformed to guidelines sent from Spain. It was divided into five regiments of heavy cavalry and dragoons. Each of these—Re, Rossiglione, Regina, Borbone, and Tarragona— was subdivided into four squadrons of three companies each. A company comprised forty to fifty horses and a slightly larger number of men, making an entire regiment roughly six hundred.[46] Reforms introduced in the 1740s broke with the established model. Implementing them was Francesco d'Eboli, Duke of Castropignano, who took command of the Neapolitan forces in 1740, following his years as ambassador to France. He wanted Neapolitan forces to mirror French models, and to do so he added three mounted regiments, reduced the number of squadrons in each to three, and increased company divisions to twelve per squadron.[47] The fracturing of regiments into more companies made the cavalry nimble for its supporting role in battles. As French field marshal Maurice de Saxe stated, "Their excellence consists in resolution, and a quick perception of every situation or circumstance capable of producing any advantage."[48] They had to move quickly and often.

The duke did not alter the size of regiments, and six hundred was the targeted capacity of each of the barracks. According to Luigi del Pozzo, designs for Aversa, Nocera, and Nola were all approved in July of 1752.[49] Documents dating from 1753 confirm that work was under way in Aversa under the direction of the military engineer Jean Baptiste Bigot, known by his Italianized surname Bigotti.[50] Bigotti would play a leading role in the campaign,

directing work at Nola and making designs for the barracks in Nocera and Naples.

Bigotti's suite of plans for Nocera provides a glimpse into the anatomy of Caroline barracks and highlights important social and political aspects of these buildings (figs. 56, 57). This almost square structure is centered on a court lined with arcades. The form follows the recommendation of Bernard Forest de Bélidor, one of the most respected writers on military architecture.[51] Stables occupied the ground floor, though no drawing survives of this level.

Above, quarters were articulated according to rank. Cadets slept in dormitories on the third floor (fig. 56). Like Vauban, Bigotti placed officers' quarters at the corners of the building to keep watch over the cadets. These twelve subalterns enjoyed multi-room suites located near the stairs.[52] The second floor, like the *piano nobile* of a palace, was for the highest ranking (fig. 57). New captains had one large reception room, or *sala*, as well as four smaller rooms and a kitchen. First captains had an *anticamera*, a *sala*, a second large room, two *retrocamere*,

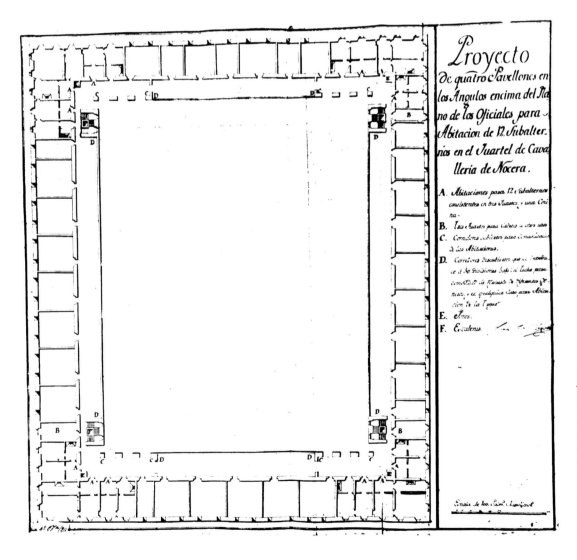

FIGURE 56
Juan Baptiste Bigotti, plan of the third floor of the cavalry barracks at Nocera (inscribed *Proyecto de quatro Pavellones en los Angulos encima del Plano de los Oficiales para Abitacion de 12 Subalternos en el quartel de Cavalleria de Nocera*), ca. 1752. Black ink with gray wash on paper. Biblioteca Nazionale, Naples, *carta geografica*, Bª-27A-23.

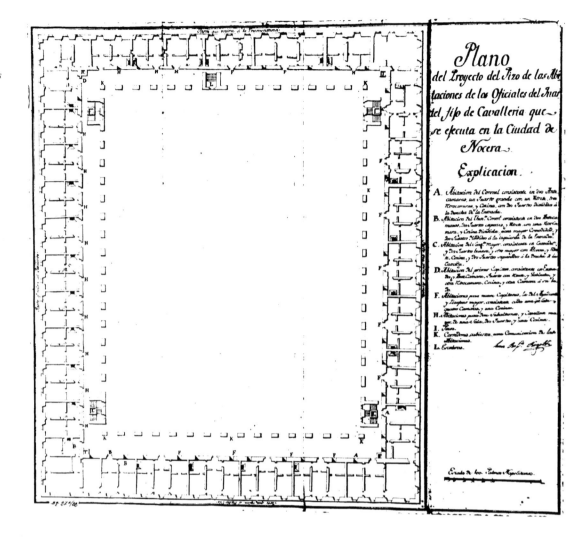

a *gabinetto*, and a kitchen. The sergeant major had the equivalent of two such suites, while the lieutenant colonel and colonel had apartments that were two rooms larger than those of the sergeant major. Duty justified differentiation of space. Colonels were external intermediaries, communicating with superiors and translating their commands into movements on the battlefield. They were literate men, who had to submit written reports. As masters of the brigade, they also had to be "attentive that the recruits and horses [were] well disciplined," requiring them to "visit the horses, praise the officers who [had] been careful of them, and severely reprimand those by whom they [had] been neglected."[53] In these tasks they relied heavily on the lieutenant colonel, who communicated with the men. Meanwhile, captains acted as housekeepers, charged with maintaining horses and armaments.[54] The apartments gave each ranking officer space to exercise his duties, but space also served to reinforce his status. As one contemporary described the rooms: "These pleasant externals are not combat weapons, to be sure, but they are a perpetual reminder to the officer of his status

and distinction, and by impressing his superiority on his own soldiers they incline men to consideration, respect, and obedience."[55] Hierarchy therefore called for more elaborate interior spaces. Yet duty and rank do not fully explain Bigotti's baronial suites. Their lordly size instead related to the men filling the highest military posts. Although they were no longer owners of regiments, nobles occupied the upper echelons of the officer class. This was not unique to Naples. Frederick II similarly would rely on *Junkers,* and Saxe advised employing *noblesse d'épée.*[56] Aristocratic commanders presented distinct benefits to monarchs. In composite monarchies that united multiple nations, noblemen who served the Crown in battle reinforced loyalty and ties of feudal obligation. Thus the officer corps of Spain and Austria comprised Walloon, Milanese, and Piedmontese noblemen.[57] Smaller states also used the military to consolidate the loyalty of aristocrats. Heavily militarized states like Piedmont-Savoy became hothouses of aristocratic military service, as the dukes drafted noblemen into commanding and bureaucratic roles in an effort to subjugate them.[58] Noblemen did not seek any position. They wanted only the most prestigious assignments and coveted the posts of cavalry officers. These positions carried the most prestige because they required horsemanship, an aristocratic art mastered in colleges and riding schools. It is therefore unsurprising that in the eighteenth century all Piedmontese cavalry officers were aristocrats.[59] Though they gained prized positions, these aristocratic cavalry officers also placed themselves under the command of their sovereign. Thus, by accepting a military commission, they inherently acknowledged royal authority.

Barracks confirmed both the nobleman's superiority within the regiment and his subjugation to his sovereign. Barrack apartments standardized living space within buildings that fell under the Crown's direct control. Yet officers' apartments also conformed to established conventions of aristocratic domestic space. Elaborate enfilade apartments were the hallmark of noble palaces. As Patricia Waddy has demonstrated, each room was used according to a carefully articulated protocol.[60] Progression to more intimate spaces was a sign of special favor or a decorous indication of status. Aristocrats who took up residence in barracks were similarly provided with multiple rooms. Further research might reveal how they were used, but the mere presence of so many rooms in officers' suites suggests that noble commanders compromised few trappings of aristocratic living. One imagines them receiving soldiers in various anterooms to confirm their own status, to recognize the standing of petty officers, and to confer favor on those in the regiment.

Consistent with Biogotti's enormous suites, the royal government of the Two Sicilies gave aristocrats more positions and better pay than other states in Europe.[61] This led the Duke of Sant'Arpino to worry that few took up the life out of inclination.[62] Noblemen appealed for positions for disobedient sons, saw the career as congruous with an ecclesiastical one for cadet branches of the family, and sought to dress their arms with honor earned in battle. Like opera boxes in the San Carlo, military positions were bestowed both to recognize loyalty and to maintain it. By the 1790s the aristocracy had so successfully filled the officer corps that the government tried to confine aristocrats to fewer posts.[63]

In contrast, the soldiery of the Two Sicilies was composed of provincials who were largely illiterate.[64] To Samuel Johnson the rank and

file "passed [their time] in distress and danger, or in idleness and corruption."[65] His appraisal was shared by the king of Prussia, who declared, "[M]en are not soldiers until disciplined."[66] Discipline included verbal reprimand, imprisonment, bastinade, and the cane. Barracks helped enforce discipline by confining soldiers to spaces where they could be supervised. The ideal cadet was one who took good care of his horse, kept himself clean, and followed orders. The cavalier also had to perfect his horsemanship and underwent several years' training before riding with the regiment. He was then armed with lightweight carbines, a pair of pistols in bucket holsters,

and a sword. In addition to pay, reward came through appreciated social status. A member of the cavalry was called *monsieur* in France, and in Austria he could add the prefix *von* to his surname.[67]

The other inhabitants of the barracks were horses. In the Renaissance Naples was renowned for the excellence of its equine stock. Even Rabelais lauded the Naples charger.[68] The horses' reputation rested on their breeding as well as training. Naples was one of the first places in Europe to adopt *haute école* techniques to hone equine agility. The most famous riding school belonged to Federigo Grisone. His treatise on horsemanship was

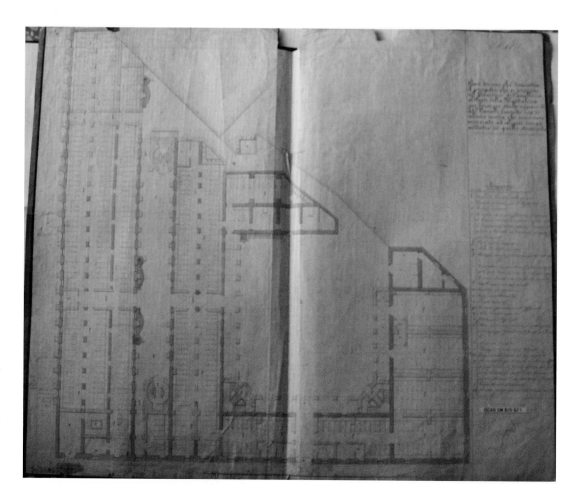

FIGURE 58
Leopoldo Vinci, copy of Juan Baptiste Bigotti, plan of the ground floor of the proposed cavalry barracks at the Ponte della Maddalena (inscribed *Pian terreno che dimostra il progetto, che si propone nel quartiere di cavalleria al Ponte della Maddalena*), 1835. Black ink with pink and yellow wash on paper. Istituto Storico e di Cultura dell'Arma del Genio, Rome, 8-D-621.

one of the earliest and most important on the subject, and his pupils found positions overseeing stables across Europe.[69] The seventeenth century, however, witnessed a decline of Neapolitan breeds and training. At the beginning of Charles's reign the court had horses sent from Parma, which it hoped to breed to bolster the Neapolitan race. Yet in 1752 a committee was formed to consider again ways for improving the cavalry's horses.[70] To make their judgments the committee members could rely on a growing body of literature on horses. Writers such as William Cavendish, Jacques de Solleysel, and François de la Guérinière had made judging equine quality more systematic. Lean types were preferred, and they had to be trained often to keep them agile and inured to fatigue.[71]

THE PONTE DELLA MADDALENA

Bigotti's plans for Nocera fulfilled the regiment's diverse needs, but those he drafted for Naples did not. Nineteenth-century copies of his poorly preserved original drawings show that he took a diagonal slice out of the building (figs. 58, 59).[72] This was necessary because the Via dell'Arenaccia skirted the site. As Fuga learned with the Albergo dei Poveri, the Arenaccia was both street and drainage channel. It coursed from Capodimonte to the Sebeto River and could not be diverted. For the cavalry, however, the complications it posed did not outweigh the benefits of the location.

Situated near the Ponte della Maddalena, the principal crossing of the Sebeto, the place had long been dedicated to horsemanship. The Aragonese first used the area for the equestrian arts, though their fifteenth-century stables were a riding school rather than a military post. It was here that Renaissance rulers reared the famous Neapolitan warhorses. In 1587

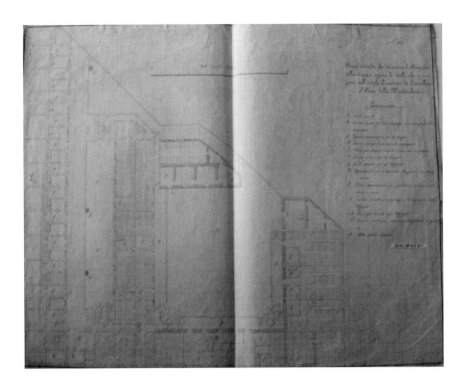

the Marchese of Sant'Elmo suggested these stables be converted for use by the cavalry.[73] Though neither the date nor nature of changes is known, Alessandro Baratta's view of the city from 1629 shows a large structure on the site labeled "Cavallerizza del Re" (fig. 60). Its plan is similar to Bigotti's, with a square courtyard in the east and a fingerlike wing to the west. Raking walls marked the ground floor of the building, but windows pierced its second level, which terminated in a loggia. The lower floor likely was devoted to stables, and the upper floors to soldiers. Yet the loggia hints that the structure could serve public functions and was probably used to view horse training in the open manège facing the river.

Due to its strategic location, the Cavallerizza became more important for the military. During the Revolt of Masaniello (1647–48) it was strongly identified with the government and was sacked by rioters. After the revolt

FIGURE 59
Giuseppe Panzera, copy of Juan Baptiste Bigotti, plan of the first floor of the proposed cavalry barracks at the Ponte della Maddalena (inscribed *Piano secondo che dimostra l'abitazione della truppa sopra le stalle, che si propone nell'istesso Quartiere di Cavalleria al Ponte della Maddalena*), 1835. Black ink with pink and yellow wash on paper. Istituto Storico e di Cultura dell'Arma del Genio, Rome, 8-D-631.

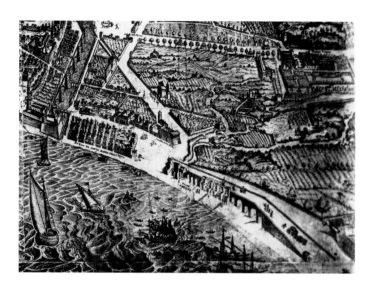

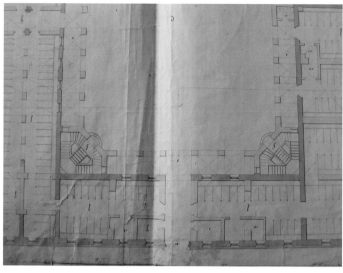

FIGURE 60
Alessandro Baratta, *Fidelissimæ Urbis Neapolitanæ*, 1629, detail showing the "Cavallerizza del Re." Engraving. Museo Nazionale di San Martino, Naples.

FIGURE 61
Leopoldo Vinci, copy of Juan Baptiste Bigotti, plan of the ground floor of the proposed cavalry barracks at the Ponte della Maddalena, 1835 (fig. 58), detail showing stairs.

Viceroy Iñigo Velez y Tassis de Guevara, Count of Oñate (1648–53), restored the building and had a portico added to protect the horses from the summer heat.[74] Yet inadequate spending after Oñate led to structural degradation. The Austrians found the Cavallerizza unfit for soldiers and shifted them to the Palazzo dei Regi Studi. When Charles returned the university to its original palace in the 1730s, he transferred men back to the Cavallerizza. The soldiers were soon joined by exotic animals, which the king housed in a menagerie adjacent to the barracks (1742).[75] Given the poor maintenance of the Cavallerizza and its limited size, it had to be improved and enlarged if it was to house a modern military.

Bigotti proposed preserving many parts of the Cavallerizza, which explains his odd divisions of space. The old structure had two courtyards, a long narrow one in the west and a square one in the east (figs. 58, 59). The existing walls of the south façade and the exterior walls of the stables would be preserved, and Bigotti rendered them in pink (fig. 58).[76] He then added yellow wash to distinguish his additions.

New partitions were added on the ground floor, particularly in the east wing, to create stalls for 477 horses. Within the northwest corner of the same wing he carved out a square chapel. And he wrapped the eastern courtyard with an arcade to buttress the old walls, shield horses during storms, and connect the different parts of the building on the upper floors, where it served as a terrace.[77] Buttresses also had to be added to the western wall of the barracks, and line the narrow western courtyard. Near these buttressed walls Bigotti positioned wells and troughs for water. The engineer also added pairs of elaborate stairs in two courtyards (fig. 61). These were joined by a fifth, in a single square stairwell near the southwestern corner of the building, which was reserved for officers, who enjoyed a separate entrance. Oddly, this southwestern portal is one of only two external openings. Such limited access would have delayed quick deployment, so Bigotti proposed large gates for the northern side of the structure.

Proceeding up one of the barrack's stairs was very similar to parading up the flights of

the Teatro di San Carlo or of Ferdinando Sanfelice's magnificent palaces. Angled flights met and divided at multiple landings. They befitted aristocratic commanders but were also to be used by soldiers and perhaps could remind them of their distinguished status as members of the cavalry. Having climbed these elaborate flights, one arrived at the upper floor, which was divided by rank. Dormitories for soldiers lined the eastern courtyard and opened onto a terrace atop the ground floor arcade (fig. 62). Each contained between ten and sixteen beds. They were also equipped with kitchens (labeled D) and separate rooms for the

supervising sergeants (labeled E). The western wing was reserved for higher-ranking officers (fig. 63). It contained twelve apartments for lieutenants, each with two rooms and a kitchen. These quarters were each joined by a single apartment for the major, who enjoyed three rooms and a kitchen.

Bigotti's section drawing shows an elegant and orderly barrack (fig. 64). Stables were outfitted with wooden hayracks and mangers, and wooden bales connected to small heelposts to separate the horses. The stairs were encased within curved wells pierced with large ogee-molded windows. Stuccoed piers formed the

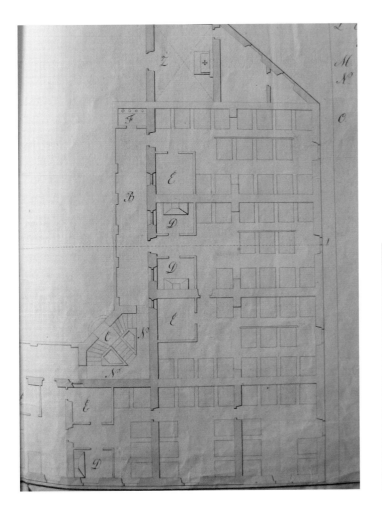

FIGURE 62
Giuseppe Panzera, copy of Juan Baptiste Bigotti, plan of the first floor of the proposed cavalry barracks at the Ponte della Maddalena, 1835 (fig. 59), detail showing a dormitory.

FIGURE 63
Giuseppe Panzera, copy of Juan Baptiste Bigotti, plan of the first floor of the proposed cavalry barracks at the Ponte della Maddalena, 1835 (fig. 58), detail showing an officer's suite.

FIGURE 64
Giuseppe Panzera, copy of Juan Baptiste Bigotti, profile and interior view of the proposed cavalry barracks at the Ponte della Maddalena (inscribed *Profilo, e Vista interiore del nuovo progetto del Quartiere di cavalleria al Ponte della Maddalena*), 1835, detail showing the courtyard. Black ink with pink and yellow wash on paper. Istituto Storico e di Cultura dell'Arma del Genio, Rome, 8-D-629.

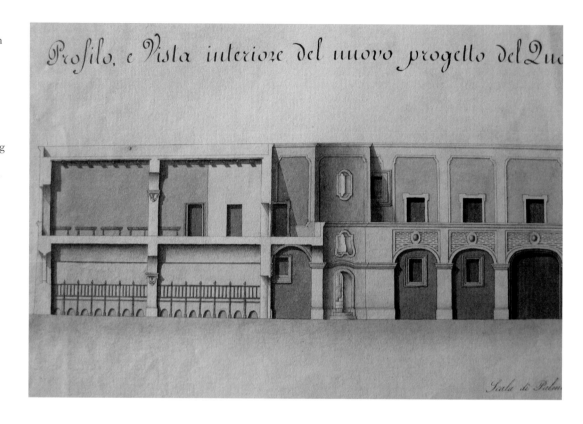

arcade and supported spandrels of brick studded with gray roundels. The ogee frames and the buttons of polished stone were common features of Neapolitan architecture, demonstrating that Bigotti respected the ornamental heritage of the bay just as he preserved the walls of the old Cavallerizza.

After a tumultuous month in 1753, Bigotti's idea of preserving large parts of the old building became unacceptable. On 1 July of that year, during the feast of St. Peter, a soldier struck an unruly celebrant in the Piazza del Mercato. The crowd reacted by pelting local guards with stones. Sentinels in the fort of the Carmine opened fire, but they were soon overwhelmed. The cavalry hastened from the Ponte della Maddalena, but it took the royal bodyguard, dispatched from Portici, to put down the rioters.[78]

This civil unrest awakened fears of revolt. Urban riots were a concern for every government in Europe, particularly after a wave of revolts in the mid–seventeenth century. In Naples the nobility helped stoke popular discontent in order to gain concessions from the Crown, which left the Two Sicilies with a long history of insurrection. The Sicilian Vespers (1282), the Conspiracy of the Barons (1485–87), the Revolt of Masaniello, the Revolt of Messina (1672–78), and the Conspiracy of the Macchia (1701) were the most notable. Justly or not, Neapolitans were perceived as turbulent and prone to riot. "Some bad influence seems to predominate, inciting its natives, because several revolts against the Monarchs have taken place there," claimed one Spanish observer.[79] Montealegre and the Caroline government knew the dangers. In 1742, when the

British fleet sailed into the bay and threatened the monarchy, the court was more concerned about the unsettling effect its appearance might have on the king's own subjects than the direct dangers it presented. Diplomats successfully convinced the fleet to anchor out of sight until a permanent settlement was reached.[80]

The unrest in 1753 therefore gave considerable concern to the royal government and new importance to the Ponte della Maddalena barracks. The barracks would be needed to protect the city from itself as much as from outsiders and signified an increasing reliance upon the military to maintain order. As Bernardo Tanucci would later claim, the monarchy maintained public order with a military presence that Neapolitans were unaccustomed to seeing in the city.[81] Architecture was a crucial visual indicator of this presence. In Turin the military might of the monarch was ingrained in the city's urban layout and architecture. Its streetscapes bore the message of Savoy absolutism.[82] The Neapolitan barracks was the architectural embodiment of a similar policy. It would be paid for entirely by the king, would be located in a prominent site, would visually express military might, and would be steered by a new minister of finance and war, Leopoldo de Gregorio, elevated to the post within a month of the riot.

De Gregorio was not new to the highest circles of the Bourbon court. Born to a family of civic administrators in Messina, he had quickly distinguished himself as a savvy reformer of customs collection.[83] He was shrewd, had a knack for numbers, but was uneasy with others. Perhaps his social insecurity was born from his status as a civic bureaucrat rather than a nobleman. Regardless, as an undersecretary he helped restructure the kingdom's finances, which guaranteed

him a prominent role in the government. By the late 1740s he had become a close advisor to the monarch and heir apparent to the aging minister of finance, Brancaccio. Before his promotion, de Gregorio proposed a new way to pay for defenses. To maintain existing coastal garrisons, he levied an 80-ducat tax on communities that benefited from their protection.[84] He likewise shifted the financial burden of regiments to the kingdom's provinces and ensured that new military installations, including all of the cavalry barracks outside Naples, would be paid for by local governments and ecclesiasts.

De Gregorio probably scrutinized the barrack projects with characteristic perspicacity. Construction in Aversa was proceeding slowly, and those barracks would be insufficient for a large number of men.[85] Better planning had to be done for the Ponte della Maddalena, and Bigotti's solution wasted space. De Gregorio therefore requested designs from other engineers. Francesco Sabatini and Francesco Collecini submitted proposals before the summer of 1754.[86] Both of these architects had debuted their talents in the *concorso clementino* of 1750.[87] Favorably impressed by their designs, Luigi Vanvitelli had called them to Naples in 1751 to help in the construction of the Royal Palace at Caserta. Designs for the cavalry barracks were their first independent projects in Naples, but these plans do not survive. With no clue about the merits of their proposals, we can only speculate why they did not get the commission.

Perhaps the site was too visually important to entrust to a young engineer. The barracks sat at the edge of a piazza that terminated the Via Marina, a thoroughfare the Crown had constructed in the 1740s. It therefore needed to be a distinguished bookend to the crowded cityscape of the port. Moreover, it would be

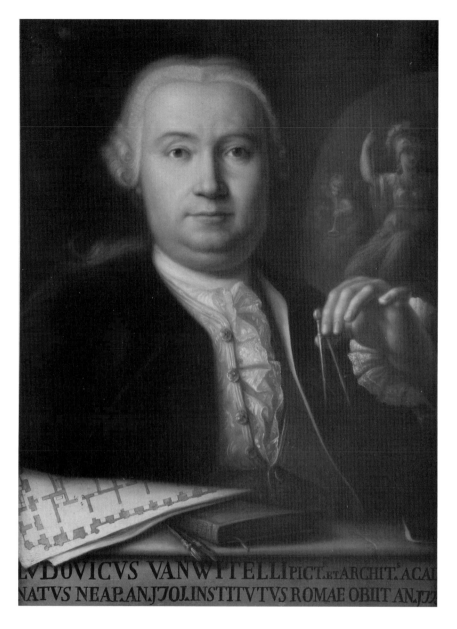

LVDOVICVS VANWITELLI PICT. ET ARCHIT. ACAD
NATVS NEAP. AN. 1700. INSTITVTVS ROMAE OBIIT AN. 17...

imperial ambassador at Portici, the barracks would be used as the staging point for the Austrian cavalcade.[88]

The royal government therefore turned to Sabatini and Collecini's superior, Luigi Vanvitelli (1700–1773) (fig. 65). Vanvitelli had been born in Naples.[89] His father, the Dutch *vedutista* Gaspar van Wittel, had been working for Viceroy Luis Francisco de la Cerda y Aragón, Duke of Medinaceli (1696–1702), when his wife gave birth to a son. They named him in honor of Gaspar's patron, and like his father, Luigi would Italianize his surname. Luigi thought himself Italian and, since he spent his childhood in the holy city, as Roman.

Nurtured on his father's skill in scenography and sharp observation, Vanvitelli began his career as a painter. Yet he longed to build, and saw Filippo Juvarra as his lodestar.[90] His earliest commission, at Santa Cecilia in Trastevere, was a chapel painted with fictive architecture. After a period in Urbino spent designing structures for Cardinal Annibale Albani, Vanvitelli made a daring Roman debut in the *concorsi* for the façade of San Giovanni in Laterano and the Trevi Fountain.[91] He lost but was commissioned to improve the Papal States' Adriatic port of Ancona, where he built his reputation on a pentagonal lazaretto (fig. 66).[92] Innovative in form and function, the lazaretto opened the way for a steady flow of commissions in Rome, which included building a new convent for Sant'Agostino, remodeling Santa Maria degli Angeli, and consulting on the stability of St. Peter's dome.

When Charles began searching for an architect for Caserta, Madrid had cited Vanvitelli as one of the best in Rome. He had authored few palaces, and, indeed, tradition holds that Nicola Salvi was preferred for the job.[93] However, the valetudinarian Salvi had

the first structure to greet a traveler arriving along the Strada delle Calabrie, as well as the principal building seen when passing out of Naples to the Royal Palace at Portici. Its importance on this royal road was confirmed in 1755 when diplomatic relations between Charles and Maria Theresa of Austria were normalized. For the first reception of the

already entrusted most of his work to Vanvitelli, making the younger architect his logical substitute. In addition, the architect had advocates. The papal nuncio, Gualtieri, helped Vanvitelli's cause, as did the first secretary of state and former ambassador to The Hague, Fogliani.[94]

Vanvitelli proved the ideal court architect. Liked by the king and queen, confided in by ministers, and valued for his efficiency, he was consulted on questions of hydraulics, archaeology, history, taste, and structure. His ability to absorb bookish knowledge and temper it with experiential expertise allowed him to confront a variety of building types and present well-adapted solutions. Initially limited to working in Caserta, by 1752 he declared, "Truly I would like to make something in Naples, to give an example of new architecture."[95] In 1754 his wish was realized when he was asked to design the cavalry barracks at the Ponte della Maddalena.

De Gregorio and Vanvitelli made the barracks the most efficient project of Charles's reign. Though many of the records are lost along with any autograph drawings, Vanvitelli's letters allow us to reconstruct its history, and designs made by nineteenth-century engineers provide an accurate record of his original building (figs. 67, 68, 69).[96]

Like most trained architects of the period, Vanvitelli received an adequate training in military architecture at the Accademia di San Luca and, perhaps like Filippo Juvarra, had observed cavalry maneuvers with interest.[97] Before he picked up his pen, Vanvitelli familiarized himself with existing fortifications and previous proposals. He studied drawings of Frederick II's Castel del Monte in Puglia and admired the austere massing of the structure.[98] He accompanied Fogliani to Capua in 1752 to inspect a site for new barracks and regretted

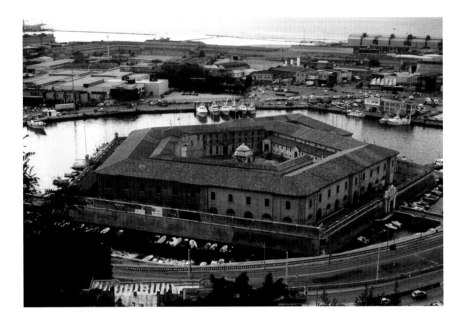

that he never saw a plan of those in Aversa.[99] He likely knew Bigotti's project for the Ponte della Maddalena, because the two had collaborated several times during the 1750s.[100] In addition, Vanvitelli was given the rejected plans of Sabatini and Collecini.[101] Vanvitelli's overall scheme may have been indebted to theirs—a hypothesis confirmed when Sabatini was appointed supervisor of construction at the Ponte della Maddalena. Indeed, Sabatini's drawing for the 1750 *concorso clementino*, which presented a school for mathematics and arts centered on an apsed courtyard, was very similar to the form Vanvitelli would adopt for the barracks (fig. 70).

De Gregorio set down the parameters of the building.[102] He required that the structure hold an entire regiment, boosting its capacity to 650 men and 580 horses. And he requested that it be completed quickly. To these were added the constraints of the difficult site, where Vanvitelli could "not lose even one palm [of space]."[103] The architect worked constantly for ten days in order to submit designs for

FIGURE 66
Lazaretto, Ancona.

FIGURE 67 (*page 110*)
Ground-floor plan of the cavalry barracks at the Ponte della Maddalena (inscribed *Maddalena-Caserma per un Reggimento di Cavalleria, Piano Terreno*), 1869. Black ink with gray wash on paper. Istituto Storico e di Cultura dell'Arma del Genio, Rome, 2-E-231.

FIGURE 68 (*page 111*)
Pozzoli, first-floor plan of the cavalry barracks at the Ponte della Maddalena (inscribed *Maddalena-Caserma per un Reggimento di Cavalleria, 1° Piano*), 1869. Black ink with gray wash on paper. Istituto Storico e di Cultura dell'Arma del Genio, Rome, 2-E-232.

Comando Territoriale di Napoli

Direzione di Napoli

Maddalena – Caserma per un Reggimento di Cavalleria
(Piano terreno)

Foglio N.º 1

Sezione 3ª (Piazza di Napoli)

Anno 1869

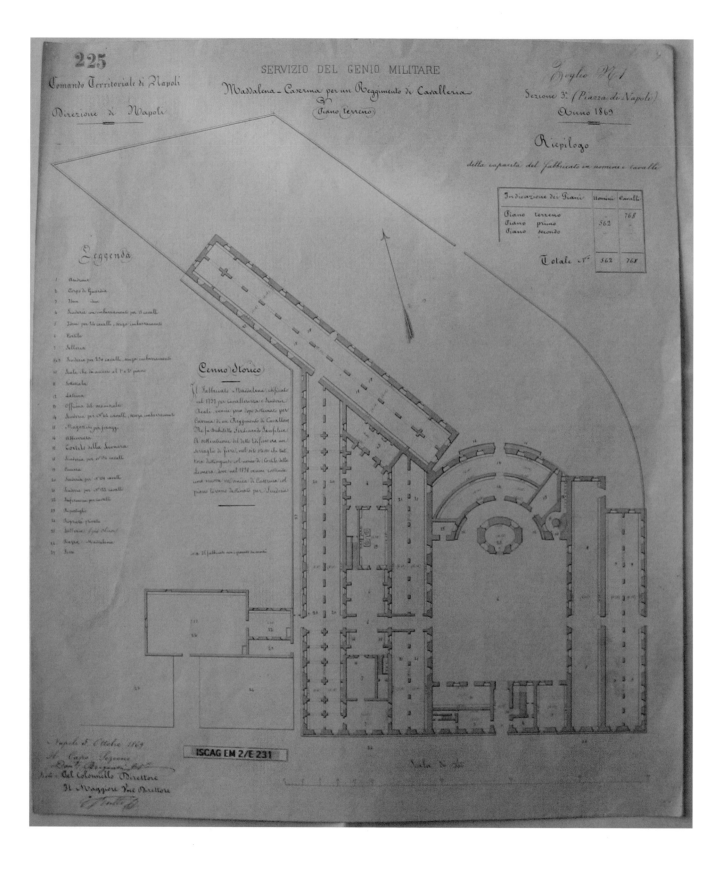

Riepilogo
della capacità del fabbricato in uomini e cavalli

Indicazione dei Piani	Uomini	Cavalli
Piano terreno		768
Piano primo	562	
Piano secondo		
Totale N.º	562	768

Leggenda

Cenno Storico

ISCAG EM 2/E 231

Napoli 5 Ottobre 1869

225

SERVIZIO DEL GENIO MILITARE

Comando Territoriale di Napoli

Direzione di Napoli

Maddalena - Caserma per un Reggim.to di Cavalleria

I°. Piano

Foglio N°

Sezione 3ª (Piazza di Napoli)

Anno 1869

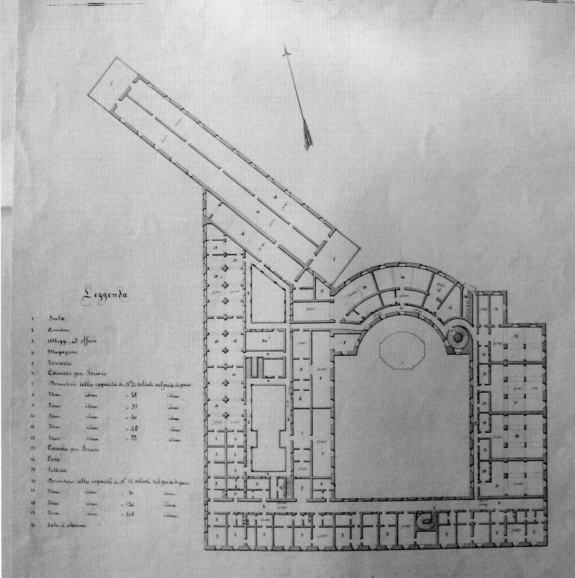

Leggenda

Scala di 1/200

Napoli 5 Ottobre 1869

SERVIZIO DEL GENIO MILITARE

Maddalena - Caserma per un Reggim.to di Cavalleria

2.o Piano

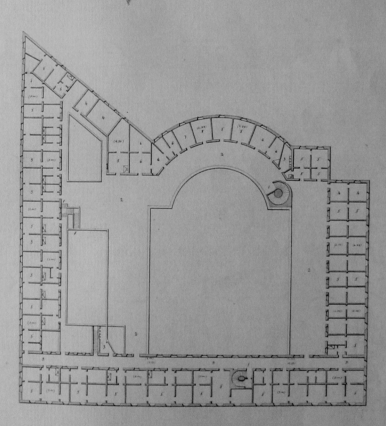

Leggenda

1. Scala
2. Terrazze
3. Latrina
4. Mensa degli uffiziali
5. Alloggi
6. Dorm.
7. Dorm.
8. Dorm.
9. Dorm.

Scala di 1/500

Napoli 5 Ottobre 1869

Il Capo Sezione

Visto del Colonnello Direttore

Il Maggiore Vice Direttore

royal review on 20 August 1754.[104] The king was infinitely pleased, and a proud Vanvitelli described his plan to his brother:

> The figure of these barracks is so irregular that one could think it a problem. I shaped it in a manner that hides all of the irregularities and even makes it appear very regular. And I made use of every bit of land so that it can comfortably house 580 horses, twelve companies of fifty men each, twelve apartments for officials with two rooms and a kitchen, and an apartment for the major with three rooms, a gallery, and a kitchen; I made the façade serious in the extreme, and one can tell that it is not a palace but a quarter for soldiers. The building will be made in three years because they do not want the horses to remain where they are, since they are necessary for keeping this most faithful populace in line. I should be congratulated for this work, but I do not hear a thing, and at meetings the engineers regard me as their enemy, since I took this commission out of their hands.[105]

Though he made enemies of them, Vanvitelli leaned heavily on the engineers' examples, which he likely improved by consulting books on military architecture.[106]

Vanvitelli's plans embody taut economy. With the exception of the angled menagerie on the upper left, which was incorporated later, nineteenth-century drawings accurately record his building. From the single entrance at the south one passed two small rooms for guards and a rectangular flight of stairs before entering the principal courtyard (fig. 71). The apsed courtyard is Vanvitelli's brilliant resolution of the cramped site. The Arenaccia forced Bigotti to eliminate the corner, but Vanvitelli's

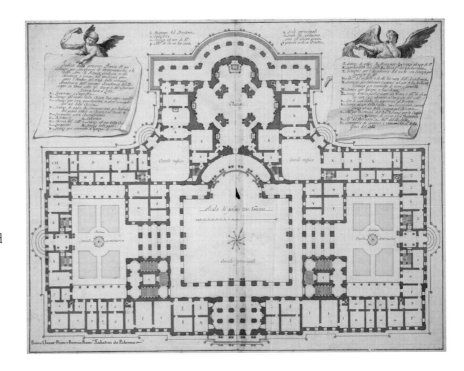

curved northern wing, perhaps indebted to Sabatini's school for mathematics and arts, allowed him to enclose the court without sacrificing space. Vanvitelli nestled an oval chapel into the curved end, like an altar within an apse. Set within this curve it could serve the spiritual needs of soldiers without intruding upon their everyday bustle. The idea drew upon his lazaretto, where the pentagonal chapel of San Rocco gave focus to a large inner plaza.[107] Yet perhaps the most direct inspiration came from the architect's rival, Ferdinando Fuga. For the Camposanto di Santo Spirito in Sassia, Fuga had situated a chapel in the apsed end of the rectangular enclosure (fig. 72).[108] Even if he followed these examples, Vanvitelli's pairing of a precious chapel with a brawny barrack was unprecedented.

Vanvitelli positioned three additional openings off of the principal axes of the eastern courtyard, vastly improving Bigotti's limited

FIGURE 69 (*opposite*)
Pozzoli, second-floor plan of the cavalry barracks at the Ponte della Maddalena (inscribed *Maddalena-Caserma per un Reggimento di Cavalleria, 2° Piano*), 1869. Black ink with gray wash on paper. Istituto Storico e di Cultura dell'Arma del Genio, Rome, 2-E-233.

FIGURE 70
Francesco Sabatini, plan for a school of mathematics and arts, 1750. Black ink with gray wash on paper. Accademia Nazionale di San Luca, Rome.

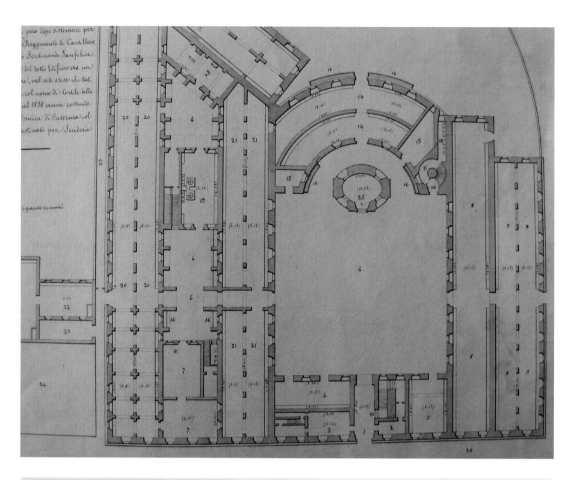

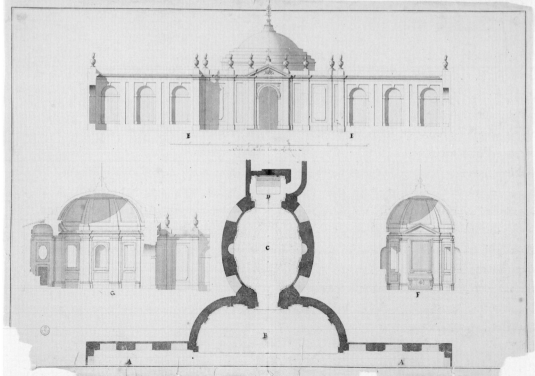

FIGURE 71
Ground-floor plan of the
cavalry barracks at the Ponte
della Maddalena, 1869 (fig. 67),
detail showing the eastern and
western courtyards.

FIGURE 72
Plan, elevation, and sections
of the Camposanto di Santo
Spirito, eighteenth century.
Black ink and gray wash on
paper. Galleria degli Uffizi,
Florence, N.607898.

access. The openings to the north and east led through stables to the exterior, while the western one passed through stables, the western courtyard, and another wing of stables, before providing access to a flanking street. Within the stables, Vanvitelli ranged stalls on a north-south axis to avoid the many partitions of Bigotti's scheme. Four long stables contained most of the horses but were supplemented by two curved ones at the back of the building and two small ones on the south side of the eastern courtyard. The architect also changed the ceiling of some stables from a continuous barrel vault into cross vaults. Jules Hardouin-Mansart had employed alternating barrel and cross vaults for the Écuries of Versailles, but Vanvitelli used the cross vault only when the structure required extra support.[109] In the western wing, cross vaulting allowed Vanvitelli to shore up the walls, thus eliminating the need for the exterior buttresses that Bigotti had proposed.

Water troughs, rendered in a light blue, are positioned along the inner and outer walls of the north wing of the principal courtyard, as well as in the western service court, but seem insufficient for a large number of horses. Perhaps additional nearby sources were used. Indeed, the water table was so high in the area that latrines located in the western service court could not be connected to sewers.[110]

Vanvitelli eliminated the individual kitchens for each dormitory and replaced them with a single large one on the northern side of the western courtyard. Behind this kitchen he positioned a narrow staircase that provided easy access to the soldiers' quarters on the upper floors. On the south side of the service court, opposite the kitchen, he positioned latrines and the saddlery. Other service rooms included two blacksmiths' shops, one located in the eastern courtyard, in a trapezoidal space adjacent to the curved stables, and another linking the northernmost edges of the western stables.

Vanvitelli simplified the stairs. A small spiral one near the chapel, a square flight near the southern entrance, and two small switchback stairs in the service court replaced Bigotti's elaborate ones. Stairs gave access to the second and third floors, where all soldiers and officers were lodged. Large dormitories, supported by piers and capable of sleeping twenty soldiers, occupied the western and eastern sides of the building (fig. 73). They were joined by slightly smaller dormitories in the curved wing and on the western side of the main courtyard. Small rooms connected to the western dormitories were designated for the regiment's pages, and the soldiers shared latrines, located near the spiral stairs in the northeast corner and accessed by an external balcony. Ten officers' quarters occupied three-, four-, and six-room suites arranged along the south. The location provided sea breezes and kept them some distance from the kitchens, forges, and stables on the ground floor. Finally, a series of storerooms extended away from the officers' quarters into the western aisle of the building, but we do not know what they held.

The third floor, the most luxurious, was devoted exclusively to officers' quarters (fig. 74). Except for the south side, Vanvitelli positioned suites around large terraces. Many apartments had fireplaces, and the largest ones, of ten rooms each, occupied the southwest corner. These noble commanders not only enjoyed abundant interior and exterior space but also shared a dining hall, located in the diagonal wing at the north. Such amenities probably helped attract aspiring nobles to serve in the cavalry, since they could adopt the career without embracing the rugged simplicity of a soldier's life.

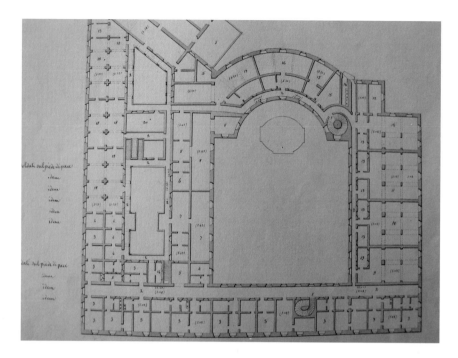

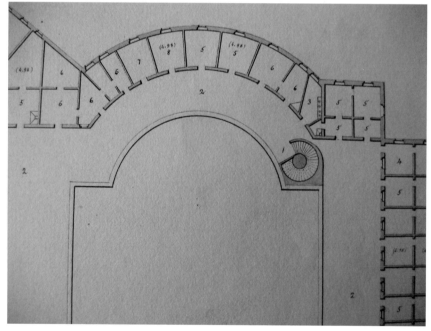

Vanvitelli turned to the façade on the last draft (fig. 53). He thought first of tone and cloaked the exterior with a "serious" mask to express its martial function. Coming only a year after Marc-Antoine Laugier's *Essai sur l'architecture* had insisted that *bienséance* determine decoration, Vanvitelli's draft precociously calibrated ornament to function.[111] Although Vanvitelli may have known the treatise, his thinking was more likely shaped by the Academy of the Arcadians in Rome. Sandro Benedetti and others have attempted to describe an Arcadian style of architecture, but this literary academy probably did not provide Vanvitelli with a particular style.[112] Rather, it influenced his approach to design. As a member of the literary circle, Vanvitelli witnessed the Arcadians' reclamation of the simple themes of Renaissance poetry. They believed language should be decorously impressed on each situation with clarity. Vanvitelli gave these ideas flesh in his lazaretto, where the corners of the pentagon seem to split apart to express the tectonic force of the walls.

Like the lazaretto, which seems anchored in Ancona's port, the south façade of the barracks unrolls along an expanse near the waterfront. Vanvitelli embraced the site with earth-hugging horizontality. Rows of windows pierce a thickly massed astylar façade. Weighing upon them from above is a wide unadorned entablature. It joins pilaster strips at the corners, which connect to a lower horizontal band to frame the upper section in a box. Yet it is a tense container. Windows press into the border, and the pressure extends to the lowest third of the wall, which splays into a podium. Needing the optical might to contain the weight from above and the horses within, this angled wall is trimmed with *piperno* quoining, sits on a stone base, and supports a rolled

cushion of *piperno* bordering the upper floors. The building's massive, sober façade visually expressed royal might for visitor and inhabitant alike.

A single rusticated portal gave access to the building from the south, though today there is an additional door. Through the portal the visitor entered a long *androne*. This dark corridor led to the sun-drenched eastern courtyard. The courtyard is the elegant core of the building (fig. 75). It feels intimate because Vanvitelli hid the third storey, placing apartments along the building's perimeter and leaving terraces to line the courtyard on three sides. He then unified the elevation with colossal pilasters at the corners and along the north wing. Behind them Vanvitelli ran a horizontal band that binds the space like a wide belt (fig. 76). Window frames on the second storey sink into the belt, while keystone motifs on the ground floor link the belt to alternating arched windows and doors. Vanvitelli set the windows within sunken recesses to create strong shadows that enhance the appearance of the walls' thickness. This gives the walls a dynamic quality that creates tension with the regimenting order of

FIGURE 75
Eastern courtyard of the cavalry barracks at the Ponte della Maddalena.

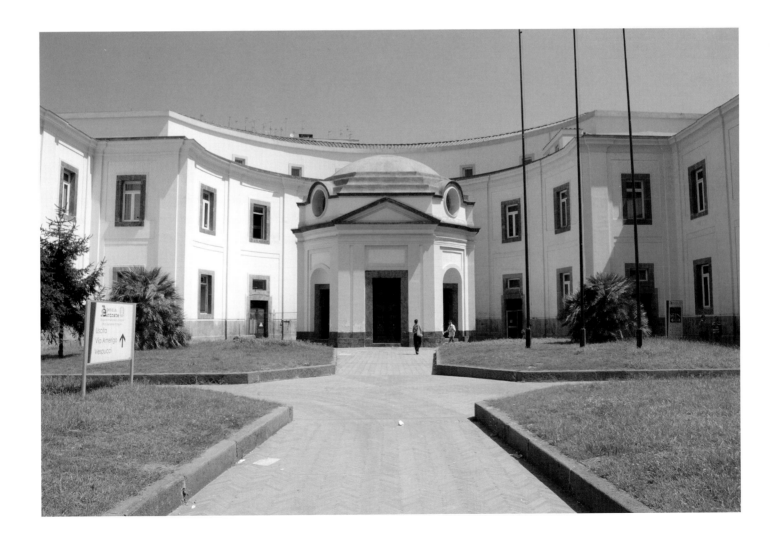

FIGURE 76
East wall of the eastern
courtyard of the cavalry barracks
at the Ponte della Maddalena.

the pilasters and horizontal band. Even door-frames spread at their bases, buckling beneath the weight.

Similar sensibilities molded the chapel (fig. 77). Unlike his pavilion for the lazaretto, the structure Vanvitelli planted in the barracks was as weighty as its surroundings. To answer the need for functional openness, he adopted the oval, which allowed him to face three doors on the courtyard and two toward the back. He framed the central portal within a staid aedicula of double pilasters and a straight pediment. The flanking doors he edged with simple *piperno* jambs, and he scooped these out of the thick walls, seeming to delight in the cavities left behind. Features of the chapel are borrowed from Borromini, the Pantheon, and Bernini, showing how Vanvitelli passed through his memory, collected bits of buildings

seen and studied, and stitched them together in an original whole. Yet the chapel is not simply a pastiche of assembled precedents. It is above all a piece of architectural sculpture crafted as a visual anchor. Vanvitelli's pupil Giuseppe Piermarini thought it the best feature of the structure and used a variation of it to focus his own designs for a barrack.

REGIMENTING WORKERS

When he submitted his designs, Vanvitelli also laid out a system of work-site supervision.[113] He ensured the barracks would be executed to his specifications, and stated that he would approve all purchase of materials. Vanvitelli made Sabatini his principal assistant.[114] In that role Sabatini commanded construction, made sure the list of laborers was accurate, authorized their pay, and signed all bills. Vanvitelli

FIGURE 77
Chapel of the cavalry barracks
at the Ponte della Maddalena.

trusted Sabatini. Born in Sicily, trained in Rome, and brought to Naples, Sabatini would become his most famous pupil. He would marry one of Vanvitelli's daughters and would eventually move to Spain, where he would have a successful career as royal architect.

Beneath Sabatini came the *capomaestro* Francesco Bernasconi. Bernasconi and his more noted brother Pietro were stonemasons from Ticino, and Vanvitelli entrusted Francesco to oversee quality craftsmanship.[115] At the Ponte della Maddalena Bernasconi directed laborers and was responsible for inspecting their work. In addition, he inspected labor lists and materials and reported all problems to Sabatini. Bills were checked by a scribe, Girolamo Iapadolini, and wages paid every second Saturday by purser Gennaro

Tartafiume. This system kept daily operations out of Vanvitelli's hands, which he needed free for responsibilities at court.

The architect personally oversaw the selection of materials. These included *piperno* for the base and window frames and volcanic *tufo* for the remainder. Vanvitelli also inserted brick bands in flat arches above the windows, though they do not figure in his purchases. Prices were finalized in December, and by summer of 1755 work on the foundations had begun. As stone arrived on the site, books on military architecture were shipped to Vanvitelli's study. Perhaps he used them to deepen his understanding of the art, or more probably he loaned them to Sabatini. The latter seems likely, since Vanvitelli only made periodic checks after work commenced.[116]

On occasion the architect was called to resolve problems. For example, in 1758 he had to investigate a dispute between a laborer and Bernasconi. A verbal argument had turned physical when the worker pushed the *capomaestro* into the lime pit. Vanvitelli backed Bernasconi, claiming that the worker triggered the clash. In addition, Vanvitelli sometimes had to make minor on-site changes, such as walling up some windows of the adjacent menagerie.[117]

Throughout construction the cavalry had to occupy the old barracks, which limited work to a single wing at a time. Horses and men periodically had to be moved to other locations so that parts could be advanced or completed. This did not suit the soldiers. In August of 1756 de Gregorio had to calm alarmed cadets who feared their temporary home in danger of collapse.[118] By August of 1757 Vanvitelli predicted that the building would be completed the following spring, but ice damage during the winter caused delays. In the summer of 1758 troops began to occupy the new barracks, the regiment increased in number, and, confirming the order the building provided, the soldiers donned uniforms for the first time.[119]

The end of the decade saw the departure of the king for Spain, and de Gregorio and Sabatini with him. Vanvitelli wanted his sons Carlo and Pietro to succeed Sabatini but feared that engineers from the military corps would overrule their appointment. He also worried about slowing momentum. The regency had slashed funding by 5,000 ducats, and Bernasconi had followed Sabatini to Madrid in 1761.[120] With Vanvitelli's guidance the project did not lose its footing. He negotiated the cost of metalwork and, in 1762, helped advocate for increased spending. In March of the following year he forecast a completion date in May. Work was finalized only in June, with the chapel and the western wing the last parts completed.[121] The final stages of construction posed some challenges to Vanvitelli's meticulous planning. For example, while *piperno* walls within the barracks prevented kicking horses from damaging them, the stucco exterior was soon pockmarked. Adding *piperno* increased costs, but the court determined that the exterior should be as soundly built as the interior, and the architect added stone facing to the lower parts of the eastern and northern walls.[122]

When it was completed, Vanvitelli received 900 ducats. With confidence, he declared that of all the Caroline barracks, his was the only one well built.[123] And he felt that his success entitled him to judge other projects. When shown a plan of the barracks in Capua, Vanvitelli proclaimed, "[T]hey know as much about architecture as I do of astronomy."[124] He was asked to inspect the barracks of Portici and found them poorly built. In Naples he strongly advocated purchasing land west of his barracks

to provide an open manège for the exercise and training of horses.[125] And in 1765 de Gregorio asked Vanvitelli to send plans for a cavalry barrack to Madrid. Vanvitelli wondered why Sabatini had not been given the commission, not knowing that his former pupil would review his proposal along with one by Ferdinando Fuga. No drawings survive, but the architect recounted one feature he borrowed from the Ponte della Maddalena: the chapel. He included it "because this is the most noble one that has been constructed to date, and might be something that would not seem wrong to me in Spain or in any other place it was constructed."[126] Sabatini instead lauded Vanvitelli for his attention to national context, stating that his design best suited the organization of the Spanish cavalry.[127] No building resulted from his Spanish plans, but Vanvitelli's skilled distillation of his vast architectural training left Naples with one of the most austerely elegant buildings commissioned by the king.

While the Maddalena quarters offered soldiers an elegant and comfortable home, the barracks gave locals security. As a policing outpost, it was tested in the months after its completion. An acute grain shortage in the spring of 1764 led to famine and epidemic. The court retreated to Caserta, and riots broke out in Naples. The district near the cavalry barracks was hardest hit. Two thousand were quarantined, and the barracks became a makeshift hospital.[128] Yet the area did not experience the unhinging chaos of the 1656 plague. Instead, the famine ended, and the district near the Ponte della Maddalena became the locus for preventive planning. Across the Sebeto River an enormous new granary replaced those situated in the heart of the city. This building, known as the Granili, was designed by Ferdinando Fuga in 1779.[129] Though the sea air was poor for storage, the site afforded greater security. The troops at the barracks could prevent rioters from raiding the city's supply, acting like a padlock for the bread box. The use of the cavalry barracks to police the city foreshadowed developments in northern Europe. In the 1790s the British government would rush to build cavalry barracks near cities to prevent possible civil unrest that might follow the French Revolution and Napoleonic Wars.[130]

At century's end a growing population and an expanding military were competing for space. Rather than cede to the encroachment of the city, the royal government shored up the importance of the barracks. The piazza in front of it was closed off with bollards so that carts and people would not impede cavalry drills.[131] Its security role had become too important to sacrifice and was its greatest urbanistic legacy.

CAVALRY BARRACKS IN EUROPE

The Caroline barracks were among the first exclusively devoted to cavalry in Europe. Their style was immediately adopted by Francesco Navone for his Quarterione in Civitavecchia (1776), which was likewise praised for its "serious and robust" architecture.[132] The Neapolitan barracks would also be followed in Spain by Sabatini's barracks for Walloon guards at Leganés (1776) and Manuel Martín Rodríguez's Cuartel de San Gil in Madrid (1789) (destroyed, now Plaza de España). These latter barracks would join the Real Cuartel de Guardias de Corps and the royal stables in a barrack district north of the Royal Palace in Madrid.[133] They also paralleled those constructed by Frederick II, Maria Theresa, and William Pitt. In contrast to those in Prussia and Austria, the Neapolitan and Spanish barracks were bright

and airy.[134] Perhaps knowing of the Neapolitan barracks, Thomas Worsley boasted to the English plenipotentiary in Naples, William Hamilton, that his new stables were so fine that "a Neapolitan would not be surprised."[135] Worsley's stables were an exception, and in fact the uniqueness of Vanvitelli's design stands out against many counterexamples in England.

In the 1750s William Pitt's government used barracks to consolidate its hold over Ireland and Scotland. Planned on an enormous scale, these U-shaped structures housed infantry as well as cavalry.[136] In London, installations were smaller. One of these, likewise intended for the cavalry and funded by the Crown, was an exact contemporary of the barracks at the Ponte della Maddalena. The Horse Guards had occupied a site in Whitehall since 1663. By the 1740s their quarters needed expansion and repair, and William Kent was asked to draw up a replacement (approved posthumously in 1749). He had to provide space for mounted troops, an infantry division, and the War Office. From a lantern-topped core, his building unfolded in a series of corridors and pavilions reminiscent of a Palladian villa. While elegant, the plan was indifferent to functional needs. Kent arrayed stables in a tangle of extending wings. In addition, the exterior, faced in Portland stone and dressed with the vocabulary of Palladio, provided no clues about the function of the building.[137] As classmates, the Horse Guards quarters and the Ponte della Maddalena barracks present opposing ideas of military architecture. Vanvitelli's simplicity fulfilled functional needs and expressed them on the exterior. In doing so, his style foreshadowed a younger generation of architects who sought authentic architectural expression of a building's function. Claude-Nicolas Ledoux is closer in spirit than the classically ordered buildings of Kent. Yet unlike French architect-theorists who encoded buildings with theoretical messages of function and reform, Vanvitelli saw his design as part of his métier. Circumstance dictated stylistic expression. And the cavalry barracks pushed Vanvitelli to think differently about style in order to provide an example of a new type of architecture.

Regardless of the style they embodied, barracks shared a common purpose. They enforced regimental order and discipline, housed aristocratic commanders in Crown-controlled spaces, and gave the military a prominent policing presence in cities. Like the Spanish Quarter, which had been planned two centuries prior, the cavalry barracks at the Ponte della Maddalena marks an urban strategy of control. Stationed in populous capitals, soldiers ensured domestic peace. They could also guarantee dynastic longevity by crushing revolts before they were fanned into revolutions. Large, often severe in style, barracks, by their mere presence, likely discouraged insurrection. They were the architectural guarantors of tranquillity.

The Foro Carolino

INVICTO CARLO REGE FEDELISSIMA CIVITAS SIMULACRO FORUMQUE *(The most faithful city presents*
to the unconquered King Charles this statue and forum)

—Inscription proposed by Luigi Vanvitelli, 1759

In the mid-1750s architecture was reshaping Naples. The Teatro di San Carlo bloomed with musical life, the Albergo dei Poveri promised mendicants shelter, and the cavalry barracks at the Ponte della Maddalena helped professionalize the military. Yet no statue publicly commemorated the monarch that commissioned them. A statue of the king had been erected in Palermo, and one would likewise be set up in Messina, but none in Naples. This is puzzling given that Charles's departure to succeed his ailing half brother in Madrid grew more likely, and diplomats mooted his succession in Naples.

The city government would eventually take up the idea for a monument, which would be framed with buildings designed by Luigi Vanvitelli (fig. 78). Rather than show the initiative of the local government, however, the rise of this Foro Carolino marked the ascendancy of the Crown in matters of civic governance. Though financed by the civic tribunal, the project was steered by the Crown and linked to the royal government's revival of trade and commerce.

The statue of the king was destroyed in 1799, but the Foro Carolino, now known as the Piazza Dante, with its broad hemicycle of shops and residences, remains one of the most vibrant squares in Naples. Various scholars have brought to light relevant documents, and, most recently, Serena Bisogno has written a monographic article on the structure. But while her research in the archives parallels my own, no author has scrutinized the entire material evidence to trace the history of the square completely.[1] By returning to the municipal archives of Naples and examining published documentary sources, I have been able to reconstruct many episodes in the planning and execution of the project. More importantly, by reading between the lines of royal dispatches and civic resolutions, I explain how the Foro Carolino reshaped the dynamic between the Crown and the city.

Its purpose, though primarily representational and political, was also largely commercial. The shops and residences framing the statue were intended by the royal government to spur trade. They gave order to an older marketplace by controlling commerce and parceling activity into individual shops. Relatively small, these homes and businesses also created

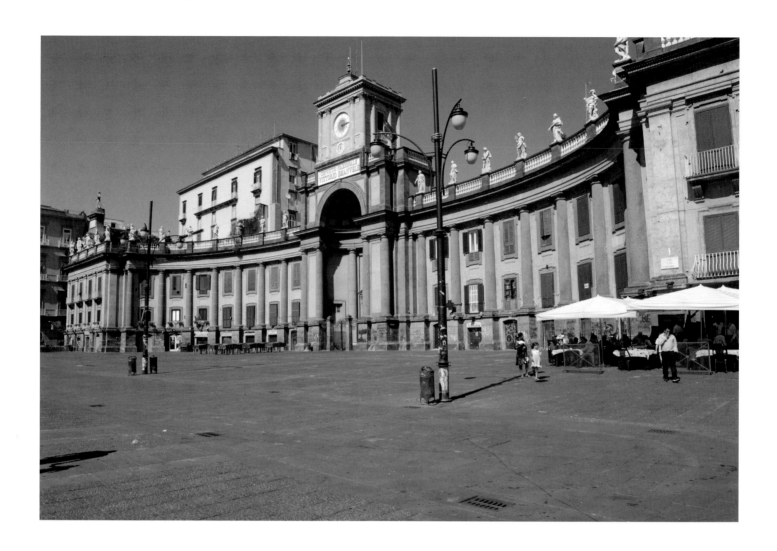

FIGURE 78
Foro Carolino (now Piazza
Dante).

space for Naples's fledgling middle class. I con-
nect the efforts made in the Foro Carolino
with broad programs of Bourbon mercantile
reform to show how architecture advanced
Caroline commercial policies.

FOREBEARS

Statues of Charles and Maria Amalia had
been cast early in their reign. In Piazza
San Domenico of Palermo the new mon-
archs replaced their Austrian predecessors
at the base of the column of the Immaculate
Conception, though they too have since been

destroyed (fig. 79).[2] The column, designed by
Giuseppe Maria Napoli in 1724, had drawn
upon Viennese examples such as the Pestsäule.
Replacing the statues at its base likely did not
completely cancel its Hapsburg associations.
Therefore, it is not surprising that the sov-
ereign did not consent to a proposal to have
statues of himself and Maria Amalia placed
below a similar column in Naples. This *gug-
lia,* or ornamented tower, of the Immacolata
was to rise along one of the principal streets
of Naples (fig. 80). Proposed by the Jesuit
Father Pepe, it would be the Society of Jesus's

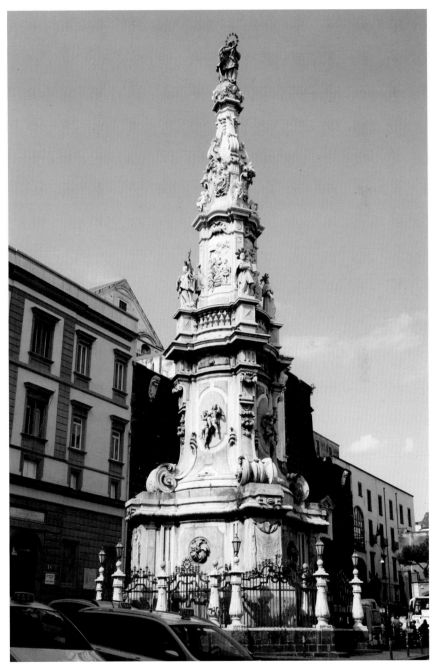

FIGURE 79
Column of the Immaculate Conception, Palermo.

FIGURE 80
Guglia of the Immaculate Conception, Naples.

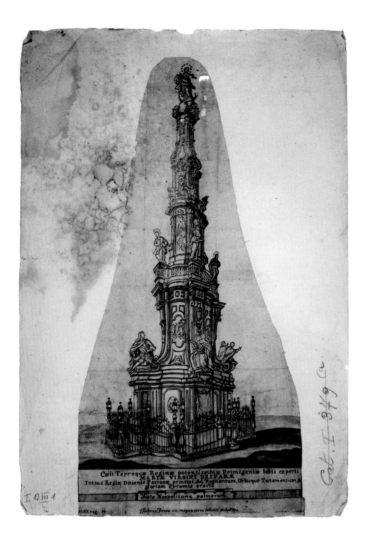

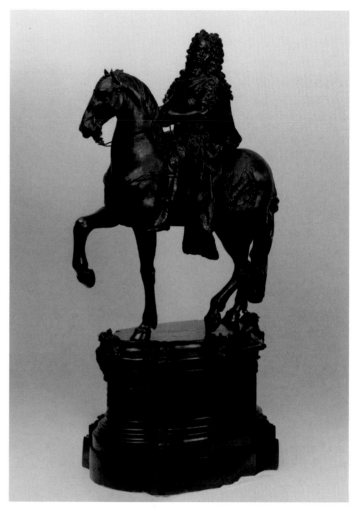

answer to the archbishop's, Domenicans', and Theatines' various monuments dotting the city. The sovereigns were detached sponsors, and to strengthen the Crown's support, Pepe thought to include their statues. Prints of this scheme circulated, lending credence to royal backing (fig. 81). Yet the simulacra were not part of the final ensemble.[3] Disagreements between the pope and the king may have tarnished the idea of the monarch at the base of a Jesuit monument. The Hapsburg associations probably posed another obstacle. Moreover, the *guglia* was not the first royal monument to occupy

the Piazza del Gesù. In 1702 the city had commissioned Lorenzo Vaccaro to craft a bronze equestrian statue of Philip V to place in the piazza. In the uprising that accompanied the Austrian seizure of the capital (1707), it was destroyed, an event recorded and illustrated in contemporary broadsheets.[4] Two statuettes of the original sculpture survive in Spain and give an idea of what the equestrian monument looked like before its destruction (fig. 82).[5] The idea of a church-sponsored monument, articulated in a Hapsburg tradition, on ground that had witnessed the destruction of Philip's

statue might not have been well received by the court. Moreover, statues of monarchs were rare in Naples. The Spanish Hapsburgs carefully avoided them.[6] Only under Charles II were two public sculptures of the king set up. One occupied the façade of the Ospizio di San Gennaro. The other, originally planned as an equestrian monument, topped a fountain in Via Monteoliveto near the Piazza Gesù.

In Sicily statues were erected more readily. For example, images of Spanish kings occupied positions above four fountains marking the intersection of Palermo's principal thoroughfares. And during Charles's reign, Messina acted with resolve to commemorate the king. Sicily's most important port had been ravaged by a plague in 1743. The royal government came swiftly to its aid, and as a mark of gratitude the city government commissioned a statue of the king. A former pensioner at the French Academy, Jean-Jacques Caffieri (1725–1792), executed a model (fig. 83), which was translated into full scale by Giuseppe Buceti and then placed atop a pedestal designed by Luigi Vanvitelli.[7] Facing the uniform façades of the Palazzata, the crowned and mantled monarch would preside over fishermen, sailors, and dockworkers. Though he seems to have paraded onto the wrong stage, it was precisely the union of refined royal image with raw commerce that resonated in Naples.

THE CITY, THE PORT, AND THE MARKETPLACE

The city government of Naples was unique.[8] Tracing its roots to the Greek precinct organization of ancient Neapolis, the government was formed of representatives from district assemblies, or *seggi*. By 1380 these *seggi* were dominated by aristocrats, who closed their rosters. Families subscribed in one of the city's *seggi* formed an urban aristocracy that rivaled the baronial nobility in prestige, if not power. A representative from each of these five noble *seggi* sat on the civic tribunal, which was led by an *eletto del popolo* from the single *seggio* of the populace. Serving semiannual terms, the six *eletti* (elected) of this council were responsible for the city's grain and water supplies, maintenance of its walls, and enacting certain

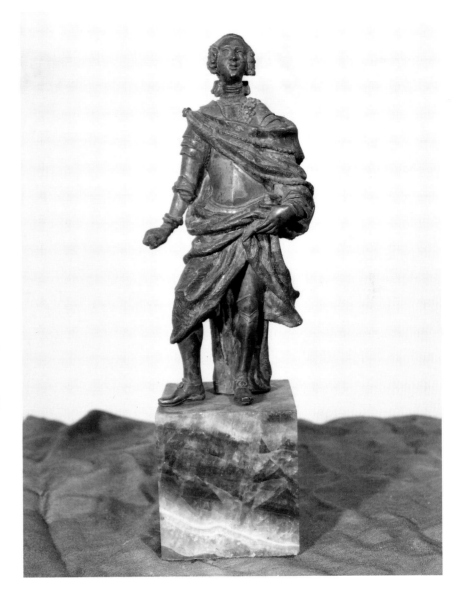

FIGURE 83
Jean-Jacques Caffieri, *Model of a Statue of Charles of Bourbon*, 1754. Silver. Museo Nazionale di San Martino, Naples.

municipal laws. They also had important ceremonial duties in public festivals.

Like the civic tribunals of other Italian principalities, the Eletti impeded the exercise of a sovereign's absolute power.[9] In Naples, the city government had even seized power and ruled independently of Queen Joanna II (1414–35) from 1418 until 1420.[10] Though they never obstructed his government, Charles found them a halting partner. Their recalcitrance was rooted in the seventeenth century, when new nobility, barred from membership in the ancient *seggi*, began to appropriate the *popolo* post.[11] As its status-conferring role grew, the tribunal became lax in its responsibilities. They poorly maintained Naples's aqueducts and allowed grain stores to run low. The royal government often issued decrees that overrode civic authority, and seized projects from them.[12] Nevertheless, while the Crown bypassed the city government on a number of important decisions, royal authority also depended upon the loyal adherence of urban elites. Thus the royal government maintained civic institutions, councils, and administrators. In other parts of the kingdom, particularly Apulia, the Crown even helped reform civic councils to make them more effective partners.[13] Economic reform was the key reason for pouring effort into making civic institutions more efficient. Effective local governance was essential for the Crown to increase agricultural production and encourage trade.

Improving trade was a hallmark of Caroline reform, and Naples, as the linchpin in the Two Sicilies' commerce, had to thrive for the kingdom to prosper. The first priority for the capital was modernizing the port to increase exports of agricultural goods. Before Charles assumed the throne, vibrant maritime commercial activity was limited by the size of the port, which had not been expanded since the beginning of the seventeenth century.[14] Merchant activity therefore became diffuse and disorganized. Ships landed at a number of small harbors ringing the bay, making customs collection more challenging and increasing the quantity of illegally imported goods. In 1738 Montealegre responded to the problem by directing Domenico Antonio Vaccaro and Giovanni Antonio Medrano to improve the port.[15] The minister wanted the mole lengthened to accommodate more ships. In addition, he had its seaward side strengthened by new rockworks and its quays lowered to facilitate loading and unloading. As for many projects early in Charles's reign, the impetus for port improvements likely came from Spain. Philip V gave considerable attention to ports, particularly Cádiz, which replaced Seville as the hub for American trade after 1717.[16] In Cádiz the royal engineer Pedro Moreau directed important physical improvements, increasing space for storage in particular.[17] A few years before Charles departed for Italy, he saw the new port when visiting the Mediterranean fleet and the city's dockyards with his parents and Patiño.

Naples likewise needed more than a larger port. Order had to be imposed upon the activity surrounding the Neapolitan harbor. Before Charles's arrival one guidebook claimed, "Here everyone can be stupefied by the number of boys, mariners, and the great population of the city."[18] Claude-Joseph Vernet's paintings and drawings from the 1740s attest to the bustle of fishermen, tradesmen, and gentlemen. Many streets fed into the narrow hook of open land near the harbor, adding to congestion. Rather than reduce crowds, the new mole compounded the problem by providing more space for ships to dock without improving the streets and warehouses around it. A 1743

drawing by Vaccaro or his assistant Giovanni Bompiede shows the port with its longer mole but an unorganized group of customs halls, warehouses, and beaches fronting the gulf (fig. 84). The drawing also presents a way to improve the area. He proposed a shorter, wider mole extending toward the existing one like a pincer, and provided two potential angles for its orientation. From either angle the architect planned to connect this new dock to the shoreline near an existing barrier that sheltered a small harbor used by local fishermen and tradesmen.

The final solution was more remarkable (fig. 85). Rather than hinged to the shoreline, this new mole was built farther out, unconnected to the coast. Two sets of causeways and bridges, the western one probably built upon the old barrier, were then constructed on either side of this mole to link it with the new Via Marina, a street that extended along the entire waterfront. These small arms constituted an ancillary wharf, which enclosed a sheltered oval of water designated for fishermen and other local mercantile activity. The solution brilliantly distilled activity into two zones, an outer one for larger-scale commerce and an inner harbor for locals. Construction began, and at some point after 1748 the Guards Corps was added at the end of the new mole (fig. 86).[19] Commonly known as the Imacolatella and dedicated to the Spanish monarchy's favored cult of the Immaculate Conception, this octagonal building, perhaps based on a model by Vaccaro, had bastioned corners and was topped with marble decorations

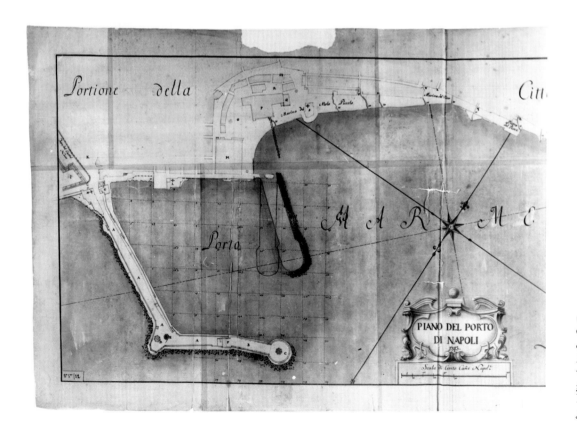

FIGURE 84
Giovanni Bompiede (attr.), plan of the port of Naples (inscribed *Piano del Porto di Napoli*), 1743, western half. Black ink with gray wash on paper. Biblioteca Nazionale, Naples, *carta geografica*, Bª-5A-52.

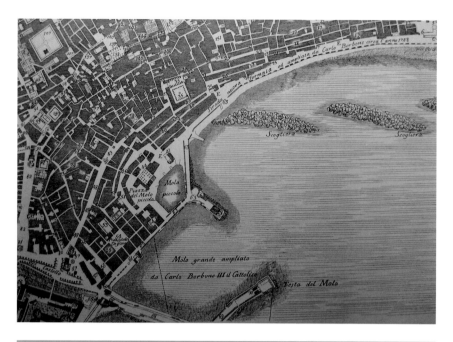

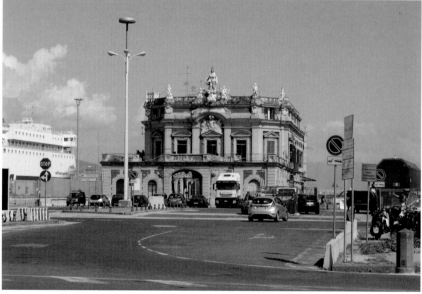

FIGURE 85
Giovanni Carafa, duca di Noja,
*Mappa topografica della città
di Napoli e de' suoi contorni,*
1775 (fig. 108), detail showing
the port of Naples after the
renovations of the 1740s.

FIGURE 86
Imacolatella, Naples.

representing the Virgin flanked by castles and
towers. Documents discovered in the Nea-
politan archives reveal that the sculptor of the
building's ornaments was Giuseppe Canart,
a Flemish-born restorer of antiquities who
would play an important role in the history of
the equestrian monument.[20] The presence of

the military at the mouth of the port was com-
mon, and it signaled the growing involvement
of the government in regulating trade.

After the enormous expense of repairing
the port, the Crown enacted laws to maintain
it. Dumping in the harbor was strictly forbid-
den, and the history of the Albergo dei Poveri
shows how vigorously the royal government
enforced this rule. Stone and dirt that washed
down from the Albergo work site alarmed the
royal government because it could silt up the
port. The king's ministers therefore rushed to
stop the practice. The government also insti-
tuted regulations to reinvigorate the nation's
merchant marine.[21] These measures included
more systematic licensing, requiring accurate
reports of goods and crew, and patrolling for
North African pirates. Though it is unclear
exactly how much these reforms contributed to
increased trade, by 1751 commerce was improv-
ing. Tonnage increased, shipbuilding grew, and
national vessels became a larger percentage of
those docking.

Perhaps urged by growing trade, the city
government considered erecting a statue near
the port, and consensus coalesced on a piazza
where the two bridges of the small mole met.
More than eighty palms wide, this space was
used as a turnabout for carriages and carts. Not-
withstanding its importance to traffic circula-
tion, city planners on 25 February 1757 decided
on this oval promontory as the site for the royal
monument. The Neapolitan archives contain a
drawing of a proposed equestrian monument
for this oval of land, and while the features of
the statue do not resemble those of the mon-
arch, it must date from this time.[22] This was
a fitting place to commemorate the king and
his commercial improvements.[23] The location
echoed the positioning of Henry IV's equestrian
monument on the Pont Neuf in Paris (1614),

an appropriate reference given that Henry was the first Bourbon king of France.[24] More-recent developments in Portugal probably had an equally determining effect. Lisbon's most important representational spaces fronted the Tagus River and had long been connected with the Portuguese capital's maritime empire. A royal palace, built for Manuel I in the early sixteenth century, linked the Lusitanian monarch with his new territories both literally and symbolically. Constructed to commemorate Vasco da Gama's return in 1499, the palace's ground floor was given over to arcaded depots for goods from Minas, India, and Guinea. In 1577 Philip II of Spain had Filippo Terzi mark the waterfront with a large Italianate tower, confirming the palace as the principal royal residence in Lisbon.[25] A large square, called the Terreiro do Paço, fronted the palace and was used for court festivals and commercial activity. In the eighteenth century John V expanded the palace, adding an opera house and a library and, parallel to the river, a porticoed wing that included a clock tower designed by Antonio Canevari.[26]

His improvements were short-lived. In 1755 a catastrophic earthquake struck Lisbon. The Neapolitan court showed particular concern, for Charles's sister, Marianne Victoria, was queen of Portugal. In addition, two of the king's architects had executed works in Lisbon. Luigi Vanvitelli helped design the chapel of St. John the Baptist (1742–50) in the church of St. Roch, and Antonio Canevari had been court architect there (1727–32). Many in Naples likely waited anxiously for news from Lisbon. The royal family survived, as did Vanvitelli's chapel. But Canevari's clock tower was destroyed along with all buildings surrounding the Terreiro do Paço.

Plans for rebuilding Lisbon were likely communicated along with notices of destruction.

Guided by the authoritarian minister Pombal, proposals for a new square on the river were articulated in rapid succession.[27] A new Praça do Commercio (first designs by Manuel da Maia in 1756) (fig. 87) was to be Lisbon's hub for trade, giving shape to economic and commercial reforms. A customs house, exchange building, and tribunal were planned for the square, along with shops and residences for merchants. Occupying its center, an equestrian statue of Joseph I (1750–77) would face the waterfront, renewing the symbolic link between the monarch and maritime trade. We can imagine the Neapolitan court taking cues from the Portuguese rebuilding, as many of the functional, architectural, and dynastic features of the Praça would have been echoed in Naples if the equestrian statue had been located near the port.

Despite the dynastic resonance, by the summer of 1757 some Neapolitan civic officials voiced misgivings over the location. Was there not a more appropriate place, with more space and better surroundings?[28] The Prince of Stigliano, one of the *eletti,* asked Luigi Vanvitelli for his frank assessment of the site. The architect dismissed the location by stating, "[The statue] is in danger of being ruined by the sea; [the space] is small and crooked, nor does it have any tolerable symmetry . . . and what is worse, the small piazza where the horse is to be situated is minimal; and [the figure of the king] will look like a little mule driver against the huge backdrop of air and sea, and if one makes a large horse, it will not fit in the small piazza."[29] Instead, he recommended the Largo dello Spirito Santo, a tract of space north of the city walls. To Vanvitelli the place was handsome and at the entrance of the most beautiful part of the city.

Indeed, the *largo* lay outside the walls at the head of the Via Toledo, the principal

FIGURE 87
Praça do Commercio, Lisbon.

FIGURE 88
Alessandro Baratta, *Fidelissimæ Urbis Neapolitanæ*, 1629, detail showing the Largo dello Spirito Santo. Engraving. Museo Nazionale di San Martino, Naples.

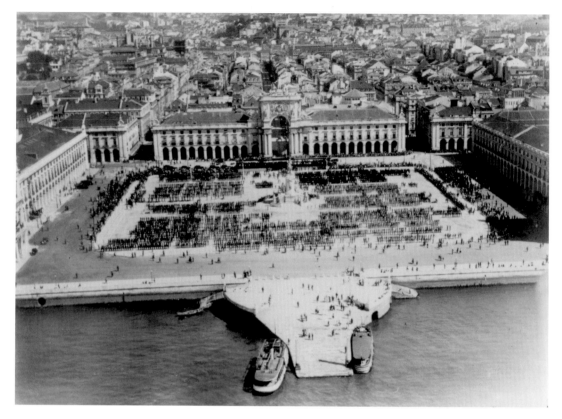

artery of Naples, which was lined with grand palaces and churches (fig. 88). The space took its name from the church of the Spirito Santo to its south and was sometimes known as the *mercato piccolo* or *mercatello* for markets that took place there. People entered the *largo* from the Via Toledo by passing the church and proceeding through the Porta Reale. Once in the *largo*, they met traffic that entered it from the east through the Port'Alba. The large rectangular piazza was enlivened by carriages, carts, and people bound for areas inside the walls or in the surrounding countryside. As Donatella Calabi has shown, marketplaces often emerged in such spaces, where urban life and rural production could easily intersect.[30] Indeed, Naples's granaries and civic oil cistern were set up in the *largo*, and farmers found an accommodating space to sell their goods without entering the narrow and crowded center of Naples. By the eighteenth century the city had expanded into areas surrounding the *largo*, yet like other marketplaces in European cities, the space maintained its older commercial purpose.

Even as the city encroached upon it, the *largo* remained a favorite space for the nobility to refine their *haute école* equestrian skills. Jan van Stinemolen's *View of Naples* from the 1580s shows three riding tracks on the site that are identical to ones illustrated in Federigo Grisone's treatise on horsemanship (fig. 89).[31] Although occupations in tranquil periods were courtly, during the Revolt of Masaniello rebels and government troops clashed over nearby granaries.[32] And as the city filled with corpses during the 1656 plague, many were carted to the *largo*. In fact, several paintings record its use as an improvised burial ground (fig. 90). These canvases, along with a votive statue of San Gaetano of Thiene placed above the Porta Reale after the plague, reminded Neapolitans of the *largo*'s gruesome past.[33] Perhaps for this reason the area remained untouched for the succeeding century.

A 1716 plan made by Giovan Battista Nauclerio provides the best record of the *largo* before Charles's reign (fig. 91).[34] The eastern edge was delimited by the city wall. This stretch of wall was marked at its northern end by the round tower of the Port'Alba and was free of abutting structures except for the tiny church of Sant'Eligio, adjacent to the gate. The palace of the Prince of Luperano flanked the Port'Alba to the north and was followed by a chain of granaries. Proceeding counterclockwise from the palace and granaries, one came to the church of San Paterno, forming its own quadrangular island. A wedge of structures intervened before the next large block, which contained the church and orphanage of the Piarists, the Casa di San Nicola, and Palazzo Bagnara. Across a side street was the large monastery of San Domenico Soriano, which was followed by a ramp leading up the hill of Montesanto. One then reached the Porta Reale, opposite which stood the riding school of "Alafano," properties belonging to Don Onofrio de Marino, and a theater noted as "the place where they put on the comedies." Finally, an independent block of structures

FIGURE 89
Jan van Stinemolen, *View of Naples*, 1582. Pen with black and brown ink on paper. The Albertina, Vienna, inv. 15444.

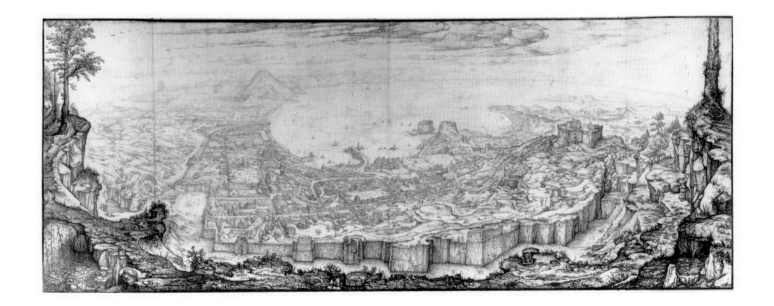

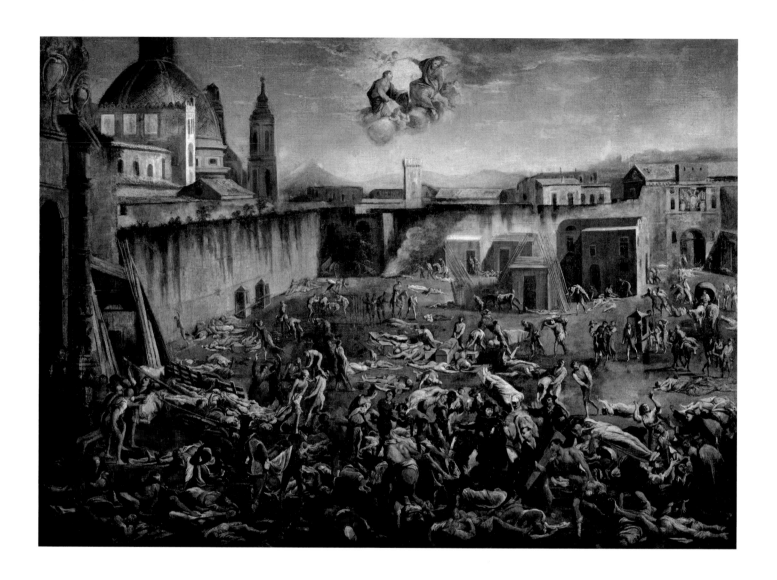

FIGURE 90
Domenico Gargiulo, called
Micco Spadaro, *Mercatello
During the Plague of 1656,*
ca. 1657. Oil on canvas. Museo
Nazionale di San Martino,
Naples.

near the Porta Reale contained houses owned
by Ferdinando Sanfelice and a certain Faralto,
as well as the church of Santa Maria della
Provvidenza, which was remodeled and
rechristened San Michele Arcangelo in 1729.[35]

The royal government's first intervention in
the piazza was to construct a market pavilion
at its center (fig. 92).[36] Ephemeral pavilions
were as common in Naples as they were in the
rest of the Spanish world; indeed, the most
famous of these was the Parián constructed
on Mexico City's Zócalo in 1702.[37] The first

market space erected by the monarchy in
Naples came in 1738, when an enclosure of
stalls was set up in front of the Royal Palace
of Naples to celebrate the marriage of Charles
and Maria Amalia (figs. 93, 94). Jointly com-
missioned by the city and the royal govern-
ment and designed by Ferdinando Sanfelice,
the pavilion contained over one hundred shops
arrayed around a central fountain. The booths
displayed rare goods procured within the king-
dom, throughout Europe, and from the eastern
Mediterranean. Figure 94 shows shops filled

FIGURE 91
Giovan Battista Nauclerio,
Largo dello Spirito Santo, 1716.
Black ink on paper. Archivio di
Stato, Naples, *sezione disegni,*
cartella xv, 14.

with luxurious plates, vases, and clocks. It also
includes an arched bay with portraits of the
king and queen, marking royal involvement
in trade and symbolizing the abundance and
prosperity that the royal couple brought to
Naples.[38] Given its success, the royal govern-
ment decided to make fairs an annual event.[39]

Some subsequent markets were more fes-
tive than functional. During carnival enclo-
sures had live animals, fountains that gurgled
wine, and temporary structures laden with
meats, cheese, and cakes. When the king gave
a signal, this re-created Cockaigne, or *cuccagna,*
was opened to an eager public.[40] Neapolitans
rushed to strip it of its edible ornament, often
ripping the live animals apart and injuring
or killing one another as they wrestled over
provisions. This ritual had been a part of civic
life in many southern Italian towns for cen-
turies. Though members of the court found

it repulsive, the royal government contin-
ued the practice, often commissioning very
elaborate architectural structures for these
cuccagne. In 1740, to celebrate the birth of the
infanta Maria Elisabetta, Sanfelice merged the
idea of the *cuccagna* and the market pavilion
(fig. 109).[41] His distinctive pagoda-like tower
(examined in the following chapter) did not
bear comestibles. Instead, food was parceled
into temporary shop stalls arranged within the
arches of the Palazzo Reale. With the royal
balcony above them, these shops merged the
image of small-scale commercial activity with
that of the monarch himself. This wedding of
the commercial and the royal influenced the
development of the Largo dello Spirito Santo.

The Spirito Santo pavilion of 1739 was out-
fitted for a fair rather than a *cuccagna* (fig. 92).
To see its wares, visitors entered the pavilion
through one of three openings. Goods were

FIGURE 92
Plan for a market pavilion in the
Largo dello Spirito Santo, 1739.
Black ink and blue-gray wash
on paper. Archivio di Stato,
Naples, *sezione disegni,* cartella
XV, 16.

FIGURE 93
Antonio Baldi, after Ferdinando
Sanfelice, plan of a market fair,
1739. Etching. Real Biblioteca,
Madrid, ARCH2/CART/5.

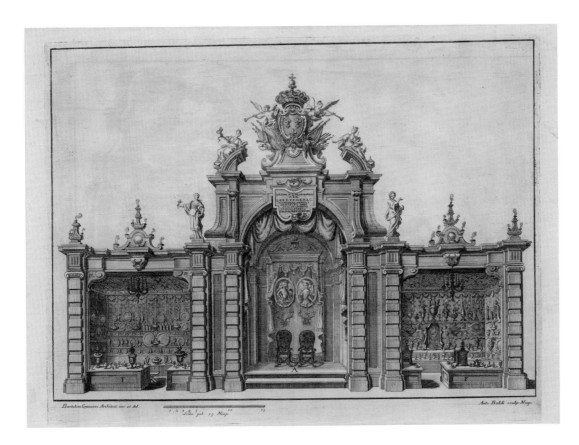

FIGURE 94
Antonio Baldi, after Ferdinando Sanfelice, elevation of a market fair, 1739. Engraving. Real Biblioteca, Madrid, ARCH2/CART/5.

displayed in shop stalls that lined the perimeter and in additional booths planned like ornamental parterres in the center of the space. The planning within the temporary pavilion had lasting consequences for the spatial organization of commerce. More than merely celebrate trade, the pavilion gave order to it. This systemization of urban commercial space was linked, as it often was in the Mediterranean, to a broad program of trade reform.[42] Thus control over the microcosms of trade fairs aligned with the Crown's increasing control over broad commercial policies and activities.

Not limited to maritime commerce or market pavilions, the royal government's cameral economics sought to improve the vitality of the entire kingdom. Spanish and Austrian economic policy had weakened southern Italy's

domestic economy. While the realm remained productive in agriculture, revenues from feudal lands in southern Italy often passed out of the kingdom as fiefs were granted to client nobility in northern and central Italy.[43] Customs revenues were sometimes used as collateral for Hapsburg dynastic goals.[44] And while the economy benefited from military protection and direct expenditures by the Crown, eighteenth-century reformers targeted the viceregency's extreme fiscalism and heavy taxation as a source of economic woe.[45] As Tanucci noted of the Austrian administration, "One knows that the income from Flanders was not enough to maintain troops in Bavaria, that Hungary even could not pay for those fortresses, that Austria and Bohemia could not maintain the court, and that those [fortresses] of Lombardy

were barely sufficient for the twelve thousand men stationed there. Their financial strength was Naples, where they extracted two million ducats annually, with which they enriched the capital of the empire."[46] To their credit the Austrians had tried to halt economic decline by reforming banks, yet more-sweeping changes were needed.[47] At the beginning of Charles's reign Montealegre instituted a Giunta del Commercio to diagnose the health of the Two Sicilies.[48] Renamed the Supreme Magistracy of Commerce, this council sought ways to stimulate agriculture and manufacturing while simultaneously identifying foreign markets.

Grain was the kingdom's largest export, and oil its richest. Some scholars in Naples, most notably Bartolomeo Intieri, argued that rather than compete with northern Europe in manufacturing, the Two Sicilies should instead bolster its strength in agricultural exports.[49] He proposed abolishing structural impediments, such as the cumbersome strata of local administration and taxes, and advocated improved transport. The royal government followed a similar blueprint. It pressured barons to increase production and improve the middlemen that monitored their stores. Meanwhile, infrastructure was vastly improved. Roads that had been in disrepair were repaved and extended.[50] Before the Bourbon government, only the roads around Naples and the thoroughfare linking it with Rome could be traveled by cart. The roads connecting the capital to Apulia, Calabria, and Abruzzo were impassable. Many tracts lacked bridges, and none had been systematically maintained. The council charged with road inspection, the Giunta di Strade, hastened to repair areas where their new king traveled. This included the long and difficult Strada delle Calabrie, improved for the royal trip to

Sicily in 1735. In addition, the "wheat road" that connected the Apulian breadbasket with the capital was repaired.[51] Beyond linking Naples to the kingdom's most agriculturally rich region, it also connected the capital to budding wool production in Foggia and enabled the establishment of silk manufacturing in Avellino.[52] The royal purse paid for large parts of the road-building campaigns, with communities served by the streets providing some subsidies. Yet the court was often unhappy with the results and reformed the Giunta di Strade to give royal military engineers more oversight. In part thanks to these efforts, transportation improved and grain production increased during Charles's reign.

Agricultural goods found export markets through the royal government's network of trade consuls.[53] In addition to traditional ties with Spain, France, the Netherlands, and Italian states, new pacts were signed with the Ottoman sultan, England, Sweden, and Denmark. These agreements allowed Neapolitan ships to weigh anchor for ports from Salonika to St. Petersburg.

Other reforms were concentrated in the capital. Beyond improving the port, Montealegre, Brancaccio, and Fogliani founded important factories for porcelain and tapestry production. Manufacture of crystal and mirrors was less successful, and they had to abandon their efforts to set up a drapers' industry when the French ambassador, keen to protect damask production in Lyon, protested.[54] In addition, the royal government began to regulate bank activity more carefully.[55] Crown agents were placed on bank boards to enforce transparent policy. Additionally, Jews were permitted by law to settle and conduct business in Naples until popular outcry led to repeal of the law.[56]

As trade grew and manufacturing took initial steps forward, the population of the capital began to increase.[57] Yet with insufficient housing, demand soared and rents threatened to follow. Montealegre avoided a crisis by prohibiting landlords from raising rents in 1742. Evictions also were forbidden unless the owner planned to occupy the premises. A 100-ducat fine was imposed on those caught violating the act, which the king renewed the following year.[58] With the housing crisis, the royal government witnessed the complexities of progress, and it would address the dual needs of commerce and housing in the *largo*.

THE EQUESTRIAN STATUE

In November the city followed Vanvitelli's suggestion of placing a statue of the king in the Largo dello Spirito Santo. Yet before they considered how to display it, they needed a sculptor. A competition, sponsored by the Eletti, was announced in 1757. The king would personally judge the entries, mirroring Louis XIV's involvement in French *places royales*.[59]

Charles was familiar with some of Europe's finest equestrian statues. Beyond those dedicated to Louis XIV, one of which the king saw in Montpellier on his way to Italy, he had also seen equestrian statues of Philip III and Philip IV in Madrid, the Medici in Florence, and his Farnese ancestors in Piacenza.[60] He also witnessed the unearthing of marble equestrian sculptures of Marcus Nonius Balbus *pater* and *filius* at Herculaneum in 1746.[61] In addition, Vincenzo and Giulio Foggini had in 1732 made a bronze statuette of Charles on horseback that Gian Gastone Medici presented to the infante (fig. 95).[62] From these many examples the king distilled a clear preference for classically restrained representations.

In the *concorso* of 1757 thirteen models were presented.[63] We know the names of most who participated. Five native sculptors—Giuseppe Sanmartino (1720–1793), Giuseppe di Trani, Gennaro Franzese, Francesco Pagano (d. 1764), and Francesco Celebrano (1729–1814)—submitted proposals. They were joined by the Genoese Francesco Queirolo (1704–1761), the Florentine Agostino Cornacchini (1686–after 1757), and a Flemish restorer living in Naples, Giuseppe Canart (1713–1791). Two models came from Valencian Ignacio Vergara (1715–1776).[64]

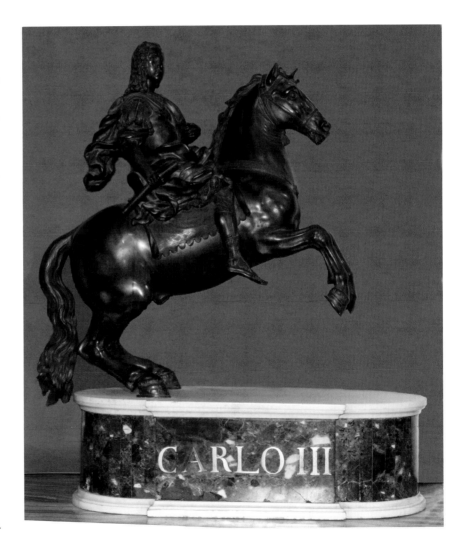

FIGURE 95
Vincenzo Foggini and Giulio Foggini, *Charles of Bourbon on Horseback,* 1732. Bronze and marble. Royal Palace, Caserta.

Another was sent from France, which Vanvitelli claimed to be from the hand of either Jacques-François-Joseph Saly (1717–1776) or Edme Bouchardon (1698–1762). The latter was probably the author, since Saly had already transferred to Copenhagen. In addition, Vanvitelli felt that Pietro Bracci (1700–1773) should submit a proposal, but it is unclear if this Roman participated.[65] Though none of the models survive, the artists' oeuvres allow us to make conjectures about what they presented.

Bouchardon was the most renowned. After an early career in Rome he had returned to Paris an accomplished portraitist. His skill as the "new Phidias" earned him the 1749 commission for the equestrian statue of the king for Place Louis XV (now Place de la Concorde).[66] For Naples he likely sent a classicizing model similar to the statue in Paris. Unfortunately the cost of a transalpine commission probably undermined serious consideration of his model.

Similar obstacles prevented serious consideration of Vergara's proposals. A member of Valencia's most renowned family of sculptors, Ignacio exerted enormous influence on art production in the city.[67] Devoting much of his time to teaching in the 1750s, his proposal demonstrated his rising status as an artistic authority in Spain. Judging from his extant works, one imagines an exuberantly baroque statue.

Cornacchini's renown rested on his equestrian monument of Charlemagne (1720–25) placed opposite Bernini's *Constantine* in the narthex of St. Peter's. Though backed by exuberant stucco and mosaic decoration, the figure of Charlemagne embodies classical restraint, and the sculptor's proposal for Naples probably followed in the same vein. Yet he was elderly in 1757, and after the court had to wait for his model to arrive, it regarded him as unfit for the commission.[68]

Queirolo had the advantage of living in Naples, where Prince Raimondo de Sangro had asked him to sculpt *Deception Unmasked* for his Sansevero family church of Santa Maria della Pietà. His equestrian statue would have been marked by similar virtuoso craftsmanship. The same could be said for Giuseppe Sanmartino, whose famed *Veiled Christ* kept company with Queirolo's *Deception* in the same chapel.[69]

Francesco Pagano had sculpted several works for the *guglia* of the Immaculate Conception and thus may have pondered royal representation previously.[70] Yet his skill did not rise above mediocrity. Francesco Celebrano had trained as a painter under Francesco Solimena, and though he would go on to have a successful career as a sculptor, he was yet untested.[71] Of Franzese and di Trani we know nothing.

Canart had come to Naples from Rome to restore ancient sculptures being unearthed at Herculaneum.[72] He excelled at extracting statues from excavation trenches without breaking them and was equally valued for his skill in detaching wall paintings and mosaics. He tended his relationship with the monarch with equal care, growing close to the king and naming his son Charles.

On the morning of 12 September 1757, the classicizing proposal of Canart won the commission.[73] According to Canart, the king commanded him to enter the competition with an earlier model for an equestrian statue that he had proposed, likely for the site in the port.[74] Royal backing helps explain how he overcame a lack of experience in crafting independent works. His restoration of the Balbi equestrian monuments is another explanation. One commentator noted that his model of Charles emulated the Balbi.[75] Of particular features, the horse received the most praise.[76] Like George

Stubbs, who drafted his scrupulous studies of equine anatomy after a trip to Rome (1754–56), Canart had developed a sharp eye for steeds while in Italy. He studied live specimens and consulted with master equestrians. He carefully read Jacques de Solleysel's *Le veritable parfait mareschal* (1672) and quoted passages from this treatise on horsemanship to explain his aesthetic decisions. He would even insist that his model be compared with actual horses by accomplished equestrians.[77] Perhaps because Canart's model had been made before the competition, his figure of the king was judged unsatisfactory. He was required to submit a second one, which was approved on 8 March of the following year.[78]

Though he improved the figure, controversy seems to have swirled around Canart's representation of the monarch in contemporary garb. Using equestrian statues of Louis XIV as evidence, critics felt that the heroic tone could only be invoked through the cuirass and buskins of ancient Rome. In a long letter Canart refuted their claim by stating that anachronism was more indecorous. Moreover, he asked why modern attire could not be embraced when the modern bridle could?[79] In his argument Canart cited Solleysel, who in the 1680 edition of *Le veritable parfait mareschal* had criticized Pierre Mignard's painting of *Louis XIV Before Maastricht* on the grounds that its representation of Louis XIV as a Roman emperor was historically irresponsible. Other Frenchmen concurred. As Marc-Antoine Laugier stated in 1753: "I do not know if the current way of dressing statues is the best and most fitting one. Why mislead posterity? Why disguise our heroes under a dress that was not customary in our times? If the Romans had had this bizarre idea we would be very annoyed with them."[80] Canart's experience at Herculaneum probably made him equally annoyed at the anachronistic practice. In fact, the sculptor appealed to the Accademia Ercolanese, the group of learned men charged with overseeing the excavations, to endorse his reasoning.[81] His petition to them is filled with impressive erudition, but it is also laden with hubris that would cause his downfall.

In July of 1758 Canart's self-assurance was in full evidence when he decided where the statue should be placed in the *largo*. Selecting a spot near San Domenico Soriano, the sculptor had a wooden box erected so that he could execute a full-scale model in situ. The Crown allowed the sculptor to select the site, but Vanvitelli blasted it, sniping that Canart, with the "air of an architect," had positioned it "facing the church of the Dominicans [San Domenico Soriano] as if the horse wanted to hear the Divine Offices."[82] The king disliked it as well and halted work. At this point the monarch dramatically changed the project. Not content with a mere monument, he desired a profound transformation of the *largo*. He ordered the city government to study the piazza and to ponder ways to use the entire space and create a monumental ensemble of sculpture and architecture.[83] The king's directives not only led to an entirely different project but also asserted royal control over affairs of the city government. Charles's usurpation of the civic authority and the royal government's direct intervention in urban space now became the project's hallmarks.

ADORNING THE PIAZZA

In August of 1758 two royal architects assessed the *largo:* Nicolò Tagliacozzi Canale and Mario Gioffredo. Canale knew the king's representational standards.[84] In 1734 he had designed the first *cuccagna* after Charles's arrival. And in 1735,

at the city's behest, he had designed an ephemeral theater in the Largo di Palazzo Reale to commemorate the Bourbon conquest of Sicily. Illustrated in the *Descrizione delle feste celebrate dalla fedelissima città di Napoli* (1735), Canale's piazza was marked at its center by fountains and towering monuments of military victory. Alternating archways and viewing boxes bordered it. Balconies were reserved for the *eletti,* and within each box a scene of royal conquest was depicted. This historical cycle culminated at the center, where a giant aedicula framed an image of the mounted monarch taking Messina. The entire structure was topped with emblems of the city, allegorical virtues, and trophies of victory. Through its careful blending of history and allegory in a space celebrating the monarch, the ephemeral theater minted the commemoration standards that would be used in the Largo dello Spirito Santo. Indeed, the author of the *Descrizione* saw Canale's decorations as a harbinger of future monuments. "Perhaps there will come a day—and we pray that it will not be far off—when festivities of greater length can be celebrated and monuments in bronze and marble can be erected to the greatness of such a prince."[85] It took twenty-four years for such hopes to be realized in the Largo dello Spirito Santo.

Canale's report, made with Gioffredo on 31 August, advocated an architectural frame.[86] To ennoble the piazza, they felt the city government should build a continuous structure masking the wall south of the Port'Alba. Costs could be offset, they claimed, if this structure contained shops and residences that the city could lease. This had also been Pombal's proposal in Lisbon.[87] Or, they posed, the city could sell individual plots and require the owners to erect structures of a uniform height and symmetry. This latter strategy had been used in the late sixteenth century to construct the Palazzata in Messina.[88] Both proposals were designed to wed any new building with innovations in commerce and trade. As Henry IV had done with the Place Royale of Paris, the Caroline court thought to make the new piazza into an experiment of economic renewal and urban transformation.[89] Shops and residences could provide highly visible space for urban merchants, perhaps encouraging local economic activity. Economic health and urban appearance would be unified, creating an image of a resurgent state under the custody of the king.

While the two architects were articulating their proposal, the city government instead planned a simpler option: to cover the wall with stucco.[90] This plaster decoration would form the backdrop for the statue, which they would enclose within an iron fence. Though they considered the suggestions of Canale and Gioffredo, they argued that a wing of shops and residences would impede upon the *largo,* which was one of the few large open spaces in the center of the city. Such constraint would displease the nobility, who still used it for riding, and deprive the city of a crucial refuge during earthquakes. They also noted that the nuns occupying a convent behind the proposed building would protest, since canon law prohibited erecting a secular structure bordering a cloister. Moreover, they pointed out, nobody knew who owned the *largo.* The monks of San Severino and the Banco dello Spirito Santo had battled over property rights years earlier without a clear resolution. Yet the city government's arguments probably masked the true motive for their opposition. Any structure would have been costly, and they had already proposed redirecting to the statue money usually spent on grain rations.[91] Despite their detailed objections, the Eletti's rhetoric did not

convince the king. He insisted on a complete transformation. From this moment forward the city government had little voice in the commission. Expected to finance it and oversee construction, they were forced to accept royal decisions.

An equestrian monument of a ruling monarch framed by uniform architecture was foreign to Italy. The statue of Charles facing the Palazzata in Messina was closest to the idea that Canale and Gioffredo advocated. There the palace backdrop predated the statue, but it still provided a unified frame for the image of the king. To grasp what Charles and the architects advocated, the city government had to look to France. Their attention was probably drawn to the heated competition for the Place Louis XV that engulfed Paris from 1748 to 1753.[92] Drawings had flooded the Bureau des Marchands, as architects proposed hemicycles, squares, circles, or octagons, shaped with scalloped edges or chamfered corners. Some cut into the old city, while others were sited on open areas. All followed the tradition of the Place Royale, which was a square centered on a statue of the king and bordered by uniformly designed buildings. These squares proliferated during the reign of Louis XIV, popping up in numerous French cities and towns. The Place Royale of Bordeaux (1733–55) was the most recent and relevant for Naples. Open on one side to the Garonne, this U-shaped space was intended to frame the statue of the king as well as facilitate commercial activity. Jacques Gabriel destroyed the old city walls to create this *place* that embraced the river and its trade.[93] Gioffredo and Canale's idea was analogous. It also would be built to improve commerce, would replace the old city walls, and would similarly be oriented to face a major urban artery. With prints of these squares

possibly in hand, the councilors could have begun to consider how their piazza would engage the French tradition.

The city also needed an architect familiar with abundant examples. In October of 1758 the Eletti called upon Luigi Vanvitelli.[94] Charles probably suggested Vanvitelli for the commission because the king and architect had discussed the piazza a month before Vanvitelli was engaged by city officials.[95] In fact, Vanvitelli began to think about the square long before he was asked to design it. He had actively followed the equestrian-statue project, designed its pedestal, and came up with his own proposal. He closely modeled his statue on the one of Marcus Aurelius in Rome and asked his brother to measure the dimensions of the pedestal, proportions of the horse, and the overall height from the head of the emperor to the ground. Vanvitelli also sent his brother to measure steps in five Roman palaces so that he could design a proper base— though it is unclear if he, as yet, had been given the commission for the base.[96] Atop the base he envisioned a horse walking with its right leg lifted. The sovereign, in the act of commanding, would wear a cuirass beneath a close-fitting jacket and the mantle of the Order of San Gennaro. By layering clothing Vanvitelli met demands for both ancient and contemporary attire, but the architect felt the saddle should be a modern one with two pistol holsters.[97]

While no drawings survive of his proposal, it probably looked much like other equestrian monuments he had designed. In 1747, with Salvi and Fuga, he had suggested embellishing the stair hall of the Royal Palace in Madrid with an equestrian monument.[98] And in 1756 he had published his *Dichiarazione dei disegni del Reale palazzo di Caserta,* which showed an

equestrian statue of Charles atop the palace's central pediment. Vanvitelli surrounded this statue with allegorical virtues, and with the royal balcony beneath it, the figuration of the sovereign on the pediment alluded to actual appearances by the king.[99]

In the first days of 1759 the architect, along with his sons and Francesco Collecini, measured the *largo*. He then met with the Eletti on 30 January. Their first priority was fixing the location of the statue, and on 3 February Vanvitelli reviewed possibilities with one of the city councilors. Three days later the architect began

to design, and he raced through several ideas before arriving at a solution.[100] Though a print by Camillo Napoleone Sasso made of an original drawing might represent one of Vanvitelli's initial proposals,[101] it possesses few qualities of the architect's work. Embellished with statues of virtues, military trophies, and fountains, the ensemble recalls festival apparatuses, such as Canale's one of 1735. But it seems to have little in common with Vanvitelli's final solution and is unlikely by the architect.

In contrast to the festive exuberance of Sasso's print, the city needed a piazza with

FIGURE 96
Luigi Vanvitelli, project for the Foro Carolino, 1759. Graphite and black ink on paper. Biblioteca della Società Napoletana di Storia Patria, Naples, 6.N.2.10.

rentable shops and houses. To characterize it as less festive, the Eletti had baptized the *largo* the Foro Carolino. It was a propitious time for forums. Excavators at Herculaneum had in 1746 extracted the sculptures of the Balbi from an area they called the "forum."[102] In Berlin Frederick II inaugurated his Forum Fredericianum in the 1740s, and during the same years Scipione Maffei helped plan a "forum" in Verona to be bounded by the Teatro Filarmonico and his lapidary museum. The commercial focus of the Caroline piazza made it more like Trajan's forum, where shops were arrayed in hemicycles, or the principal marketplace of Naples, the Mercato Grande, founded by the Angevins in the thirteenth century as a "forum."[103]

Vanvitelli planned such a commercial forum with shops and residences in an exedra. A working drawing by him now in the Biblioteca della Società Napoletana di Storia Patria (fig. 96) shows how the architect adapted and evolved his ultimate scheme.[104] Vanvitelli unified the wings and central niche by making them equal in height. Attentive to the urban context, he incorporated the Port'Alba by overlaying it with Tuscan pilasters. He then balanced this gate with a false one at the opposite end. Four-bay straight segments provided a transition between the hemicycle and the gates. He articulated these with pilasters, while he distinguished the hemicycle with engaged columns. He then blackened the page with sketching where these two parts converged (fig. 97). When he had decided on a solution, he shifted his hand and rendered three-quarter columns at the corner of the curved wings, which transition through doubled pilasters to the straight segments.

Like his Trevi Fountain (fig. 98), the Foro Carolino sits atop a large base and is dominated by an arch. Yet Vanvitelli's building is

FIGURE 97
Luigi Vanvitelli, project for the Foro Carolino, 1759 (fig. 96), detail of the hemicycle, showing flaps with the balustrade.

commercial rather than palatial. Shops would occupy the Foro's plinth, though Vanvitelli fails to indicate doors on the drawing. Above these shops he positioned three-storey residences, which are marked by square windows on the first floor and larger rectangular ones on the second. After an intervening Doric entablature, Vanvitelli placed an attic storey.[105]

The architect used simple ornamentations. Military trophies adorn the Port'Alba and the false gate and also top the central niche. Reliefs of trophies likewise decorate the space between the columns flanking the niche. Reducing ornament allowed Vanvitelli to emphasize the statue, which he elevated to the height of the entablature by adding steps to its base. Though the niche was intended to shelter the king's image, he extended the platform into the piazza. With greater focus on the equestrian monument and a clear response to fiscal needs, Vanvitelli would seem to have satisfied all parties.

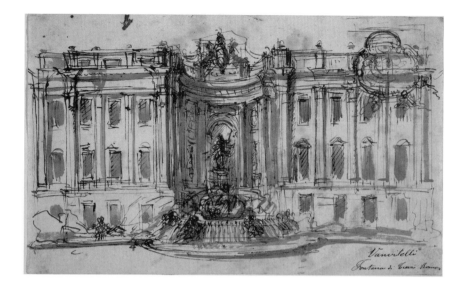

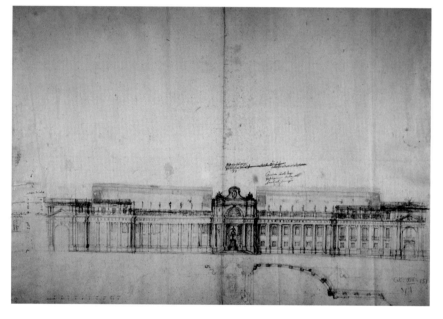

FIGURE 98
Luigi Vanvitelli, proposal for the Trevi Fountain, 1730–32. Pen and brown ink with gray wash on paper. William B. O'Neal Fund, National Gallery of Art, Washington, D.C.

FIGURE 99
Luigi Vanvitelli, project for the Foro Carolino, 1759 (fig. 96), showing flaps with the balustrade.

Yet as the city government had warned, the nuns of San Sebastiano, whose convent lay behind the Foro, were unhappy with a grand secular building bordering their property. Not only had the architect violated the long-standing prohibition of secular structures rising next to convents, but also the attic storey extended above the old city wall to provide a clear view into their cloister. Vanvitelli was

asked to eliminate it, and with two flaps he covered the offending storey.[106] On the flaps he drew a balustrade topped with statues (fig. 99). This change remade the hemicycle into a Neapolitan St. Peter's Square, with sculptures of royal virtues on the balustrade intended to amplify the square's representational resonance.

Vanvitelli introduced more changes in his final plan, which circulated in a print of 1761 (fig. 100). He pushed the structure farther into the *largo* to deepen the residences and to compensate for space lost with the elimination of the attic. He made the windows of the residences larger, and at the king's request he provided each with a balcony.[107] Since the wings adjoining the Port'Alba now extended beyond it, Vanvitelli de-emphasized the gateways by topping them with a narrow attic and pediment, a revision already visible on the right side of the preparatory drawing.

The curved arms had to be extended to meet the increased depth, but rather than change the number of bays or their dimensions, Vanvitelli added two pilasters, one near the niche and the other where the curved and straight segments met. He also added a column to make that transition less crowded. As the building was extended, the statue likewise was pushed forward. Vanvitelli also changed the entablature, replacing the Doric frieze with an unadorned Ionic one.

The print presents the shops as uniform, which suppresses any sense of property boundaries. Records instead reveal that while the city financed the majority of the Foro, part of it was built by landowner Francesco Cito, and the southern gateway belonged to the nuns of San Sebastiano.[108] Enticed by profits from leasing shops and apartments, Cito agreed to erect the portion of the hemicycle from the fifth bay south of the niche. He was required to follow

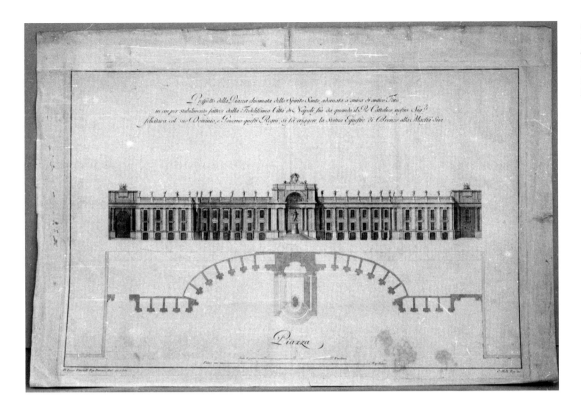

FIGURE 100
Carlo Nolli, plan and elevation
of the Foro Carolino, 1761.
Engraving. Museo Nazionale
di San Martino, Naples, *cartella
Ricciardi*, 15959.

Vanvitelli's design, to supply his shops with uniform wooden doors, and to rent to "vendors of nice things and tradesmen that [would] not prove embarrassing or create noise or any filth."[109] Future research will hopefully bring to light more about the people who worked and lived in these tidy shops and modest apartments. Given the context of Caroline commercial and housing reform, we can imagine the Foro inhabited by tradesmen.

CONSTRUCTION AND COMPLICATION

On 30 June Vanvitelli and his sons laid the stakes for the building, and three days later a palisade was constructed to shield the work site from the *largo*. By August work on the foundations had begun, though the city voted approval only on 7 September.[110] Together with Canale, who acted as collaborating supervisor, Vanvitelli set down requirements to master mason Gaetano Santoro.[111] He specified that the foundations plumb forty palms. He insisted on superior materials and ordered that each *piperno* block be washed in water, then covered with cement, before being locked into place. Aware that the foundations might cut into the city walls, Vanvitelli required a bracing layer of stone be inserted at all such incisions. Finally, the architect wanted bricks fired in Ischia to be used on the exterior, while those from Gaeta could be employed for the rest of the structure. A similarly scrupulous contract bound the *pipernieri* Francesco Ferraro and Giuseppe Stizza to carve the columns, cornice, and window and door frames.[112]

On 30 January 1760, after Charles left for Spain, Vanvitelli appeared before the city councilors, and again on 21 June. We do not

know what they discussed, but that summer the architect made a stucco model of the pedestal.[113] With the base in place by September, responsibility fell to Canart to execute a full-scale model. At this point the sculptor decided to embellish his original by adding four figures at the feet of the king's horse, probably representing conquered territories.[114] He then calculated the costs of an iron skeleton, a high-quality gesso model, and the bronze sculpture. Canart projected that the total cost would be 5,000 ducats. Concerned that the Eletti might resist paying such a large amount, he suggested that they compare his estimate with the costs of statues of Louis XIV or Saly's monument of Frederick V in Copenhagen.[115]

Instead, the city asked Francesco Queirolo for a counterestimate. The aged master concluded he could do the work for 1,500 ducats, and the enormous discrepancy placed the project in jeopardy.[116] Meanwhile, Vanvitelli negotiated in advance with Giuseppe Giardoni, the most qualified bronze founder in Rome.[117] The architect also followed the city's directive to engage Carlo Nolli to engrave his plan of the Foro, which was ready by 27 January 1761 (fig. 100). The print was needed "so that the king could see the effect of the generous donation of the city and, together with the entire world, be the envied spectator of that work."[118] A print could also obligate the city to see the project to completion.

With Vanvitelli proceeding, and the interested king inquiring from Madrid, the city government reengaged Canart in August of 1761. They demanded that he complete the model by November for 1,500 ducats. They stipulated that it be subject to their critical review and, if found unsatisfactory, required the sculptor to pay another artist to make a substitute. Canart refused, outraged by their right to judge his final product. How could they, "people not of the profession," criticize him when the king had already approved?[119] Having needled him into defiance, the city dismissed him.[120] The councilors likewise rejected Canart's model in favor of Queirolo's. Yet the Genoan died in late 1761, and a young Tommaso Solari was called to execute his model. In his letter of 9 December accepting the commission, Solari noted his several years of work at Caserta.[121] It is likely that Solari had Vanvitelli's backing, since the architect seems to have opposed Canart from the beginning of the project.

In July of 1762 the coffered conch of the niche neared completion. Looking at the Foro today, we can see how Vanvitelli used the niche optically to animate the structure (fig. 101). Rather than shape it as a perfect half circle, the architect extended the cornice to pinch the space. High and narrow, it extends slightly beyond the flanking wings and appears squeezed by them. The massing of columns on either side of the arch contributes to this effect. The compressed arch would have both sheltered the statue and seemingly thrust it into the square. The effect is not surprising given that Vanvitelli had criticized the lack of a sheltered visual context when the statue had been planned for the port location.

When this dramatic framing was completed, the city signed a contract with Solari.[122] It set his pay and stipulated that the iron braces for the model be sturdy enough to support its bronze replacement without struts. It also required that he inspect the wax impression before casting and that his work be subject to review, not by the city councilors, but by a jury of artists and architects. A wax model now in the Museum of the Legion of Honor in San Francisco was the sculptor's small-scale

bozzetto for the final sculpture (fig. 102). Likely dating to 1762, when Solari signed his contract, the model shows Charles wearing a cuirass, a sash, and the mantle of a heraldic order. The particular chivalric order is difficult to ascertain in the model. It could be the Golden Fleece or the Order of San Gennaro, collars of which adorn other royal portraits. In contrast to the dramatic sweeps of fabric that envelop him, the king's expression and gesture are restrained. Solari idealized the king's facial features, narrowing his eyes, shrinking his nose, and eliminating his ever-present grin. They give the king an air of classicizing detachment. His gaze is distant, and his head turns left, in the direction of the Porta Reale and Via Toledo. By directing the king's attention toward the heart of the city, Solari engages the sculpture with its urban context. Yet the king's torso is turned away. In his left hand he holds the horse's reigns, while his right grasps a baton topped with a lily. Lilies also adorn the saddle, the saddlecloth, and bridle. Like an ancient emperor, the king does not use stirrups, and he wears Roman buskins. His horse also conveys classical restraint. Other than its head and neck, its muscles are relaxed, and it seems statically posed rather than dramatically moving. Like most equestrian monuments, Solari's embodies the majesty of the king—set upon a high pedestal, the classicizing portrait would command the space of the Foro with an expression of distant authority.

After Solari's model had been translated to full scale in April of 1765, a committee of artists reviewed it.[123] They suggested that the horse's head be moved back, that its muscles be relaxed, its legs less bent, and its tail and mane handled more finely. They also recommended that a more recent portrait of the king be procured, that his right arm be shifted farther

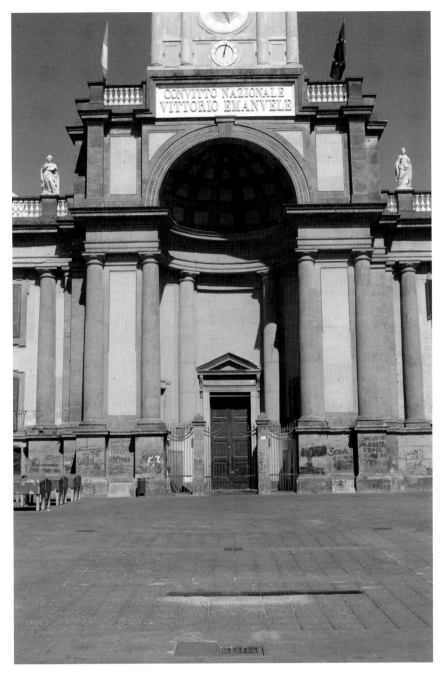

FIGURE 101
Central niche of the Foro Carolino.

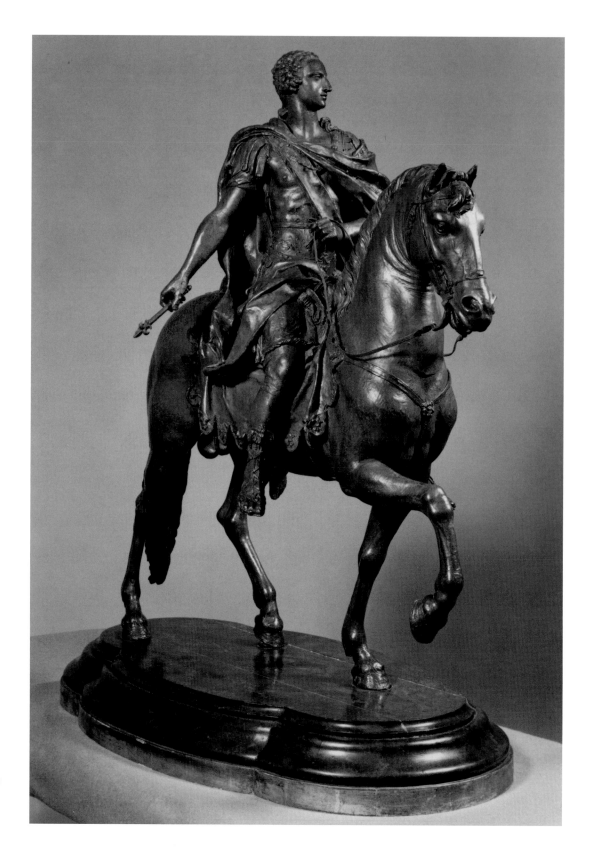

FIGURE 102
Tommaso Solari, *Charles III on Horseback,* 1762. Wax on metal-armature base. Fine Arts Museums of San Francisco, Mildred Anna Williams Collection, 1978.8.

back, his knees and legs moved forward, and the left hand positioned nearer his chest. They felt these changes should be implemented first on the small model and then translated to the larger one. Once the changes were made, the committee declared that the wooden box surrounding the sculpture be dismantled. The model was then painted green to resemble bronze until the city could cast it, which never occurred.[124]

Solari also would carve the royal crest surmounting the building, for which Vanvitelli loaned him Juvarra's *Raccolta di targhe* (1711).[125] Though it is represented too small in the 1761 print to find exact correspondence with any plate in Juvarra's book, it appears similar to Barberini crests that adorn the crossing of St. Peter's. Along with the crest, Solari sculpted the festoons supporting it, as well as the marble lions that would guard the base of the statue. The escutcheon was joined on the roofline by twenty-six statues of allegorical virtues. Antonio del Medico, a sculptor-cum-mason who had rented his nearby warehouses to construction crews, offered to pay for two statues in 1763 and sell the others at the price of 190 ducats each. Since he owned quarries at Carrara and advertised his offer in a pamphlet, the city ordered twelve. These, executed by anonymous craftsmen, top the left side of the building. The work was poor, and Vanvitelli disliked del Medico's manner of forcing his way into projects.[126] The architect likely communicated how each statue should be represented, as he had at Caserta. There, for example, Vanvitelli dictated that Magnificence be represented as "a matron with a noble air and have a crowned head. With her right hand she will be pouring out riches from a cornucopia, and she will hold in her left hand a plan of this royal palace."[127] A sheet from Caserta

shows the architect sketching multiple small-scale statues of allegorical figures that, while not identifiable as any particular ones for the Foro, may be related to them.[128]

Displeased by the work produced in Carrara, the city government asked local sculptors to carve the remaining fourteen for the same price. Two of these sculptors, Giuseppe Sanmartino and Francesco Pagano, had competed for the equestrian monument. They were joined by two less-renowned practitioners, Paolo Persico and Gaetano Salomone. Salomone was paid for only one statue, and Pagano's death, in 1764, limited his contribution.[129] Three were sculpted by Sanmartino and have been identified on stylistic grounds (e.g., fig. 103).[130] The remaining sculptures were crafted by Persico, and they constitute the bulk of his oeuvre.[131] Though Valor, Philosophy, Nobility, Constance, Abundance, Military Architecture, Peace, Study, and the "Belle Arti Liberali"[132] are named in documents, not all can be securely identified. Neither guidebooks nor civic records name them, leading one to conclude that their personifications were less important than their cumulative effect. This assumption is confirmed by the fact that they cannot easily be discerned from the ground.

While the allegorical message of these figures was vague, the benefits of Caroline rule were made explicit through inscriptions facing each side of the monument's pedestal. These texts recounted the king's military victories, his new law code, and commercial improvements. They likewise lauded him for cultural accomplishments, noting buildings at Caserta and Naples, and the excavation of Herculaneum. Finally, the inscriptions enumerated the works Charles had undertaken for the city's benefit.[133]

For those crowded in neighborhoods south and east of the Foro, its most important

contribution was not the statue but the ordered open space of the piazza. Indeed, Vanvitelli's curved front seems to respond to the pressure of people spilling into it from adjacent districts. And though it helped satiate the city's thirst for more housing, the Foro's curving façade, lower roofline, and use of engaged columns differed from all previous domestic architecture in Naples. Its vocabulary was Roman, and this uniqueness heightened the contrast with the densely developed city. Vanvitelli's compression of the flanking portals indeed makes the arms appear to open more dramatically within the city (fig. 104). He cast the gates in shadow and broke the upper pediment of the south gate as if it were being squeezed shut by the force of the expanding piazza. Vanvitelli used this tense

articulation to endow the Foro with a sense of dynamism, as if it had forcibly to assert its place in the city. By de-emphasizing the portal, the architect also shifted the center of the *largo*. Before the construction of the hemicycle, the portal was the monumental focus of the space, but by casting it in shadow, Vanvitelli redirected emphasis toward the statue and niche. His design allowed the equestrian statue visually to claim the space for the monarchy. Indeed, the architectural vocabulary of the Foro helped the monarchy to assert its place within the Neapolitan urban context. Thus, like the king who arrived from without to establish a new dynasty, Vanvitelli's structure is stylistically foreign and marks a new type of urban space in Naples, one visibly dominated by the Crown.

FIGURE 103
Giuseppe Sanmartino, allegorical virtue, 1764. Marble.

FIGURE 104
Port'Alba, at the side of the Foro Carolino.

IN THE SHADOW OF THE FORO

Despite the Foro's architectural success, the city was slow to pay Solari and Vanvitelli. Poor financiers, they had tapped the budget for grain rations to fund the project. The Crown bore much of the responsibility for pushing the Eletti to take this risky step, and the gamble had disastrous consequences. Before the final statues were set in place, famine struck. The city's grain stores near the Foro Carolino were emptied, and riots broke out over bread. Charles stemmed the crisis by sending Spanish grain to his former subjects. But the famine irreparably damaged the reputation of the tribunal. Having failed in their principal responsibility, their power was swiftly redistributed. The city government began its final decline and was abolished in 1800 to be replaced by a less powerful and more bureaucratic civic government.[134]

The Foro Carolino proved an architectural instrument for asserting royal control over the capital (fig. 105). The king limited the city government's voice from the start and architecturally asserted the monarchy's place in the heart of Naples.[135] The nobles accustomed to riding in its expanse now did so beneath the equestrian statue of the king. Temporary markets were now made into permanent shops controlled by architecture and edicts. A rambling space outside of the city gates was given a royal focus and imbued with political significance. This assertion of royal prerogative in civic government, commerce, and urban development lies at the heart of the Foro. Yet royal policy was not always as effective or far-reaching as it seemed. Many Caroline commercial reforms faltered in the famine of 1764. Visual claims of successful royal policy papered over these shortcomings, and the Foro Carolino was the embodiment of such propaganda.

As a magnet of urban development the Foro had immediate effects. A strong ally of the king, Marcantonio Doria, Prince of Angri, had his nearby palace designed in clear imitation of it. The trapezoidal site of the palace,

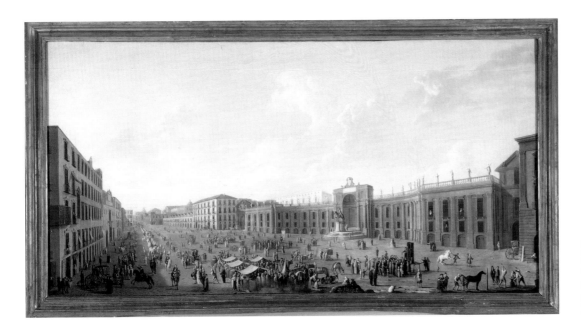

FIGURE 105
Pietro Fabris, *View of the Foro Carolino,* second half of the eighteenth century. Oil on canvas. Patrimonio Nacional, Madrid, 10022318.

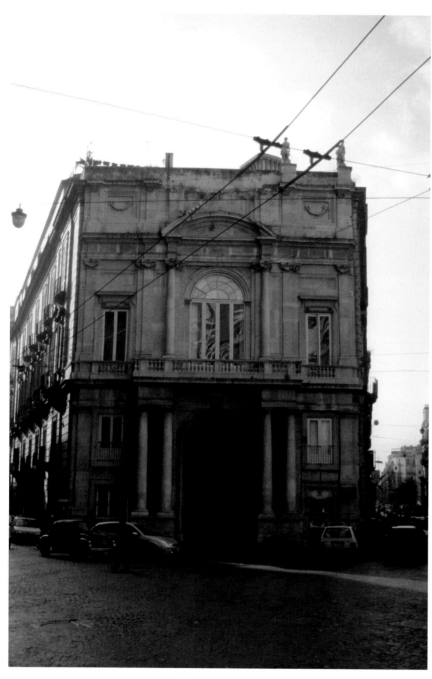

FIGURE 106
Palazzo Doria D'Angri, Naples.

immediately south of the Porta Reale, fronted three important thoroughfares: the Via Toledo to the west, the Via di Monteoliveto to the east, and the Via di San Biagio to the south. The most important of these was the narrow Via di San Biagio. Slicing through the heart of Naples, it was lined with noble palaces, the grandest of which was the seventeenth-century Palazzo Maddaloni, across the street from the Prince of Angri's parcel. In 1755 the prince followed tradition by planning a palace facing Via di San Biagio. But after the erection of the Foro Carolino, the prince had the principal façade reoriented to the north. Though the northern edge of the site offered the least street frontage, it greeted those who arrived past the Foro through the Porta Reale. After establishing an urbanistic link, the prince made an architectural connection by engaging Carlo Vanvitelli to design it (fig. 106). Helped by his father, Carlo copied details from the Foro such as the window frames on the second floor and statues lining the roof.[136] When the Palazzo D'Angri was completed, in the 1780s, the visual parallel between it and the Foro Carolino made the prince's alliance with the monarch clear.

The assertion of royal power in the Foro eventually extended to other urban spaces in Naples. In 1781 Francesco Sicuro reordered the Mercato Grande by lining it with a perimeter of shop stalls and creating a similarly controlled space for commerce. Even after revolutionary mobs destroyed the equestrian monument in 1799, the Foro Carolino's representational significance remained intact. Joachim Murat (r. 1808–15) projected a similar half-round design in his Foro San Gioacchino facing the Palazzo Reale. After the expulsion of Murat, this square would become Bourbon, and Charles's son would rename

FIGURE 107
Foro Ferdinandeo (now Piazza del Plebiscito).

it the Foro Ferdinandeo (now Piazza del Plebiscito) in 1815. Dominated by the votive church of St. Francis of Paola, the curved wings designed by Leopoldo Laperuta likewise contained shops (fig. 107). Most importantly, Ferdinand IV had Antonio Canova sculpt a model for an equestrian statue of Charles to accompany his own.[137] This grandiose urban theater of royal power was one bookend to the Via Toledo. The other was the Foro Carolino. Together the royal hemicycles constituted urban poles that claimed Naples for the dynasty.

All vestiges of Bourbon rule were eliminated in the Foro Carolino during the nineteenth century. A clock tower was added to the niche, which became the entrance to a school that was opened within the former convent of San Sebastiano. After unification, a statue of Dante was placed on the square, which was renamed in his honor.[138] Sculpted in a studio located in the Albergo dei Poveri, it was set in place in 1871 to celebrate Naples's acceptance of a common Italian identity. The inscription— "The unity of Italy represented in the monument to Dante"—renewed the political message of the square but bound Naples's identity to a unified Italy rather than a sovereign. Thus it is not the name or image of the king that survives, but the order he gave to commerce and a monumental political space in the heart of Naples.

The Duke of Noja Map

Naples had never witnessed a building program as vast and far-reaching as that from 1734 to 1759. No subsequent king of the Two Sicilies would rival it, and few monarchs in Europe oversaw a program that could equal or surpass it. Built for the populace, the buildings also addressed an audience of ambassadors and travelers. In Naples they saw a city revived by a confident and secure monarchy. But for those that did not visit the capital or read diplomatic dispatches, the new *imago urbis* was inaccessible.

To advertise the city in all corners of Europe, the monarchy had to publish it. In collaboration with the city government, it chose to do so with a map (fig. 108). The map, matching the scale and ambition of the building program, would be among the largest and most splendid of the entire century. It did more than merely represent. As J. B. Harley has urged, we must read between the lines of maps to fully grasp their meanings.[1] Silences and amplifications in cartography reflect broader issues of power, legitimacy, and control. Therefore, I argue in this chapter that the map was part of a program of royal propaganda, heralding the monarchy's contributions to Naples.

First, it is important to consider the context of print and ephemera in which the map was produced. The first chapter of this book considered the ways the stage was used to reflect

values of sovereignty. Its spectacles reinforced the king's beneficial role and citizens' proper duty to the monarchy. Similar political messages were encoded in the elaborate temporary architecture of the *cuccagna*. As noted in the last chapter, these lavish ephemeral sets were covered with meats and cheeses and embellished with fountains of wine. At the monarch's signal the populace was given free reign to strip the architectural idyll of its riches. These displays of natural bounty and royal largesse were deployed for select occasions, usually to commemorate an event of dynastic importance. Thus the *cuccagna* was strongly identified with the Crown, and prints made of the one in 1740 help reveal how its ephemeral architecture played a role in Bourbon propaganda.[2] To celebrate the birth of the infanta Maria Elisabetta, Ferdinando Sanfelice designed a magnificent ephemeral set composed of three parts. Temporary market stalls, with viewing balconies positioned above them, were set up within the arches of the Palazzo Reale (fig. 109). An exedra of similar shops and balconies faced the palace and were connected to it through two triumphal arches. However, the most impressive feature was the tower at the center. Called a "pyramid" by contemporaries, the tower encased geometrically complex stairs that allowed visitors to ascend higher than any building in the city.

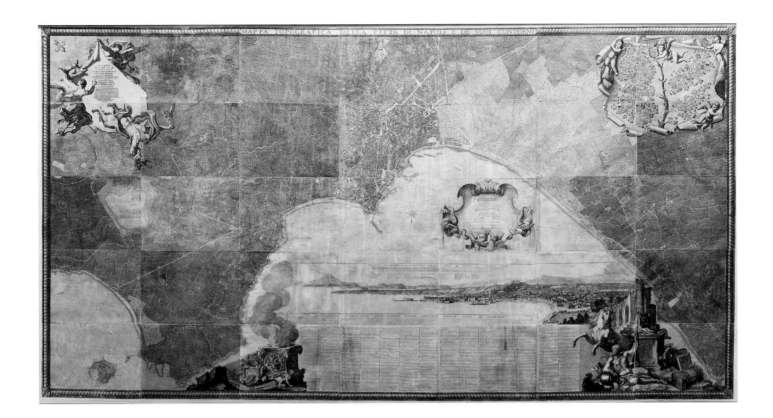

The pinnacle was crowned by a giant Bourbon lily, which sprouted smaller fleur-de-lis in a sign of royal progeny. Paintings adorning the base of the monument tower celebrated the infanta's birth and depicted mythological figures associated with Naples: the Sebeto River, nymphs, and sirens. These images drew upon an allegorical formula that would also be used in printed works, including the map. A printed report accompanied the engravings, which, in addition to describing the structure, recounted the festivities, including an evening performance of four hundred musicians positioned along the external stairs and balconies of the pyramid. The marvel of the spectacle, the iconography of Bourbon prosperity, and the inclusion of Neapolitan myths and symbols were the three principal components of all ephemera during the king's reign.

Several *cuccagne* were celebrated in print, and two books were devoted to the celebration of royal festivities in 1735 and 1749.[3] Like similar volumes that marked ascensions, births, and marriages, they proclaimed the dynasty and were distributed to other courts as politically pregnant gifts.[4] The king recognized the power of print. He was an amateur engraver, had opinions on intaglio technique, founded a school of engraving near Naples, and set up a royal printing press.[5] Creating the royal press required enormous effort by many members of the court. Royal ministers procured movable type from Venice and Holland and commissioned typefounders to cast Hebrew and Greek letters. Luigi Vanvitelli helped procure paper, and the king personally visited the royal printing house to supervise activities. The Neapolitan court therefore knew that copper

FIGURE 108
Giovanni Carafa, duke of Noja,
*Mappa topografica della città di
Napoli e de' suoi contorni,* 1775.
Engraving. Museo Nazionale di
San Martino, Naples.

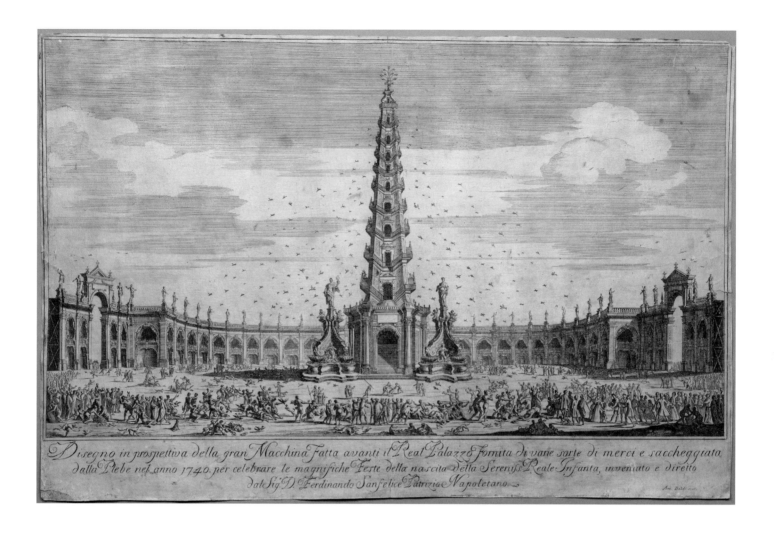

Disegno in prospettiva della gran Macchina Fatta avanti il Real Palazzo Fornita di varie sorte di merci e saccheggiata dalla Plebe nel anno 1740 per celebrare le magnifiche Feste della nascita della Sereniss Reale Infanta, inventato e diretto dal Sig D. Ferdinando Sanfelice Patrizio Napoletano

Am. Baldi sculp.

FIGURE 109
Ferdinando Sanfelice and Carlo Baldi, *Disegno in prospettiva della gran Macchina Fatta avanti il Real Palazzo Fornita di varie sorte di merci e saccheggiata dalla Plebe nel anno 1740 per celebrare le magnifiche Feste della nascita della Sereniss.ma Reale Infanta, inventato e diretto dal Sig.r D. Ferdinando Sanfelice Patrizio Napoletano*, 1740. Engraving. Biblioteca della Società Napoletana di Storia Patria, Naples.

plates held important communicative potential. Inked and pulled, they could burnish the image of the realm, proclaiming the generosity of the sovereign and the devotion of the populace. Individual sheets of the Foro Carolino, a magnificent book on the Royal Palace at Caserta, and multiple volumes on the finds at Herculaneum would all be produced in the royal press. Together they constituted a Bourbon corpus that promoted cultural advancements, architectural achievements, and royal magnificence.

The court also promoted its importance in Rome through prints. The Kingdom of Naples, as a fiefdom of the papacy, symbolically renewed its vassalage each year on 28 June. The monarch sent a white horse bearing a silver vessel filled with coins to the Vatican, and the name of the event, *chinea*, derived from the description of this ambling horse. Though it marked the consignment of feudal dues to the papacy, under Philip II the *chinea* became an important expression of Spanish power and influence.[6] The celebration grew in importance and pomp and, by the eighteenth century, had become one of the most important festivals in Rome.[7] Two elaborate ephemeral sets accompanied fireworks displays in Piazza Santi

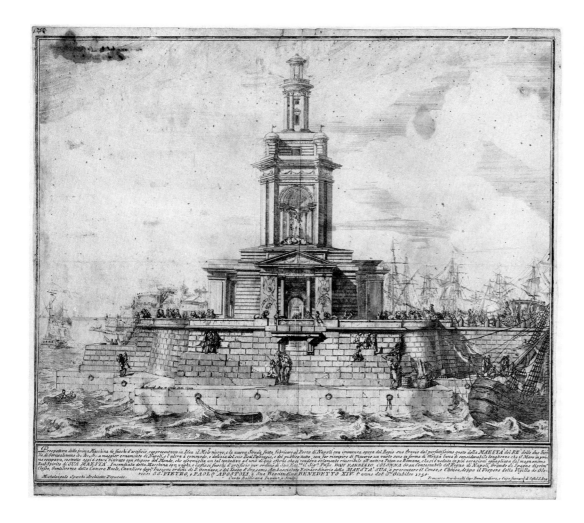

FIGURE 110
Michelangelo Specchi and
Jérome-Charles Bellicard, *Prima
macchina della chinea, il molo
nuovo di Napoli,* 1750. Etching.
Istituto Nazionale per la
Grafica, Rome, FN 10845 (168).

Apostoli, or in some cases Piazza Farnese, where the Colonna princes, as grand constables of the kingdom and extraordinary ambassadors in Rome, oversaw the event. In the eighteenth century prints were issued to commemorate these sets. And these prints became important mouthpieces for the monarchy and tools of royal propaganda.

Looking at the sets represented in the prints, one notes only allusive praise for the monarchy. Mythological allegories and idealized architecture obliquely referenced domestic reforms, architectural improvements, or dynastic events. Yet the texts in the captions helped make such references more explicit. The earliest to note Caroline reforms was a print of a *chinea* set in 1740. The set depicted a free port, and the print's inscription applauded royal maritime improvements. In 1750 another set represented the new port of Naples (fig. 110). In 1752 two sets marked the foundation of the Royal Palace of Caserta. Others trumpeted the rediscoveries in Herculaneum (1749) or the reform of the University of Naples (1751). Barracks were celebrated in *chinea* sets of royal military quarters (1753) and fortresses (1757, 1759). And triumphal arches, bridges, and backdrops celebrated the monarchy throughout

Charles's reign (1746, 1751, 1755, 1756). Printed on paper, and even silk, images of the *chinea* were widely distributed, and their messages of dynamic and beneficial rule in Naples were broadcast throughout Europe. It is within the context of printed propaganda that the map of Naples unfolded.

The court had shown an early interest in cartography. In 1742 the royal government gave the Farnese fragments of the ancient marble map of Rome, the *Forma Urbis Romae,* to the pope as part of a diplomatic agreement.[8] Those fragments would be arranged with others in the Capitoline Museum by Giambattista Nolli, an architect, surveyor, and engraver from Como. Nolli subsequently crafted the *Nuova topografia di Roma* (1748), the most important ichnographic map of the eighteenth century. And Secretary Fogliani would be one of the first recipients of Nolli's map.[9]

Nolli's early career helps illuminate the many meanings of maps in eighteenth-century Italy. He was first employed as a "geometer" in the cadastral mapping of Lombardy.[10] This project was initiated by the imperial government as part of a broader land-reform effort. The cadastral map aimed to ascertain land use in order to increase revenue from the Milanese territory.[11] A large number of surveyors and cartographers were dispatched to create exhaustive and exact renderings of the territory. Their maps were planimetric, or ichnographic, but also documented land use and used aerial perspectives to show topography.[12] One of the most scientifically ambitious and exact cartography efforts of the era, the mapping of Lombardy helped Vienna exert greater control over its transalpine territory.

The cadastral map was largely administrative in nature and limited in audience, but Nolli took its lessons in scientific exactitude to Rome to create his map. By carefully measuring structures and mapping them to scale on the page, Nolli produced an ichnographic plan with churches, palaces, courtyards, piazzas, and cloisters rendered with unprecedented precision. Like the cadastral maps, the Nolli one served multiple functions. It documented districts (*rioni*) of the city, thus serving an administrative purpose. It also heralded ancient and modern Rome in its borders, where representations of both types of structures are shown. Finally, its inscriptions celebrated the papacy itself, and in this way it fulfilled a political role.

Looking at Nolli's map, the court must have realized that existing ones of Naples were inadequate. Cartographers had immortalized the city in numerous bird's-eye views and a few tentative chorographic maps.[13] Among the most widely circulated was Dupérac and Lafréry's single-sheet plan printed in 1566 and reissued many times. But the most important was Alessandro Baratta's multiplate view, first printed in 1627 and revised and reissued in 1629, 1670, and 1679 (fig. 111).[14] A perspective plan, it lacked the scientific exactitude of Nolli's, but it did present important representational precedents. First, at almost a meter high and two and a half meters long, it was monumental. Given the overall size and the level of detail rendered on each sheet, one can imagine that it was meant to hang on a wall and be viewed like a painting, with viewers delighting in both its overall impact and its smallest features. Second, the map seems to have been an official, rather than a commercial, publication. Dedicated to Viceroy Antonio Álvarez de Toledo, Duke of Alba (1622–29), it depicts his coat of arms in the upper right. In addition, the legend of the first edition was written in Spanish rather than Italian. But as the large title in the border declares—"FIDELISSIMÆ

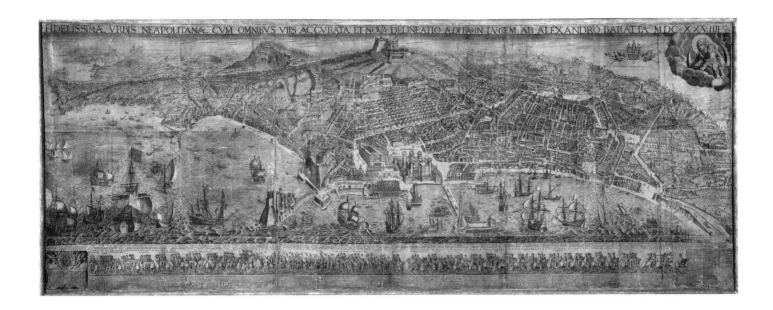

VRBIS NEAPOLITANÆ"—the map celebrates civic fidelity alongside viceregal authority. This theme of civic loyalty carries over into the lower border. There, a cavalcade of civic officials, including the *eletti,* proceeds the entire length of the map. The text identifies the procession as the ceremonial one that traditionally accompanied the arrival of a new viceroy. Thus the image of the city is bound up with a message of political harmony. This theme recurred throughout the century. In at least two large prints of Neapolitan processions, a cavalcade of local authorities is shown against a view of the city.[15] More importantly, the role accorded civic authorities in maps and city views would carry forward into the eighteenth century.

Ultimately the city government of Naples would sponsor the new map, but the cause found its true champion in the charismatic and learned Neapolitan nobleman Giovanni Carafa, Duke of Noja (1715–1768). The Duke of Noja, like the Prince of Sansevero, was one of Naples's eminent aristocratic polymaths, and his military service to the Crown, like

that of Vauban and Erik Dahlbergh, deepened his knowledge of science, math, engineering, war, and cartography. Gifted with enormous personal initiative, he charted a unique career path on his way to producing the new map of Naples.

Much like Christopher Wren, the duke had started his career as a professor of mathematics and was granted a supernumerary chair at the University of Naples. But he was a nobleman, making his appointment atypical for the time. When the War of Austrian Succession broke out, the duke left the professorate for the battlefield, where he fielded and commanded a proprietary regiment of Apulian soldiers. It seems his military service, spent charting troop movements and surveying battlefield topography, left the duke with a deep interest in cartography.[16]

Math, war, and cartography were allied arts. As Montemar's Italian campaign revealed, maps were essential tools for any general. Building fortresses, planning sieges, and moving troops depended upon accurate

FIGURE 111
Alessandro Baratta, *Fidelissimæ Urbis Neapolitanæ,* 1629. Engraving. Museo Nazionale di San Martino, Naples.

representations of territory, cities, and defenses. Thus geography was considered fundamental training for any prince or commander, and military academies taught mathematics and cartography. In Spain, Philip V explicitly charged military engineers with cartography as one of their duties.[17] And some of the most remarkable architects of the period had careers that encompassed military service, geometry, and mapping. François Blondel (1618–1686) best embodies the soldier as mathematician and architect.[18] His architectural career began with a series of fortress plans, which he carefully mapped within their territorial context. Later designs for cities and fortifications were direct results of his early engagement in warfare, and expertise in military architecture helped him rise to become head of the Académie d'Architecture.

Conversely, military culture permeated cartography.[19] Siege views and maps stressed military objectives and conveyed the sort of territorial control that military commanders sought. As kings of the largest and most geographically dispersed realms, Philip II and Philip IV understood the martial dimension of maps and used cartography to help consolidate power over their realms.[20] For example, Philip II combined his fortification projects in the Netherlands with cartography by commissioning Jacob van Deventer to document the newly fortified cities. He also had Anton van den Wyngaerde draw numerous views of the cities in his realms.[21] These maps and views graphically embodied his physical hold on his empire. Similarly, Philip IV's atlas of Spain by Pedro Teixeira contributed to the image of his universal power.[22] Thus atlases and maps were not merely tools for reference. They were geographic manifestos of territorial power.[23] As the Baratta map demonstrates, Naples had

long been mapped, both physically and within the metaphorical atlas of Spanish power.

The Duke of Noja's first cartographic projects were related to engineering. He was charged with mapping a civic aqueduct, the Acqua Carmignano.[24] Marking blockages and breaches, the project must have awakened him to the vast benefit an accurate map of infrastructure could have for urban planning. Architects, ministers, and planners could chart improvements comprehensively. While he was making his study of the Carmignano, the duke was also creating a series of wooden models of the kingdom's fortresses for display at Capodimonte.[25] The models followed the example of Vauban, who had made a similar set for Louis XIV. Yet rather than herald recently captured citadels as Vauban's had, the Duke of Noja's models recorded fortresses that had long been a part of the kingdom's defenses. In this respect his models shored up the kingdom's military and geographic identity instead of celebrating military triumph.

The duke's next move in cartography was surprising, even considering these experiences mapping aqueducts and making models. In 1750 he took the unprecedented step of publishing a letter calling for an ichnographic plan of Naples.[26] In the letter the duke underlined the inadequacy of existing maps, dismissing those available by stating that one had a better idea of a city in Japan or Tartary than Naples. He highlighted the benefits a new one could have for civic pride, claiming that Naples was unique in possessing both natural beauty and a rich ancient history. Naples needed a map to celebrate these inherent qualities, but the duke was quick to note that the map also could "illustrate the sumptuous public works of our glorious monarch"[27] and record a city that was a fourth larger than it was at the opening of the

century. The duke asserted that descriptions, no matter how precise, were useless if one could not see a place, and he blasted potential critics by stating that abandoning cartography was a sign of barbarism. He also stressed a map's practical virtues. The city was suffering under the weight of its size. It needed to expand quickly and with sufficient urban infrastructure. The duke posited that the planning of public buildings, aqueducts, sewers, and street illumination could all benefit from a map. Growth could be guided, buildings sited, and costs calculated. Thus the motives of public utility and civic glory were united in the duke's idea.

On 29 April 1750 the civic tribunal of San Lorenzo agreed to finance the cost of measuring and printing a map.[28] The city government stressed the map's importance for a foreign audience and the fact that many other cities already had ichnographic maps. Though the city financed it, the Crown would take an active role in the map's creation, as it had with the Foro Carolino. The king would be cited as "father" of the project in the dedication, and the court suppressed competing proposals until the map was complete.[29] In 1753 Charles granted a royal patent to the city, ensuring it copyright protection for the map within the kingdom.[30] As the patent indicates, much of the measurement had been completed by then, and a contract was signed with an engraver in 1754.[31] However, publication would be delayed until 1775, by which time the duke had died, leaving the architect Niccolò Carletti to bring it to completion under the direction of the Prince of Monteroduni.[32]

To map the city, the Duke of Noja employed a small team of six assistants.[33] They used survey chains and measuring rods to plot each street, palace façade, and piazza. They recorded measurements to scale as they worked, using sheets of paper attached to a plane table. Set atop a sturdy tripod base, the plane table was a simple and mobile tool that transformed cartography. By looking through an alidade, the draftsman could set proper angles and, with a small crew of surveyors, record correct distances to scale. This table had been in existence since the sixteenth century, when the German mathematician Johannes Richter, known as Praetorius, invented it. Often known as the *tavoletta pretoriana*, it was not widely used until the eighteenth century.[34] Employed in the mapping of Lombardy, the table reduced errors by allowing surveyors to draw the map on site. But while it was relatively simple, using it required skill, and in 1728 Angelo Maria Ceneri wrote a treatise on the table in which he deployed illustrations and explanations to demonstrate its proper use. His treatise was followed in 1751 by Giovanni Jacopo de Marinoni's book, which dealt more broadly with making ichnographic maps.[35] With illustrations and clear instructions, these books made scientific cartography accessible to a broader audience.

Ceneri describes the table as a simple rectangular surface that did "not exceed by much the dimensions of a piece of paper."[36] Supported by a tripod, the table itself rested upon a swiveling pivot so that it could easily be turned. The mapmaker then used an alidade to sight the two endpoints of the measured space. The task required a sharp eye, but also a good team of surveyors who, using chains, accurately recorded distances and calculated them to scale.[37] Ceneri summarized the basic technique in a few pages but went on to detail potential problems and solutions. If only one point was known, triangulation could help establish the other. If the distance was too great to be measured, a similar geometric calculation helped.

Even the obstacle of inaccessible terrain did not impede Ceneri from mapping it with the *tavoletta*. In fact, the Bolognese author enthusiastically proposed using the table for other purposes, such as measuring heights and parallelograms.

Given the thorough exposition of such treatises, the Duke of Noja posited that the table was so simple to use that, "with a few measurements, great distances can be measured quickly and recorded exactly."[38] It still required knowledge of mathematics, but the duke was certain that "among us [Neapolitans] there [were] not lacking people, able and honored, capable of operating the *tavoletta* with facility and singular mastery," who could produce a map.[39] Principal among those the duke had in mind, beyond himself, was Antonio Francesco Vandi, a seasoned engineer and mapmaker who had worked on the Milanese cadastral maps, collaborated with Nolli in Rome, and in 1753 produced an ichnographic map of L'Aquila.[40] The duke called Vandi his pupil and employed him as his principal aide. Vandi was the project's paymaster, and he checked the duke's measured drawings before going over the graphite lines with a pen. In addition to Vandi, there were five other men on the duke's team. Two men were charged with extending the chain, while a third noted and calculated measurements. A fourth served as a porter. The final member was the duke's son Pompeo, who also helped calculate measurements.

One can imagine the many challenges the seven men faced in the crowded streets of Naples. Their surveying, which required patience and precision, competed with the concourse of daily life and local traffic. They must have found reprieve in the courtyards of palaces or cloisters, the latter of which required papal permission to enter and measure.[41]

Having charted even the least accessible tracts of land within Naples, the survey team did not stop where the city ended. Like the surveyors in Lombardy, they hiked the countryside, mapping swamps, hills, coastlines, islands, and the slopes of Vesuvius. To chart such vast areas, they used triangulation, a mainstay of mapmaking, more than the *tavoletta pretoriana*.

Drafting the city and landscape was only part of their task. They assigned each building a number, which they would later use to label them all in a key accompanying the map. Cartographic footnotes, these descriptions were, for the most part, succinct. The duke also had to secure engravers and, with the Eletti, procure paper. Among the engravers he contracted was Pietro Campana, a seasoned member of Nolli's Roman team.[42] Meanwhile, responding to the city's request for advice, Luigi Vanvitelli recommended they use the highest-quality paper available.[43]

If he laid out all the copper plates next to each other, as they are now shown in the Museo di San Martino in Naples, the duke must have marveled at his creation. When united, the sheets of the duke's plan of Naples would dwarf most others. The map measures a grand 5.016 meters by 2.376 meters (fig. 108). It encompasses large swaths of the surrounding countryside, stretching to Portici in the east and to the island of Nisida in the west. It is not strictly ichnographic. Buildings are rendered in plan, but as with the maps of Lombardy, some topographic features are rendered in perspective, and plants are represented in elevation. Thus a flat city is ringed by a countryside shown in slight visual repoussé. In addition, an index dominated the lower portion of the map, and above it allegorical representations of the city flanked a perspective view of Naples. Symbols of the king and the civic government

also adorned the map, respectively occupying the upper left and right corners.[44]

The map's size and geographic scope are remarkable. Only three of the thirty-five plates represent the city. This wide and distant view shares characteristics with plans of French chateaux, which incorporate the surrounding countryside, or the 1762 map of the Savoy royal hunting lodge of Stupinigi. The scope of these plans underlined the buildings' topographical context and reinforced the connection between chateaux and country, and by showing the major roads that connected the capital with the country, the Duke of Noja likewise stressed the capital's links to the provinces. It is not surprising that he did so given the large sums that the royal government spent to improve the thoroughfares leading into the capital.

Defenses are de-emphasized. Like the Madrid of Pedro Teixeira's map (1656), the Paris of Michel-Étienne Turgot's map (1739), and the London of John Rocque's map (1748), the Duke of Noja's Naples spreads beyond its ancient walls and seems poised to encompass its immediate environs.[45] Civic boundaries, sharply marked by walls and bastions in many plans of the seventeenth century, soften and spread. At the fringe, two Caroline structures, the Albergo dei Poveri and cavalry barracks, appear less like urban outlays than like harbingers of expansion. The population of Naples, already one of the largest cities in Europe, was growing, and the duke was able to imply a dynamic future.

The map's embrace of suburban areas may also have an ideological significance. Barbara Naddeo has argued that the inclusion of suburbs represents the civic tribunal's desire to visually extend its jurisdiction over a geographic area beyond its administrative power.[46] While this may be true, the duke's letter suggests an additional reason. He highlighted the rich tradition of Neapolitan *villegiatura* and cited the need to plan new villas with greater care.[47] On the map villas dot the slopes of Vesuvius, to the east, and fill the rocky coastline of Posillipo, to the west. Including Naples's coastal environs was not unusual, since both historical and contemporary images included the city's natural setting (see fig. 111). While the Duke of Noja followed this cartographic tradition, he also used the suburbs to reflect royal topography. The two suburban palaces of Capodimonte and Portici dictate the map's northern and eastern limits. They seem to circumscribe Naples and imply the monarchy's power over and beyond the capital. As Hilary Ballon has argued, maps of Henry IV's Paris alluded to dynastic command over France.[48] Likewise, the map of Naples evokes royal power over the kingdom, for the road that passes through Portici and the alleys in the gardens of Capodimonte extend beyond the map's edge to suggest a larger topography of royal power.

One must also regard the map's scale as part of civic and royal propaganda. To be seen in its entirety, the map needed to be hung on a large wall, endowing the *imago urbis* with the monumentality of a *mappamondo*. The viewer would need to stand at a distance to take it in with a single glance, move close to examine the city at eye level, walk its length to see hills, mountains, and the coast, and stoop or crane to scrutinize ornamental details. The size monumentalized the map's ability to describe, proclaiming that its story would be an epic, with the city, its monarchy, and civic institutions cast in spectacular grandeur. The Duke of Noja's map therefore heralds Bourbon Naples, and its propagandistic aggrandizement of royal achievements dovetails with the publication of commemorative books and *chinea* prints.

Yet, fittingly, the duke featured the city's most important institution, the Tribunal of San Lorenzo, in the upper right corner of the map. There the page is seemingly rent open by putti who pull a drape of bullion-fringed cloth through the gash (fig. 112). Depicted on the fabric is a tree with six branches that represent the *seggi* of Naples. Each of the five aristocratic branches is weighted with the bounty of its members' noble family crests. By highlighting the nobility and giving them such prominence, the image, one might conclude, celebrates them and the city government more than the king. Yet atop the tree rests the royal coat of arms, supported by a putto wearing the hide of Acheloos, one of the ancient Greek mascots of the city. This symbolic representation makes the king's role at the top of society clear and converts the tree into a diagram of harmonic governance in which royal authority is

supreme. However, like the rich satin drape, the tribunal's financing lay behind the project, and the duke rightly shows them bursting through the page to expose their support.

Indeed, the space devoted to the city is slightly larger than the dedication to the sovereign in the upper left. There the duke overtly lauds Charles, to whom he dedicates the map on the unfurled hide of an ox. Though the king had already departed for Spain, he is commemorated in the inscription as the "father" of the mapping project. The city's financing is also noted, the *eletti* are listed, and the current king, Ferdinand IV, is mentioned. Surrounding the inscription, allegorical figures tumble through the sky (fig. 113). A sun, distinguished by a Bourbon fleur-de-lis, blazes onto the map at the upper left. A siren, probably Parthenope, the mythical founder of Naples, inquiringly looks toward the light as she directs the viewer's attention to the inscription with her right hand. Opposite her, Fame delicately pinches the hide between two fingers while turning to sound a trumpet. Below, Mercury flies above the Neapolitan countryside, bearing his caduceus and a cornucopia. These figures constitute a dramatic ensemble proclaiming beneficent rule. The city, symbolized by the siren, looks to the Bourbon sun for direction as bounty is brought to the land through Mercury's stewardship and Fame heralds the accomplishment.

Much of the Caroline bounty can be seen in the buildings depicted. The Teatro di San Carlo, cavalry barracks, Albergo dei Poveri, and Foro Carolino are all present, despite the fact that the barracks and Foro were begun after measurement was completed in 1753. Not only did the duke and Carletti add later buildings, but they also exaggerated existing ones. The colossal Albergo dei Poveri is shown with Fuga's original five courtyards

FIGURE 112
Giovanni Carafa, duke of Noja, *Mappa topografica della città di Napoli e de' suoi contorni*, 1775 (fig. 108), detail showing the upper right corner.

despite the king's decision in 1752 to make it a more modest three-court structure (fig. 114). Scientific ichnography was therefore regarded as adaptable and could be altered to create an outsized image of Bourbon Naples.

This exaggeration of Bourbon building extended to the perspective view inserted in the lower portion of the map (fig. 115). At first the *veduta* seems as topographically rooted and accurate as the ichnography of the plan. Unlike all previous artists who had chosen a bird's-eye perspective or had seemingly drawn the city from the crow's nest of a ship in the harbor, the *veduta*'s artist, Antonio Joli, depicted Naples from a position on the slopes of Vesuvius. Yet his ostensible rigor betrays inconsistencies.[49] The Albergo dei Poveri, again in its grander paper incarnation, springs out of the landscape as if it climbed the hill from its low-lying location. The foreground privileges the cavalry barracks. And on a bald hill near the top of the *veduta* the royal hunting lodge of Capodimonte lords over the city in a state of completion it would not reach until the nineteenth century. Thus the viewer's attention moves from one prominent Bourbon structure to another, manipulated into seeing Naples as a city predominated by Caroline markers.

Though the map and view emphasize newly minted buildings, the duke used allegory and antiquity to reference the capital's history. Below the *veduta* lies a group of figures that symbolize the city (fig. 116). The old man and goose represent the Sebeto River, and the rampant horse symbolizes Naples. Above them an ancient aqueduct extends toward the distance, probably the Aqua Augusta that supplied the Roman fleet at Misenum. To this group's left, ancient objects are scattered around a pedestal bearing a Greek inscription (fig. 117). Atop the pedestal sit pristinely preserved vases and

FIGURE 113
Giovanni Carafa, duke of Noja, *Mappa topografica della città di Napoli e de' suoi contorni*, 1775 (fig. 108), detail showing the upper left corner.

FIGURE 114
Giovanni Carafa, duke of Noja, *Mappa topografica della città di Napoli e de' suoi contorni*, 1775 (fig. 108), detail showing the Albergo dei Poveri.

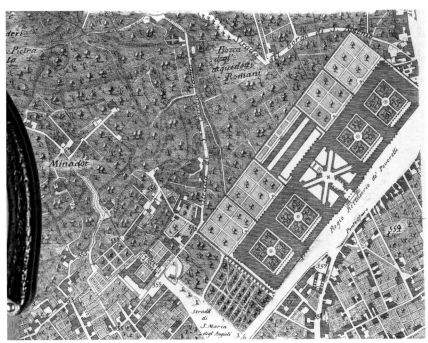

scrolls. Below, the torso of a sculpture of a youth lies on its side next to coins and three architectural fragments. These artifacts recall the Roman artifacts discovered at Herculaneum, where vases, statues, and papyrus scrolls were unearthed, and it is no coincide that they occupy a place nearest the location of

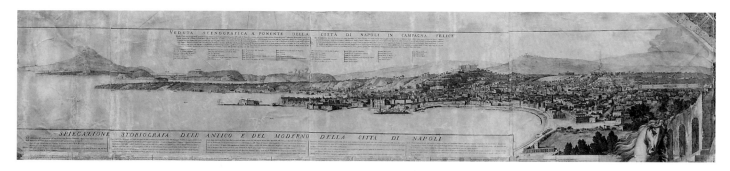

FIGURE 115
Giovanni Carafa, duke of Noja, *Mappa topografica della città di Napoli e de' suoi contorni*, 1775 (fig. 108), detail showing the *veduta* of Naples (after Antonio Joli).

FIGURE 116
Giovanni Carafa, duke of Noja, *Mappa topografica della città di Napoli e de' suoi contorni*, 1775 (fig. 108), detail showing allegorical figures representing the Sebeto and Naples.

FIGURE 117
Giovanni Carafa, duke of Noja, *Mappa topografica della città di Napoli e de' suoi contorni*, 1775 (fig. 108), detail showing antiquities represented in the lower right corner.

Herculaneum and Portici on the map. Yet the objects also emphasize Naples's foundation as a Greek colony. For example, the inscriptions are all Greek, and the coins are those of the Greek city of Neapolis.[50] Naples was proud of its Greek origins, and Neapolitan Hellenism fed a wealth of *campanilismo* from literature to architecture. Writers such as royal historiographer Giambattista Vico argued that Greek Naples was older than Rome.[51] And the Duke of Noja sought to publish his collection of southern Italian Greek coins, vases, and inscriptions.[52] In fact, two of the inscriptions featured on the map make explicit reference to Naples's history and were drawn from fragments in the duke's collection.[53]

Ancient references are not limited to the *veduta*. They extend into the map, where texts, particularly in the countryside, highlight ancient sites. The tomb of Virgil, the ancient temples of Fortuna and Venus Euplea, and the Roman retreats belonging to Lucullus are all noted. So too are the ancient walls of Naples. Dotted lines provide a condensed urban history by noting the extent of Greek, Roman, medieval, and Renaissance Naples. Exalting the antiquity of the city alongside its growth was appropriate, since Charles both modernized Naples and unearthed the bay's past at Herculaneum.

This coupling of ancient and modern recurs in the scale. Within an escutcheon borne up

from the sea by dolphins, the Neapolitan palm is set against the English foot, the Parisian foot, the Roman palm, and the Greek geometric foot. The foreign measurements place Naples in league with other European capitals, while the unusual inclusion of ancient measurements engages the city with its past. Indeed, ancient mensuration was a concern for the king and his royal antiquarians. Setting modern equivalents for the Greek and Roman feet proved crucial for reconstructing the ancient geography of the bay. Ottavio Bayardi, the scholar whom the king charged with publishing the finds at Herculaneum, even devoted the first volume of his *Prodromo delle antichità d'Ercolano* (1752) to defining and historically placing the Greek foot.[54] The duke likely read Bayardi's research and used his scholarship to amplify the map's historical scope, inserting Caroline Naples into the city's story as one of its most significant chapters.

Greek and Bourbon, ancient and modern, the map both celebrated and created history. The Duke of Noja represented a historical and modern capital and enshrined the Bourbon city in the chronicles of Naples. Yet the map transcends its Bourbon context. In scale, beauty, and erudition, the map remains remarkable. Few preceding city maps packed as much onto the page. The date and construction of recent buildings, notes of historical places and events, ancient and modern measurements, historical inscriptions, an allegorical diagram of the city government, a *veduta,* heraldic symbols of Naples, and scientifically measured buildings, streets, and piazzas—all share space. It is not surprising that a copy of the map was sent to the Royal Society in London; it contained a feast of data that would entice any scholar.[55] In the history of cartography, the Duke of Noja's map became an important point of departure for Giovanni Antonio Rizzi Zannoni's meticulous atlas of the kingdom (1781–1812). Yet while the grandeur of Rizzi Zannoni's project rivaled the duke's map, the later map's dispassionately observed plates of coastlines, mountains, and ports lacks the visual poetry, historical erudition, and civic celebration of the earlier map. Benedetto Croce famously termed guidebook author Carlo Celano "a lover of Naples."[56] So was the Duke of Noja when he declared, "And certainly, if I have any virtue in which I may glory, it is that of always having thoughts of true love for my homeland."[57] His attachment to his city thankfully led to the most magnificent map ever made of Naples and one of the most marvelous images of the city in the eighteenth century.

Conclusion

The mid–eighteenth century was an era when philosophers and scholars not only lauded the intrinsic benefit of building but also stressed its requisite public role. In Paris, Marigny, as head of the king's works, managed expectations amid a raft of pamphlets and books that called for the unity of majesty and public utility.[1] It was believed that public buildings could renew civic life, and in response new building types proliferated and spread across the continent. Opened to a wider public, theaters, marketplaces, museums, and academies altered the social, urban, and architectural character of small cities and capitals alike. From Kassel (Museum Fredericianum, 1769) to Oxford (Radcliffe Camera, 1737–49) and Lisbon (Praça do Commercio, begun 1756), each corner of Europe experienced this chapter of urban renewal.[2] In Italy governments created new spaces for museums, archives, poorhouses, government offices, the military, libraries, and theater.[3] All of these spaces were open to a widening public and were accompanied by public debates and discourses. Scipione Maffei spurred developments in Verona and Turin, while Francesco Bianchini and Lione Pascoli spearheaded important improvements in Rome.[4] In Naples the gestation of the Albergo dei Poveri embodied the changing political and cultural dynamics of architectural commissions. Several proposals accompanied its creation, and a flurry of scathingly anticlerical printed works influenced its financial and administrative relationship with local religious foundations. Moreover, stylistic severity, long lauded for its potential to express power, found new advocates in theorists like Laugier, who stressed utility and economy. The Albergo dei Poveri and cavalry barracks embodied the new emphasis on decorum. Finally, the terms "good government" and "public happiness" began to appear with regularity in discussions of architecture and reform. An ethic of government building emerged, molded on principles of just rule similar to those espoused by Montesquieu and Rousseau. Yet despite the growing concern for public utility and greater attention to public discourse, the buildings themselves often asserted the royal government's control. This contradiction has not been sufficiently emphasized but cannot go unnoticed when examining the urban development of Naples under Charles of Bourbon. For despite the undeniable benefits that Caroline buildings had for Naples, many were built so that the Crown could concentrate civic activities under its purview. Indeed, it is impossible purely to link Neapolitan structures with an awareness of architecture's public good. History reveals not so much comprehensive urban strategy as practical responses to immediate social problems, economic reforms, and political policy.

One therefore must not overstate the aims of Bourbon building, despite the fact that many structures answered public needs. Public utility was a hallmark of Caroline building without being its clear motivation.

The public building campaign begun during Charles's reign continued after the king's departure. In the 1760s the university was moved out of the Palazzo dei Regi Studi, which was remade into the Reale Museo Borbonico to display artifacts from Herculaneum and the equally impressive Farnese collection. More significantly, the court commissioned Ferdinando Fuga to design a cemetery and a granary.[5] Begun in 1762, the monumental public cemetery was designated for those who could not afford burial. Previously, the poor were interred in a pit within the Ospedale degli Incurabili, in the heart of Naples. Citing the fetid smell of decomposing bodies, the court ordered a new cemetery be constructed well beyond the eastern edge of the city. At the end of a newly designed road to the east of the Albergo dei Poveri, Fuga projected a simple square enclosure bounded on three sides by walls and on the fourth by a wing containing a chapel, custodian's residence, vestibule, and mortuary. Within the large open plaza Fuga opened three hundred sixty shafts for common burial and added six additional ones in the vestibule. Each shaft was seven meters deep and numbered. The numbers corresponded to the days of the calendar year, and shafts were used on a rotating basis. Each day a different one was opened and then sealed until the following year. The walls of the vast court were plainly articulated with pilaster strips. On the exterior, inscriptions and a pediment with a skull ornamenting the tympanum mark the main entrance. The cemetery's simple austerity and charitable function echo those of the Albergo

dei Poveri, and it similarly fit the dictates of public utility by both removing an unsanitary practice from the city and providing aid to the needy.

The other massive structure that Ferdinand IV commissioned Fuga to design was the enormous granary near the port (fig. 118). Begun in 1779 near the Ponte della Maddalena, the building was designed for easy unloading and storage of grain shipments. Equipped with its own docks, the Granili had three sets of ramps that allowed pack animals to carry provisions to magazines on each of its four floors. Central corridors functioned like interior streets, connecting to the ramps and opening onto magazines. On each floor, sixty storerooms occupied the seaward half of the building, while eighty-seven filled the opposite side. When built, the storerooms exceeded the city's needs, and some came to be used as an arsenal and ropewalk. Built to help provision the capital, the Granili thus also had a military role. Future research will hopefully answer questions of how the Granili fit into the context of grain supply and military infrastructure. Much clearer is the architectural context. It joined the Albergo dei Poveri, cavalry barracks, and cemetery in a family of large utilitarian structures.

More than stylistic features or urban changes, the quality of public good unifies many Bourbon buildings in Naples. Indeed, given Charles's active role in the Neapolitan royal government during his son's minority, it is tempting to regard the cemetery as a continuation of the Caroline campaign. Undoubtedly Charles's example, if not his direct dictates, guided his successor's commissions. Buildings continued to rise for the civic welfare of Naples, making it an important Caroline legacy.

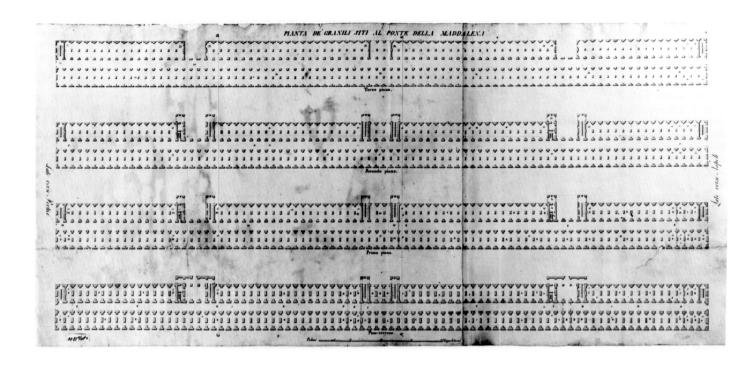

PIANTA DE GRANILI SITI AL PONTE DELLA MADDALENA

FIGURE 118
Ferdinando Fuga, plan of the Granili, 1779. Black ink on paper. Biblioteca Nazionale, Naples.

MADRID

Charles's other principal architectural legacy was the use of buildings in tandem with political reform. Relationships with urban, feudal, and ecclesiastical elites changed with each new structure. Military, commercial, and mendicant reforms were as important as stones and mortar, and this marriage of reform and architecture continued in Madrid during the first years of the king's reign.

Returning to Madrid in 1759, Charles stated, "Here I have much to do,"[6] and began another series of building commissions. Mostly, the court completed projects that were already under way. The Prado, the Hospital General, and several city gates, including the Puerta de Alcalá, were either refashioned or completed during his reign.[7] More characteristic of the king's Neapolitan architectural patronage was the Casa de la Aduana (fig. 119).[8] Designed to house the kingdom's

customs administration, the building was the physical embodiment of the Crown's fiscal policies. Two Sicilians were central to the building's history. One was Leopoldo de Gregorio, Marquis of Squillace (Esquilache in Spanish), who became the king's principal minister in Madrid. Called from his post as minister of finance in Naples, he enjoyed the king's full confidence and was assigned the most difficult tasks of implementing commercial reform and economic development.[9] The pace and scale of reforms introduced by de Gregorio were ambitious. He implemented laws to regulate commerce, paid existing debts, shrank the royal household, introduced measures to prevent price fluctuations, eliminated some customs duties, and sought to revise customs rates more broadly. As the historians Stanley and Barbara Stein note, "Great historical perspective is not needed to conclude that no Spanish minister of the eighteenth century undertook as broad

FIGURE 119
Real Casa de la Aduana,
Madrid.

and far-reaching a program of accelerated reform as did [de Gregorio] from the moment of his arrival at Madrid."[10]

The other was Francesco Sabatini, Vanvitelli's son-in-law, the architect de Gregorio selected for the construction of a new Casa de la Aduana. This Sicilian engineer had been called to Madrid after his successful oversight of the cavalry barracks at the Ponte della Maddalena, where he had worked directly with de Gregorio. Their collaboration, born at the barracks, would lead to several years of dynamic urban change in Madrid.

Madrid was less populous and less densely populated than Naples, but it was the center of a far more cosmopolitan court, which teemed with clergy, aristocrats, jurists, and diplomats. The city was filled with public buildings and spaces commissioned by the Hapsburgs and

Bourbons as well as private palaces, theaters, churches, and cloisters. The most important ongoing architectural project was the construction of a new Palacio Real on the site of the Alcázar, destroyed in a catastrophic fire in 1734.

Yet despite its splendor, Madrid's basic infrastructure was poor. Few roads were paved, and most ran with sewage that inhabitants dumped from their windows.[11] Plans and attempts to improve the streets had been made under Bourbon auspices in 1717, 1735, and 1751. None yielded long-term results. Madrilenians continued to walk unsanitary streets and protected themselves against the filth by wearing large-brimmed hats and long tunics. The hats and capes also served in smuggling goods past customs agents. For a fiscally astute mind like de Gregorio's, improving the urban infrastructure therefore held possible fiscal

benefits. By removing the urban ill, de Gregorio reasoned, the royal government could ban the attire and thus reduce smuggling.[12] In 1761 a proposal to improve the streets, authored by Sabatini, was approved by the monarch.[13] The architect proposed digging cesspits in all buildings and paving the streets. By 1762 work began on the most important arteries of the capital, and simultaneous action was taken to install sewage pits. By 1765 most work had been completed, and public light posts were installed. According to one account, Madrid was one of "the cleanest cities that one will find."[14]

The Real Casa de la Aduana was begun in the same years and was part of much broader revenue reform than merely banning caps and tunics. As the *casa* was being planned, de Gregorio was exploring ways to increase customs collection, prevent smuggling, and bolster commercial activity. To do the latter, he aimed to loosen the grip on trade exercised by the oligopoly of merchant houses in Cádiz and to alter the pattern of controlled shipping at Havana. By 1765 he had decided to strengthen the court's hand by introducing a Reglamento del Comercio Libre. Its vast vision of opening trade routes and simplifying duties would be tempered, but even incremental change disturbed aristocratic, merchant, and clerical elites.[15]

Architecture seems to have helped give shape to trade policies, as Sabatini projected the enormous customs house in Madrid at roughly the same time. Overseen by de Gregorio and backed by royal financing, the Casa de la Aduana rose on one of Madrid's principal streets, the Calle de Alcalá, near the Puerta del Sol. Its ground floor housed storerooms for various products and goods, while the upper floors accommodated offices, which could be reached from a centrally located staircase. The

functional combination of offices and warehouses in a single structure was very similar to the complex distribution of space that Sabatini had overseen at the cavalry barracks in Naples. Here, however, Sabatini adapted the exterior to the Spanish architectural vocabulary. He followed the example of most of Madrid's buildings and used granite on the lower floors and brick for the upper storeys. Yet he omitted the usual iron balconies and added pedimented windows and a heavy cornice to give the *casa* the air of an Italian palace. Interestingly, Sabatini's initial design was much simpler (fig. 120). He originally proposed to frame the upper floors in a masonry-bordered box. Long rows of simply framed windows would sink into the lower band of the frame in a way more similar to their treatment at the cavalry barracks in Naples. The reasons for using the barracks as a model were multiple. De Gregorio and Sabatini knew it well, and the barracks incorporated offices, stables, storerooms, and sleeping quarters much as the Casa de la Aduana compressed storage and office space into one building.

Further research may yet reveal the exact date Sabatini changed the façade of the Casa de la Aduana, but it is tempting to date it to 1765, when de Gregorio suggested changes in the distribution of rooms.[16] Moreover, the date is historically significant. In 1765 the minister introduced the first *reglamento,* and it is likely that he would have wanted the Casa de la Aduana to reflect the court's confidence in and commitment to reform. In this context, providing a more ornamented façade suggested regal magnificence in a way that a simpler articulation did not. While this observation must remain speculative, it is undeniable that the building was closely connected with the economic regulations that consumed the court

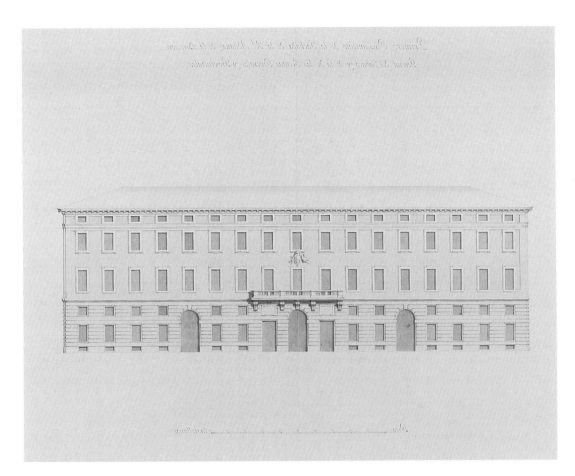

FIGURE 120
Francesco Sabatini, first design
for the façade of the Real Casa
de la Aduana, 1761. Black ink
on paper. Museo de Historia
de Madrid.

during the first years of Charles's reign. In fact, no building the king commissioned in Naples or Madrid accompanied the same degree of far-reaching reform. Structures in Naples reshaped the Crown's relationship with ecclesiasts, aristocrats, and local elites individually, but the Casa de la Aduana had ramifications for many sectors of Spanish society. A local smuggler, an Andalusian magnate, and a Castilian bishop might all see their existing privileges challenged by the reforms that the Casa de la Aduana and the Reglamento del Comercio Libre represented.

In 1766 reform collided with political interests intent upon maintaining the status quo. The *reglamento* had raised fears among local and national elites that de Gregorio might press for even greater centralization, but it was the regulation of public attire that helped spark open rebellion against his policies.[17] When street and sewage repairs neared completion, the minister published an edict on attire, banning the problematic hats and capes. Following the pattern set by similar edicts issued by Philip V and Ferdinand VI, enforcement was lax at first. But soon *alguaciles* of the Sala de Alcaldes de Casa y Corte were shearing capes in the streets.[18] In March of 1766 popular discontent with the clothing edicts flared into a revolt, or *motín*, against Charles, de Gregorio, and the circle of Italians loyal to the minister. Mobs turned on the royal government, sacked

de Gregorio's residence, attacked royal guards, and broke into prisons to free convicts.[19] Associating architecture with the government, they vandalized Sabatini's home and tore down streetlamps the Crown had set up.[20] Facing a coup, the king fled to Aranjuez. Meanwhile local elites, led by the Consejo de Castilla, intervened on behalf of the mobs and sided against the minister and his reforms. The role that these local powers had in fanning the riot remains unclear, but the results of the *motín* were stark. The king, faced with open resistance in Madrid, asked for de Gregorio's resignation. Sabatini also asked to return to Italy, but his request was denied.[21] The riot was blamed on the Jesuits, a fact that contributed to their expulsion from Spain the following year.

The *motín* has been characterized as the most serious threat to Spanish royal power since the Revolt of the Comuneros (1520–21). It exposed deep political tensions between the Crown and established powers in Castile. Economic reform, urban improvement, and the king's Italian minister helped spark the *motín,* but resistance to centralization of power by the Crown underpinned it. Thus the political climate in Spain was different from that which the court confronted in Naples, and future study will hopefully reveal how architecture's role in advancing reform was likewise different. In general ways other structures reflected the reformist spirit of the royal government, and some specific projects, such as the Hospital General and Gabinete de Ciencias Naturales, connect to initiatives such as mendicant reform and promotion of science. Yet the deeper context of political change and social control has yet to be explored. Merely looking at Naples and Madrid after Caroline improvements might lead one to believe these renewed cities were similarly conceived and achieved. Both gained new public buildings that consolidated urban activity into ordered architectural settings. Many of these structures appear stylistically similar through their sober articulation. But the power of architecture to do more than shape space and cities—its power to mold the very political system—saw its limitations with the Casa de la Aduana. Instead, Naples seems to have been the capital where Caroline architecture most effectively built the city as well as the state.

Introduction

1. On Philip V's long battle for Spain, see Kamen 2001, 1–102.

2. For recent biographies, see Mafrici 1999; Lavalle Cobo 2002; Pérez Samper 2003. For her political role, see also Kamen 2001, 103–38; Noel 2004; López-Cordón Cortezo 2009.

3. Wittkower 1999, 3:21.

4. See the important studies by Ballon (1991), Escobar (2003), Brown and Elliott (2003), J. Collins (2004), Pollak (1991), and Scott (2009).

5. The duc de Saint-Simon observed that "all her thoughts turned to making them [her children] independent sovereigns in the lifetime of King Philip. . . . Day and night she meditated on this grand design, for the foreign policy of Spain must hinge upon it." Saint-Simon 2007, 359. See also Walling 2009, 243.

6. Alberoni (quoted in Kamen 2001, 121) stated: "a good war is necessary, until the last German has been driven out [of Italy]." On his policy, see also Tabacchi 2009. On Patiño's role, see Kamen 2001, 172–75.

7. The queen explicitly stated that Charles should go to Italy as soon as possible so that he would be ready to take possession of the territories should the Grand Duke of Tuscany die. Cited in López-Cordón Cortezo 2009, 149.

8. On the festivities, see Urrea 1989, 41–49.

9. "Va dunque e vinci; la più bella corona d'Italia ti attende." Buttà 1877, 1:12.

10. The papacy disputed the investiture of both Philip III and Charles II. See de Cavi 2009, 136–38; Carrió-Invernizzi 2008, 255–56.

11. Schipa 1923, 1:13.

12. On the conquest, see De Napoli 1934.

13. Anglophone scholarship often uses "Charles VII." "Charles of Bourbon," which I use, was the title commonly used by the court. See Tanucci 1980–2003, 1:534–52, 570, 605.

14. "Conoscono il gran bene che ne risulterà se potranno avere un Re che risieda qui." Observation of Prince Bartolomeo Corsini quoted in Ajello 1972, 491.

15. "Grazie a dio non siamo più provinciali." Quoted in Garofalo 1963, 11.

16. On Toledo, see Hernando Sánchez 1994. On the composite union of the Spanish monarchy, see Elliott 1992; Kamen 2008, 96–125.

17. On their patronage, see de Cavi 2009, 132–245.

18. Carrió-Invernizzi 2008, 265–418; Galasso 1982, 1:17–26, 121–41.

19. Galasso 1994, 124–38, 185–216.

20. Spagnoletti 1996, 129–45.

21. "Vive il re e muora il mal governo." Quoted in Carrió-Invernizzi 2008, 234. On the general loyalty to the person of the Spanish monarch during times of unrest, see R. Villari 1987, 56; Elliott 2009, 177–80.

22. Strazzullo 1968, 175–215.

23. Petraccone 1974, 135–47; Hills 2004; Strazzullo 1968, 81.

24. Fiengo 1990, 105–34.

25. This trope was used in *Descrizione delle feste celebrate* 1735, 3.

26. Frederick II 1789, 18.

27. See Kamen 2001, 163.

28. In addition to Charles, her children were Philip (Duke of Parma and Piacenza), Luis (archbishop of Toledo and primate of Spain, later Count of Chinchón), Mariana Victoria (queen of Portugal), María Teresa (dauphine of France), and María Antonia (queen of Sardinia).

29. On Charles's character, see Fernán-Nuñez 1898, 2:39–60;

F. Rousseau 1907, 1:6–16; Schipa 1923, 1:64–69; Acton 1956, 12–26.

30. Schipa 1923, 1:64–65.

31. Fernán-Nuñez 1898, 2:39–60.

32. On Spanish ceremonial, see Elliott 1989, 142–51.

33. "le plus honnête homme de Roi qui ait jamais existé." A. Goudar 1781, 76.

34. "Non manca il Re assolutamente di coraggio, non manca di bella apertura di testa, di vivacità d'ingegno, d'un ottimo giudizio, essendovi stata maniera in un'ora e mezza di discorso di toccar vari tasti, entrar in diversi punti ed in questo modo riconoscere le qualità poc'anzi esposte, che non saranno riconosciute . . . o da chi non le sa ben distinguere, essendo come sono nel Re rivestite d'una eroica modestia." Quoted in Pastor 1938–61, 35:481–82.

35. Gray's report of 1754 is transcribed in *Enlightened Despotism* 1967, 129.

36. Schipa 1923, 1:64.

37. See Origlia 1753–54, 2:230–309; Zucco 1977; Parslow 1998; Deupi 2006, 237–51.

38. See Vázquez-Gestal 2009; Ajello 1972, 498–502.

39. "In molte cose opera egli stesso come ministro e ogni giorno passa molte ore da solo nello studio; si fida pienamente del proprio giudizio ed è talmente ostinato che raramente lo si convince a cambiare opinione. Ha idee molto alte delle sue prerogative e della sua indipendenza ed è convinto di essere il sovrano più assoluta d'Europa." Quoted in Ascione 2009, 315.

40. On absolutism more generally, see Cosandey and Descimon 2002; Beik 2005; J. B. Collins 2009, xiv–xxv; Nussdorfer 1992, 3–10, 168–99. On the powers of the Spanish Crown,

see Kamen 2008, 38–73. On kingship in the mid–eighteenth century, see Beales 2005, 28–56.

41. His minister of justice, Bernardo Tanucci, noted that "in campagna, ove non è consiglio di Stato, il Re segretamente fa il segretario di Stato." Tanucci 1980–2003, 2:684.

42. "It is by the choice of his ministers, by his doing business along with them . . . that this prince won the confidence and hearts of his subjects." Grosley 1769, 2:210–11.

43. Vázquez-Gestal 2009.

44. On Caroline cameral reforms, see Venturi 1972; Ajello 1985, 159–64, 175–76; Carpanetto and Ricuperati 1987, 3–8, 34–38, 91–112; Ferrone 1995, 123–80; Montinori 2000, 24; Vázquez-Gestal 2008, 524–743.

45. Maria Amalia remains understudied. For her character, see F. Rousseau 1907, 1:9, 13–15; Mafrici 2010.

46. See Wilkinson-Zerner 1993, 63–171; Brown and Elliott 2003; Escobar 2003 and 2009.

47. Charles III 2001–2, 1:192, 198, 204, 237, 309, and 2:62–63, 101.

48. See Heckmann 1972, 42–159; Magirius 2005, 32–104.

49. See Moli Frigola 1993.

50. Curcio 2000; Antinori 2008.

51. Kadatz 1983, 125–36; Cracraft 1988, 147–249; Lombaerde 2001; Ottenheym 2005; Stevenson 2000; Berger 1994, 45–52, 91–106, 154–62.

52. H. Minor 2010, 152–215.

53. For the praises of Charles, see Vanvitelli 1756, 13; Vitruvius 1758, dedication, v.

54. Wilkinson 1985.

55. Habel 2002, 3–10; Ballon 1991, 7–8; Escobar 2003, 61–83.

56. This opinion of British consul Charles Allen (1734) is transcribed in *Enlightened Despotism* 1967, 128.

57. See Thomson 1993, 1–49.

58. See Hersey 1969, 21–24.

59. See Fraile 1997, 32–38, 85–86.

60. See Hersey 1983, 217–19.

61. "Il lusso pubblico è quello che mostrano le corti de' sovrani nelle loro pubbliche funzioni o interne o fuori dello stato, come nelle pubbliche comparse, nelle feste, nelle fabbriche,

nelle ambascierie ec. Lusso pubblico anco è da dirsi quello delle comunità nel volersi distinguere l'une dall'altre per alcune fabbriche, come di case pubbliche, di piazze, di fontane, o per feste ec." Transcribed in *Economisti classici italiani* 1804–16, 10:125.

62. "[L]a grandezza e la felicità di un monarca è inseparabile da quella de' suoi sudditi." Ibid., 226. See also Muratori 1996, 269–74; Wahnbaeck 2004, 15–54; Stapelbroek 2008, 165–207.

63. Goldsmith 1796, 76–77.

64. See Zambelli 1973; Stapelbroek 2008, 90–106.

65. For negative appraisals, see Sitwell 1931, 69; Garofalo 1963, 18; Villani 1977, 9–11, 159–60.

66. For the most recent survey, see Blunt and Lenzo 2006.

67. Following Spanish organization, royal engineer was the most important architectural post in the kingdom. See Cámara Muñoz 1990, 45–83; 1989, 5–23. Charles reformed the hierarchy and added new titles from 1738 to 1751. See Buccaro 2003, 17–22.

68. Blasco Esquivias 1995; Tovar Martín 1995.

69. Locke 1996, 1:2–3.

70. See Gurlitt 1887, 536; Brinckmann 1915, 1:174; Fagiolo dell'Arco 1963, 86; Rykwert 1980, 276; Matteucci 1988, 140; Benedetti 1997, 12–29, 83–95; de Seta 1998; Wittkower 1999, 3:23–24; Garms 2000, 577–78.

71. Pinto 2000, 119; V. Minor 2006, 26–60.

72. Ferdinando Bologna (1982) has made an effort to trace outside influences on Neapolitan art.

73. Sterne 1768, 32.

74. Acton 1956, 105–6.

Chapter 1

1. "la capitale du monde musicien." Brosses 1986, 1:401.

2. "il causa pendant une moitié de l'opéra et dormit pendant l'autre." Ibid., 398.

3. Charles III 2001–2, 2:363.

4. On existing archival material, see Belli 1987; Ascione 2003. The most essential works are Traversier 2009; Ciapparelli 2003; DelDonna

2002; Robinson 1990; Cantone 1987; Mancini 1987d; Fabbri 1987; Greco 1980; Croce (1896) 1968; Taddei 1817; Napoli-Signorelli 1787–90.

5. "La musique est sur-tout le triomphe des Napolitains." Lalande 1786, 7:192.

6. Grosley 1769, 1:61.

7. "Cours, vole à Naples écouter les chef-d'ouvres de *Leo*, de *Durante*, de *Jommelli*, de *Pergolèse*." J.-J. Rousseau 1768, 227.

8. See Heartz 2003.

9. The conservatories of Santa Maria di Loreto, Santa Maria della Pietà dei Turchini, Sant'Onofrio a Capuana, and the Poveri di Gesù Cristo were the most important. See Fabris 2007, 24–28; Robinson 1972, 13–24.

10. Fabris 2007, 15–30.

11. Quoted from a letter of 25 April 1770 from Pietro Metastasio to the singer Carlo Broschi, in Burney 1796, 2:404–5.

12. Ciapparelli 2003, 225.

13. On its location and foundation, see Croce (1896) 1968, 2:160.

14. See Prota-Giurleo 2002, 3:76.

15. Invectives against the immoral activity surrounding the "Teatruccio Nuovo" were delivered by Gennaro Maria Sarnelli (1739), 10).

16. On its closing, see Mancini 1964, 18; Greco 1981, 50; Croce (1896) 1968, 2:275.

17. Prota-Giurleo 2002, 3:76.

18. On Vaccaro's career, see de Dominici 2003–8, vol. 2, pt. 2, 911–30; Pane 2004, 307; Lattuada 2005. On the Teatro Nuovo, see Napoli-Signorelli 1787–90, 6:249; Morelli 1780; Mancini 1961; Greco 1980; Cantone 1987, 51, 77; Cotticelli and Maione 1996, 137–58; Tortora 2005, 253–59.

19. "[C]on tanto giudizio avea fatto nascere il possibile dall'impossibile; e ciò disse per l'angustia del sito." De Dominici 2003–8, vol. 2, pt. 2, 918.

20. On the San Bartolomeo, see Prota-Giurleo 2002, 1:68; Cantone 1987, 50–51; Ciapparelli 2003, 224–26; Cotticelli and Maione 1996, 57–94; Cappellieri 2000.

21. In 1644 Philip IV expanded the percentage the Incurabili received. See Bianconi and Walker 1984, 265–66, for comparison of this system to others.

22. See DelDonna 2009, 214–19; Cotticelli 2000.

23. Mancini 1961, 95.

24. On these changes, see Croce (1896) 1968, 2:260, nos. 2, 3; Holmes 1993, 93.

25. Charles III 2001–2, 2:178.

26. On Santiesteban and the formation of the court, see Vázquez-Gestal 2009.

27. Consul Edward Allen to the Duke of Newcastle, Naples, 24 July 1734, National Archives, London, SP 93/9, 58r–v. Quoted in Acton 1956, 32.

28. An article on this subject is promised by Vázquez-Gestal.

29. This testament is cited in López-Cordón Cortezo 2009, 148–49.

30. See Astarita 1992, 36–67; Montinori 2000, 24; Ajello 1985, 159–64, 175–76; Villani 1968, 256–63.

31. Galasso 1982, 2:583–608.

32. On the ritual welcoming of the viceroys, see Labrot 2009, 80–81. On the king's reaction to the nobility, see Charles III 2001–2, 1:372.

33. Vázquez-Gestal 2009, 44.

34. On Elizabeth's musical abilities and opinions on music, see Morales 2009, 190–92.

35. On the reintroduction of opera in Spain, see Cotarelo y Mori 1917, 43–142; J. Carreras 1996–97; Morales 2009; Stein and Leza 2009, 256–60.

36. Charles III 2001–2, 2:574, 237, 262, 288.

37. On the accidental collision, see Onofri 1789, 130. Bernardo Tanucci recorded a homicide near the theater in 1737. See Tanucci 1980–2003, 1:203.

38. Labrot 2009, 101.

39. The court requested more space in 1736; see Croce (1896) 1968, 2:271, no. 2.

40. Bartolomeo Corsini outlined the method of royal finance in September and October of 1736. See Holmes 1993, 97. On the purchase, see Croce (1896) 1968, 2:271, no. 2.

41. "correspondesse alla dignità della risorta monarchia ed alla popolazione di una delle più grandi metropoli dell'Europa." Taddei 1817, 4.

42. Charles III 2001–2, 1:227, 287.

43. For a history of the Teatro della Pergola, see Zangheri and Zorzi 2000, 17–25.

44. See documents transcribed in Fiengo 1983, 78.

45. On Montealegre's character and reforms, see Villani 1977, 22–25, 155–57; Ajello 1972, 500–501, 642–94.

46. On the stonelaying, see the comments of the Florentine ambassador cited in Zilli 1990, 173.

47. "se non si lascerà qualche tempo per respirare." Quoted in Ajello 1972, 500.

48. For these festivities, see Ascione 2003, 40; Mamczarz 1988, 445–47; Fossati 1987, 56–64.

49. On the importance of the Farnese music texts, see Burney 1771, 350. On the use of Emilian stage designers, Mancini 1987c, 9–62.

50. See Charles III 2001–2, 2:162.

51. Salazar y Castro 1716.

52. See Tovar Martín 2000.

53. See Adorni 2008, 99–136; Fornari 1994.

54. Gaetana Cantone was the first to suggest that the location was the principal interest of the Neapolitan court; see Cantone 1987, 57. On dynasty and theater in northern Italy, see Jarrard 2003, 53–89.

55. In the 1720s Montesquieu judged the theater useless for such a small duchy. See Adorni 2008, 117–18.

56. See Ivanovich 1687, 401–3. Alfonso Chenda was the first to construct enclosed theater boxes in Italy. These were made for a 1639 performance in the *salone* of the Palazzo del Podestà in Bologna. See Guccini 1988, 33; Ricci 1971, 160. On their financial importance, see Glixon and Glixon 2006, 17–33.

57. "Una sola cosa però è quella che discredita la massima, il sapersi esservi intenzione di farlo servire ad uso pubblico, né ammettervi persone che previo il pagamento, ciò che per altro disconviene alla dignità di principe." *Corrispondenze diplomatiche veneziane* 1992, 430.

58. See the Venetian ambassador's dispatch of 19 March 1737 in ibid., 428.

59. "De la mejor arquitectura, simetría, proporción, y comodidad, excediendo en las ventajas à los otros Teatros de Italia." Cited in Croce (1896) 1968, 2:271.

60. See Lenzi 2000.

61. Rava 1953, 25.

62. On Ottoboni and Juvarra, see Viale Ferrero 1970, 19–53. Clement XI's ban, instituted at the beginning of his pontificate, was lifted in 1710. Guccini 1988, 63.

63. On the rediscovery, see Parslow 1998, 23.

64. See Fontana 1725; Mazzocchi 1727; Maffei 1728.

65. On its history see de Cavi 2009, 159–212.

66. See Prota-Giurleo 1952, 21–28.

67. On the chapel in Madrid, see Barbeito 2005.

68. Fabris 2007, 18–19; 2005.

69. Ciapparelli 2003, 244–47.

70. Cámara Muñoz 1990, 60–71; Fiengo 1983, 18–26; Buccaro 2003, 17–22.

71. See Capalbo and Savaglio 2004, 23–47, 106–16.

72. The best study of Medrano is Marías 2004, 270–72.

73. Santiesteban noted the king "trabajaba con mucho gusto en la fortification" and had sophisticated opinions on buildings in Parma. See Urrea 1989, 45, 49.

74. Mariano D'Ayala credits him with making the walls. See D'Ayala 1835, 80.

75. The best biography of Carasale is found in BNN, MS XV, G, 32, "Ingresso in Napoli del sereniss[imo]: Infante di Spagna D. Carlo di Borbone e sua esaltazione al trono," 3:65v–66r.

76. Goldoni 1935–56, 7:482–85.

77. Cited in Holmes 1993, 110.

78. "Las Proporciones presentadas para sù fabrica por Angel Carasal sí han reducido por d.ho Ing.ro Director (Don Juan Medrano) à los p[la]nos Justos." Cited in Cantone 1987, 60.

79. Croce (1896) 1968, 2:178, no. 1.

80. Mancini 1987d, 10.

81. Onofri 1789, 131. On the cavalry and elephant, see Grosley 1769, 2:233; Lalande 1786, 7:438.

82. The Teatro Nuovo also had a royal box. The king never attended, but the royal box had to be maintained. See Croce (1896) 1968, 2:306.

83. For a recent examination, see Ricci 2009.

84. Alberti 1988, 274.

85. Carini Motta 1987, 52–55.

86. The architect Luigi Vanvitelli vouched for the acoustical warmth of wooden theaters: "interiormente con gli ornamenti di legno per toglierli il rimbombo che avrebbe col quale rimarrebbe confusa la voce." Quoted in Fagiolo dell'Arco 1963, 56. Payment documents to the machinist Zaccharia Denise for the construction of the stage are cited in Mancini 1964, 24.

87. First noted by Mancini 1987a, 32.

88. The painting was one of a series of *vedute* of Naples commissioned by Lord John Brudenell between 1756 and 1758. See *All'ombra del Vesuvio* 2003, 199–200.

89. "ornamento più caro de' nostri spettacoli." Napoli-Signorelli 1787–90, 6:250.

90. Grosley 1769, 2:232.

91. See Barbeito 2005, 200.

92. In constructing the corridor, the architects followed the advice of Ferdinando Sanfelice, who advised that any additions to the palace should make sure to "portare eguali li piani." Quoted in Schipa 1902, 110. For the completion of the corridor, see Croce (1896) 1968, 2:284.

93. An image of the drawing has been published in *Ritorno al barocco* 2009, 2:301.

94. This drawing was discovered by Cantone (1987, 48).

95. Milizia 1773, 76.

96. Wilkinson 1975, 65–74; Marías 2008, 425–37.

97. In describing the façade, the Florentine agent stated, "La Maestosa facciata del sud.o teatro fù scoperta in esso doppo desinare con esservi vista sù della Porta una grand'arme con Quattro statue a fianchi formate p. ora di stucco, somigliante Marmo." ASF, *Mediceo del Principato*, filza 4140. Cited in Fiengo 1983, 78.

98. "Ora anche nell'atto del divertimento non può non ricordarsi di volta in volta del suo insigne benefattore." The inscription, composed by Minister of Justice Bernardo Tanucci, read, "CAROLUS UTRIUSQUE SICILIAE REX PULSIS HOSTIBUS CONSTITUTIS LEGIBUS MAGISTRATIBUS ORNATUS LITERIS ARTIBUS EXCITATIS ORBE PACTO THEATRUM QUO POPULUS OBLECTARET EDENDUM CENSUIT ANNO REGNI IV ANNO MDCCXXXVII." Onofri 1789, 138, 131.

99. After a medallion of Ferdinand the Catholic was found during the excavation of foundations, a proposal circulated to name the theater San Ferdinando. On the significance of the naming, see Traversier 2009, 51–53.

100. This royal subsidy included the value of the San Bartolomeo at 12,086 ducats. See Croce (1896) 1968, 2:178, no. 1; 272, no. 3; 275.

101. "Le théâtre est reussi magnifique, & on entend la voix mieu que dans aucun autre." Charles III 2001–2, 2:249.

102. "Quel di Parigi non vale la metà di questo." Tanucci 1980–2003, 1:192–93.

103. "il re entrando nella sala, maravigliando l'opera grande e bellissima, battè le mani all'architetto, mentre plausi del popolo onoravano il re, cagione prima di quella magnificenza. . . . In mezzo all'universale allegrezza il re fece chiamare Carasale, e pubblicamente lodandolo dell'opera, gli appoggiò la mano su la spalla come segno di protezione e di benevolenza." P. Colletta (1843) 1992, 68. Praise of the king was woven into the prologue of the opening performance: "Genio Real, di già compita è l'opra, / Che seppe concepir tua vasta idea: / Ecco il nuovo, sublime, ampio teatro, / Di cui più vasto Europa ancor non vide. / Ben da me si provide / A quanto uopo facea / Per superar dell'altre Etadi i preggi, / Nè Roma ne vantà chi lo pareggi." The chorus then exclaimed, "Viva Carlo, Carlo viva!" See Croce (1896) 1968, 2:281–82.

104. On their trial, see Strazzullo 1984, 161–62; Cantone 1987, 62–63; Ferri Missano 1988.

105. On the fall of Santiesteban, see Vázquez-Gestal 2009, 25–26.

106. The Princess of Belmonte's attack on Carasale began after a social affront in her palace. On their conflict and her fall from influence, see Schipa 1923, 1:321–26.

107. Burney claimed there were fourteen or fifteen rows. See Burney 1771, 330. Burney counted thirty seats per row, but Lalande reported twenty-six. The latter was correct. Lalande 1786, 7:200; Croce (1896) 1968, 2:276, no. 2.

108. Burney 1771, 330.

109. Lalande 1786, 7:200; Sharp 1767, 78–79.

110. Sharp 1767, 79.

111. On the royal guard's privileges, see Croce (1896) 1968, 2:276, no. 1.

112. All drawings of the theater as built show twenty-eight boxes on the level of the king's box. This is confirmed by Dumont's drawing. The upper three tiers contained two additional boxes according to Burney 1771, 330. Fewer boxes are recorded by Lalande 1786, 7:198; Napoli-Signorelli 1787–90, 6:250. Sharp reported that the upper three tiers of boxes were not sold, and could be rented on a nightly basis. One could not buy a single seat but had to rent an entire box. See Sharp 1767, 79.

113. On boxes in Italy, see Ivanovich 1687, 402–3. At the San Carlo, boxes were likewise considered private properties that were alienable only by royal decree. In 1737 a box in the first or second tier cost 770 ducats, and the annual subscription fees were 280 ducats. Croce (1896) 1968, 2:275–76, no. 2.

114. Croce (1896) 1968, 2:277, no. 2; 275–76, no. 2; *Corrispondenze diplomatiche veneziane* 1992, 484–85.

115. See Tanucci 1980–2003, 1:189.

116. A similarly detailed spatial hierarchy was devised simultaneously in Turin for the ostentation of the Holy Shroud. Scott 2009, 152–53.

117. See Croce (1896) 1968, 2:277.

118. Robinson 1990.

119. On the social role of theater boxes, see Vaussard 1962, 159–69.

For descriptions of the boxes in the San Carlo, see Grosley 1769, 2:232; Burney 1771, 330.

120. Sharp 1767, 76.

121. "riempiuti di dame, adorne di ricchissimi abiti, e di preziosissime gemme, com'altresì di cavalieri in abiti di sfarzosissima gala." *Gazetta di Napoli*, 5 November 1737.

122. "I lumi copiosi de' palchetti riverberati e in mille guise moltiplicati dalle scintillanti gemme di tanta nobiltà, cangiano la notte nel più bel giorno, e l'uditorio in una dimora incantata di Circe o di Calipso." Napoli-Signorelli 1787–90, 6:252.

123. "S'è deliberato di non permettere ad alcuno di far aggiungere, così dal di dentro, come al di fuori arma di sorta alcuna, oltre quell'indifferente geroglifico in pittura che sara commune per tutte le loggie del detto teatro." *Corrispondenze diplomatiche veneziane* 1992, 485.

124. On these efforts, see Rao 1992, 284; Montinori 2000, 25–29; Ajello 1972, 526–38.

125. "Charlotte Gaetani d'Arragon, Princesse de St. Sévére, represente tres humblement à V.M. que le Prince son mary Luy ayant donné esperance d'avoir une loge au second étage pres des ses amies pour pouvoir être en bonne compagnie, mais entendant dire à present qu'on veut lui en donner un au premier étage, elle a recours à l'auguste refuge de la Royale Clemence de V. M.; affin qu'Elle d'aigne accorder une satisfaction si juste a la supplicante, qui ne cessera de faire des voeux pour la plus parfait felicité de V.M. etc." Cited in Croce (1896) 1968, 2:275, no. 3.

126. "Onde ciascuno comparisce in pubblico con un'apparenza di morigeratezza e di civiltà, che in privato non sa possedere, e si sforza di comparire qual realmente dovrebbe essere. . . . Perciò fuori di casa e nelle numerose brigate si sfoggiano quelle pompose vesti e quelle attillature che ciascuno solitariamente nella sua propria abitazione non usa portare. Come le robe da camera sono agli abiti di comparsa, così la morale interna è all'esterna.

Or questo bel contegno esteriore, quantunque apparente è di grand'utile alla società ed agl'individui, e potrebbe ancora penetrare nell'interno dell'animo, se più si moltiplicassero le occasioni di vivere in pubblico." Milizia (1847) 1973, 84–85.

127. Alberti 1988, 268.

128. Elias 1983. For a different interpretation of the social control exercised through the spectacles in the San Carlo, see McClung 1998.

129. See Lalande 1786, 7:200; Filangeri cited in Greco 1981, 57.

130. "Du libertinage & de l'impiété, & depuis sa correction, l'Ecole des mauvaises moeurs & de la corruption." Riccoboni 1738, 12. The problem was pronounced in France as well. See Johnson 1995, 26–29.

131. Caroline regulations were published as *Piano che si forma per dar sistema e buona condotta nel nuovo teatro eretto in Corte per le tre rappresentazioni drammatiche che ogni anno si dovrano fare con compagnia di migliori cantanti e dei migliori ballerini.* See Croce (1896) 1968, 2:276, no. 2.

132. Accounts confirm that no clapping took place. See Burney 1771, 339; Croce (1896) 1968, 2:339.

133. "Coercet ac spectatoribus silentium, philosophorum scholis dignum, indicit." Vico 1982–2004, 9:220.

134. Ballet troupes were imported from Venice. See Holmes 1993, 94.

135. See Prota-Giurleo 1952, 104–25. Comic opera was performed only once in the San Carlo during the king's reign. See Maione and Seller 2005, 26. On debates surrounding Neapolitan comedy and the cultural effects of forbidding it, see Naddeo 2001.

136. Sharp 1767, 75.

137. See Sparti 1989; Giordano and Marchesi 2000.

138. Carpanetto and Ricuperati 1987, 85–88; Dixon 2006, 27, 32–33, 37–38.

139. For an evaluation of libretti from the period, see Accorsi 2003; Di Benedetto 2000.

140. The king's perspective is recounted in Onofri 1789, 133; Dietz 1966, 103.

141. On the performance, see Maione and Seller 2005, 19; on the opera's history, see Heller 1998.

142. Feldman 2010, 227–91.

143. See Heartz 2003, 362. On Knobelsdorff, see Kadatz 1983, 40, 125–34.

144. "nobilitare i sentimenti d'una moltitudine di Cittadini." Milizia 1773, 28.

145. Holmes 1993, 108–17.

146. Metastasio 1951–65, 4:172–73.

147. "Si strilla, come sulla piazza del Mercato." Vanvitelli 1976–77, 2:162.

148. Quoted from Metastasio's letter to Farinelli of 25 April 1770. Transcribed in Burney 1796, 2:405.

149. Ibid., 406.

150. "Le premier Orchestre de l'Europe pour le nombre & l'intelligence des Symphonistes est celui de Naples." J.-J. Rousseau 1768, 354.

151. On the size of the orchestra, see Prota-Giurleo 1927a, 1927b.

152. Dresden's orchestra expanded from 27 to 40, Turin's from 22 to 39, and Berlin's from 28 to 40. For a table of these numbers, see *The New Grove Dictionary of Opera*, s.v. "Orchestra."

153. Quantz (1752) 1966, 200. For other instances in which composers changed style for different architectural settings, see Wolff 2000, 165–66; Meyer 1978; Forsyth 1985, 9.

154. Quoted in Degrada 1977, 239.

155. Mancini 1987a, 36–46; 1987b.

156. Mozart 1962–75, 1:358.

157. Kranich 1933, 2:199–240; Tintelnot 1939, 112–13; Mullin 1970, 56; Izenour 1977, 52.

158. See Strazzullo 1974, 155; Ciapparelli 1999, 21–29.

159. On Pöppelmann's theater, see Heckmann 1972, 145–47. On the Bourbon-Wettin theatrical parallels, see Dietz 1966, 99; Caraffa 2006, 288–93. Performances at the San Carlo were suspended for a period of mourning after the death of the queen of Poland in 1757. See Tanucci 1980–2003, 5:494.

160. See Tamburini 1991, 34.

161. "Ho veduto il vasto regio Teatro, il quale però non è riuscito nella proporzione e buon gusto uguale

a quello di V. M., anche a riguardo degli ornamenti." Quoted in Croce (1896) 1968, 2:285, no. 1.

162. The first monograph on an opera house was *La maison de l'Opéra* (1743), which contained thirteen plates of Knobelsdorff's Königliche Oper. On the dynastic importance of the *Narrazione,* see McClung 1998.

163. *Il nuovo Regio Teatro di Torino apertosi nell'anno MDCCXL disegno del Conte Benedetto Alfieri* (1761).

164. Hammitzch 1906, 83; Tintelnot, 1939, 114; Leclerc 1946, 190–209.

165. "En Vérité nous devrions avoir honte de n'avoir pas dans toute la France une seule salle de spectacle, si ce n'est celle des Tuileries, peu commode et dont on ne se sert presque jamais. La salle de l'Opéra, bonne pour un particulier qui l'a fait bâtir dans sa maison pour jouer sa tragédie de *Mirame,* est ridicule pour une ville et un peuple comme celui de Paris. Soyez bien certain que le théâtre proprement dit de la salle de Naples est plus grand de toute la salle de l'Opéra de Paris, et large à proportion." Brosses 1986, 1:399.

166. Voltaire 1877, 488, 499.

167. Dumont's book was titled *Parallèle de plans de plus belles salles de spectacles d'Italie et de France* (1763). On Soufflot's voyage, see Rabreau 1975.

168. On the Querelle, see Isherwood 1996.

169. Chaumont 1766, 17–18; Patte 1782, 17–18.

170. See Mezzanotte 1982, 41–68.

171. Mancini, Muraro, and Povoledo 1985–95, vol. 1, tome 2, 189–98.

172. The few exceptions include Forsyth 1985, 77–100; Fabbri et al. 1998; Moretti 2008, 95–125; Howard and Moretti 2010.

173. For a brief summary of eighteenth-century ideas on acoustics, see Marchesi Cappai 1935, 149–53.

174. See Arnaldi 1762, 18. Kircher's theory of sound was outlined in his *Musurgia Universalis* (1650). Patte followed Kircher's theory. See Patte 1782, 5–18.

175. Mersenne 1648; Chaumont 1766, 8–10.

176. Newton (1730) 1979, 64–72; Saunders 1790, 5–25.

177. "Perché un teatro sia armonico credo non vi siano fondate teorie . . . quella figura sempre con felice riuscita." Quoted in Mancini, Muraro, and Povoledo 1985–95, vol. 1, tome 2, 270–75.

178. Beranek 2004, 624.

179. Ibid., 14–15.

180. Ibid., 624–25, 181.

181. Mancini, Muraro, and Povoledo 1985–95, vol. 1, tome 2, 185–89.

182. Mielziner 1970, 55.

Chapter 2

1. See Valenzi 1995, 7–11.

2. Guerra 1995.

3. Vives 1999. On other early modern attitudes toward mendicancy, see Geremek 1994, 186–91; Carmichael 1986, 99–100.

4. Capasso 1883, 155–68.

5. See Filangeri Ravaschieri-Fieschi 1875, 1:320; Di Meglio and Vitolo 2003, 44–71.

6. Gentilcore 1999, 132–47; Filangeri Ravaschieri-Fieschi 1875, 1:6–24, 2:97–99.

7. In the mid–seventeenth century the Santa Casa dell'Annunziata boasted a patrimony of 200,000 *scudi* and by 1717 counted a history of thirty thousand estate donations. See Filangeri Ravaschieri-Fieschi 1875, 1:117–18.

8. Strazzullo 1968, 205–39.

9. Schott 1660, 264–65.

10. On the northern Italian attempts, see Pullan 1978, 1009; Aikema and Meijers 1989, 249. On Rome, see Keyvanian 2005, 301–5.

11. Evans 1982, 52; Geremek 1994, 220; Lis and Soly 1979, 112–21.

12. Ballon 1991, 166–98.

13. Foucault 1965, 39; Gutton 1974, 129–36; Geremek 1994, 220–29.

14. Pérez de Herrera 1975, 51–132.

15. Ibid., 226–28.

16. Ibid., 205–22, 230.

17. Cavillac 1975, xcviii–cxxiv; Jiménez Salas 1958, 89–103.

18. See Guardamagna 2001, 85.

19. An edict of 14 February 1667 required beggars to present themselves for confinement by 3 March.

Eight hundred were taken in by that deadline. On its history, see Filangeri Ravaschieri-Fieschi 1875, 2:37, 49–52; Petroni 1864, 18; Carrió-Invernizzi 2008, 267–71.

20. Carrió-Invernizzi 2008, 271–73. Cosimo Fanzago sculpted the statues of San Pietro and San Gennaro in 1667. Bartolomeo Mori executed those of the king and viceroy in 1668. Galasso 1982, 2:120; Petroni 1864, 10.

21. Pandolfi 1671.

22. A *quindennio* was a fee paid every fifteen years. See Filangeri Ravaschieri-Fieschi 1875, 2:37, 67.

23. See Geremek 1994, 224; Gutton 1974, 127.

24. Quoted in Heath 1963, 146.

25. See Gutton 1974, 129–30; Pullan 1978, 1020; Molenti 1995, 30–31; Stargard 1995, 89–159.

26. Henderson 2006, 113–49.

27. Foster 1973; Welch 1995, 117–44.

28. Jetter 1986, 99, 158–59.

29. "una sola chiesa servisse a tutti." Cited in Braham and Hager 1977, 139.

30. In Palermo potential architects of the Albergo dei Poveri were instructed to make "una chiesa che fosse ad un tempo stesso comune a tutti, e per tutti divisa." Quoted in Vitella 1999, 19.

31. See Guardamagna 2001.

32. Sterne 1768, 16–17.

33. The first of these is *Il mendicare abolito nella città di Montalbano da un pubblico ufizio di Carità* (1693). It is clear that Guevarre also authored *La mendicità provveduta nella città di Roma coll'ospizio pubblico fondato dalla pieta, e beneficenza di Nostro Signore Innocenzo XII Pontefice Massimo: Con le risposte all'objezioni contro simili fondazioni* (1693). His final treatise was *La mendicità sbandita col sovvenimento de' poveri tanto nelle città che né Borghi, Luoghi, e Terre de' stati di quà, e di là da' Monti, e Colli di Sua Maestà Vittorio Amadeo* (1717).

34. Guevarre 1717, 40, 111–10, 121, 137, 171.

35. Molenti 1995, 69.

36. A copy of the *"tratado"* of Turin's poorhouse, referring to

La mendicità sbandita, was given by the king to the governors of the Albergo dei Poveri of Naples on 9 March 1751. "El Rey passo di manos el adjunto tratado del Hospital General de Turin y otros de aquellos estados," ASN, *Ministro degli Affari Ecclesiastici,* 138, 61v.

37. Moricola 1994, 5; Petraccone 1974, 131–34.

38. "la formazione di un luogo per li invalidi, ove saranno racchiusi assieme coi poveri." Transcribed in Ajello 1972, 587.

39. Jiménez Salas 1958, 202–3.

40. See Guerra 1995, 157–62. For a broader examination of early Bourbon commercial policy and its relation to the Albergo project, see Ajello 1972, 461–717. We know Montealegre contemplated the French model in ASN, *Segreteria d'azienda,* 7, 62.

41. His proposal is discussed by Michelangelo Schipa (1923, 2:95).

42. Letter from Montealegre to Giovanni Brancaccio cited in Petroni 1864, 66, no. 37.

43. The best history of Neapolitan involvement is in Schipa 1923, 1:329–95.

44. Fogliani remains the least studied Caroline minister. For a brief biography, see ibid., 2:2–3.

45. "Uomo di statura grande, viso lungo, pelo biondo, di mente mediocramente ornato, non molto inteso delli usi delle corti, molto inclinato per la Francia, facile a sbilanciare nelle espressioni sue ed a ravvedersene poi con le sue promesse, e per dire il tutto in poche parole uomo lungo e inconcludente negli affairi." Quoted in ibid., 2:3.

46. Nicoloso 1995; Vitella 1999, 18–46.

47. Onofri 1803, 465–67.

48. On the reference to Prague, see documents cited in Filangeri Ravaschieri-Fieschi 1875, 3:183. For the queen's visit, see Moli Frigola 1993, 281. The Invalidenhaus was never completed. See Brucker and Vilímková 1989, 137–41.

49. On Rocco, see Zerella 1968, 11–32.

50. The titles of Rocco's treatises were *Progetto secondo Ritrovati, Modi,* *e Regole per formare un generale ritiro per tutti li Poveri del Regno* and *Progetto terzo per la providenza a togliere la difficoltà come si debba fare, che li Poveri, che sono ammogliati, ò sieno vedovi, o vedove con figli piccoli, e che non abbiano da andare per la città mendicando, assegnando loro il vivere proporzionato alla fatica, se sia possibile &c.* Cited in Onofri 1803, 323.

51. "Precedente l'esame fatto da una Giunta di Togati Ministri ha S.[ua] M.[aestà] approvata l'idea posta in campo dal Padre Rocco dell'Ordine de' Predicatori di chiudere in un Albergo, con pochi anche Lavorieri, a forma di quello, che si suol praticare in altri Paesi, i Poveri, tanto Uomini, che Donne, che in gran numero dimorano in questa città." ASV, *Segr. Stato, Napoli,* 227, 367r–v. Filangeri Ravaschieri-Fieschi 1875, 3:181–82; ASN, *Ministro degli Affari Ecclesiastici,* 143, 117r.

52. The council convened on 1 August 1748. ASN, *Segreteria d'azienda,* 5, 47.

53. See Origlia 1753–54, 1:296.

54. See Guerra 1995, 220, no. 112.

55. Schipa 1922.

56. On Canevari, see *Dizionario biografico degli italiani,* s.v. "Canevari, Antonio"; Santoro 1969, 202; Dixon 2006, 86–94. Barbera, 2007.

57. ASN, *Segreteria di Stato di Azienda,* 47, 5.

58. ASN, *Ministro degli Affari Ecclesiastici,* 109, 51v.

59. ASN, *Segreteria di Stato di Azienda,* 52, 2.

60. Nicoloso 1995, 123; Vitella 1999, 22.

61. ASN, *Ministro degli Affari Ecclesiastici,* 109, 51v.

62. "Molto migliaia di persone." ASV, *Segr. Stato, Napoli,* 227, 367r. A typical request from Naples asks

al proprio tiempo, que de orden del Rey devuelvo à S.[ua] Ex.[ellenz]a, la adjunta carta del Cónsul de Génova D. Bartolome Poggi . . . que basteará que el nuevo diseño se haga con la distinción del numero de gente de que es capas, de las oficinas, ó sean laboratorios, de las habitaciones de los Ministros, y de los alojamientos de los hombres, y mujeres . . . que tocante al diseño de Turin, se desean los diseños separados del Hospital de la caridad; que está en la calle, llamada del Po, y del Colegio de las Provincias, situado en la Plaza Carlina, con las distinciones que se han declado sobre el Albergue de Pobres de Génova, y así mismo que se podrá de nuevo escribir al que enviado el diseño del Albergue de Pobres de Roma, declandosele la distinción del numero de gente de que es capaz.[idad] aquel diseño.

ASN, *Ministro degli Affari Ecclesiastici,* 110, 42r. See also ASN, *Ministro degli Affari Ecclesiastici,* 109, 120r, in which the court desires "un idea compiuta del disegno."

63. Fuga was paid for coming to the city to present the design on 2 April 1749. "El rey ha recuesto que por el R.[ea]l Camera se pagues cien doblones oro al arquitecto Caballero Fuga por el Dibujo formado por el, y que ha venido da Roma particularmente aquí para formarlo, del Albergue de Pobres que ocurra erigirse por sul Maj.[estad] en esta cuidad." ASN, *Ministro degli Affari Ecclesiastici,* 116, 31v–32r. See also ASV, *Segr. Stato, Napoli,* 228, 298r.

64. Brancone noted that Vaccarini was compensated for his efforts. ASN, *Ministro degli Affari Ecclesiastici,* 120, 80r. In April of 1750 he asked the minister of commerce to arrange the return shipment of Vaccarini's model. "Reviendo per restituido à D. Juan Bap.ta Vaccarini en Palermo el modele que venido al rey per el Albergue de Pobres." ASN, *Ministro degli Affari Ecclesiastici,* 127, 54v.

65. Vanvitelli 1976–77, 1:228. On Portocarrero's prominence, see Guerra 1995, 218, no. 64. See also ASV, *Segr. Stato, Napoli,* 229, 109r.

66. On his career, see Milizia 1781, 2:380–87; Kieven 1988; *Macmillan Encyclopedia of Architects,* s.v. "Fuga, Ferdinando"; Palmer 2004, 3–145; H. Minor 2010, 59–90, 126–84.

67. On the Accademia di San Luca, see Hager 2000, 23–37.

68. "nasce naturalmente nella mente degli Omini, e si perfezziona poi con li buoni studij." Quoted in Azzaro 1996, 56.

69. "che l'Architetto si regoli in miglior forma dall'altre Fabriche gia stabilite." Ibid.

70. On Fuga's early contact with the Spanish and Neapolitan courts, see the anonymously written "Elogio del Sig. Cavaliere Don Ferdinando Fuga" 1788; *Filippo Juvarra a Madrid* 1978, 37–40; Sancho 1991, 245–48; Antinori 2001.

71. Strazzullo 1979, 320.

72. See Schipa 1923, 1:274.

73. *Dizionario biografico degli italiani*, s.v. "Brancone, Gaetano Maria."

74. "soggetto d'intelligenza, dottrina, probità e zelo per il real servizio." Quoted in Ajello 1972, 630.

75. "uomo di piccolo spirito, di niuna letteratura: molto divoto e banalmente ambizioso." Genovesi 1962, 60.

76. "qualche paglietta di Napoli." Quoted in Ajello 1972, 631.

77. "Fuga spaventa richiedendo un mezzo milione, quando Brancone autore di tal pensiero, con tre cento mila, crede potersi eseguire, e dice di non imbrogliarsi neppure in trovar questi, avendo l'idea, come nell'anno scorso fu scritto di tassare i Luoghi Pii." ASV, *Segr. Stato, Napoli*, 228, 289r. See also ibid., 233, 149r.

78. "così adattate, distinte, è chiaro." ASN, *Ministero degli Affari Ecclesiastici*, 120, 79r–v, 80v.

79. These drawings, never doubted as the first presentation draft for the Albergo, have previously been dated as early as 1748. See Guerra 1995, 172; Kieven 1988, 69–72.

80. On the Escorial and hospital architecture, see Kubler 1982, 44–45. Prints of the Escorial circulated in Naples. See Vanvitelli 1976–77, 2:514, 517.

81. Guerra 1995, 172. The royal government proposed demolishing the musical conservatory of Santa Maria di Loreto for the creation of the Albergo. See Robinson 1972, 21.

82. Authors lauded the view of Naples from the sea. As Carlo Celano stated, "Dal mare apparisce in forma d'un nobilissimo teatro, perchè vedesi situata nella falda delle colline di S. Erasmo . . . ed è spettacolo degno d'esser veduto da mare in occasione di qualche festa di notte, quando le finestre sono adornate da quantità di lumi: confesso, che cosa più dilettosa veder non si può in terra." Celano 1856–60, 1:61–66.

83. Braham and Hagar 1977, 143.

84. Hills 2004, 121–23.

85. During the early eighteenth century the importance of confession was reemphasized in written treatises. These included Ludovico Sabbatini d'Anfora's *Il clero santo o santificato* (1730) and Giuseppe di Jorio's *Istruzione per li confessori di terre e villaggi* (1740). See De Maio 1971, 240.

86. Reservations were first voiced in November of 1749. See ASN, *Ministero degli Affari Ecclesiastici*, 23, 55r–57v. Concern about selecting an appropriate site spread beyond the court. In his 1750 letter calling for a map of Naples, the duke of Noja stated that it could help planners select an appropriate site for the "Ospedale de' poveri." See Carafa (1750) 1969, 17. On the Via dell'Arenaccia, see De la Ville sur Yllon 1888, 153.

87. Curcio 1998, 180.

88. See Schipa 1923, 1:269.

89. "El Caballero Fuga con un manuscrito el mismo en que se halla distintamente explicada su idea, como también un Plano formado por otro sujeto del sitio, y el terreno, y una relazion del Ing.[ero] Lucas Vechione del Tribunal de Fortificaciones qua trata del agua perenne que actualmente existe en che conservatorio del Loreto, y como pueda aumentare." ASN, *Ministero degli Affari Ecclesiastici*, 121, 59r–60r.

90. The original report was submitted 30 November 1749 to Michele Reggio, commander of the navy, and passed to Brancone a few days later.

In visto dela relacion de V.[uestra] E.[xcelencia] del 30 caído respectivo al Edificio p.[ar]a Albergue de Pobres q.[ue] contiene distintam.[en]te los puntos concludes [concluyes] p.[o]r V.[uestra] E.[xcelencia] col el Architecto [Arquitecto] Caball.[er]o Fuga, de las reflexiones de este p.[o]r la q.[ue] mira ā los tres sitios de Loreto, de Puerta Nolana, de S. Ant.[oni]o Abad, y de la merito de tales sitios, hab.[endo]le el rey confirmandose con el uniforme parerer de ambos habiendo en q.[ue] sea fundado tal Albergue en el sitio determinado entre los Puertas Nolana, y la del Carmen, en preferen.[ci]a del primero de Loreto como mas ventajosos, y útil para el cual efecto de aquellos a V.[uestra] E.[xcelencia] la Planta del mismo como tambien el dibujo ya hecho p.[a]ra el menzionado [mencionó] Albuergue p.[o]r el d.[ic]ho Caball.[er]o Fuga con la acomodazion [acomodación] hecha en el delas oficinas en figura regular quadrelungar, asimismo hab.[en]lo venido S.[ua] M.[aesta]d en aprobar el dictamen de V.[uestra] E.[xcelencia] en q.[ue] segun el dibujo estando las oficinas situadas p.[o]r ellas la fabrica, y subcesivam.[en]te haberse el cuarto adyacente de las necesarias se entiende el de las sinistra [izquierda] hab.[en]do ya S.[ua] M.[aesta]d dado la orden al sobre d.[ic]ho Architecto [Arquitecto] Fuga q.[ue] con la posible solicitad dispenga sea dicho en d.[ic]ha Ciu.[da]d de Roma base su direccion en molde de su dibujo, debiendo tamb.[ie]n haber los estudios en grande de aquellos partidas de fabrica q.[ue] le parereran los mas difíciles . . . y habiendo resuelto en el particular del Agua necesaria ā d.[ic]ho Albergue, q.[ue] en primer lugar sea tratado, y examinado este necesario punto, y q.[ue] tal efecto trate V.[uestra] E.[xcelencia] con Maresca p.[o]r el adquisto del Agua, que ahora se pierde p.[o]r la canaltura rota, y respecto à la otra parte del Agua q.[ue] va a los molinos examine, si reherrandose los conductos q.[ue] llevan el Agua a Mataloni

[Maddaloni], y adquiriendose porto al refleccion m.[a]s cantidad de Agua. Podrá detenerse el intento de darse igualm.[en]te el Agua a d.[ic]hos Molinos de esta Ciu.[da]d, y al Albergue la porcion tan necesaria p.[a]ra lavar, bebidar deles Bestias, y los de mas cosas p.[a]ra los cuales no sea de Menester el Agua limpida, y clara, desando S.[ua] M.[aesta]d al notorio zelo de V.[uestra] E.[xcelencia] el procurar la tiracion deste principal punto del Agua, q.[ue] puede tamb.[ie]n servir p.[a]ra la fabrica del mismo Albergue haviendo igualm.[en]te S.[ua] M.[aesta]d aprobado sean puertes los requentes en d.[ic]ho sitio ya determinado, y q.[ue] p.[o]r ahora sea solam.[en]te comprado aquel tereno q.[ue] sea considerado necesario p.[a]ra construccion delas oficinas y la quarto parte del dibujo.

Ibid., 123, 55r–57r.

91. Ibid., 121, 59r–61r.

92. Fiengo 1990, 96–104.

93. See documents in Francobandiera and Nappi 2001, 59, nos. 1–3; Bianchini 1859, 355.

94. Palmer 2004, 101–5.

95. "Dalla sua lettera la necessità di doversi formare un modello per l'edificio di un'opera cotanto magnifica, ed essendo nel tempo stesso ricordevole il re della proposizione già buon tempo da V.[ostro] S.[ignore] fattami a voce, cioe che per formarsi in Roma tal modello di legno eran sufficienti ducati cinquecento Napoletani." ASN, *Ministro degli Affari Ecclesiastici*, 120, 102v–103r.

96. Ibid., 79r–80r, 102v–103r, 130v.

97. Vitella 1999, 19.

98. On these uses of models, see Kieven 1999, 204–5.

99. Hager 1975, 349; Braham and Hager 1977, 140; Andreozzi 1984.

100. "qualche altra piccolo somma . . . far seguire tutto il disbrigo del modello con tutta la possibile celerità." Dispatch of 4 July 1750. ASN, *Ministro degli Affari Ecclesiastici*, 130, 28r–v.

101. Informing First Secretary of State Fogliani that the model was complete, Brancone asked him to send 200 ducats to Fuga and instruct the architect to send the model to Naples by sea. It arrived in Naples in January. Ibid., 132, 130r; 136, 109r.

102. "Luogo adattato, anche per comodo, e sodisfazion del Pubblico, che h.a l'osservi." Letter of Cappellano Maggiore Celestino Galiani dated 2 March 1751. Ibid., 687, unnumbered sheet.

103. Brancone initiated the land purchase. The catalyzing factor was an expected gift from the Duke of Modena, a client ally of the king. There is no evidence that this money arrived. See ASV, *Segr. Stato, Napoli*, 232, 366v. Documents relating to the purchase of the land date from January through early March of 1751. These dispatches document a cost of 23,000 ducats to be paid over the course of a year. See ASN, *Ministro degli Affari Ecclesiastici*, 136, 8r, 81r–v. See also Francobandiera and Nappi 2001, 59, nos. 1–3; L. Bianchini 1859, 355.

104. "Abbiamo desiderato di erigere in questa capitale un Generale Albergo dei Poveri di ogni sesso ed età, e quivi introdurre le proprie e necessarie arti, affinchè tal opera riesca grata agli occhi di Dio, e di beneficio di questa città e Regno." The edict is transcribed in Filangeri Ravaschieri-Fieschi 1875, 3:160, no. 1.

105. "Il Re, e la Regina sono andati a Caserta per fare gran disegni con Vanvitelli, il quale presso a Fogliani pare che in contri assai più di Fuga fatto venire da Brancone per il Reclusorio de' Poveri." ASV, *Segr. Stato, Napoli*, 233, 149r.

106. "Fu ordinato a Vanvitelli il Disegno d'un gran Palazzo con Quattro Cortili." Dispatch of 25 March 1751 in ibid., 158r.

107. Giovanni Bompiede's report on the failed excavation was written on 18 March 1751 and reached Brancone on 21 March.

Stante la fatica fatta da due giorni, e due notti . . . in aggottare acqua, affine di continuoare á profondare il cavamento, oltre palmi ventinove, del pavamento del cantiere dalla parte di Tramontana dell'Albergo dei Poveri, non ostante che si fatto poste in lavora tre Trombe, due delle qual d'attrazzione, e l'altra à Rosario, con due passa mano di lati, in quali lavori vi vanno impiegati più di cento persone con grave spesa, mi pare d'obbligo, per non spendere infruttuosam.[en]te, da una parte all'E.[cellenz]a V.[ostr]a, accio si compiaccia ordinarmi come mi devo comportarmi per bene del Sevizio Reale. Parimente faccio presente à V.[ostr]a E.[cellenz]a come fino alli d.[ett]i palmi ventinove non si è ritrovato terreno vergine, e che avendo fatto piantare un palo di palmi undici nel fondo del cavamento già detto per osservare la qualità del terreno sotto posto, questo è entrato con grande facilità per altri palmi otto in nove con . . . una grande sorgiva oltre di quelle che vi erano, et avendo fatto far diligenza in che livello si trovai il fondo del cavamento con il livello ordinario del mare, si è rientrata palmi cinque più sotto del d.[ett]o livello. Per l'ultimo l'E.[cellenz]a V.[ostr]a può considerare la quantità d'acqua che n'è aggotata, che li pozzi delle paludi circonvicini ne sono quasi in secco.

ASN, *Casa Reale Antica*, 838. "Sobre lo obrado en el excavam.[en]to de los fundam.[en]tos sur el terreno de Loreto para la construcción de Albergue de Pobres, nomo también de las verías p.to con los diligencias usadas al Cab.[alle]ro Fuga uridante con los denos Pobres sores en el reconcimiento de otros sitos par cual construcción." 22 March 1751, ASN, *Ministro degli Affari Ecclesiastici*, 138, 96r–v. "Respecto al nuevo sito expresado d. S. M.[aria] del Ángeles disponga assiem detto . . . medesimo Caballero Fuga todas aquellas varias experiencias sobre el agua y el terreno que por el mismo Caballero Fuga será formar lungo en que sito." 28 March 1751, ibid., 112v–113v.

108. Brancone signed the following document on 20 March 1751:

Videro un sito distante da quello di Porta Nolan ache propriam.[ent]e si produce al Largo di Porta Capuana, e considerarono esser l'aria della med.[esim]a qualità di quella di Porta Nolana: che la spesa del suolo sarebbe stata egualm.[ent]e eccessiva, perche paludoso: che qualora si fosse voluto far'uso dell'acqua della Bola che viene da Poggioreale, sarebbe stata da 7 in 8 palmi al di sotto del pian terreno: che l'uso dell'altra acqua de' mulini sarebbe stato poco superiore al pien terreno: E che finalm.[ent]e le med.[esime] difficoltà incontrate nel Sito di Loreto, si sarebbono parim.[ent]e circa i fondamenti ritrovate in tal nuovo sito. Quindi si portarono essi ad observar l'altra della Polveria vecchia, alquanto discosto da Porta Capuana, ma disposto il luogo più superiore. Ma incontrarono la Relivantissima difficoltà che l'acqua tra 12 palmi sotto al pian terreno. Finalm.[ent]e riconobbio il sito sotto le Croci di S. Maria degli Angioli, che si produce al Borgo di S. Antonio Abate considerarono la perfezzione dell'aria, l'aspetto del sito tutto a mezzogiorno, e che il vento di tramontana non s'impediva dalla colline sono assai più basse, ed in maggior rilevante distanza: che il modello per l'Albergo, non ostante che fosse stato foggiato in quadro, potea disporsi con maggior lunghezza, onde avvansandosi il sito dalla parte di dietro, sarebbe stato assai più libero il gioco de' venti: che tal bel sito sarebbe dentro l'abitato: che il suolo non essendo di paludi, ma di arbusti sarebbe costato più di due terzi meno di quello di Loreto: che il terreno sarebbe stato utilissimo per la fabbrica, e che con poca profondità si sarebbe trovato il solido, per le fondamente. Da lumi ricevuti dagli esperti di quell luogo, oltre dell'acqua altra volta già osservata,

la quale è 3 palmi sotto al pian terreno, Ritrovarono per buona sorte un'altro *corso* d'acqua cola in parte più superiore al piano della strada da circa palmi 10:circostanza rilevantissima e profitevolissima per costruzione dell'Albergo. Tutti i sud.[ett]i fatti concernenti tal sito si sono in quest'oggi da medesimi periti unitam.[ent]e con due de' primi Maestri Muratori discussi in un longretto fra loro tenuto. E siccome uniformam.[ent]e si è figurate l'impossibilità della fabrica nel primo sito di Loreto, così si e stimata profitevole e vantaggioso fra tutti gli altri siti quello di S. Maria degli Angioli.

ASN, *Casa Reale Antica,* 838.

109. ASN, *Ministro degli Affari Ecclesiastici*, 138, 96r–v.

110. The Deputazione della Salute was the civic council charged with overseeing public health in the city and had been created after the 1656 plague. By 1 May the poor were placed in the houses "of Venetians" near the church of Sant'Antonio Abbate and the Franciscan monastery of Santa Maria degli Angeli alle Croci, located to the northwest of the new site. Ibid., 138, 125v; 140, 6r–7r, 58v–59r.

111. For a contemporary assessment of the area, see Parrino 1725, 22.

112. "Fuga refarà il suo per il Reclusorio de Poveri mentre ora invece di quadro, deve essere bislungo, ma nel terreno designato s'incontra l'istessa difficoltà per i Fondamenti, non trovandosi il terreno Vergine." ASV, *Segr. Stato, Napoli,* 234, 130r.

113. See dispatch of 2 October 1751, ASN, *Ministro degli Affari Ecclesiastici*, 145, 18r–v.

114. A print of the Hôtel Dieu was found in the Archivio di Stato di Napoli and is now stored with the Albergo drawings. Guerra was the first to note Soufflot's possible influence on the Albergo. He believed the French architect intervened directly, but this would have been premature in the summer of 1750, when plans were still being made for the Porta

Nolana site. See Guerra 1995, 185. For Soufflot's visit, see Mondain-Monval 1918, 22–25.

115. ASN, *Ministro degli Affari Ecclesiastici*, 140, 102r.

116. Vanvitelli 1976–77, 1:31.

117. Fuga was informed of this priority on 15 May 1751 and reminded in a letter of 3 July. See ASN, *Ministro degli Affari Ecclesiastici*, 140, 93r–v; 142, 63r–v.

118. Guerra 1995, 207; Pevsner 1976, 147.

119. Guerra 1995, 197–210.

120. Guerra has shown that Fuga probably drew the idea for this ambulatory space from Carlo Fontana's design for a church in the Colosseum. Ibid., 197.

121. Ibid., 210.

122. Chierici 1931. See also G. Pane 1966, 76.

123. See Dell'Aja 1987, 22–26; R. Pane 1954; Donatone 1986, 121–29.

124. Unfortunately the arched windows provided the only illumination for the transverse corridors. Francesco Salmi, in a letter to Giovanni Bottari, observed: "il disegno dello spedale di Napoli [Albergo dei Poveri] senza lumi nelle corsie lunghe un quarto miglia misurato, salvo due finestroni nelli due estremi." Transcribed in Fichera 1937, 69.

125. Laugier 1977, 98. See similar debates in England in Stevenson 2000, 5–29, 85–105.

126. Stendhal 1958, 350.

127. "non piaciono, onde patisce la crisi del non edificandum." Vanvitelli 1976–77, 1:31.

128. "Vanvitelli *fa le cose pulite.*" Vanvitelli's emphasis. Ibid., 1:36–37.

129. Francobandiera and Nappi 2001, 59, nos. 1–3; L. Bianchini 1859, 355.

130. See ASN, *Ministro degli Affari Ecclesiastici*, 125, 24r–v; 143, 116r–77r; 145, 22v–23r; 148, 116v–117r; 150, 12r–v; 151, 16v–17r; and 157, 16r–v.

131. The architect detailed the work of the *pipernieri* in a manuscript report entitled *Misura finale di tutti li lavori di piperni in servizio del Reale Albergo dei Poveri.* G. Pane 1966, 78. It is now housed in the Biblioteca

della Facoltà di Architettura of the University of Naples.

132. For detailed analysis, see Strazzullo 1969, 163–72; Guerra 1995, 187–93. Court engineer Giuseppe Alviano was named proxy overseer. ASN, *Ministro degli Affari Ecclesiastici*, 150, 84v–86v.

133. ASN, *Ministro degli Affari Ecclesiastici*, 157, 13r–15v; 158, 65v–66v.

134. Bottari 1754, 115.

135. Baggio and del Co 2000, 70–89.

136. ASN, *Ministro degli Affari Ecclesiastici*, 157, 13r–15v; 158, 65v–66v.

137. The revised *istruzioni* are reprinted in Strazzullo 1969, 163–72.

138. The administrative reshuffling renewed momentum for the project. Additional land was purchased on 18 May 1753. ASN, *Ministro degli Affari Ecclesiastici*, 164, 34v.

139. The five plan drawings are signed and dated by Fuga and Brancone. On their provenance, see G. Pane 1966, 81, no. 14. Though they present a five-court building, work began on only three. "Se empieza por ahora a la fabrica de los tres frotespicios ò sean prospectos esto es el de medio, que servirá por la habitación de los oficiales según el Dibujo y en el cual será el ingreso a la Iglesia, y que los otros dos frotespicios de corades laterales a la detta Iglesia." Dispatch of 3 July 1751, ASN, *Ministro degli Affari Ecclesiastici*, 142, 63r–v. The two section drawings are labeled with the same script as the others, but neither is signed or dated by Fuga.

140. On the parlatori, see Onofri 1789, 107.

141. On the contested negotiations, see Fiengo 1990, 130–36, 162, 172.

142. Fuga labeled the portal beneath the armor "Porta del corpo di guardia de soldati per cautela del medesimo." He had used identical sculptural motifs above guards' rooms of the Palazzo della Consulta.

143. "REGIUM TOTIUS REGNI PAUPERUM HOSPITIUM."

144. Though the aediculae in these drawings reflect Fuga's draftsmanship, the figures seem to have been executed by a different artist. Given the loose execution and the use of red chalk, it seems likely that these parts were done by a local painter or sculptor who was influenced by Francesco Solimena.

145. On the royal subsidy, see L. Bianchini 1859, 335. Brancone hoped to imitate the examples of "Prague and other German cities" that depended on private support. Filangeri Ravaschieri-Fieschi 1875, 3:183. For example, the Prince of Palagonia left a bequest on 1 September 1749, and Giulio Iachino left one in September of 1753. See ASN, *Ministro degli Affari Ecclesiastici*, 121, 62r; 168, 89r. Many refused to give, including the painter Francesco de Mura. See Francobandiera and Nappi 2001, 62, no. 23. Private philanthropy has been generally overlooked as a source of support in poorhouses of the eighteenth century. For a study that gives proper emphasis to private charity, see Cavallo 1989, 93–97.

146. "confusioni e guai." Letter of 17 October 1750. ASV, *Segr. Stato, Napoli*, 231, 366v.

147. The Banco della Pietà offered 10,000 ducats in July of 1750. Francobandiera and Nappi 2001, 74, no. 86. On the threat to close foundations, see ASV, *Segr. Stato, Napoli*, 231, 99v; 232, 366v–367r.

148. The Discalced Carmelites paid 1,400 ducats on 2 May 1751. The monks of the Certosa di San Martino offered 1,000 ducats to Albergo on 26 January 1751. ASN, *Ministro degli Affari Ecclesiastici*, 136, 106r; 140, 65v–66r.

149. "affare ingiusto." Quoted in De Maio 1971, 371.

150. "È il re Cristianissimo il papa dei certosini." Reported by Tanucci 1914, 1:106.

151. Brancone went so far as to threaten suppression of the monastery in June of 1751. ASV, *Segr. Stato, Napoli*, 234, 190v. The gift was made on 19 June 1751. ASN, *Ministro degli Affari Ecclesiastici*, 142, 23v; ASV, *Segr. Stato, Napoli*, 234, 348r–v.

152. The Jesuits paid 400 ducats, while the Dominicans offered 1,000. These contributions date from March and August of 1752. ASV, *Segr. Stato, Napoli*, 236, 208r; 237, 126v. The Cassinesi paid 1,970 ducats. Filangeri Ravaschieri-Fieschi 1875, 3:196. The Carthusians offered 500 ducats. ASN, *Ministro degli Affari Ecclesiastici*, 157, 114r–v.

153. Vitella 1999, 18.

154. The suppression took place on 15 December 1751. ASN, *Ministro degli Affari Ecclesiastici*, 148, 49r–50r. The patrimony of the Coloritani was valued at 34,036 ducats. See L. Bianchini 1859, 355.

155. On the funding, see Dandelet 2007. These donations were questioned by Bernardo Tanucci in 1742. Tanucci 1980–2003, 1:543.

156. See Brancone's letters to Alfonso de Ligorio in Telleria 1950, 1:236.

157. "I ministri che circondano il re non potrebbero essere peggiori." Quoted in Pastor 1938–61, 35:56.

158. Dandelet 2001.

159. Garofalo 1963, 11.

160. *Ragioni per la Fedelissima, ed Eccellentissima città di Napoli* 1719, 73.

161. Carpanetto and Ricuperati 1987, 106–13.

162. On Caroline diplomacy with Rome, see Melpignano 1965.

163. This anonymous pamphlet is titled *Considerazioni proposte a Sua Maestà, che Dio guardi, sull'espediente che può maggiormente contribuire al ristabilimento dello stato del regno di Napoli* and is now housed in the BSNSP, MS XXI, d, 7, fols. 1–75.

164. On Corsini-Bourbon relations, see Pastor 1938–61, 34:354–97.

165. De Maio 1971, 185–91.

166. Michel 1983.

167. Fuga had designed the Quirinal Kaffeehaus. See Stoschek 1998, 159–63. The architect and Panini were also friends. When Panini visited Naples in 1762, he was hosted in Fuga's home. See Vanvitelli 1976–77, 2:840.

168. Pastor 1938–61, 35:480–82.

169. Haskell 1998, 9. In 1773 Cochin noted that the figures were far too large in respect to the buildings. For his comments and a full bibliography, see *Settecento a Roma* 2005, 244–45.

170. De Maio 1971, 206. On the cult of the Immaculate Conception in Spain, see Stratton 1994, 5–121.

171. On these renovations, see Strazzullo 1991, 130–43; Castanò 2003, 194–98.

172. See Fernandes Pereira 1995; Lattanzi 1995.

173. On the impasse over the Spanish and Roman Inquisition in Naples, see C. Black 2009, 41–45.

174. "meglio fatto per essere Gran Visire di Costantinopoli." Quoted in De Maio 1971, 206.

175. ASN, *Ministro degli Affari Ecclesiastici*, 148, 1v–2r; Vanvitelli 1976–77, 1:72.

176. Pastor 1938–61, 35:51–57.

177. See Genovesi in *Economisti classici italiani* 1804–16, 10:157.

178. Moricola 1994, 27–31.

179. D'Arbitrio and Zivello 1999, 37–38.

180. See Tanucci 1980–2003, 12:546.

181. The exact percentages are 53.3 percent by recommendation, 27 percent by forced enclosure, and 19.8 percent by application. These statistics date from the years 1751–58 and are examined in Moricola 1994, 38, 46–47.

182. See Moricola 1994, 43, 57, 120; D'Arbitrio and Zivello 1999, 63–72, 103–8.

183. On 21 December 1764 Tanucci wrote, "Fuga mi ha spaventato nella spesa, che dice necessario." ASV, *Carte de Gregorio*, 25, 13r. On the Albergo's failure during the famine, see ASV, *Segr. Stato, Napoli*, 271, 149r.

184. D'Arbitrio and Zivello 1999, 39–256.

185. Arrom 2000, 43–75.

186. Milton 2007, 154–80.

187. Guerra 1995, 215.

188. Jiménez Salas 1958, 158–59; Huget-Termes 2009.

189. On hospital's gestation and Sabatini's contribution, see Calatrava 1993a; Pisapia 1993; Sambricio 1986, 205–18.

190. See both Bentham 1995, 30; Howard 1780, 99.

191. The duke of Noja was a member of the Royal Society and sent them a copy of his map. See Bevilacqua 2004a, 350.

192. On the relationship between Adam and Bentham, see Bentham 1968–, 4:305–7, 309–11. Given the importance of the commission, it is likely that most architects working in Rome knew about the Albergo project.

193. See Evans 1982, 68, 318–44; Buccaro 1992, 105–10.

Chapter 3

1. The only article is Manzi 1969.

2. Kamen 2001, 188.

3. See T. Colletta 1981, 11–19.

4. Viceroy Pedro de Toledo (1532–53) undertook construction of the watchtowers in the sixteenth century. Pasanisi 1929; Faglia 1974, 13–22; Fenicia 2003, 57–76.

5. Roja is cited in Capel 2005, 232.

6. Roberts 1956, 16–18; Parker 1996, 13–16; Pollak 1991, 13–34.

7. See Eberhardt 1973; Hernando Sánchez 2000.

8. See Hernando Sánchez 2000, 522–26.

9. See Cámara Muñoz 1998, 59–81.

10. Hernando Sánchez 2000, 533–41.

11. Spagnoletti 1996, 20–26.

12. T. Colletta 1981, 11, 12, 57.

13. Entrusting Capua to a small defensive force would not have been unusual. Fortresses were "faites afin qu'une petite force résiste à une plus grande, ou un petit nombre d'hommes à un plus grand nombre." Errard 1600, 32.

14. As the military engineer Vauban stated, "Attaquer toujours par le plus faible des places et jamais par le plus fort." Vauban 1737, preface.

15. On the conquest, see Schipa 1923, 1:94–120; De Napoli 1934, 23–37, 72–86; Mafrici 2009.

16. The term "military revolution" was coined by Michael Roberts to describe the dramatic advances in military technology of the seventeenth century. See Roberts 1956, 1; Pollak 1991, 13–34. On eighteenth-century changes, see J. Black 1994, 9–15; Luh 2004, 83–99; Duffy 1987, 3–34.

17. Horsley 1744, 76.

18. Vauban used this term contemptuously to describe gentlemen dilettantes. Quoted in Langins 2005, 339.

19. See Spagnoletti 1996, 205, 209, 243–44.

20. See Origlia 1753–54, 2:327; Sansone Vagni 1992, 65–69.

21. Blessich 1895, 74.

22. Langins 2004, 37–46.

23. On these improvements, see D'Ayala 1835, 45; Schipa 1923, 1:335, 337; T. Colletta 1981, 40–57.

24. Duffy 1987, 35–46.

25. Montesquieu 1989, 338. Montesquieu had visited Naples in 1728, and the first Italian edition of the *Spirit of the Laws* was published there in 1750. See Di Rienzo and Formica 1998, 214.

26. See Hanlon 1998, 47–142; Spagnoletti 1996, 51–84, 182–95, 211.

27. Galasso 1982, 2:583–608.

28. See D'Ayala 1847, 337; Bologna 1958, 120–22.

29. BSNSP, MS XXI, C, 29.

30. See Schipa 1923, 1:334, no. 6; 338, no. 3; ASN, *Segreteria di Guerra e Marina*, 893, busta 2; Ajello 1972, 683.

31. The artillery corps was founded on 13 November 1744. See del Pozzo 1857, 51. On the arms manufactory, see Rubino 1975.

32. Del Pozzo 1857, 41.

33. Croce 1926, 386; Di Stefano 1970, 755.

34. Muller 1755, 222.

35. Antonio da Sangallo the Younger is credited with the first barrack design. Hale 1968, 523. For a recent study of Vauban's role in fortification improvements, see Virol 2003, 162.

36. See Vauban 1693, 86.

37. See Duffy 1975, 80; Dallemagne 1990, 42–65.

38. Tovar Martín 1995, 181–82.

39. Capel 2005, 246–49.

40. ASV, *Segr. Stato, Napoli*, 232, 306r.

41. Urrea 1989, 45, 49; Marías 2004, 270–72.

42. See Charles III 2001–2, 2:64.

43. On the Portici barracks, see ASN, *Segreteria di Stato di Casa Reale*, 894, unnumbered sheet. On the Palazzo Reale, see Schipa 1923, 1:337. For Caserta, see Vanvitelli 1976–77, 1:289.

44. On tactics, see Starkey 2003, 53. For contemporary perspectives, see Frederick II 1762, 119; Saxe 1757, 90.

45. Manzi 1969.

46. Schipa 1923, 1:329–31.

47. See BSNSP, MS XXI, C, 29.

48. Saxe 1757, 62–63. Saxe's opinions would have been particularly relevant in Naples. As illegitimate son of the king of Poland, he had helped reform the large Polish cavalry that Queen Maria Amalia knew from her youth.

49. Del Pozzo 1857, 62.

50. See Fiengo 1977, 28, 44; Carletti 1776, 53. Surviving drawings that bear Bigotti's signature include BNN, *carta geografica*, Bª-5C-51, Bª-27A-22, Bª-27A-23, Bª-27A-78, Bª-26-33, Bª-19-62, Bª-19-60.

51. Bélidor 1754, 72.

52. Contemporaries such as John Muller (1755, 223) advised locating staircases in the corners of the building.

53. Frederick II 1762, 38, 234.

54. Vauban 1737, 122–29.

55. Charles Léopold Andreu de Bilistein's opinion from 1763, quoted in Duffy 1987, 85.

56. See Starkey 2003, 21. Saxe tempered his advocacy, clarifying, "the privileges of birth [should be] required to be supported by those of merit." Saxe 1757, 13.

57. Hanlon 1998, 47–80, 202–19.

58. Barberis 1988, 19–21, 48–50, 109–11.

59. Ibid., 172–87; P. Bianchini 2002, 267–71.

60. Waddy 1990, 1–13.

61. Schipa 1923, 1:334.

62. De Luna 1760, 114–15.

63. Rao 1992, 286–308.

64. Illiteracy and province of origin were reported in documents. ASN, *Segreteria di Guerra e Marina*, 893, busta 2.

65. Boswell 1998, 927.

66. Frederick II 1762, 3. See also Boswell 1998, 927; Saxe 1757, 79–82. Military discipline was not admired by all. Voltaire blisteringly satirized it in *Candide* (1759).

67. Duffy 1987, 117, 120, 132.

68. See Rabelais 1991, 96.

69. Worsley 2004, 54.

70. On the kingdom's horses in the Bourbon period, see ASN, *Segreteria di Guerra e Marina*, 893, busta 2; Charles III 2001–2, 2:439. The committee of 1752 comprised Neapolitan nobles and military officers. ASV, *Segr. Stato, Napoli*, 236, 313r.

71. See Cavendish 1657; Solleysel 1672.

72. The 1835 copies, bearing inscriptions that claim they are exact copies of Vanvitelli's original drawings, are found in the Istituto Storico e di Cultura dell'Arma del Genio in Rome. They include plans of the ground floor, first floor, and a section of the building. The ground-floor plan (8-D-6-21) is signed by Leopoldo Vinci, while the first-floor plan (8-D-631) and section (8-D-629) are signed by Giovanni Panzera. The drawings were first noted by Garms 1975, 190–92.

73. See BNN, MS *Brancacciana*, I, E, 10, 130r–136v.

74. Celano 1856–60, 5:663; D'Ayala 1847, 55.

75. See L. Bianchini 1859, 444; BSNSP, MS XXIX, C, 7, 115r–v; Parrino 1725, 225; Strazzullo 1969, 138, no. 5. On the menagerie, designed by Ferdinando Sanfelice, see Sigismondo 1788–89, 2:197; Aprato 1964.

76. In the label to his drawing Bª-19-60, Bigotti stated that the structure would use "alcune mura che sono incominciate ad alzarsi tempo addietro in quello stesso sito."

77. The arcade lining the eastern court is labeled "Corridors that are projected to buttress the old walls, to connect the troops on the first floor, and to cover the horses in times of storms and calm them."

78. ASV, *Segr. Stato, Napoli*, 239, 3r–v; Vanvitelli 1976–77, 1:237.

79. The opinion of eighteenth-century Spanish historian Nicolás de Jesús Belando, quoted in Vázquez-Gestal 2009, 42–43. See also Mozzillo 1992, 79–123.

80. Schipa 1923, 1:360–62.

81. "Il Re ha mutato questa nazione bollente con una ferma e costante giustizia, con una truppa che non hanno mai veduto sì prepotente i Napoletani in casa loro." Tanucci 1980–2003, 3:143.

82. Pollak 1991, 55–148, 193–243.

83. See Strazzullo 1997.

84. Local governments, called *università*, paid the bulk of maintenance costs, while ecclesiasts provided roughly a fourth. ASV, *Segr. Stato, Napoli*, 233, 10r, 31r; Schipa 1923, 2:118.

85. See Vanvitelli 1976–77, 1:354.

86. Ibid., 1:345–336.

87. On the early careers of Sabatini and Collecini, see Costanzo 2006, 111–13, 120–24.

88. ASV, *Segr. Stato, Napoli*, 243, 330r.

89. The principal biographies of Vanvitelli are Vanvitelli Jr. (1823) 1975; Milizia 1781, 2:348–60.

90. See Vanvitelli Jr. (1823) 1975, 15; Milizia 1781, 2:349. On the stylistic relationship between Juvarra and Vanvitelli, see Cantone 2000.

91. See Kieven 1991b; Pinto 1986, 114–20.

92. P. Carreras 1977, 1–36.

93. See Sancho 1991, 245–48; Kieven 1991a, 175; Pinto 1986, 187; Kieven 2000.

94. See Garms 1992, 219; ASV, *Segr. Stato, Napoli*, 233, 149r; and a letter of 6 April 1751 in ASN, *Segreteria di Stato di Casa Reale*, 894, unnumbered sheet.

95. "Veramente avrei piacere di fare qualche cosa in Napoli, per dare un saggio di architettura a modo." Vanvitelli 1976–77, 1:155.

96. Three plans of the barracks made by an engineer named Pozzoli in 1869 were first cited by Garms 1975, 191. They are housed in the Istituto Storico e di Cultura dell'Arma del Genio in Rome as numbers 2-E-231, 2-E-232, and 2-E-233. We can assume that they accurately reflect the original building, since few changes after the 1760s are recorded in surviving documents. The single addition was the incorporation of the old menagerie into the barracks in the early nineteenth century. It is the angled wing extending to the northwest.

97. Millon 1984, 279–81.

98. BNN, MS XV, A, busta 9, 3r.

99. Vanvitelli 1976–77, 1:110, 354.

100. On Bigotti and Vanvitelli, see Garms 1975, 191.

101. Vanvitelli 1976–77, 1:345.

102. Ibid.

103. "ove non ne perdo né pure un palmo." Ibid., 347.

104. Ibid., 350–53.

105. "La figura di questo quartiere è talmente irregolare che si puol dare per problema. Io l'ho condotta in modo che faccio sparire tutte le irregolarità, anzi pare regolarissimo, et ho risparmiato ogni sito e perciò vi pongo comodamente 580 cavalli, 12 compagnie di 50 uomini l'una, 12 appartamenti per officiali di due camera et una cucina, un appartamento per il Maggiore di 3 camere, una galleria et una cucina; la facciata l'ho fatta seria all'ultimo segno, e si conosce che non è palazzo ma quartiere di soldati. Si farà la fabrica in tre anni, perché non si vogliono rimanere li cavalli che vi sono, essendo necessarii per tenere a dovere il fedelissimo popolaccio. Questi lavori mi servono di merito, ma non vedo cosa alcuna, ed all'incontro questi ingegneri mi si fanno nemici capitali, perché gli levo dale mani questi lavori." Ibid., 353–54.

106. Vanvitelli owned three books on fortification, though he did not mention the titles. Ibid., 425, 520.

107. P. Carreras 1977, 29, 31.

108. Curcio 1998, 195–99.

109. On the vaulting of stables, see Worsley 2004, 143.

110. Constructing sewers in the swampy land near the barracks was eventually deemed too costly.

Che nell'antico quartiere, primamente si rinovasse, una sola latrina riceveva le immondizie, e questa si ripuliva quando era ripiena. Nella nuova fabrica ce ne sono aggiunte altre Quattro dippiù coll'ugual peso di doverle mettere secondo l'occorrenza, il Re, dopo avere esaminato il sito con attenzione e previdenza, mi cadde in mente dare corso alle immundizie verso il Sebeto, perche la pendenza è troppo tenue dal quartiere al fiume, ed il costo si face una cloaca andante verso quella posta avrebbe sorpassato di molto

li ducati mille e sarebbe restate del tutto inutile, perchè le materie sono grosse restie, non già acqua corrente, che ogni piccolo prudenza consiglio antico è patentemente riconosciuto . . . [yet the inability to resolve the problem] hanno prodotto il insopportabile presente incomodo del puzzo dannosi agl'uomini ed alli cavalli.

BNN, MS XV, A, 8, busta 5, 65r.

111. For an examination of Laugier's thought within the context of other French theorists, see Szambien 1986, 92–98. Renato de Fusco has suggested that Vanvitelli knew Laugier's treatise. See de Fusco 1967, 16–17.

112. On "Arcadian architecture," see Benedetti 1997, 12–29, 83–95; V. Minor 2006, 97–114.

113. Vanvitelli states that his work-site system was approved along with the designs in the summer of 1754. BNN, MS XV, A, 8, busta 5, 2r–3r.

114. "Come architetto subalterno Francesco Sabatini, mio discepolo, il quale dovrà presidere ed offistece alla Fabrica affinche il Capo M.[aesto] Muratore, e gli artisti tutti, eseguiscono con puntualità cio che conviene. Dovra riconoscere, se la nota, o sian liste degli operarii corispondono alla quantità notata, e dopo tal recognizione dovra sotto scrivere quella, accio venga effettuato legitimamente il pagamento del Pagatore. Parimente dovrà sotto scrivere ogni nota dei materiali che saranno condotti alla fabrica; ogni conto, che debbasi tarare a prezzi doverosi, si quale dovrà consigliarsi meco, per togliere ogni conto giusto: tutte le spese minute che occorreranno parimente ne sotto scriverà la nota." Ibid.

115. On the career of Bernasconi, see Costanzo 2006, 230–32.

116. See Vanvitelli 1976–77, 1:376, 407, 424, 425, 428, 491, 498, 3:412. A complete accounting of the costs helps determine the most active periods of construction.

	20 gennaio 1755	300
	1 giugno	1200
	1 agosto	1000
	5 settembre	1000
	19 ottobre	1000
	31 dicembre	1000
	duc.[ati]	5500
1756	1 marzo	1000
	12 aprile	1000
	31 maggio	1000
	19 luglio	1000
	28 agosto	1000
	30 settembre	1000
	27 novembre	1000
	duc.[ati]	7500
1757	8 gennaio	1000
	10 marzo	1000
	30 aprile	1500
	3 giugno	1500
	14 luglio	1000
	24 agosto	1000
	22 ottobre	1000
	14 novembre	1500
	27 dicembre	1000
	duc.[ati]	10500
1758	1 febbraio	1200
	16 marzo	1000
	22 aprile	1500
	26 maggio	2000
	24 giugno	1500
	5 agosto	1000
	1 settembre	1000
	4 ottobre	1000
	8 novembre	1000
	18 dicembre	1000
	duc.[ati]	12200
1759	5 febbraio	1000
	26 marzo	1500
	16 maggio	1000
	12 giugno	1000
	18 luglio	1000
	14 agosto	1500
	20 settembre	1625
	25 settembre con altra de 22 ott.[ob]re ditto per la separazione del mandrone che ritrovava vicino al Quartiere sudetto	500,20
	29 ottobre	1000
	9 dicembre	1000
	duc.[ati]	12125,20

1760		
	25 febbraio	1000
	12 aprile	1000
	24 maggio	1000
	16 luglio	1000
	5 settembre	1000
	20 novembre	1000
	2 dicembre	1000
	duc.[ati]	7000

1761		
	26 gennaio	1000
	8 aprile	1000
	23 maggio	1000
	duc.[ati]	3000

Segue il denaro liberato dal di 6 giug.[n]o 1761 tempo in cui piglio posesso della Segreteria di Stato del dispaccio di Azienda, e comm.[er]cio l'Ec.[clentiss]mo Sig.[nor]e D. Gio.[vanni] Asen.o di Goyzuetta a tutto il 22 dic.[embre] del cadene anno 1762.

23 giugno 1761		1000
22 agosto		1000
14 ottobre		1000
17 ottobre		1000
16 dicembre		1000
duc.[ati]		5000

1762		
	16 gennaio	1000
	20 febbraio	1000
	29 marzo	2000
	13 maggio	2000
	10 giugno	2000
	26 luglio	1000
	30 luglio	1000
	14 settembre	1000
	23 ottobre	1000
	30 novembre	1000
	23 dicembre	2000
	duc.[ati]	15000

ASN, *Segreteria d'azienda,* diversorum anno 1763, 5.

117. See the architect's letters to de Gregorio dated 15 May 1757 and 11 August 1758 in BNN, ms xv, A, 8, busta 5, 8r, 12r.

118. Ibid., 8r; Vanvitelli 1976–77, 1:581.

119. Vanvitelli 1976–77, 2:109, 180, 234; Tanucci 1980–2003, 13:353–54.

120. Vanvitelli 1976–77, 2:479, 487, 531, 586, 735. On spending cuts, see ASN, *Segreteria d'azienda,* diversorum anno 1763, 5.

121. ASN, *Segreteria d'azienda,* diversorum anno 1763, 5; Vanvitelli 1976–77, 3:28, 57.

Essendosi fino ad ora Erogati ducati 377825 . . . manca di terminare la sola capella ed alcuni travezzi disponi, si deve ricostruire il tetto della porzione del Quartiere verso la Lioneca, lo da un si è fatto e manca di canali non ancora pronti nella Real fornace di Portici.

Li devono battere porzione degl'astrachi, e far le tonache sulle mura di stalloni, ed in portare delle abitazioni degl'officiali alle quali non si trafeà actual.[men]te. Le mangiatoje de cavalli nelli stalloni sono compiute, di M.[aestro] d'Ascia e d'ogni altro di fabrica. Con le bosolate, le porte e finestre de quartieri e dell'abitazioni si lavorano del M.[aestro] d'Ascia siche con tal metodo sperar che dovesse essere terminato nel mese di maggio.

Io vengo di avere ottenuto il vantaggio unico di servire il Re coll'avere edificato d.[ett]o quartiere comodo, fortissimo, in un sito limitato ad oltre modo irregolare che è quanto devo umiliare.

Letter from Vanvitelli dated 13 January 1763, BNN, ms xv, A, 8, busta 5, 34r, 39r.

122. See Vanvitelli's letter of 22 June 1763, BNN, ms xv, A, 8, busta 5, 52r, 58r:

mentre stanno attacati con la capezza per prendere aria gli anelli di ferro apposti nelle mura esteriori di d.[ett]o quartiere con le zampe d'avanti guastano la tonaca e scavano delle buche deturbando notabilmente detta fabrica; con idea per rimediare questa . . . sarebbe di apponer intorno dei lastroni di piperno, come dià di maggior accosto ne ho fatto la prova fini all'altezza degli anelli ove stanno legati.

La foderasse di piperni la base della Fabrica affinche non fossi detorsata dai cavalli, mancava terminare il muro del circondario esteriore, che già era compiuto dalla parte di dietro del quartiere, ove sono stati fatti pezzi, e vuoti che per abevecare i cavalli, quale muro poi che vedesi dalla porta del Sebeto e l'altro lato della clausura che darà rialzasi di fabrica dal suolo circa 6 palmi remetendo con questo (senza spesa dippiu) occupato il sito che il Re volle per il quartiere e per questo effetto; destinandone un altro compensatino alla faccia della città che si teneva vasche vitela e suini dal mercato, sotto alcuni archi del Ponte medesimo della Maddalena. Quindi è che proseguire lo istesso ordine di piperni si conducano anula far questo uso circondario, al quale saranno posti gli cavalli per collocare li caselli;

Nel 3.o lato de quartieri che de soldati corrispondono verso le paludi dei P.[adri] di S. Domenico Maggiore che erano destinate di chiudere come posto per li cavalli.

123. "Non ò più veduto interiormente questo quartiere; ma in onor della verità mi conviene dire essere questo l'unico quartiere, che S.[ua] M.[aestà] il Re N.[ostr]o Sig.[or]e à di bene Edificato . . . è molto grande comodo con disegno quantunque il sito sta irregolarissimo. Onde dopo questo passo di tanto tempo, non può Esigere ancora per molti anni in appresso, che quelli residi che Esigono tutte le case che li affittanno, li quali si conservano, allorquando il ripasso di ogni piccolo mantenimento." From a letter dated 20 February 1772 to Antonio del Rio, the secretary of war after de Gregorio's departure. BNN, ms xv, A, 8, busta 5, 63v. See also Vanvitelli 1976–77, 3:181, 207, 229.

124. "li quali sanno di Architettura come io so di Astronomia." Vanvitelli 1976–77, 2:343–44. See also the cites listed in the following note.

125. Vanvitelli 1976–77, 3:181; Tanucci 1980–2003, 9:456, 14:458; BNN, ms xv, A, 8, busta 5, 48r.

126. "perchè questo è il più nobile che sia stato fatto fin'ad ora, cosa che non mi farà torto in Spagna ed in qualunque altro loco che si fabbricasse." Quoted in Sambricio 1986, 203.

127. Calatrava 1993b, 521.

128. Vanvitelli 1976–77, 3:169.

129. Faraglia 1892; Giordano 1997, 102–10.

130. Worsley 2004, 221–22.

131. ASN, *Segreteria d'azienda,* diversorum anno 1794, 1.

132. See J. Collins 2004, 263–64.

133. See Rodríguez Ruiz 1993, 23–28.

134. See Duffy 1987, 127.

135. Quoted in Worsley 2004, 144.

136. Douet 1998, 19–43.

137. Colvin et al. 1963–82, 5:437–40; Worsley 2004, 221–22.

Chapter 4

1. Gleijeses 1970; Buccaro 1989; Nappi 1967; Bisogno 2010.

2. Neil 2004, 370–72; Rubbino 2004; Grönert 2011.

3. Nor did the king and queen attend the dedication of the monument. Inscriptions instead vouched for royal support. See Salvatori 1985, 75–92; Conelli 2000, 172–83.

4. One of these broadsheets is conserved in the Bibliothèque Nationale de France, Département des Estampes et Photographie, RESERVEFOL-QB-201(82).

5. Fittipaldi 1980, 15–16; Santiago Paez 1967.

6. See de Cavi 2009, 252–55; Carrió-Invernizzi 2008, 273–74.

7. See Fittipaldi 1980, 115; Mauceri 1920. The statue cost 2,200 ducats. The city paid 600 ducats, while private donations accounted for the balance. See a letter from city administrators to Leopoldo de Gregorio dated 10 December 1755, ASV, *Carte de Gregorio,* 37, 57. The director of the French Academy recommended Caffieri to the court, and de Gregorio requested the pedestal on 7 September 1754. See Vanvitelli 1976–77, 1:366, 376, 404.

8. On its history, see Tutini 1641, 111–28, 251.

9. See Nussdorfer 1992, 168–253; Scott 2009, 145–59.

10. Sabatini 1974, 150.

11. Tutini 1641, 245–50; Hills 2004, 35–37.

12. Fiengo 1990, 109–29; Ajello 1968.

13. Faraglia 1883, 229–52.

14. De Cavi 2009, 29–36.

15. Pessolano 1993, 90–107; Poleggi 2003, 85–90.

16. Kamen 2001, 171.

17. Capel 2005, 256.

18. "Qui può ogn'uno stupire in vedere nell'infinità de' Ragazzi figli de' Marinari la gran popolazione della città." Parrino 1725, 201.

19. Construction of the Via Marina lasted from 1740 to 1749. See Strazzullo 1969, 37. On the Imacolatella, see Garms and Cantabene 2005, 124–35.

20. A letter of 5 March 1775 from Antonio del Medico states that a piece of marble "da me proveduto anni fa per la statua della SS.ma [Santissima] Concezione eretta sopra il Palazzo della Deputazione della Salute, e che fù scolpita dal Sig.[ore] D.[on] Giuseppe Canart, unito con due piccolis.[sim]mi pezzo di pochi palmi ne recevei docati 900." ASN, *Maggiordomia maggiore e soprintendenza generale di Casa Reale, amministrazione generale dei siti reali,* 1381.

21. De Rosa 1968, 333–42; Fortunato 1760, 84–87; Ostuni 1993.

22. Serena Bisogno, who discovered the drawing, attributes it to Vaccaro. See Bisogno 2010, 145–48.

23. The city explicitly stated that the monument should be erected near the port to recognize Charles's encouragement of trade. ASMUN, sezione municipalità, seconda serie, opere pubbliche, 124, *Riassunto di scritture per la statua equestre della Maestà del Re Carlo III,* unnumbered sheet (hereafter referred to as ASMUN, *Riassunto*).

24. On the Pont Neuf, see Ballon 1991, 115–25.

25. Wilkinson-Zerner 1993, 77–79.

26. See Delaforce 2002, 1–116.

27. França 1965, 67–176; Maxwell 1995, 87–110; Delaforce 2002, 287–303.

28. Vanvitelli 1976–77, 2:92.

29. "è pericoloso ad essere rovinato dal mare; è piccolo, è storto, né ha niuna simetria soffribile . . . e quello che è peggio la piazzetta è minima, onde il cavallo dovrebbe proporzionarsi; et ecco un burattino all'immenso ambiente del aria e mare, se si fa il cavallo grande non entra nella Piazzetta." Ibid., 89.

30. Calabi 2004, 49.

31. Grisone 1550, 50, 84.

32. Faraglia 1883, 42.

33. The statue of San Gaetano was added in 1658. When the Porta Reale was destroyed in the late eighteenth century, the statue was moved to the Port'Alba, where it still stands. See Nicolini 1905, 156. On the paintings, see *Micco Spadaro* 2002, 150–53.

34. Alisio 1965.

35. Adriani and Malangone 2005, 285–88.

36. The unpublished drawing shown in figure 92 was approved by the king and signed by Tanucci in October of 1739.

37. See Lugar 1986, 59.

38. *Civiltà del '700 a Napoli* 1979, 2:322–23.

39. *Capolavori in festa* 1997, 227–29.

40. Murray 1960.

41. *Capolavori in festa* 1997, 220–21.

42. Braudel 1992, 2:35–41; Calabi 2004, 93–130.

43. Spagnoletti 1996, 131–66; Dandelet 2001, 48.

44. Marino 1988, 158–59.

45. See Chorley 1965, 141–48.

46. "Si sa che le rendite di Fiandra non bastano per mantenere le truppe della Baviera, quelle d'Ungheria non bastano per quelle piazze, quelle dell'Austria e Boemia non possono mantener la Corte e quelle di Lombardia appena bastano per i dodicimila uomini che vi tengono. Il loro forte a denaro era Napoli, onde cavavano due milioni di ducati annui, coi quali si arricchiva la Metropoli dell'Impero." Quoted in Ajello 1972, 543. See also Di Vittorio 1969, 30–84.

47. Di Vittorio 1993, 249–53.

48. The magistracy was founded on 26 November 1739. See Schipa 1923, 2:102.

49. See Chorley 1965, 19–59; Stapelbroek 2008, 63–65.

50. Ostuni 1991, 29–55.

51. Villani 1977, 12.

52. Marino 1988, 195–241.

53. In 1738 the Two Sicilies had consuls in Rome, Civitavecchia, Leghorn, Genoa, Marseilles, Alicante, Malaga, Cadiz, Lisbon, Majorca and Minorca, Cagliari, Bastia, Malta, Ancona, Ferrara, Trieste, Ragusa (modern Dubrovnik), Corfu, and Zante. See Schipa 1923, 2:101; del Pozzo 1857, 44.

54. Schipa 1923, 2:127.

55. Avallone 1995, 16–19.

56. De Sariis 1792–97, 2:9–10; Schipa 1923, 2:106.

57. From 1688 to 1742 the population grew by 64 percent, and would grow another 10 percent between 1742 and 1763. Steady immigration from the countryside as well as an increased birthrate led the boom. Petraccone 1974, 135–47.

58. De Simone 1976, 93–94.

59. On the patronage of Louis XIV's *places royales*, see Cleary 1999, 14–21.

60. On Charles's visit to Montpellier and his travels through Tuscany and Emilia, see Urrea 1989, 36–49.

61. On the rediscovery, see Parslow 1998, 42. These statues were displayed in the garden loggia of the Royal Palace of Portici. See *Notizie del bello, dell'antico, e del curioso* 1792, 43.

62. Fittipaldi 1980, 51; Lankheit 1962, 80.

63. ASMUN, *Riassunto,* unnumbered sheet; Nappi 1967, 205–6.

64. Payments made to Vergara confirm his participation. See Nappi 1967, 206, no. 5.

65. On Bouchardon, Saly, and Bracci, see Vanvitelli 1976–77, 2:92; *Grove Dictionary of Art,* s.v. "Saly, Jacques-François-Joseph."

66. Cleary 1999, 241–42. Laugier was the one who termed him a "new Phidias." See Laugier 1977, 96. We know that the city fathers eventually received a print of Bouchardon's *Louis XV,* but this arrived only on 10 April 1766. "Che avendo il disegno, o modello d'una statua Equestre dell'odierno Re Cristianissimo Luigi XV ultimamente fatta, lo passio in mio potere per osservarsi." Copy of a letter dated 10 April 1766, ASMUN, *Riassunto,* unnumbered sheet.

67. *Oxford Art Online,* s.v. "Vergara, Ignacio."

68. On Cornacchini's *Charlemagne,* see Johns 1993, 62–64. See also Vanvitelli 1976–77, 2:99.

69. Sansone Vagni 1992, 547–53; Mormone 1972, 573–81.

70. See Salvatori 1985, 88–92; Mormone 1972, 556–62.

71. See Fittipaldi 1980, 211.

72. See Mormone 1972, 572; Strazzullo 1998, 43–44; Porzio 2008.

73. ASMUN, *Riassunto,* unnumbered sheet. On 24 September the sculptor requested a larger studio to construct the full-scale model. Strazzullo 1998, 44.

74. ASMUN, *Riassunto,* unnumbered sheet. On Canart's connection to the earlier site, see Onofri 1789, 77.

75. See Porzio 2008, 216, 228; Carletti 1776, 254–55.

76. ASMUN, *Riassunto,* unnumbered sheet; Vanvitelli 1976–77, 2:115.

77. See Canart's signed letters in ASMUN, *Riassunto.*

78. According to Vanvitelli, Queirolo's portrait was better. See Vanvitelli 1976–77, 2:115. On the submission of a second model, see Fittipaldi 1980, 64. For its approval, see ASMUN, *Riassunto,* unnumbered sheet.

79. Letter of 3 July 1758 addressed to Bernardo Tanucci, ASMUN, *Riassunto,* unnumbered sheet.

80. Laugier 1977, 98. On Solleysel's debate, see Boyer 2002.

81. Canart's letter of 3 July 1758 addressed to Bernardo Tanucci, director of the Accademia Ercolanese, ASMUN, *Riassunto,* unnumbered sheet:

Nello esecuz.[io]ne pertanto della sud.[et]ta Statua Equestre sorge il dubbio qual più convenga vestim.[en]to e adorno alla statua medesima. Prende motivo il dubbio dallo scorgersi, che tutte statue simigliam.[en]ti erette ai Monarchi di Francia della dichiarata devoz.[io]ne de' suoi sudditi, e che osservandosi some sparse in ogni provincia di quel vasto regno, si rimsirano di un tenore così inalterabile, che può danno a divedere deciso presto quella illuminata ragione il carattere sistematico in tal genere, cioè a dire col monarca cavalcante senza sella, senza pistole, e vestito come, suol dirsi Eroicam.[en]te a gambe, e braccia nude, co' soli costumi a Piedi, corazza finta di pelle, che ne cinge il Busto, ed un Panno R.[ea]le che ricopre con magnificenza la Persona, e finalm.[en]te con gran Peruccone alla Delfina.

Io a credere pertanto, che l'idea di statuarsi de Nostri tempi sia stato quella d'imitare l'Eroiche vestimenta praticate dagli Antichi ma scorgendo l'inconvenienza d'una Esattissima imitazione non contorne alle nostre costumanze, sembrami che siane risultato un misto del tutto rimproprio, di cui una porzione non punto analoga all'altra, forma una sconcordanza, ed anacronismo nella professione statuaria.

Simile sempre questa ed inalterabile né suoi principij relativi alla proprietà ed analogia delle parti della Natura, fonda la sua perfezione nella più adeguata imitazione di questa. Non così accade però nelle vestimenta e adorno del suo prototipo. In ciò deve l'arte uniformati ai tempi, alle persone, e siccome questi cambiarsi col giro de' secoli, nelle costumanze, così l'arte imitandoli nella loro stessa variazione, adempie il dover suo. Infatti addattandosi gl'Antichi Professori alle maniere de' loro tempi, ci danno un tacito insegnam.[en]to di far noi lo stesso nei Nostri. Quindi se imprendendo noi a rapresentare in Statua Equestre un Marco Aurelio, o Giulio Cesare, si facesse nelle regole, e positure, colle quail oggi di si lavela sopra della stoffe ed armi sembrarebbe giustam.[en]te ridicolo pensam.[en]to; non veggo perche lo stesso non si abbia a dire,

se nel rapresentare Statue Equestri de' Monarchi de Nostri tempi, si faccia nelle guise, che gli antichi hanno adoperato.

A tale proposito, anche riguardo alle maniere più espressive, con sui debbasi esigiar un Destriero Generoso, mi ha fatto non poco sensazione il pensamento di M.r Solleysel nella sua opera del Perfetto Maneschalco, cui sembra conveniente che siccome nel nostro secolo, si è ridotto a tutta perfezione l'arte di cavalcare; ed adestrare li cavalli a modi più dolci, ed obbedienti, che gli Antichi non han saputo: così decente cosa ella sia che i nostri profittino nelle Statue Equestri di tale perfezione dell'arte cavalleresca ond'è che quell'autore si avvanza a biasimare le Statue Equestre degli Antichi, e molto più che in oggi le imita. Se a V.[ostra]E.[ccelenza] fosse in piacere di dare una scorsa altrattato istruttivo che M.r Solleysel ne forma sull'assunto lo ritrovera al Capitolo III della seconda parte della Sud.[et]ta sua opera a carte 18.

82. "[Canart] si era dato l'aria di architetto, onde aveva già situato la statua . . . in faccia la porta di una chiesa de Domenicani, quasicché il cavallo vi volesse sentire gli Offici Divini." Vanvitelli 1976–77, 2:250–51.

83. ASMUN, *Riassunto,* unnumbered sheet; Vanvitelli 1976–77, 2:251.

84. On Canale's career, see Rizzo 1982; Costanzo 2006, 280–86.

85. *Descrizione delle feste celebrate* 1735, 30, 54.

86. According to Canale, the *largo* must be

nobile per ogni parte intendosi per tale, che da ogni parte abbia edificii Nobili, e conspicui, e per lo meno sgombro da bassi, ed volgari oggetti. Questo Largo, Luogo della M.ta del Rè prescelto, considerandosi nel suo essere in parte trovasi circonscritto da edificii, ed in parte trovasi ignobile . . . [the side with the wall remade]

in una limitata regolata altezza di botteghe, e stanze sopra [to make the Largo] circonscritto da edificii di dovuta semetria disposti ravvisandosi il lato d'oriente con gli edificii di questa città del Palazzo della Conservaz.ne, indi il Palazzo del M.sre renuccini in sequela la Torre di Port'Alba, costo poi la casa del Mon.he di S. Sebastiano, in seguito poi i nuovi edificii con botteghe, e stanze sopra.

È vantaggioso apro di questa Ecc.ma città, mentre li impiego ne darebbe il vantaggio lucro, oppure questa Ecc.ma città potrebbe dare a censo il suolo sud.o ed a spese del censuario farsi li sodetti edificii, con legge prescritto di stimata altezza, e regola semetria.

ASMUN, *Riassunto,* unnumbered sheet.

87. França 1965, 99.

88. Aricò 1999.

89. On the changing significance of the first Place Royale, which was not planned with an equestrian statue, see Ballon 1991, 57–113.

90. ASMUN, *Riassunto,* unnumbered sheet:

Si compiacque Vostra Maestà con suo Real Dispaccio in data de 3 agosto progs.mo: pas.o di ordinarci a darle conterza del preciso luogo del Largo dello Spirito Santo, ove si pensava di situare la Statua Equestre, che quello Pubblico, per attestare con una visibile prova il suo amore, il suo ossequio, e la sua gratitudine verso il suo amabilissimo sovrano, stabili di consagrarla come un perpetuo monumento delle sue tante obbligazioni. Nello stesso dispaccio si degnò la Maestà Vostra di comandarci a spiegare il nostro sentimento per adornare il cennato Largo, che dovea contenere una si per Noi gloriosa memoria . . . che per maggiore accerto d'incontrare il Suo real gusto, abbiamo fatto fare dalli nostri Architettti una regolare Topografica Pianta, che ci diamo l'onore di presentare a

Vostra Maestà, affinche avendola sotto i suoi purgatissimi occhi, prevalendosi di quelle cognizioni matematiche, che Vostra Maestà possiede, e di quei lumi particolari, che l'Altisssimo concede a sovrani per la felicità de loro vassali, possa stabilire il punto proprio, ove la statua dovrarsi piantare, e che dovrà essere decorata da un cancello di ferro sostenuto da pilastri elegantemente costrutti per cingerla . . . che uscendosi da Porta Alba nel Largo dello Spirito Santo, caminandosi per retta linea che taglia quella porzione del Largo, designate dalla Pianta, verso l'opposto lato, si và ad incontrare il Palazzo del Principe della Bagnara, indi, dopo una strada che conduce al Quartiere detto del Cavone, ritrovansi due Palazzetti al fianco destro de' quali vedesi la Chiesa di S. Domenico Soriano de PP. Domenicani, attacata al Monastero de' medesimi Padri, che si unisce alla casa de' Mastelloni nuovamente costrutta, e che ha angolo all'ampia strada, che conduce a vari Quartieri; Questo lato . . . non è capace, ne richiede altro ornamento. Sopra viene poi la Porta dello Spirito Santo [Porta Reale], appresso viene la Chiesa di S. Michele Arcangelo restando dalla parte di dietro alcune Botteghe; continua dopo la detta chiesa un Palazzino del D. Ferdinando Sanfelice, in appresso poi si vengono alcune umili stanze terrene, ove al presente si ripongono gli ordigini appartementini alla Cavallerizza, che qui vi si esercita; Ma queste casuccie fra poco dovranno essere una nobile abitazione, che faranno fabbricarci alcuni Galantuomini benestanti della Casa del Giudice Cito, che fanno premurose istanze alla città, per rimovere certe insusoistenti difficoltà, per le quali se l'era impedita una tal fabbrica, e per questo mezzo quella parte più ignobile resterà decorata da questo nuovo edificio; continuandosi a caminare su la man destra si vede la lunga

muraglia della città che fa clausura al Monistero delle Nobili Donne di S. Sebastiano, e poi nel fine della d.[ett]a muraglia sporge in fuori un pezzo della casa delle ridette Monache, che tengono appigionata, e dopo aver fatto questo giro delli tre descritti lati, siamo arrivati di nuovo a Porta Alba. . . . Altro avevano pensato, che di tirare una Linea Paralella della Larghezza della summento-vata muraglia . . . e nello spazio fra posto di trenta palmi della cannata paralella di edificarsi camere ter-rene per uso di Botteghe, con le stanze di sopra per l'alloggio degli Artieri; ma questo sentimento a Noi non è piaciuto. . . . Per prima non ci à un libero, e non contrastato dominio, poichè i PP. Benedettini del Monistero di S. Severino pretendono, che ad essi appartenga, ed essendosi ne scorsi anni agitate una tal controversia, restò sospesa, et indicisa; ed a questa difficolta si aggiunge ancora quella della pretensione della casa, e Banco dello Spirito Santo sopra di esso Largo. Per seconda il Largo è l'unico, che vedesi nel centro della città, e dove piacere ed utile della Nobiltà si esercita il nobile esercizio della Cavallerizza, onde con tal ristrizione verrebbe non poco a deturparsi. Anni addietro il fù Conte di Conversano molto calore pretese di fabbricarsi un Palazzo [but the city refused for the aformentioned reason]. Non sarà cosa vana il riflettere, che in tempo de' terremoti una gran parte della Nobiltà, e del ceto civile si son ricourati con le carozze, ed anche a piedi in questo Largo, con la fiducia di ritrovare in esso la di loro sicurezza, o almeno un efficace rimedio per guarire la turbata fantasia. [Per terzo] che le sudette camere e bassi dovendo venire attacati alla muraglia della quale si parla ed essendo questa una parte della clausura di S. Seba-stiano . . . vien proibito espressa-mente da sagri canoni l'attaccare edificj secolari alla clausura delle monache, per i gravi disordini, che possono nascere da un somigliante attaccamento. . . . Si è pensato per far cosa più facile, e più decente, di mettere in stucco tutta la mura-glia . . . e nella sua sommità farci un cornicione dello stesso stucco, con proporzionato sporto in fuori da un caso all'altro, senza niente ristringere il Largo.

91. See Bisogno 2010, 174, no. 9.

92. On Place Louis XV, see Patte 1765; Tadgell 1978, 175–81; Cleary 1999, 209–42.

93. Cleary 1999, 157–63.

94. "Gli signori Eletti hanno raccomandato D. Luigi Vanvitelli di fare una pianta del Largo, o sia Piazza dello Spirito S.[an]to dove dovrà situarsi la R.[ea]l Statua Equestre del S.[u]a M.[aes]tà, conche d.[et]to R.[egi]o Ingegniere debba erigere, ciocchè si è esposta dalla città, all M.[aes]tà Sua." ASMUN, *Riassunto*, unnumbered sheet.

95. Vanvitelli 1976–77, 2:291.

96. Ibid., 2:92. Bisogno believes that Vanvitelli had already been commissioned to design the base, though there is no evidence of this. See Bisogno 2010, 150.

97. Vanvitelli 1976–77, 2:99.

98. Sancho 1991, 219–23.

99. Vanvitelli 1756, 14; Fagiolo-dell'Arco 1963, 29.

100. Vanvitelli 1976–77, 2:291, 295.

101. See Sasso 1856, 1:481.

102. See Parslow 1998, 42.

103. Guidebooks of the sev-enteenth and eighteenth centuries described the mercato grande as the "Foro Magno." See Parrino 1725, 220; Celano 1856–60, 4:185; De Frede 1969, 44, 116;

104. BSNSP 6.N.2.10 has been attributed to Vanvitelli on stylistic grounds. See de Seta 1973, 277, no. 132.

105. On the left side of the draw-ing Vanvitelli gives the height of the lowest portion of the building as 46½ palms. The distance from the cornice to the attic is measured as 11½ palms.

106. The conflict with the sisters must have taken place in March of 1759, since Vanvitelli showed the king a new design on 2 April. In another letter he makes clear that it was the king who ordered him to make the changes. The city must have approved between 10 April, when Vanvitelli recorded his intention to submit the design to them, and 26 June, when he reported laying stakes for the foundations. Vanvitelli 1976–77, 2:325, 333. "In appresso (non si comprende con quel consiglio) le Religiose di San Sebastiano ricorsero a S.[ua] M.[aestà] per il danno, che dicevano gli apportava il sollevamento di quella Nuova Fabbrica. S.[ua] M.[aestà] ordinò che si dovesse procurare la quiete, e contentamento di quelle religiose; senza lodere l'idea principale dell'opera onde fù di mestieri togliere il 3.o piano, o sia il quarto superiore delle alte abitazioni, e rimpastare tutta l'idea." ASMUN, *Riassunto*, unnumbered sheets.

107. Vanvitelli 1976–77, 2:669. The king had likely seen similar balconies in the Plaza Mayor of Madrid. These balconies functioned like viewing stands during the tournaments that frequently took place in the square. However, such use would not be repeated in Naples. On Madrid, see Escobar 2003, 174–79.

108. On the nuns' portal, see Bisogno 2010, 153.

109. ASMUN, *Tribunale delle Fortificazioni, Conclusioni,* 19 1846, 176r:

La concessione da farsi a D. Fran-cesco Cito del suolo fra il muro di S. Sebastiano e le fabbriche degli ornate da farsi per la real Statua Equestre, che nell'annetta pianta si distingue col colorito di torchino, giusta li segni posti dal Cav. Vanvitelli: Rappresentiauro ivi su le primo all E.[cellentis-sim]e V.[ostr]e che questo sito cade molto a proposito concedersi a D. Francesco Cito per esser contiguo al suolo antico che colà possiede; Imperò d.[ett]o luogo il med.[esim]o Cito dovendo in d.[ett]o nuovo sito fabbricare, si è offerto far tutte quelle fabbriche secondo la detta delineaz.[io]ne

che nello stesso tipo servono per gli ornate sud.[ett]i e per racchiudere il nuovo edificio, che intende costruirsi, e così d.[ett]e fabbriche esteriori co gl'ovviati da ordinarsi e disporsi dal Cav. Vanvitelli farsi tutte a spese di esso Cito, e ben anche a sue spese fare la porta simile a quella di port'Alba, e con quelle modificazioni, ed aggiunzioni che stimerà il Cav. Vanvitelli . . . ed altresì che le sopramenzionate Botteghe debbano aver le porte di legno tutte a simetria, e poste come si stimerà meglio dalla città, e debbano sempre essere addette servire per uso di venditori di galanterie e di mestieri che non diano imbarazzo al di fuori, ne rechino rumore, o sporchezza alcuna ma diano decoro, ed ornam.[ent]o alla nuova piazza che dovrà ivi formarsi.

110. Vanvitelli 1976–77, 2:350, 351.

111. The contract between the Eletti and Vanvitelli, dated 7 September 1759 (ASMUN, *Riassunto*, unnumbered sheet), reads as follows:

[Vanvitelli's design] il quale se l'avesse intesa di D. Nicola Tagliacozzi Canale ordinario Architetto di questa F.[edelissim]a città affinché formato avesse minuita di tutti li parti, e Condig.ni dei residui specie de' lavori di d.[ett]e fabbriche, questa l'idea e disegno fatto, ne da esso Architetto Vanvitelli, e questro per la totale chiarezza delle cose da partitarsi.

Esputosi da esso M.[urato]re Gaetano Sabtiro; il m.[edesi]mo ha portato offerta per la sud.[ett]a opera, colli prezzi in essa notati, e colle condizioni spiegate nella minuita fatta dal precitato R.[ea]l Architetto Vanvitelli cioè

P.[ri]mo si dichiara, che rimanesso tenuto ed obbligato esso M.[urato]re Gaetano di stare in tutto subordinato all'ordinaz.[io]ne e direz.[io]ne del d.[ett]o m.[aestr]o Vanvitelli, e fare tutti li Lavori di fabbriche alla totale, ed intiera perfez.[io]ne di

per l'ottima qualità de' materiali di calce, pietre, mattoni, pozzolane, arena, mischia di calce, quanto per l'ottima qualità de' magisteri alla totale sodisfazione, ed approvaz.[io]ne di d.[ett]o R.[ea]l Architetto Vanvitelli, ad affato che si conducca al solo fine della dovuta perfez.[io]ne ed esatta esecuz.[io]ne di d.[ett]a opera, giusta quel tanto da d.[ett]o R.[ea]l Architetto sarà ordinate, e tenute del sud.[ett]o suo disegno.

[Second, foundations for pedestal and building be] palmi quaranta, e per quel prezzo che resterà ad estinz.[io]ne di candela per ogni canna cuba, dovendosi fare li sud.[ett]i cavam.[en]ti di tutta regolarità e colle face a piombo.

[The third point sets pay for foundations deeper than forty palms.]

4.0 per tutte le casse chiuse con legnami [all have to be accounted for and detailed in each part].

5.0 le fabbriche dentro terra fare li cavamenti per la buona qualità de' materiali, di pietre, calce di tutta perfez.[io]ne pozzolane di buona qualità, arena di lave, acqua, buon'impatto della calce con le pozzolane, ed arena sud.[ett]a maestranza in maniera che le d.[ett]e pietre debbono essere poste bene commesse ed incatenate, e bene allattate, e ripiena di calce in tutte le loro face. Come più si dichiara, che tutte le pietre debbano essere poste nell'acqua, e bene bagnate . . . ed obbligato d.[ett]o M.[urato]re Gaetano a fare la taglia in d.[ett]a fabbrica di scarpa [the city walls] per q.[ua]nto sarà il bisogno, e spianare il fondo di sotto a piano orizzontale, ad effetto che le fabbriche sud.[ett]e poggiano sopra di un piano esatto orizzontale per la loro ferma esistenza quali tagli se li dovessero bonificare a d.[ett]o M.[urato]re Gaetano, oltre dal prezzo [fixed].

[The sixth point sets pay for work detailed in number five.]

[The seventh point sets pay for those parts not mentioned.]

[The eighth point requires brick of Ischia] ben cotti, scalati, e ferrigni dell'ottima qualità, ben conessi, ed incatenati, bene ripieni, ed allatteti in calce e posti con la dovuta simetria e proporz.[io]ne.

[The ninth point requires brick from Gaeta for the remainder of the building.]

112. BNN, MS XV, A, 8 bis, busta 3, 125r.

113. Vanvitelli 1976–77, 2:466, 534, 535, 572.

114. Ibid., 848.

115. Canart wrote as follows:

Che sia formato di calce, e pozzolana, con stucco bianco al disopra, nella quale non sia porzione alcuna di gesso. Secondo che abbia l'ossatura di ferro al di dentro, di modo che possa resistere, essia di duratura, affinche venga formato con comodo, e pulizia, e distuto con tutti li finim.[en]ti come le dovesse servire per cavarne il getto per la statua di Bronzo. [It will have an iron frame] che non si può risparmiare e fatta senza economia, come si dovesse fare un scheletro.

L'altezza della statua reale palmi tredici, ed in azione di cavalcare, trà il cavallo, e la statua verrà l'altezza di palmi dieci sette e mezzo.

Quando si compiaceranno di tempo in tempo favorire di vedere la formaz.[io]ne che averà a farsi colla veduta d'un cavallo vivo de' più bei formati, e col parere de Cavallerizzi, e maestri di essi cavalli in Luogo spazioso ove posson introdursi cavalli scelti per confrontare il modello, poiche non ho altra mira . . .

5000 ducati a costruire l'espressato modello. Io ristretto ad una richiesta

onestiss.[im]a, e moderata, potranno li E.[cellenze] V.[ostre] informarsi quanto sii costati ogn'una delle Statue Equestri, che sono nelle Provincie di Francia, e più recentem.[ent]e quella, che sia stà costruduendo in Danimarca.

ASMUN, *Riassunto,* unnumbered sheet. See also Vanvitelli 1976–77, 2:848. On trade relations with Denmark, see De Rosa 1968, 351.

116. "Mi obligo fare per il prezzo di ducati 1,500 con che per altro mi venga fatto in quel Luogo un cassotto capace coperto chiuso intorno in modo che non entrà vento con tutti li comodi di finestroni telari e intelate per aprire e serare quando occorera, con li andati comodi per girare intorno al modello o per poterlo lavorare in alto in basso non a spesa mia." Letter from Francesco Queirolo dated 24 September 1760, ASMUN, *Riassunto,* unnumbered sheet. See also Vanvitelli 1976–77, 2:592.

117. Vanvitelli 1976–77, 2:594–96, 598, 831. Giardoni and Vanvitelli had worked together previously. The founder had crafted the gilded bronze parts of Vanvitelli's chapel of St. Roch for Lisbon. See Montagu 1996, 162. Giardoni's letter to the Eletti is dated 9 July 1759. "Avendo io infrasto scandagliato la spesa, che vi vorebbe se si dovesse fare un Cavallo di Metallo con Personaggio sopra il med.[esim]o simile a quello del Campidoglio di Roma, dico che la spesa possi ascendere a scudi 22000 in circa compreso il Metallo, calo del med.[esim]o Forme, Cera, e Fattura fino alla totale perfezione dell'opera, prescindendo dalla spesa del trasporto quando dett'opera si faccia in Roma, siccome dalla spesa dell'officina, stigli, e Fornaci facendosi altrove." ASMUN, *Riassunto,* unnumbered sheet.

118. "Affinche S.[ua] M.[aestà] C.[attolica] che dio guarda riconoscesse l'Effetto del generoso dono della Fedelissima città, ed'Insieme il Mondo tutto di tal'opera, ne Fosse Invidiabile spettatore." ASMUN, *Riassunto,* unnumbered sheet. On the print's circulation, see Vanvitelli 1976–77, 2:643, 651–52, 655, 3:444–45; ASV, *Carte de Gregorio,* 40, 69.

119. "Poi non è della stima, ed interesse d'un Professore doversi obbligare di soggiacere alle varietà dell'opinioni, trattandosi di persone non di professione, se non piacesse il modello in grande, semprecche non corrisponda al piccolo, che meritò l'approvaz.[io]ne di S.[ua] M.[aestà] C.[attolica] la mattina de' 12 Sett.[emb]re 1756 a preferenza d'altri tredici, parte a Roma, e parte construtti in Napoli." ASMUN, *Riassunto,* unnumbered sheet.

120. Canart was paid for his efforts on 9 August 1762. See Nappi 1967, 211, no. 26.

121. "Cuiroli [Queirolo] scultore defonto, il quale si era esibito di fare il modello sul Largo della Statua Equestre per il prezzo di 1500, per ciò io Tommaso Solari scultore, che ho l'onore di servire S.[ua] M.[aestà] nelle statue, e sculture di Caserta, mi avanzo a concedere à fare questo Modello, in tutto e per tutto secondo le condizioni le quali lo faceva il ditto Sig.[nor]e Cuirolo defonto, agiongendo io a quelle condizioni, che mi basta, che mi venga somministrata la soma di ducati due cento, in due volte, acciò possa servirmi per le piccole spese del modello in Grande fatto su la piazza è sopra il piedestallo nel termine di mesi sette, al più un'anno; quale modello sarà al piacimento delle Eccell.[entissi]me loro, e de' professori pittori ed in caso che non piacesse; io non intendo, ne voglio, altra soma di pagamento; ed al'oposto, se piacerà, come spero nella Misericordia di Dio, mi daranno il compiamento dalli mille cinque cento." Tommaso Solari to the Eletti, 9 December 1761, ASMUN, *Riassunto,* unnumbered sheet. See also Vanvitelli 1976–77, 2:848.

122. Vanvitelli 1976–77, 2:831; Nappi 1967, 207–8, 211, no. 27; ASMUN, *Riassunto,* unnumbered sheet.

123. The report, dated 15 April 1765, is in Vanvitelli's handwriting:

[Both large and small model] ambedue in perfetta proporzione nel tutto ed anche in molte parti; ma siccome il Sud.[ett]o Scultore D. Tomaso Solari ha fatto un foglio di alcuni cose, che egli vuole perfezionare in d.[ett]o modello Grande; noi in esecuzione di quello che degli Ec.[cellentissi]mi Sig.[nor]i ci hanno comandato desideravano che il Sud.[ett]o Scultore faccia le mutazioni, secondo la nota da esso esibita sopra il modello piccolo prima di farle sopra il modello grande; anzi aggiungiamo alla nota del Sud.[ett]o Scultore valenti le sequenti cose, che esso farà come appresso.

P.[rim]o che il cavallo debba restare più mabrigliano, cioè, colla testa più addietro.

2.o Li muscoli siano più vestiti, non tanto distinti.

3.o Che lo stesso risistimento si faccia alle due gambe d'avanti, cioè alle stinchi delle medesime, ed allora rimarranno più dolci i ginocchi, e meno piegata fra l'ugna della gamba, che alza.

4.o Le cose di dietro ingropparle della parte d'avanti acciò rimanga più aggroppato il cavallo, e non rimarrà il cavallo lungo.

5.o Che si debbino fare più leggeri i crini del collo e della coda.

6.o Rispetta alla testa dell'Eroe, il Sud.[ett]o Sig.[or]e deve procurare di avere un ritratto che somigli a S.[ua] M.[aestà] C.[attolica] per farlo in effetto somigliante ed accostare più la corona di allora.

7.o Il braccio destro dovrà portarlo più indietro, per dare maggior spunto alla figura.

8.o La mano sinistra dovrà accostarla più al petto per tener meglio la briglia, e ponere il gomito più fuori.

9.o Procurà di portare le ginocchie dell'Eroe più avanti alle spalle del cavallo, e conseguentemente anche le gambe.

10.o Il panno o sia mano che poggia sulla sinistra dovrà farlo un poco più leggero acciò meglio per riconosca il nudo.
Francesco de Mura
Giuseppe Bonito
Giuseppe Sanmartino
Corrado Giaquinto
Luigi Vanvitelli.

ASMUN, *Riassunto,* unnumbered sheets.

124. The wooden palisade was removed on 20 March 1766, and Solari was paid in June. Some members of the city council wanted additional changes but were assured of the statue's perfection by the committee of artists.

Tutta volta, qualche Ecc.[ellentissi]mo per diligenza maggior esame e critica ha avuto, che la parrucca de Rè Cattolico aver dovesse minor quantità di ricci; che le punte dei piedi dell'Eroe dovessero essere meno rivolte verso le spalle del cavallo; che si dovessero accrescere li già minorati crini, sul collo del cavallo, e finalmente, che mancava la corona d'alloro sulla testa dell'Eroe.
È fatto con l'altima diligenza, nelle parti, con ottima proporzione nel tutto, onde la stimiamo opera bella assai, e degna di stare con tutto decoro nella nostra Fedelissima metropoli.

ASMUN, *Riassunto,* unnumbered sheet. Vanvitelli 1976–77, 3:382; Nappi 1967, 212–14.

125. Nappi 1967, 215, no. 37; Vanvitelli 1976–77, 3:412.

126. Two reports dated 18 and 26 February 1763 in ASMUN, *Riassunto,* unnumbered sheets. See also Nappi 1967, 216. On Vanvitelli's dislike of del Medico's manner, see Fittipaldi 1980, 64.

127. BNN, MS XV, A, 9, busta 5, 169r. On the role of the architect in determining sculptural programs, see Montagu 1989, 147–50.

128. See *L'esercizio del disegno* 1991, 80.

129. Nappi 1967, 216, no. 43; 217, no. 46.

130. Catello 1988, 161; 2004, 143.

131. Rizzo 1981, 30.

132. Nappi 1967, 216–17, nos. 41, 44, 46, 47; ASMUN, *Riassunto,* unnumbered sheet.

133. The inscriptions, by Alessio Symacchio Mazzochi, were given to city councilors on 22 June 1762. See ASMUN, *Riassunto,* unnumbered

sheet. The text was reprinted in Mazzocchi 1771–1824, 1:222–25.

134. ASMUN, *Riassunto,* unnumbered sheets; Catello 2004, 143. On the famine and the subsequent decline of the city government, see Moscati 1972, 725–28; Venturi 1973.

135. John Scott has traced a similar "taming" of municipal space in Turin. See Scott 2009, 153–59.

136. On the construction history of the Palazzo D'Angri, see Pessolano 1980, 37–54.

137. Buccaro 1989, 29–30; S. Villari 1991, 223–33.

138. Rubino-Mazziotti 1931; Gleijeses 1970, 45–55.

Chapter 5

1. Harley 2001, 52–147. See also Jacob 2006, 269–360.

2. See *Capolavori in Festa* 1997, 220–21, 229.

3. See *Descrizione delle feste celebrate* 1735. On the gestation of the latter book, see H. Minor 2001.

4. On the distribution of the *Narrazione delle solenni reali feste,* see H. Minor 2001, 412, no. 1.

5. On Charles as engraver, see Schipa 1923, 1:68–69. For one of the king's sharper condemnations of a print, see H. Minor 2001, 414. On the royal press, see D'Iorio 1998.

6. See Dandelet 2001, 56–57.

7. On the eighteenth-century *chinea,* see Moore 1995; Sassoli 1994.

8. Michel 1983, 1006–7.

9. Bevilacqua 1998, 51. On the importance of the *Forma Urbis* for Nolli's ichnographic technique, see Pinto 1996.

10. See Bevilacqua 2004b, 24–25.

11. See Harris 2003, 40–61.

12. On the ichnographic plan, see Pinto 1976.

13. See Michalsky 2008.

14. On Baratta's map, see Pane 1986; Naddeo 2004, 27–35.

15. These cavalcades were to welcome Maria of Austria in 1632 and to celebrate the marriage of Charles II in 1680. See *Piante e vedute di Napoli* 2007, 80–81, 138–39. Neapolitan procession prints differ from others in

the prominence they accord a *veduta* of the city. On other procession images, see Pollak 2010, 235–43.

16. *Dizionario biografico degli italiani,* s.v. "Carafa, Giovanni"; Origlia 1753–54, 2:295.

17. The subjects taught at the Military Academy of Barcelona were arithmetic, elemental geometry, trigonometry and practical geometry, fortification, artillery, cosmography (which included geography and cartography), statics, and civic architecture. See Galland Seguela 2005, 206–12.

18. See Gerbino 2010, 10–40.

19. See Pollak 2010, 61–231.

20. See Hernando 2002.

21. See Kagan 1989, 44–53.

22. See Kagan 2002.

23. See also Harley 2001, 110–47.

24. Fiengo 1990, 135–38.

25. Blessich 1894, 183.

26. See Carafa (1750) 1969. The letter was directed to Niccolò Fraggiani according to contemporary sources. Blessich 1895, 74.

27. "rendere illustri le pubbliche sontuose opere del nostro glorioso Monarca." Carafa (1750) 1969, 2.

28. The city granted a monthly allowance of 52 ducats. Blessich 1895, 74–75. The literature on the map is growing. Important works include Venturi 1972, 45–49; de Seta 1969, 1:216–23; Di Mauro 1982; Valerio 1993, 75–78; Bevilacqua 1995; Di Mauro 2003; Pane 2003; Bevilacqua 2004a; Naddeo 2004, 35–43.

29. See De Falco 1998, 570–71.

30. Matacena 2008, 158–59.

31. Royal printer Vittorio Barcaccio had been compensated for proofs as early as 1770. See payment documents published in Nappi 1998, 879.

32. See Alisio 1969.

33. Bevilacqua 1995, 106–7.

34. See Harris 2003, 48–51; Pedly 2004.

35. Ceneri 1728; Marinoni 1751.

36. "non eccede di molto l'estensione di un foglio di carta." Ceneri 1728, 6.

37. Ibid., 6–9.

38. "con poche misure lunghi spazi di terreno presto ed esattamente

restano delineati." Carafa (1750) 1969, 12.

39. "né fra noi mancano persone abili, ed onorate, che adoperando la Tavoletta con facilità, e maestria singolare." Ibid.

40. Bevilacqua 1995, 106–7.

41. Ibid., 106.

42. The other engravers acknowledged on the map were Giuseppe Aloja and Francesco Lamarra.

43. See Vanvitelli 1976–77, 2:663–64.

44. Authorship of the map's decorative scheme has been debated. Giulio Pane proposed Luigi Vanvitelli originated the program. Leonardo Di Mauro, I think rightly, argued that the decoration reflects, through its inclusion of objects from Carafa's own collection, the influence of the duke. See Pane 1979, 398–99; Di Mauro 1982, 329–30.

45. The duke of Noja presumably knew Rocque's map of London, since he visited the city in 1758–59. See Bevilacqua 1995, 112, no. 15; Tanucci 1980–2003, 5:735; Bevilacqua 2004a.

46. Naddeo 2004, 40–41.

47. Carafa (1750) 1969, 13–15.

48. Ballon 1991, 212–49.

49. De Seta 1981c, 143–45.

50. See also Di Mauro 1982, 326.

51. Vico 2001, 90.

52. See Bevilacqua 1995, 100; Cortese 1921, 157.

53. See Di Mauro 1982, 320–21.

54. Bayardi 1752, 1:249–430. On other efforts to define ancient measurement, see Revillas 1743; Pedly 2004, 44–47; Rowland 1998, 129–35.

55. Bevilacqua 2004a, 350.

56. Croce 1893.

57. "E certamente se di alcuna virtù io mi posso gloriare, ella è di aver nutrito sempre pensieri di vero amore per la mia patria." Carafa (1750) 1969, 5.

Conclusion

1. Wittman 2007, 97–195.

2. Bergdoll 2000, 43–71.

3. Curcio 2000, xi–xxx.

4. Ibid., xii; H. Minor 2010, 152–57; Johns 1993, 22–38.

5. On these buildings, see Giordano 1997, 91–110.

6. "Aquí hay mucho que hacer." Quoted in *Carlos III y su época* 2003, 351.

7. See Sambricio 1986, 189–260.

8. Martínez Medina 1993c, 1993a.

9. Stein and Stein 2003, 37–42. See also Paquette 2008.

10. Stein and Stein 2003, 40.

11. See Blasco Esquivias 1995, 116–24.

12. De Gregorio explicitly stated this aim in his letter describing the aftermath of the ban. ASV, *Carte de Gregorio,* 39, 64.

13. See Martínez Medina 1993b; Sambricio 1982, 253–63.

14. Contemporary observation quoted in Martínez Medina 1993b, 394.

15. Stein and Stein 2003, 69–80.

16. For these changes in plan, see Martínez Medina 1993c, 389.

17. Stein and Stein 2003, 80.

18. Ibid., 91.

19. Ibid., 83–88.

20. Vanvitelli 1976–77, 3:278.

21. Ibid., 293.

Accorsi, Maria Grazia. 2003. "*Etica Nicomachea* nei primi drammi 'italiani' di Metastasio." In *La tradizione classica nelle arti del XVIII secolo e la fortuna di Metastasio a Vienna,* edited by Mario Valente and Erika Kanduth, 365–403. Rome.

Acton, Harold. 1956. *The Bourbons of Naples (1734–1825).* London.

Adorni, Bruno. 2008. *L'architettura a Parma sotto i primi Farnese, 1545–1630.* Reggio Emilia.

Adriani, Fiammetta, and Marilena Malangone. 2005. "I lavori di 'modernamento' di Domenico Antonio Vaccaro." In *Domenico Antonio Vaccaro: Sintesi delle arti,* edited by Benedetto Gravagnuolo and Fiammetta Adriani, 277–305. Naples.

Aikema, Bernard, and Dulcia Meijers. 1989. "I mendicanti: Chiesa e ospedale di San Lazzaro." In *Nel regno dei poveri: Arte e storia dei grandi ospedali veneziani in età moderna 1474–1799,* edited by Bernard Aikema and Dulcia Meijers, 249–71. Venice.

Ajello, Raffaele. 1968. "Legislazione e crisi del diritto comune nel Regno di Napoli: Il tentativo di codificazione carolino." In *Saggi e ricerche sul Settecento,* 178–215. Naples.

———. 1972. "La vita politica napoletana sotto Carlo di Borbone." In *Storia di Napoli,* vol. 7, no. 1, 459–717. Naples.

———. 1985. "Gli 'Afrancesados' a Napoli nella prima metà del Settecento: Idee e progetti di sviluppo." In *I Borbone di Napoli e I Borbone di Spagna,* edited by Mario di Pino, 1:159–76. Naples.

Alberti, Leon Battista. 1988. *On the Art of Building in Ten Books.* Translated by Joseph Rykwert, Neil Leach, and Robert Tavernor. Cambridge, Mass.

Aldimari, Biagio. 1691. *Historia genealogica della famiglia Carafa.* 3 vols. Naples.

Algarotti, Francesco. 1755. *Saggio sull'opera in musica.* Venice.

Alisio, Giancarlo. 1965. "L'ambiente di Piazza Dante in antichi rilievi inediti." *Napoli nobilissima,* ser. 3, 4:185–92.

———. 1969. "Le correzioni del Carletti alla pianta del duca di Noja." *Napoli nobilissima,* ser. 3, 8:223–26.

———. 1972. "Sviluppo urbano e struttura della città." In *Storia di Napoli,* vol. 8, no. 2, 311–66. Naples.

———. 1979. *Urbanistica napoletana del Settecento.* Bari.

All'ombra del Vesuvio: Napoli nella veduta europea dal Quattrocento all'Ottocento. 2003. Exh. cat. 2nd ed. Naples.

Andreozzi, Elena. 1984. "L'intervento di Fuga nell'Ospizio apostolico di San Michele a Ripa Grande: Il Carcere delle Donne." *Ricerche di storia dell'arte* 22:43–54.

Andrés Gallego, José. 2003. *El motín de Esquilache: América y Europa.* Madrid.

Antinori, Aloisio. 2001. "Note su Troiano Acquaviva d'Aragona protoilluminista e committente di Ferdinando Fuga." In *Ferdinando Fuga 1699–1999: Roma, Napoli, Palermo,* edited by Alfonso Gambardella, 115–26. Rome.

———. 2008. *La magnificenza e l'utile: Progetto urbano e monarchia papale nella Roma del Seicento.* Rome.

Aprato, Germana. 1964. "Il serraglio di Sanfelice al Ponte della Maddalena." *Napoli nobilissima,* ser. 3, 3:237–46.

Aricò, Nicola. 1999. "Un'opera postuma di Jacopo Del Duca: Il Teatro Marittimo di Messina." In *L'urbanistica del Cinquecento in Sicilia,* Storia dell'urbanistica: Sicilia III, edited by Aldo Casamento and Enrico Guidoni, 172–93. Rome.

Arnaldi, Enea. 1762. *Idea di un teatro nelle principali sue parti simile a teatri antichi all'uso moderno accomodato.* Vicenza.

Arrom, Silvia Marina. 2000. *Containing the Poor: The Mexico City Poor House, 1774–1871.* Durham, N.C.

Ascione, Imma. 2003. "Le fonti documentarie." In *Storia della musica e dello spettacolo a Napoli: Il Settecento,* edited by Francesco Cotticelli and Paologiovanni Maione, 1:33–56. Naples.

———. 2009. "Elisabetta Farnese e Carlo di Borbone." In *Elisabetta Farnese, principessa di Parma e regina di Spagna,* edited by Gigliola Fragnito, 287–315. Rome.

Astarita, Tommaso. 1992. *The Continuity of Feudal Power: The Caracciolo di Brienza in Spanish Naples.* Cambridge.

Avallone, Paola. 1995. *Stato e banchi pubblici a Napoli a metà del '700: Il Banco dei Poveri, una svolta.* Naples.

Azzaro, Bartolomeo. 1996. "L'arte di 'maneggiar fabriche' in un cantiere romano del settecento: La presenza di Sardi e Fuga." *Palladio,* n.s., 17:51–66.

Baggio, Carlo, and Enrico del Co. 2000. "Tra diffidenza e innovazione: La meccanica in architettura." In *Storia dell'architettura italiana: Il Settecento,* edited by Giovanna Curcio and Elisabeth Kieven, 1:70–91. Milan.

Ballon, Hilary. 1991. *The Paris of Henri IV: Architecture and Urbanism.* Cambridge, Mass.

———. 1999. *Louis Le Vau: Mazarin's Collège, Colbert's Revenge.* Princeton.

Barbeito, José Manuel. 2005. "Spaces for Court Music." In *The Royal Chapel in the Time of the Hapsburgs: Music and Ceremony in the Early Modern European Court*, edited by Juan José Carreras and Bernardo García García, translated by Yolanda Acker, 197–215. Woodbridge, Suffolk.

Barbera, Filippo. 2007. "Giacomo Antonio Canevari Architetto (1681–1764)" Ph.D. diss., Università degli Studi di Napoli Federico II.

Barberis, Walter. 1988. *Le armi del principe: La tradizione militare sabauda*. Turin.

Bayardi, Ottavio Antonio. 1752. *Prodromo delle antichità d'Ercolano*. 5 vols. Naples.

Beales, Derek. 2005. *Enlightenment and Reform in Eighteenth-Century Europe*. London.

Beik, William. 2005. "The Absolutism of Louis XIV as Social Collaboration." *Past & Present* 188:195–224.

Bélidor, Bernard Forest de. 1754. *La science des ingenieurs dans la conduite des travaux de fortification et d'architecture civile*. 2nd ed. The Hague.

Belli, Carolina. 1987. "Il San Carlo attraverso le fonti documentarie." In *Il Teatro del Re: Il San Carlo da Napoli all'Europa*, edited by Franco Carmelo Greco, 173–96. Naples.

Benedetti, Sandro. 1997. *L'architettura dell'Arcadia nel Settecento romano*. Rome.

Bentham, Jeremy. 1968–. *The Correspondence of Jeremy Bentham*. Edited by Timothy Sprigge. 12 vols. London.

———. 1995. *The Panopticon Writings*. Edited by Miran Božovič. London.

Beranek, Leo. 2004. *Concert Halls and Opera Houses: Music, Acoustics, and Architecture*. 2nd ed. New York.

Bergdoll, Barry. 2000. *European Architecture, 1750–1890*. Oxford.

Berger, Richard. 1994. *A Royal Passion: Louis XIV as Patron of Architecture*. Cambridge.

Bevilacqua, Mario. 1995. "Tra Napoli, Roma e l'Europa: Alcune lettere di Giovanni Carafa duca di Noja." *Napoli nobilissima*, ser. 4, 34:99–116.

———. 1998. *Roma nel secolo dei lumi: Architettura, erudizione, scienza nella Pianta di G. B. Nolli "celebre geometra."* Naples.

———. 2004a. "Napoli capitale nell'Europa dei lumi: La formazione di Giovanni Carafa di Noja e la nascita della *Mappa topografica della città di Napoli e de' suoi contorni*." In *Ferdinando Sanfelice: Napoli e l'Europa*, edited by Alfonso Gambardella, 343–54. Naples.

———. 2004b. "Nolli, Piranesi, Vasi: Percorsi e incontri nella città del Settecento." In *Nolli, Vasi, Piranesi: Immagine di Roma antica e moderna*, exh. cat., edited by Mario Bevilacqua, 18–29. Rome.

Beyer, Andreas. 1998. "Napoli." In *Storia dell'architettura italiana: Il Quattrocento*, edited by Francesco Paolo Fiore, 434–59. Milan.

Bianchini, Luigi. 1859. *Della storia delle finanze del Regno di Napoli libri sette*. 3rd ed. Naples.

Bianchini, Paola. 2002. *Onore e mestiere: Le riforme militari nel Piemonte del Settecento*. Turin.

Bianconi, Lorenzo, and Thomas Walker. 1984. "Production, Consumption, and Political Function of Seventeenth-Century Opera." *Early Music History* 4:209–96.

Bilistein, Charles Léopold Andreu de. 1763. *Fragments militaires, pour servir de suite au Végèce François ou institutions militaires pour la France*. Amsterdam.

Bisogno, Serena. 2010. "Il Foro Carolino e la statua equestre di Carlo di Borbone." *Napoli nobilissima*, ser. 6, 6/7:145–88.

Black, Christopher F. 2009. *The Italian Inquisition*. New Haven.

Black, Jeremy. 1994. *European Warfare, 1660–1815*. New Haven.

Blasco Esquivias, Beatriz. 1995. "Filippo Juvarra alla corte di Madrid: L'architettura nella capitale della Spagna attorno al 1736." In *Filippo Juvarra: Architetto delle capitali da Torino a Madrid, 1714–1736*, edited by Antonio Bonet Correa and Beatriz Blasco Esquivias, 105–41. Turin.

Blessich, Aldo. 1894. "La carta topografica di Napoli di Giovanni Carafa duca di Noja." *Napoli nobilissima*, ser. 1, 4:183–85.

———. 1895. "La pianta di Napoli del duca di Noja, storia della pianta." *Napoli nobilissima*, ser 1, 1:74–77.

Blunt, Anthony, and Fulvio Lenzo. 2006. *Architettura barocca e rococò a Napoli*. Rev. ed. Milan.

Bologna, Ferdinando. 1958. *Francesco Solimena*. Naples.

———. 1982. "La dimensione europea della cultura artistica napoletana nel XVIII secolo." In *Arti e civiltà del Settecento a Napoli*, edited by Cesare de Seta, 31–78. Bari.

Boswell, James. 1998. *Life of Johnson*. Edited by R. W. Chapman. Oxford.

Bottari, Giovanni. 1754. *Dialoghi sopra le tre arti del disegno*. Lucca.

Boyer, Jean-Claude. 2002. "Portrait équestre, archéologie et Querelle des Anciens et des Modernes: Le Louis XIV de Mignard jugé par Solleysel." In *Le cheval et la guerre du XVe au XXe siècle*, 333–46. Versailles.

Braham, Allan, and Hellmut Hager. 1977. *Carlo Fontana: The Drawings at Windsor Castle*. London.

Braudel, Fernand. 1992. *Civilization and Capitalism, 15th–18th Century*. Translated by Siân Reynolds. 3 vols. Berkeley.

Brinckmann, Albert. 1915. *Die Baukunst des 17. und 18. Jahrhunderts*. 3 vols. Berlin.

Brosses, Charles de. 1986. *Lettres d'Italie du président de Brosses*. Edited by Frédéric d'Agay. 2 vols. Paris.

Brown, Jonathan, and John H. Elliott. 2003. *A Palace for a King: The Buen Retiro and the Court of Philip IV*. Rev. ed. New Haven.

Brucker, Johannes, and Milada Vilímková. 1989. *Dientzenhofer: Eine bayerische Baumeisterfamilie in der Barockzeit.* Rosenheim, Germany.

Buccaro, Alfredo. 1989. "Architetture e spazi urbani: I tre fori napoletani." *Agora* 2:27–30.

———. 1992. *Opere pubbliche e tipologie urbane nel Mezzogiorno preunitario.* Naples.

———. 2003. "Da 'architetto vulgo ingeniero' a 'scenziato artista': La formazione dell'ingegnere meridionale tra Sette e Ottocento." In *Scienziati artisti: Formazione e ruolo degli ingegneri nelle fonti dell'Archivio di Stato e della Facoltà di Ingegneria di Napoli,* edited by Alfredo Buccaro and Fausto De Mattia, 17–43. Naples.

Bulifon, Antonio. 1703. *Giornale del viaggio d'Italia dell'invittissimo, e gloriosissimo monarca Filippo V.* Naples.

Burney, Charles. 1771. *The Present State of Music in France and Italy; or, The Journal of a Tour Through Those Countries, Undertaken to Collect Material for a General History of Music.* London.

———. 1796. *Memoirs of the Life and Writings of the Abate Metastasio, Including Translations of His Principal Letters.* 3 vols. London.

Buttà, Giuseppe. 1877. *I Borboni di Napoli al cospetto di due secoli.* 3 vols. Naples.

Calabi, Donatella. 2004. *The Market and the City: Square, Street, and Architecture in Early Modern Europe.* Translated by Marlene Klein. Aldershot, Hampshire.

Calatrava, Juan. 1993a. "Hospital General de Madrid, 1769–1797." In *Francisco Sabatini: 1721–1797,* exh. cat., edited by Delfín Rodríguez Ruiz, 395–408. Madrid.

———. 1993b. "Intervenciones diversas en proyectos de cuarteles." In *Francisco Sabatini: 1721–1797,* exh. cat., edited by Delfín Rodríguez Ruiz, 521–31. Madrid.

Cámara Muñoz, Alicia. 1989. *Arquitectura e ingeniería en el reinado de Carlos III.* Madrid.

———. 1990. *Arquitectura y sociedad en el Siglo de Oro: Idea, traza, y edificio.* Madrid.

———. 1998. *Fortificación y ciudad en los reinos de Felipe II.* Madrid.

Cantone, Gaetana. 1987. "Il Teatro del Re: Dalla corte alla città." In *Il Teatro del Re: Il San Carlo da Napoli all'Europa,* edited by Gaetana Cantone and Franco Carmelo Greco, 45–80. Naples.

———. 2000. "Juvarra e Vanvitelli: L'architettura del tardo barocco al neoclassicismo." In *Luigi Vanvitelli e la sua cerchia,* edited by Cesare de Seta, 46–52. Naples.

Capalbo, Mario, and Antonello Savaglio. 2004. *Mare Horribilis: Le incursioni musulmane, il mercato degli schiavi e la costruzione delle torri costiere in Calabria Citra.* Cosenza.

Capasso, Bartolommeo. 1883. "Sulla circoscrizione civile ed ecclesiastica e sulla popolazione della città di Napoli dalla fine del secolo XIII fino a 1809." *Atti dell'Accademia Pontaniana* 15:99–225.

Capel, Horacio. 2005. "Los ingenieros militares y el sistema de fortificación en el siglo XVIII." In *Los ingenieros de la monarquía hispánica en los siglos XVII y XVIII,* edited by Alicia Cámara, 231–67. Madrid.

Capolavori in festa: Effimero barocco a Largo di Palazzo (1683–1759). 1997. Exh. cat. Naples.

Cappellieri, Alba. 2000. "Il Teatro di San Bartolomeo da Scarlatti a Pergolesi." *Studi pergolesiani / Pergolesi Studies* 4:131–56.

Carafa, Giovanni, duke of Noja. (1750) 1969. *Lettera ad un amico contenente alcune considerazioni sull'utilità, e gloria, che si trarrebbe da una esatta carta topografica della città di Napoli, e del suo contado.* Reprinted in Cesare de Seta, *Cartografia della città di Napoli: Lineamenti dell'evoluzione urbana,* vol. 3. Naples.

Caraffa, Costanza. 2006. *Gaetano Chiaveri (1689–1770), architetto romano della Hofkirche di Dresda.* Rome.

Carini Motta, Fabrizio. 1987. *The Theatrical Writings of Fabrizio Carini Motta.* Edited by Orville K. Larson. Carbondale, Ill.

Carletti, Niccolò. 1776. *Topografia universale della città di Napoli in Campagna Felice.* Naples.

Carlos III y su época: La monarquía ilustrada. 2003. Edited by Isabel Enciso Alonso-Muñumer. Barcelona.

Carlson, Marvin. 1989. *Places of Performance: The Semiotics of Theater Architecture.* Ithaca.

Carmichael, Ann. 1986. *Plague and the Poor in Renaissance Florence.* Cambridge.

Carpanetto, Dino, and Giuseppe Ricuperati. 1987. *Italy in the Age of Reason, 1685–1789.* Translated by Caroline Hinnitt. London.

Carreras, Juan José. 1996–97. "'Terminare a schiaffoni': La primera compañía de ópera italiana en Madrid (1738/39)." *Artigrama* 12:99–121.

Carreras, Pietro. 1977. "Studi su Luigi Vanvitelli." *Storia dell'arte* 24/25, supplement.

Carrió-Invernizzi, Diana. 2008. *El gobierno de las imágenes: Ceremonial y mecenazgo en la Italia española de la segunda mitad del siglo XVII.* Madrid.

Castanò, Francesca. 2003. "Gli interventi di Filippo Buonocore e Paolo Posi nella chiesa cattedrale di Napoli." In *Napoli-Spagna: Architettura e città nel XVIII secolo,* edited by Alfonso Gambardella, 191–200. Naples.

Catello, Elio. 1988. *Sanmartino.* Naples.

———. 2004. *Giuseppe Sanmartino: 1720–1793.* Naples.

Cavallo, Sandra. 1989. "Charity, Power, and Patronage in Eighteenth-Century Italian Hospitals: The Case of Turin." In *The Hospital in History,* edited by Lindsay Granshaw and Roy Porter, 93–122. New York.

Cavendish, William. 1657. *Méthode et invention nouvelle de dresser les chevaux.* Antwerp.

Cavillac, Michel. 1975. Introduction to *Amparo de pobres,* by Cristóbal Pérez de Herrera. Madrid.

Celano, Carlo. 1856–60. *Notizie del bello, dell'antico, e del curioso della città di Napoli.* Rev. ed. Edited by Giovanni Battista Chiarini. 5 vols. Naples.

Ceneri, Angelo Maria. 1728. *L'uso dello strumento geometrico detto la tavoletta Pretoriana.* Bologna.

Charles III, king of Spain. 2001–2. *Lettere ai sovrani di Spagna.* Edited by Imma Ascione. 3 vols. Rome.

Chaumont, Chevalier de. 1766. *Veritable construction d'un theatre d'opéra a l'usage de France suivant les principes des constructeurs italiens avec toutes les mesures & proportions relatives à la voix expliqué e par des règles de géométrie, & des raisonnements physiques.* Paris.

Chierici, Gino. 1931. "L'Albergo dei Poveri a Napoli." *Bollettino d'arte* 25:439–45.

Chorley, Patrick. 1965. *Oil, Silk, and Enlightenment: Economic Problems in XVIIIth Century Naples.* Naples.

Ciapparelli, Pier Luigi. 1999. *Due secoli di teatri in Campania (1694–1896): Teorie, progetti e realizzazioni.* Naples.

———. 2003. "I luoghi del teatro e l'effimero: Scenografia e scenotecnica." In *Storia della musica e dello spettacolo a Napoli: Il Settecento,* edited by Francesco Cotticelli and Paologiovanni Maione, 1:223–329. Naples.

Civiltà del '700 a Napoli, 1734–1799. 1979. Exh. cat. Edited by Raffaello Causa. 2 vols. Florence.

Cleary, Richard. 1999. *The Place Royale and Urban Design in the Ancien Régime.* Cambridge.

Colletta, Pietro. (1843) 1992. *Storia del Reame di Napoli.* Reprint, Milan.

Colletta, Teresa. 1981. *Piazzeforti di Napoli e Sicilia: Le "Carte Montemar" e il sistema difensivo meridionale al principio del Settecento.* Naples.

Collins, James B. 2009. *The State in Early Modern France.* 2nd ed. Cambridge.

Collins, Jeffrey. 2004. *Papacy and Politics in Eighteenth-Century Rome: Pius VI and the Arts.* Cambridge.

Colvin, Howard, J. Mordaunt Crook, Kerry Downes, and John Newman. 1963–82. *The History of the King's Works.* Edited by Howard Colvin. 6 vols. London.

Conelli, Maria Ann. 2000. "The 'Guglie' of Naples: Religious and Political Machinations of the Festival 'Macchine.'" *Memoirs of the American Academy in Rome* 45:153–83.

Corrispondenze diplomatiche veneziane da Napoli. 1992. Vol. 16. Edited by Mario Infelise. Rome.

Cortese, Nino. 1921. "Aspetti e visioni della Napoli del Settecento." *Napoli nobilissima,* ser. 2, 2:152–58.

Cosandey, Fanny, and Robert Descimon. 2002. *L'absolutisme en France: Histoire et historiographie.* Paris.

Costanzo, Salvatore. 2006. *La scuola del Vanvitelli: Dai primi collaboratori del maestro all'opera dei suoi seguaci.* Naples.

Cotarelo y Mori, Emilio. 1917. *Orígenes y establecimiento de la opera en España hasta 1800.* Madrid.

Cotticelli, Francesco. 2000. "Teatro e scena a Napoli tra Viceregno e Regno nel Settecento." *Italica* 77:214–23.

Cotticelli, Francesco, and Paologiovanni Maione. 1996. *Onesto divertimento, ed allegria de' popoli.* Milan.

Cracraft, James. 1988. *The Petrine Revolution in Russian Architecture.* Chicago.

Croce, Benedetto. 1893. "Un innamorato di Napoli." *Napoli nobilissima,* ser. 1, 2:65–70.

———. (1896) 1968. *I teatri di Napoli.* 2 vols. Reprint, Naples.

———. 1926. "Scene della vita dei soldati spagnuoli a Napoli." In *Studi di storia napoletana in onore di Michelangelo Schipa,* 385–409. Naples.

Curcio, Giovanna. 1998. "L'ampliamento dell'ospedale di Santo Spirito in Sassia nel quadro della politica di Benedetto XIV per la città di Roma." In *Benedetto XIV e le arti del disegno,* edited by Donatella Biagi Maino, 177–231. Rome.

———. 2000. "Il buon governo e la pubblica felicità: Architetture per la città e lo stato." In *Storia dell'architettura italiana: Il Settecento,* edited by Giovanna Curcio and Elisabeth Kieven, 1:xi–xxxvii. Milan.

Dallemagne, François. 1990. *Les casernes françaises.* Paris.

Dandelet, Thomas. 2001. *Spanish Rome, 1500–1700.* New Haven.

———. 2007. "Paying for the New St. Peter's: Contributions to the Construction of the New Basilica from Spanish Lands, 1506–1620." In *Spain in Italy: Politics, Society, and Religion, 1500–1700,* edited by John Marino and Thomas Dandelet, 181–95. Leiden.

D'Arbitrio, Nicoletta, and Luigi Zivello. 1999. *Il Reale Albergo dei Poveri di Napoli: Un edificio per le "arti della città" dentro le mura.* Naples.

D'Ayala, Mariano. 1835. *Memorie storico-militari dal 1734 al 1815.* Naples.

———. 1847. *Napoli militare.* Naples.

de Cavi, Sabina. 2009. *Architecture and Royal Presence: Domenico and Giulio Cesare Fontana in Spanish Naples (1592–1627).* Newcastle upon Tyne.

de Dominici, Bernardo. 2003–8. *Vite de' pittori, scultori ed architetti napoletani.* Edited by Fiorella Sricchia Santoro and Andrea Zezza. 2 vols. Naples.

De Falco, Anna. 1998. "Giovanni e Francesco Gravier." In *Editoria e cultura a Napoli nel XVIII secolo,* edited by Anna Maria Rao, 567–77. Naples.

De Frede, Carlo. 1969. "Da Carlo I D'Angiò a Giovanna I (1263–1382)." In *Storia di Napoli,* 3:1–334. Naples.

de Fusco, Renato. 1967. "Vanvitelli e la critica del Settecento." *Napoli nobilissima,* ser. 3, 6:14–24.

Degrada, Francesco. 1977. "L'opera napoletana." In *Storia dell'opera,* edited by Alberto Basso, vol. 1, no. 1, 238–99. Turin.

Dekker, Thomas. 1621. *Greevous grones for the poore.* London.

Delaforce, Angela. 2002. *Art and Patronage in Eighteenth-Century Portugal.* Cambridge.

De la Ville sur Yllon, Ludovico. 1888. "Il Ponte della Maddalena." *Napoli nobilissima,* ser. 1, 7:153–55.

DelDonna, Anthony R. 2002. "Production Practices at the Teatro di San Carlo, Naples, in the Late 18th Century." *Early Music* 30:429–45.

———. 2009. "Opera in Naples." In *The Cambridge Companion to Eighteenth-Century Opera,* edited by Anthony R. DelDonna and Pierpaolo Polzonetti, 214–32. Cambridge.

Dell'Aja, Gaudenzio. 1987. *Il Pantheon dei Borboni in Santa Chiara di Napoli.* Naples.

del Pozzo, Luigi. 1857. *Cronaca civile e militare delle Due Sicilie sotto la dinastia Borbonica dall'anno 1734 in poi.* Naples.

de Luna, Alonzo Sanchez, duca di Sant'Arpino. 1760. *Lo spirito della guerra, o sia l'arte di formare mantenere e disciplinare la soldatesca.* Naples.

De Maio, Romeo. 1971. *Società e vita religiosa a Napoli nell'età moderna (1656–1799).* Naples.

De Napoli, Giuseppe. 1934. *La fine della dominazione austriaca nel mezzogiorno d'Italia e la battaglia di Bitonto del 25 maggio 1734.* Milan.

De Rosa, Luigi. 1968. "Navi, merci, nazionalità, itinerari in un porto dell'età preindustriale: Il porto di Napoli nel 1760." In *Saggi e ricerche sul Settecento,* 332–70. Naples.

de Sariis, Alessio, ed. 1792–97. *Codice delle leggi del Regno di Napoli.* 12 vols. Naples.

Descrizione delle feste celebrate dalla fedelissima città di Napoli per lo glorioso ritorno dalla impresa di Sicilia della Sacra Maestà di Carlo di Borbone Re di Napoli, Sicilia, Gerusalemme, &c. 1735. Naples.

de Seta, Cesare. 1969. *Cartografia della città di Napoli: Lineamenti dell'evoluzione urbana.* 3 vols. Naples.

———. 1973. "Disegni di Luigi Vanvitelli architetto e scenografo." In *Luigi Vanvitelli,* edited by Renato de Fusco, 275–77. Naples.

———. 1981. *Architettura, ambiente e società a Napoli nel '700.* Turin.

———. 1998. "Luigi Vanvitelli, l'antico e il neoclassico." In *Luigi Vanvitelli,* edited by Cesare de Seta, 157–66. Naples.

De Simone, Ennio. 1976. "Case e botteghe a Napoli nei secoli XVII e XVIII." *Revue internationale d'histoire de la banque* 12:77–140.

Deupi, Jill Johnson. 2006. "Cultural Politics in Bourbon Naples, 1734–1799: Antiquities, Academies, and Rivalries with Rome." Ph.D. diss., University of Virginia.

Di Benedetto, Renato. 2000. "Music and Enlightenment." In *Naples in the Eighteenth Century: The Birth and Death of a Nation State,* edited by Girolamo Imbruglia, 135–53. Cambridge.

Dietz, Hans-Bertold. 1966. "The Dresden-Naples Connection, 1737–1763: Charles of Bourbon, Maria Amalia of Saxony, and Johann Adolf Hasse." *International Journal of Musicology* 5:95–130.

Di Mauro, Leonardo. 1982. "Significati e simboli nella decorazione della mappa del duca di Noja." In *Arti e civiltà del Settecento a Napoli,* edited by Cesare de Seta, 319–34. Bari.

———. 2003. "Giovanni Carafa di Noja." In *All'ombra di Vesuvio,* exh. cat., 2nd ed., 408–9. Naples.

Di Meglio, Rosalba, and Giovanni Vitolo. 2003. *Napoli angioino-aragonese: Confraternite, ospedali, dinamiche politico-sociali.* Salerno.

D'Iorio, Aniello. 1998. "La stamperia reale dei Borbone di Napoli: Origini e consolidamento." In *Editoria e cultura a Napoli nel XVIII secolo,* edited by Anna Maria Rao, 354–74. Naples.

Di Rienzo, Eugenio, and Marina Formica. 1998. "Tra Napoli e Roma: Censura e commercio librario." In *Editoria e cultura a Napoli nel XVIII secolo,* edited by Anna Maria Rao, 201–36. Naples.

Di Stefano, Roberto. 1970. "Urbanistica dal 1656 al 1734." In *Storia di Napoli,* vol. 6, no. 2, 751–66. Naples.

Di Vittorio, Antonio. 1969. *Gli austriaci e il Regno di Napoli 1707–1734: Le finanze pubbliche.* Naples.

———. 1993. "Crisi economica e riforme finanziarie nel mezzogiorno dei primi decenni del XVIII secolo." In *La finanza pubblica in età di crisi,* edited by Antonio Di Vittorio, 245–53. Bari.

Dixon, Susan. 2006. *Between the Real and the Ideal: The Accademia degli Arcadi and Its Garden in Eighteenth-Century Rome.* Newark, Del.

Donatone, Guido. 1986. *Il chiostro grande del Monastero di Santa Chiara.* Naples.

Douet, James. 1998. *British Barracks, 1700–1914: Their Architecture and Role in Society.* London.

Duffy, Christopher. 1975. *Fire and Stone: The Science of Fortress Warfare, 1660–1860.* London.

———. 1987. *The Military Experience in the Age of Reason.* London.

Dumont, Gabriel-Pierre-Martin. 1763. *Parallèle de plans de plus belles salles de spectacles d'Italie et de France.* Paris.

Eberhardt, Jürgen. 1973. "Das Kastell von L'Aquila degli Abruzzi und sein Architekt Pyrrhus Aloisius Scrivà." *Römisches Jahrbuch für Kunstgeschichte* 14:139–246.

Economisti classici italiani di economia politica: Parte moderna. 1804–16. 50 vols. Milan.

Elias, Norbert. 1983. *The Court Society.* Translated by E. F. N. Jephcott and Stephen Mennell. New York.

Elliott, John H. 1989. *Spain and Its World, 1500–1700.* New Haven.

———. 1992. "A Europe of Composite Monarchies." *Past & Present* 137:48–71.

———. 2009. *Spain, Europe, and the Wider World, 1500–1800.* New Haven.

"Elogio del Sig. Cavaliere Don Ferdinando Fuga." 1788. In *Abecedario pittorico,* by Pellegrino Antonio Orlandi. Florence.

Enlightened Despotism. 1967. Edited by Stuart Andrews. London.

Errard, Jean. 1600. *La fortification reduicte en art et demonstrée.* Paris.

Escobar, Jesús. 2003. *The Plaza Mayor and the Shaping of Baroque Madrid.* Cambridge.

——. 2009. "A Forum for the Court of Philip IV: Architecture and Space in Seventeenth-Century Madrid." In *The Politics of Space: European Courts ca. 1500–1750,* edited by Marcello Fantoni, George Gorse, and Malcolm Smuts, 121–40. Rome.

L'esercizio del disegno: I Vanvitelli; Catalogo generale del fondo dei disegni della Reggia di Caserta. 1991. Exh. cat. Edited by Claudio Marinelli. Rome.

Evans, Robin. 1982. *The Fabrication of Virtue: English Prison Architecture, 1750–1840.* Cambridge.

Fabbri, Paolo. 1987. "Vita e funzioni di un teatro pubblico e di corte nel Settecento." In *Il Teatro di San Carlo, 1737–1987,* edited by Franco Mancini, 2:61–75. Naples.

Fabbri, Paolo, Angela Farina, Patrizio Fausti, and Roberto Pompoli. 1998. "Il Teatro degli Intrepidi di Giovan Battista Aleotti rivive attraverso le nuove tecniche dell'acustica virtuale." In *Giambattista Aleotti e gli ingegneri del Rinascimento,* edited by Alessandra Fiocca, 195–206. Florence.

Fabris, Dinko. 2005. "The Royal Chapel in the Etiquettes of the Viceregal Court of Naples During the Eighteenth Century." In *The Royal Chapel in the Time of the Hapsburgs: Music and Ceremony in the Early Modern European Court,* edited by Juan José Carreras and Bernardo García García, translated by Yolanda Acker, 162–72. Woodbridge, Suffolk.

——. 2007. *Music in Seventeenth-Century Naples: Francesco Provenzale (1624–1704).* Aldershot, Hampshire.

Fagiolo dell'Arco, Marcello. 1963. *Funzioni, simboli, valori della Reggia di Caserta.* Rome.

Faglia, Vittorio. 1974. "La difesa anticorsara in Italia dal XVI secolo: Le torri costiere, gli edifici rurali fortificati." *Castella* 10:7–29.

Faraglia, Nunzio Federigo. 1883. *Il comune nell'Italia meridionale (1100–1806).* Naples.

——. 1892. "Le fosse del grano." *Napoli nobilissima,* ser. 1, 1:39–43.

Farnese, Ottavio. 1613. *Quaestiones definitae ex triplici philosophia, rationali, naturali, morali.* Parma.

Feingold, Mordechai. 2004. *The Newtonian Moment: Isaac Newton and the Making of Modern Culture.* New York.

Feldman, Martha. 2010. *Opera and Sovereignty: Transforming Myths in Eighteenth-Century Italy.* Chicago.

Fenicia, Giulio. 2003. *Il Regno di Napoli e la difesa del Mediterraneo nell'età di Filippo II (1556–1598): Organizzazione e finanziamento.* Bari.

Fernandes Pereira, José. 1995. "L'architettura di Mafra." In *Giovanni V di Portogallo (1707–1750) e la cultura romana del suo tempo,* edited by Sandra Vasco Rocca and Gabriele Borghini, 71–80. Rome.

Fernán-Nuñez, Carlos José. 1898. *Vida de Carlos III.* 2 vols. Madrid.

Ferri Missano, Antonella. 1988. "Il processo a Giovanni Antonio Medrano: Indizi per una storia della fabbrica della reggia di Capodimonte." *Atti dell'Accademia Pontaniana* 37:197–216.

Ferrone, Vincenzo. 1995. *The Intellectual Roots of the Italian Enlightenment: Newtonian Science, Religion, and Politics in the Early Eighteenth Century.* Translated by Sue Brotherton. Atlantic Highlands, N.J.

Fichera, Francesco. 1937. *Luigi Vanvitelli.* Rome.

Fiengo, Giuseppe. 1977. *Documenti per la storia dell'architettura e dell'urbanistica napoletana del Settecento.* Naples.

——. 1983. *Organizzazione e produzione edilizia a Napoli all'avvento di Carlo di Borbone.* Naples.

——. 1990. *L'acquedotto di Carmignano e lo sviluppo di Napoli in età barocca.* Florence.

Filangeri Ravaschieri-Fieschi, Teresa. 1875. *Storia della carità napoletana: Conservatori, ritiri, collegi, convitti.* 3 vols. Naples.

Filippo Juvarra a Madrid. 1978. Edited by Cesare Greppi. Madrid.

Fittipaldi, Teodoro. 1980. *Scultura napoletana del Settecento.* Naples.

Fontana, Carlo. 1725. *L'Anfiteatro Flavio.* The Hague.

Fornari, Milena. 1994. "Il Teatro Farnese: Decorazione e spazio barocco." In *Pittura in Emilia e in Romagna: Il Seicento,* edited by Jadranka Bentini and Lucia Fornari Schianchi, 2:92–101. Milan.

Forsyth, Michael. 1985. *Buildings for Music: The Architect, the Musician, and the Listener from the Seventeenth Century to the Present Day.* Cambridge, Mass.

Fortunato, Nicola. 1760. *Riflessioni di Nicola Fortunato giureconsulto napoletano intorno al commercio antico, e moderno del Regno di Napoli.* Naples.

Fossati, Fiorella. 1987. "La spettacolazione degli spazi pubblici a Piacenza dal 1695 al 1741." In *La Parma in festa: Spettacolarità e teatro nel Ducato di Parma nel Settecento,* edited by Luigi Allegri and Renato Di Benedetto, 37–80. Modena.

Foster, Philip. 1973. "Per il disegno dell'Ospedale di Milano." *Arte lombarda* 18:1–22.

Foucault, Michel. 1965. *Madness and Civilization.* Translated by Richard Howard. New York.

Fraile, Pedro. 1997. *La otra ciudad del rey: Ciencia de policía y organización urbana en España.* Madrid.

França, José-Augusto. 1965. *Une ville des lumières: La Lisbonne de Pombal.* Paris.

Francobandiera, Claudio, and Eduardo Nappi. 2001. *L'Albergo dei Poveri: Documenti inediti XVIII–XX secolo.* Naples.

Frederick II, king of Prussia. 1762. *Military Instructions Written by the King of Prussia for the Generals of His Army.* London.

———. 1789. *The History of My Own Times.* Pt. 1. Translated by Thomas Holcroft. London.

Galanti, Giuseppe Maria. (1796) 2000. *Breve descrizione della città di Napoli e del suo contorno.* Reprint, Cava de' Tirreni.

Galasso, Giuseppe. 1982. *Napoli spagnola dopo Masaniello: Politica, cultura, società.* 2 vols. Florence.

———. 1994. *Alla periferia dell'impero: Il Regno di Napoli nel periodo spagnolo (secoli XVI–XVII).* Turin.

Galland Seguela, Martine. 2005. "Los ingenieros militares españoles en el siglo XVIII." In *Los ingenieros militares de la monarquía hispánica en los siglos XVII y XVIII,* edited by Alicia Cámara, 205–29. Madrid.

Gallego, José Andrés. 2003. *El motín de Esquilache, América y Europa.* Madrid.

Garms, Jörg. 1974. *Disegni di Luigi Vanvitelli.* Naples.

———. 1975. "Kleine archivalische Beiträge zu Luigi Vanvitellis Werk." *Römische historische Mitteilungen* 17:185–92.

———. 1982. "Ultimi contributi vanvitelliani." In *Arti e civiltà del Settecento a Napoli,* edited by Cesare de Seta, 137–49. Bari.

———. 1992. "Vanvitelli architetto di corte a Roma e a Napoli." In *Barocco napoletano,* edited by Gaetana Cantone, 217–32. Rome.

———. 1993. "Sabatini, Vanvitelli, Fuga y Roma." In *Francisco Sabatini, 1721–1797,* exh. cat., edited by Delfín Rodríguez Ruiz, 61–72. Madrid.

———. 2000. "Luigi Vanvitelli (1700–73)." In *Storia dell'architettura italiana: Il Settecento,* edited by Giovanna Curcio and Elisabeth Kieven, 2:556–79. Milan.

Garms, Jörg, and Giuliana Cantabene. 2005. "Il Palazzo Abbaziale di Loreto a Mercogliano e l'Immacolatella nel porto di Napoli." In *Domenico Antonio Vaccaro: Sintesi delle arti,* edited by Benedetto Gravagnuolo and Fiametta Adriani, 113–36. Naples.

Garofalo, Gaetano. 1963. *La monarchia borbonica a Napoli.* Rome.

Genovesi, Antonio. 1962. "Vita." In *Illuministi italiani,* edited by Franco Venturi, 5:47–83. Milan.

Gentilcore, David. 1999. "'Cradle of Saints and Useful Institutions': Health Care and Poor Relief in Counter-Reformation Naples." In *Health Care and Poor Relief in Counter-Reformation Europe,* edited by Ole Peter Grell and Andrew Cunningham, 132–50. London.

Gerbino, Anthony. 2010. *François Blondel: Architecture, Erudition, and the Scientific Revolution.* London.

Geremek, Bronislaw. 1994. *Poverty: A History.* Translated by Agnieszka Kolakowska. Oxford.

Giordano, Gloria, and Jehanne Marchesi. 2000. "Gaetano Grossatesta: The Choreographer-Impresario in Naples." *Dance Chronicle* 23:133–91.

Giordano, Paolo. 1997. *Ferdinando Fuga a Napoli: L'Albergo dei Poveri, il Cimitero delle 366 Fosse, i Granili.* Lecce.

Gleijeses, Vittorio. 1970. *La Piazza Dante a Napoli.* Naples.

Glixon, Beth L., and Jonathan E. Glixon. 2006. *Inventing the Business of Opera: The Impresario and His World in Seventeenth-Century Venice.* Oxford.

Goldoni, Carlo. 1935–56. *Tutte le opere di Carlo Goldoni.* 14 vols. Milan.

Goldsmith, Oliver. 1796. "The Deserted Village." In *A collection of poems, containing Goldsmith's Deserted village.* Bath.

Goudar, Ange. 1781. *Le procès des trois rois: Louis XVI de France-Bourbon, Charles III d'Espagne-Bourbon, et George III d'Hanovre.* London.

Goudar, Sara. 1774. *Relation historique des divertissements du Carnaval de Naples.* Naples.

Greco, Franco Carmelo. 1980. "Il teatro." In *Civiltà del Settecento a Napoli, 1734–1799,* exh. cat., edited by Raffaello Causa, 2:372–80. Florence.

———. 1981. *Teatro napoletano del '700, intellettuali e città fra scrittura e pratica della scena.* Naples.

Grisone, Federigo. 1550. *Gli ordini di cavalcare.* Naples.

Grönert, Alexander. 2011. "Independence in the Imperial Realm: Political Iconography and Urbanism in Eighteenth-Century Palermo." In *Reading the Royal Monument in Eighteenth-Century Europe,* edited by Charlotte Chastel-Rousseau, 131–52. Burlington, Vt.

Grosley, Pierre Jean. 1769. *New observations on Italy and its inhabitants: Written in French by two Swedish gentlemen.* Translated by Thomas Nugent. 2 vols. London.

Guardamagna, Laura. 2001. "La lotta al pauperismo: Ospedali e ospizi." In *Ferdinando Fuga, 1699–1999: Roma, Napoli, Palermo,* edited by Alfonso Gambardella, 83–94. Naples.

Guccini, Gerardo. 1988. Introduction to *Il teatro italiano nel Settecento,* edited by Gerardo Guccini, 9–68. Bologna.

Guerra, Andrea. 1995. "L'Albergo dei Poveri di Napoli." In *Il trionfo della miseria: Gli Alberghi dei Poveri di Genova, Palermo, e Napoli,* 153–223. Milan.

Guevarre, André. 1693a. *Il mendicare abolito nella città di Montalbano da un pubblico ufizio di Carità.* Translated by Giovanni Filippo Cecchi. Florence.

———. 1693b. *La mendicità provveduta nella città di Roma coll'ospizio pubblico fondato dalla pietà, e beneficenza di Nostro Signore Innocenzo XII Pontefice Massimo: Con le risposte all'obiezioni contro simili fondazioni.* Rome.

———. 1717. *La mendicità sbandita col sovvenimento de' poveri tanto nelle città che né Borghi, Luoghi, e Terre de' stati di quà, e di là da' Monti, e Colli di Sua Maestà Vittorio Amadeo.* Turin.

Gurlitt, Cornelius. 1887. *Geschichte des Barockstiles in Italien.* Stuttgart.

Gutton, Jean-Pierre. 1974. *La société et les pauvres en Europe (XVIe–XVIIIe siècles).* Paris.

Habel, Dorothy Metzger. 2002. *The Urban Development of Rome in the Age of Alexander VII.* Cambridge.

Hager, Helmut. 1975. "Carlo Fontana e l'ingrandimento dell'ospizio di S. Michele: Contributo allo sviluppo architettonico del tardo barocco romano." *Commentari* 26:344–59.

———. 2000. "Le Accademie di Architettura." In *Storia dell'architettura italiana: Il Settecento,* edited by Giovanna Curcio and Elisabeth Kieven, 1:20–49. Milan.

Hale, J. R. 1968. "The End of Florentine Liberty: The Fortezza da Basso." In *Florentine Studies: Politics and Society in Renaissance Florence,* edited by Nicolai Rubinstein, 501–32. London.

Hammitzch, Martin. 1906. *Der moderne Theaterbau.* Berlin.

Hanlon, Gregory. 1998. *The Twilight of a Military Tradition: Italian Aristocrats and European Conflicts, 1500–1800.* London.

Harley, J. B. 2001. *The New Nature of Maps: Essays in the History of Cartography.* Edited by J. H. Andrews. Baltimore.

Harris, Dianne. 2003. *The Nature of Authority: Villa Culture, Landscape, and Representation in Eighteenth-Century Lombardy.* University Park, Pa.

Haskell, Francis. 1998. Introduction to *Benedetto XIV e le arti del disegno,* edited by Donatella Biagi Maino, 3–11. Rome.

Heartz, Daniel. 2003. *Music in European Capitals: The Galant Style, 1720–1780.* New York.

Heath, James. 1963. *Eighteenth-Century Penal Theory.* Oxford.

Heckmann, Hermann. 1972. *Matthäus Daniel Pöppelmann: Leben und Werk.* Berlin.

Heller, Wendy. 1998. "Reforming Achilles: Gender, *Opera Seria,* and the Rhetoric of the Enlightened Hero." *Early Music* 26:562–81.

Henderson, John. 2006. *The Renaissance Hospital: Healing the Body and Healing the Soul.* New Haven.

Hernando, Augustín. 2002. "Poder, cartografía y política de sigilo en la España del siglo XVII." In *El atlas del rey planeta: La "Descripción de España y de las costas y puertos de sus reinos" de Pedro Teixeira (1634),* edited by Felipe Pereda and Fernando Marías, 71–97. Madrid.

Hernando Sánchez, Carlos José. 1994. *Castilla y Nápoles en el siglo XVI: El virrey Pedro de Toledo; Linaje, estado y cultura (1532–1553).* Valladolid.

———. 2000. "El Reino de Nápoles: La fortificación de la ciudad y el territorio bajo Carlos V." In *Las fortificaciones de Carlos V,* edited by Carlos José Hernando Sánchez, 515–53. Madrid.

Hersey, George. 1969. *Alfonso II and the Artistic Renewal of Naples, 1485–1495.* New Haven.

———. 1983. "Carlo di Borbone a Napoli e a Caserta." *Storia dell'arte italiana: Monumenti di architettura* 12:215–64.

Hills, Helen. 2004. *Invisible City: The Architecture of Devotion in Seventeenth-Century Neapolitan Convents.* Oxford.

Holmes, William C. 1993. *Opera Observed: Views of a Florentine Impresario in the Early Eighteenth Century.* Chicago.

Horsley, William. 1744. *A Treatise on Maritime Affairs; or, A Comparison Between the Commerce and Naval Power of England and France.* London.

Howard, Deborah, and Laura Moretti. 2010. *Sound and Space in Renaissance Venice: Architecture, Music, Acoustics.* New Haven.

Howard, John. 1780. *The state of the prisons in England and Wales, with preliminary observations, and an account of some foreign prisons and hospitals.* 2nd ed. London.

Huget-Termes, Teresa. 2009. "Madrid Hospitals and Welfare in the Context of the Hapsburg Empire." *Medical History Supplement* 29:64–85.

Isherwood, Robert. 1996. "Nationalism and the *Querelle des Bouffons.*" In *D'un opéra l'autre: Hommage à Jean Mongrédien,* edited by Jean Gribenski, Marie-Claire Mussat, and Herbert Schneider, 323–30. Paris.

Ivanovich, Cristoforo. 1687. *Memorie teatrali di Venezia.* Venice.

Izenour, George. 1977. *Theater Design.* New York.

Jacob, Christian. 2006. *The Sovereign Map: Theoretical Approaches in Cartography Throughout History.* Translated by Tom Conley. Edited by Edward H. Dahl. Chicago.

Jarrard, Alice. 1996–97. "The Escalation of Ceremony and the Ducal Staircases of Italy." *Annali di architettura* 8:159–78.

———. 2003. *Architecture as Performance in Seventeenth-Century Europe: Court Ritual in Modena, Rome, and Paris.* Cambridge.

Jetter, Dieter. 1986. *Das europäische Hospital von der Spätantike bis 1800.* Cologne.

Jiménez Salas, Maria. 1958. *Historia de la asistencia social en España en la edad moderna.* Madrid.

Johns, Christopher M. S. 1993. *Papal Art and Cultural Politics: Rome in the Age of Clement XI.* Cambridge.

Johnson, James H. 1995. *Listening in Paris: A Cultural History.* Berkeley.

Juvarra, Filippo. 1711. *Raccolta di Targhe fatte da Professori primarj in Roma, disegnate ed intagliate dal cav. D. Filippo Juvarra.* Rome.

Kadatz, Hans-Joachim. 1983. *Georg Wenzeslaus von Knobelsdorff: Baumeister Friedrichs des Großen.* Leipzig.

Kagan, Richard L. 1989. "Philip II and the Geographers." In *Spanish Cities of the Golden Age: The Views of Anton van den Wyngaerde,* edited by Richard L. Kagan, 40–53. Berkeley.

———. 2002. "Arcana imperii: Mapas, ciencia y poder en la corte de Felipe IV." In *El atlas del rey planeta: La "Descripción de España y de las costas y puertos de sus reinos" de Pedro Teixeira (1634),* edited by Felipe Pereda and Fernando Marías, 49–70. Madrid.

Kamen, Henry. 2001. *Philip V of Spain: The King Who Reigned Twice.* New Haven.

———. 2008. *Imagining Spain: Historical Myth and National Identity.* New Haven.

Keyvanian, Carla. 2005. "Concerted Efforts: The Quarter of the Barberini Casa Grande in Seventeenth-Century Rome." *Journal of the Society of Architectural Historians* 64:292–311.

Kieven, Elisabeth. 1988. *Ferdinando Fuga e l'architettura romana del Settecento.* Rome.

———. 1991a. *Architettura del Settecento a Roma nei disegni della Raccolta Grafica Comunale.* Rome.

———. 1991b. "Il ruolo del disegno: Il concorso per la facciata di San Giovanni in Laterano." In *"In urbe architectus": Modelli, disegni, misure; La professione dell'architetto, Roma, 1680–1750,* edited by Bruno Contradi and Giovanna Curcio, 78–123. Rome.

———. 1999. "'Mostrar l'inventione': The Role of Roman Architects in the Baroque Period; Plans and Models." In *Triumph of the Baroque: Architecture in Europe, 1600–1750,* edited by Henry Millon, 173–206. New York.

———. 2000. "Vanvitelli e Nicola Salvi a Roma." In *Luigi Vanvitelli e la sua cerchia,* edited by Cesare de Seta, 53–64. Naples.

Kircher, Athanasius. 1650. *Musurgia Universalis.* Rome.

Kotzebue, August von. 1811. *Souvenirs d'un voyage en Livonie, a Rome et a Naples, faisant suite aux souvenirs de Paris.* Paris.

Kranich, Friedrich. 1933. *Bühnentechnik der Gegenwart.* 2 vols. Munich.

Kubler, George. 1982. *Building the Escorial.* Princeton.

Labrot, Gérard. 2009. "Féodal, courtisan, citadin: L'aristocrate napolitain sous le regard de Domenico Confuorto (1679–1699)." In *Le nobiltà delle città capitali,* edited by Martine Boiteux, Catherine Brice, and Carlo M. Travaglini, 77–112. Rome.

Lalande, Joseph Jérôme de. 1786. *Voyage en Italie.* 2nd ed. 9 vols. Paris.

Langins, Janis. 2004. *Conserving the Enlightenment: French Military Engineering from Vauban to the Revolution.* Cambridge, Mass.

———. 2005. "Eighteenth-Century French Fortification Theory After Vauban: The Case of Montalembert." In *The Heirs of Archimedes: Science and the Art of War Through the Age of Enlightenment,* edited by Brett Steele and Tamera Dorland, 333–60. Cambridge, Mass.

Lankheit, Klaus. 1962. *Florentinische Barockplastik: Die Kunst am Hofe der letzten Medici, 1670–1743.* Munich.

Lattanzi, Marco. 1995. "I giochi della diplomazia: Il tempo di Giovanni V fra Roma e Lisbona." In *Giovanni V di Portogallo (1707–1750) e la cultura romana del suo tempo,* edited by Sandra Vasco Rocca and Gabriele Borghini, 475–80. Rome.

Lattuada, Riccardo. 2005. "Domenico Antonio Vaccaro, pittore scultore e decoratore, 'ornamento della sua patria.'" In *Domenico Antonio Vaccaro: Sintesi delle arti,* edited by Benedetto Gravagnuolo and Fiammetta Adriani, 21–61. Naples.

Laugier, Marc-Antoine. 1977. *An Essay on Architecture.* Translated by Wolfgang Herrmann and Anni Herrmann. Los Angeles.

Lavalle Cobo, Teresa. 2002. *Isabel de Farnesio: La reina coleccionista.* Madrid.

Leclerc, Hélène. 1946. *Les origines italiennes de l'architecture théâtrale moderne.* Paris.

Lenzi, Deanna. 2000. "Francesco Galli Bibiena, Teatro Filarmonico di Verona." In *I Bibiena, una famiglia europea,* exh. cat., edited by Deanna Lenzi and Jadranka Bentini, 328–30. Venice.

Lis, Catharina, and Hugo Soly. 1979. *Poverty and Capitalism in Pre-industrial Europe.* Atlantic Heights, N.J.

Locke, John. 1996. *An Essay Concerning Human Understanding.* Edited by Kenneth Winkler. 2 vols. Indianapolis.

Lo Gatto, Ettore. 1934. *Gli artisti italiani in Russia.* Rome.

Lombaerde, Piet. 2001. "Antwerp in Its Golden Age: 'One of the Largest Cities in the Low Countries' and 'One of the Best Fortified in Europe.'" In *Urban Achievement in Early Modern Europe: Golden Ages in Antwerp, Amsterdam, and London,* edited by Patrick O'Brien, 99–127. Cambridge.

López-Cordón Cortezo, María Victoria. 2009. "Elisabetta Farnese e il governo della Spagna." In *Elisabetta Farnese, principessa di Parma e regina di Spagna,* edited by Gigliola Fragnito, 139–62. Rome.

Lugar, Catherine. 1986. "Merchants." In *Cities and Society in Colonial Latin America,* edited by Louisa Schell Hoberman and Susan Migden Socolow, 47–75. Albuquerque.

Luh, Jürgen. 2004. *Kriegskunst in Europa.* Cologne.

Luigi Vanvitelli. 1998. Edited by Cesare de Seta. Naples.

Maffei, Scipione. 1728. *Degli anfiteatri e singolarmente del Veronese.* Verona.

Mafrici, Mirella. 1999. *Fascino e potere di una regina: Elisabetta Farnese sulla scena europea (1715–1759).* Cava de' Tirreni.

———. 2009. "La politica spagnola in Italia: Elisabetta Farnese e la guerra di successione." In *Elisabetta Farnese, principessa di Parma e regina di Spagna,* edited by Gigliola Fragnito, 267–85. Rome.

———. 2010. "Una principessa sassone sui troni delle Due Sicilie e di Spagna: Maria Amalia Wettin." In *All'ombra della corte: Donne e potere nella Napoli borbonica (1734–1860),* edited by Mirella Mafrici, 31–49. Naples.

Magirius, Heinrich. 2005. *Die Dresdner Frauenkirche von Georg Bähr.* Berlin.

Maione, Paologiovanni, and Francesca Seller. 2005. *Teatro di San Carlo di Napoli: Cronologia degli spettacoli (1737–1799).* Naples.

Mamczarz, Irene. 1988. *Le Théâtre Farnese de Parme et le drame musical italien (1618–1732).* Florence.

Mancini, Franco. 1961. "Due teatri napoletani del XVIII secolo: Il nuovo ed il San Carlo." *Napoli nobilissima,* ser. 3, 1:95–100.

———. 1964. *Scenografia napoletana dell'età barocca.* Naples.

———. 1987a. "Il San Carlo del Medrano: 4 novembre 1737–13 febbraio 1816." In *Il Teatro di San Carlo, 1737–1987,* edited by Franco Mancini, 1:25–88. Naples.

———. 1987b. "Il San Carlo del Niccolini dal 12 gennaio 1817 ad aggi." In *Il Teatro di San Carlo, 1737–1987,* edited by Franco Mancini, 1:89–168. Naples.

———. 1987c. "Le scene, i costumi." In *Il Teatro di San Carlo, 1737–1987,* edited by Franco Mancini, 3:7–196. Naples.

———. 1987d. "La storia, le vicende amministrative." In *Il Teatro di San Carlo, 1737–1987,* edited by Franco Mancini, 1:9–24. Naples.

Mancini, Franco, Maria Teresa Muraro, and Elena Povoledo. 1985–95. *I teatri del Veneto.* 4 vols. Venice.

Mandeville, Bernard. 1725. *An Enquiry into the Causes of the Frequent Executions at Tyburn.* London.

Manzi, Pietro. 1969. "Carlo di Borbone e Luigi Vanvitelli antesignani delle moderne caserme." *Bollettino dell'Istituto Storico dell'Arma del Genio* 35:11–60.

Marchesi Cappai, Carlo. 1935. *Acustica applicata all'architettura.* Milan.

Marías, Fernando. 2004. "Ferdinando Sanfelice, Juan Antonio Medrano y los Borbones de España: De Felipe V a Carlos III." In *Ferdinando Sanfelice: Napoli e l'Europa,* edited by Alfonso Gambardella, 267–82. Naples.

———. 2008. "La arquitectura del palacio virreinal: Entre localismo e identidad española." In *Las cortes virreinales de la Monarquía española,* edited by Francesca Cantù, 425–43. Rome.

Mariette, Jean. 1727. *L'architecture française.* 3 vols. Paris.

Marino, John A. 1988. *Pastoral Economics in the Kingdom of Naples.* Baltimore.

Marinoni, Giovanni Jacopo de. 1751. *De re ichnographica, cujus hodierna praxis exponitur.* Vienna.

Martínez Medina, África. 1993a. "Francisco Sabatini y Madrid." *Reales sitos* 30:37–44.

———. 1993b. "Instrucción para el nuevo empedrado y limpieza de Madrid." In *Francisco Sabatini, 1721–1797,* exh. cat., edited by Delfín Rodríguez Ruiz, 391–94. Madrid.

———. 1993c. "Proyecto para la Real Casa de la Aduana." In *Francisco Sabatini, 1721–1797,* exh. cat., edited by Delfín Rodríguez Ruiz, 387–91. Madrid.

Matacena, Bruno. 2008. "La pianta del duca di Noja e alcuni nuovi documenti." *Napoli nobilissima,* ser. 5, 9:156–60.

Matteucci, Anna Maria. 1988. *L'architettura del Settecento.* Turin.

Mauceri, Enrico. 1920. "Una statua in bronzo di Carlo di Borbone eretta in Messina nel 1757." *Napoli nobilissima,* ser. 2, 1:87–88.

Maxwell, Kenneth. 1995. *Pombal, Paradox of the Enlightenment.* Cambridge.

Mazzocchi, Alessio. 1727. *In mutilum Campani amphiteatri titulum aliasque nonnullas campanas inscriptiones commentarius.* Naples.

———. 1751. *Dissertatio historica de cathedralis ecclesiae neapolitanae.* Naples.

———. 1771–1824. *Opuscula quibus orationes dedicationes, epistolae, inscriptiones, carmina, ac diatribae continentur.* 3 vols. Naples.

McClung, William. 1998. "The Decor of Power in Naples, 1747." *Journal of Architectural Education* 52:38–48.

Melpignano, Andrea. 1965. *L'anticurialismo napoletano sotto Carlo III.* Rome.

Merlotti, Andrea. 2000. *L'enigma delle nobiltà: Stato e ceti dirigenti nel Piemonte del Settecento.* Florence.

Mersenne, Marin. 1648. *Harmonicorum.* Paris.

Metastasio, Pietro. 1951–65. *Tutte le opere.* Edited by Bruno Brunelli. 5 vols. Milan.

Meyer, Jürgen. 1978. "Raumakustik und Orchesterklang in den Konzertsälen Joseph Haydns." *Acustica* 41:145–62.

Mezzanotte, Gianni. 1982. *L'architettura della Scala nell'età neoclassica.* Milan.

Micco Spadaro: Napoli ai tempi di Masaniello. 2002. Exh. cat. Edited by Brigitte Daprà. Naples.

Michalsky, Tanja. 2008. "Gewachsene Ordnung: Zur Chorographie Neapels in der Frühen Neuzeit." In *Räume der Stadt: Von der Antike bis heute,* edited by Cornelia Jöchner, 267–88. Berlin.

Michel, Olivier. 1983. "Les péripéties d'une donation: La *Forma Urbis* en 1741 et 1742." *Mélanges de l'école Française de Rome: Antiquité* 95:997–1019.

Mielziner, Jo. 1970. *The Shapes of Our Theatre.* New York.

Mignot, Claude. 1999. "Urban Transformations." In *The Triumph of the Baroque: Architecture in Europe, 1600–1750,* edited by Henry Millon, 315–32. New York.

Milizia, Francesco. 1773. *Del teatro.* Venice.

———. 1781. *Memorie degli architetti antichi e moderni.* 3rd ed. 2 vols. Parma.

———. (1847) 1973. *Principj di architettura civile.* 2nd ed. 2 vols. Reprint, New York.

Millon, Henry. 1984. *Filippo Juvarra: Drawings from the Roman Period, 1704–1714.* Pt. 1. Rome.

Milton, Cynthia E. 2007. *The Many Meanings of Poverty: Colonialism, Social Compacts, and Assistance in Eighteenth-Century Ecuador.* Stanford.

Minor, Heather Hyde. 2001. "Rejecting Piranesi." *Burlington Magazine* 143:412–19.

———. 2006. "'*Amore regolato*': Papal Nephews and Their Palaces in Eighteenth-Century Rome." *Journal of the Society of Architectural Historians* 65:68–91.

———. 2010. *The Culture of Architecture in Enlightenment Rome.* University Park, Pa.

Minor, Vernon Hyde. 2006. *The Death of the Baroque and the Rhetoric of Good Taste.* Cambridge.

Molenti, Elisabetta. 1995. "L'Albergo dei Poveri di Genova." In *Il trionfo della miseria: Gli Alberghi dei Poveri di Genova, Palermo, e Napoli*, 17–77. Milan.

Moli Frigola, Montserrat. 1993. "Rêveries italianas de María Amalia de Sajonia entre estética e innovación." *Bulletin de l'Institut Historique Belge de Rome* 63:279–306.

Mondain-Monval, Jean. 1918. *Soufflot: Sa vie, son ouvre, son esthétique.* Paris.

Montagu, Jennifer. 1989. *Roman Baroque Sculpture: The Industry of Art.* New Haven.

———. 1996. *Gold, Silver, and Bronze: Metal Sculpture of the Roman Baroque.* Princeton.

Montenari, Giovanni. 1733. *Del Teatro Olimpico di Andrea Palladio.* Padua.

Montesquieu, Charles-Louis de Secondat, baron de. 1989. *Spirit of the Laws.* Translated by Anne M. Cohler, Basia Carolyn Miller, and Harold Samuel Stone. Cambridge.

Montinori, Giovanni. 2000. "The Court: Power Relations and Forms of Social Life." In *Naples in the Eighteenth Century: The Birth and Death of a Nation State*, edited by Girolamo Imbruglia, 22–43. Cambridge.

Moore, John E. 1995. "Prints, Salami, and Cheese: Savoring the Roman Festival of the Chinea." *Art Bulletin* 77:584–608.

Morales, Nicolas. 2009. "'La virtuosa coronata': Élisabeth Farnèse et l'implantation de l'opéra à la cour d'Espagne." In *Elisabetta Farnese, principessa di Parma e regina di Spagna*, edited by Gigliola Fragnito, 187–206. Rome.

Morelli, Cosimo. 1780. *Pianta e spaccato del nuovo teatro di Imola.* Rome.

Moreno, Fernando Díez, and Ana Jiménez Díaz-Valero. 2000. "Sabatini, arquitecto para el Ministerio de Hacienda." *Reales sitos* 37:69–73.

Moretti, Laura. 2008. *Dagli incurabili alla pietà: Le chiese degli ospedali grandi di Venezia tra architettura e musica (1522–1790).* Florence.

Moricola, Giuseppe. 1994. *L'industria della carità: L'Albergo dei Poveri nell'economia e nella società napoletana tra '700 e '800.* Naples.

Mormone, Raffaele. 1972. "La scultura (1734–1800)." In *Storia di Napoli*, vol. 8, no. 2, 549–606. Naples.

Moscati, Ruggiero. 1972. "Dalla reggenza alla repubblica partenopea." In *Storia di Napoli*, vol. 8, no. 1, 719–90. Naples.

Mozart, Wolfgang Amadeus. 1962–75. *Mozart: Briefe und Aufzeichnungen.* Edited by Wilhelm Bauer and Otto Deutsch. 7 vols. Basel.

Mozzillo, Atanasio. 1992. *La frontiera del Grand Tour: Viaggi e viaggiatori nel Mezzogiorno borbonico.* Naples.

Muller, John. 1755. *A Treatise Containing the Practical Part of Fortification.* London.

Mullin, Charles. 1970. *The Development of the Playhouse.* Berkeley.

Muratori, Lodovico Antonio. 1972. *Della perfetta poesia italiana.* Edited by Ada Ruschioni. Milan.

———. 1996. *Della pubblica felicità, oggetto de' buoni principi.* Edited by Cesare Mozzarelli. Rome.

Murray, Alden. 1960. "The Court and the Cuccagna." *Metropolitan Museum of Art Bulletin* 18:157–67.

Naddeo, Barbara Ann. 2001. "Urban Arcadia: Representations of the 'Dialect' of Naples in Linguistic Theory and Comic Theater, 1696–1780." *Eighteenth-Century Studies* 35:41–65.

———. 2004. "Topographies of Difference: Cartography of the City of Naples, 1627–1775." *Imago Mundi* 56:23–47.

Napoli-Signorelli, Pietro. 1787–90. *Storia critica de' teatri antichi e moderni.* 6 vols. Naples.

Nappi, Eduardo. 1967. "Verità e leggenda nella storia dell'arte napoletana, 1: Il Foro Carolino." *Annali di storia economica e sociale* 8:189–219.

———. 1998. "L'editoria napoletana nell'Archivio Storico del Banco di Napoli." In *Editoria e cultura a Napoli nel XVIII secolo*, edited by Anna Maria Rao, 877–900. Naples.

Narrazione delle solenni reali feste fatte celebrare in Napoli da S.M. il Re delle Due Sicilie Carlo. 1749. Naples.

Neil, Erik. 2004. "L'architetto Tommaso Maria Napoli O.P. (1659–1725)." In *Ferdinando Sanfelice: Napoli e l'Europa*, edited by Alfonso Gambardella, 365–76. Naples.

Newton, Isaac. (1730) 1979. *Opticks; or, A Treatise of the Reflections, Refractions, Inflections & Colours of Light.* Reprint, New York.

Nicolini, Fausto. 1905. "Dalla Porta Reale al Palazzo degli Studi." *Napoli nobilissima*, ser. 1, 14:129–35, 156–58, 177–81.

Nicoloso, Paolo. 1995. "L'Albergo dei Poveri di Palermo." In *Il trionfo della miseria: Gli Alberghi dei Poveri di Genova, Palermo, e Napoli*, 79–151. Milan.

Noel, Charles C. 2004. "'Bárbara Succeeds Elizabeth . . .': The Feminisation and Domestication of Politics in the Spanish Monarchy, 1701–1759." In *Queenship in Europe, 1660–1815: The Role of the Consort*, edited by Clarissa Orr, 155–85. Cambridge.

Notizie del bello, dell'antico, e del curioso che contengono le reali ville di Portici, Resina, lo Scavamento di Pompejano, Capodimonte, Cardito, Caserta, e S. Leucio. 1792. Naples.

Il nuovo Regio Teatro di Torino apertosi nell'anno MDCCXL *disegno del Conte Benedetto Alfieri.* 1761. Turin.

Nussdorfer, Laurie. 1992. *Civic Politics in the Rome of Urban VIII.* Princeton.

Onofri, Pietro d'. 1789. *Elogio estemporaneo per la gloriosa memoria di Carlo III monarca delle Spagne e delle Indie.* Naples.

———. 1803. *Elogi storici di alcuni servi di Dio.* Naples.

Origlia, Giangiuseppe. 1753–54. *Istoria dello studio di Napoli.* 2 vols. Naples.

Ostuni, Nicola. 1991. *Le comunicazioni stradali nel Settecento meridionale.* Naples.

———. 1993. "Strade liquide e terrestri nel mezzogiorno in età moderna e contemporanea." In *Sopra i porti del mare,* vol. 2, *Il Regno di Napoli,* edited by Giorgio Simoncini, 42–45. Florence.

Ottenheym, Konrad. 2005. "Amsterdam 1700: Urban Space and Public Buildings." In *Circa 1700: Architecture in Europe and the Americas,* edited by Henry Millon, 118–37. New Haven.

Palmer, Vanessa. 2004. "Architettura." In *Il Palazzo della Consulta e l'architettura romana di Ferdinando Fuga,* edited by Francesco Nevola and Vanessa Palmer, 3–183. Rome.

Pandolfi, Giuseppe. 1671. *La povertà arricchita o vero l'Hospitio de' poveri mendicanti fondato dall'Eccellentissimo Signor Don Pietro Antonio Raymondo Folch de Cardona.* Naples.

Pane, Giulio. 1966. "Ferdinando Fuga e l'Albergo dei Poveri." *Napoli nobilissima,* ser. 3, 5:72–84.

———. 1979. "Vanvitelli e la grafica." In *Luigi Vanvitelli e il '700: Atti del Congresso Internazionale di Studi Napoli-Caserta 5–10 novembre 1973,* 2:369–410. Naples.

———. 1986. "Fidelissimae urbis neapolitanae." *Napoli nobilissima,* ser. 3, 25:28–39.

———. 2003. Introduction to *Mappa topografica della città di Napoli e de' suoi contorni,* by Giovanni Carafa, duca di Noja. Naples.

———. 2004. "Domenico Antonio Vaccaro e Ferdinando Sanfelice tra rivalità e collaborazione." In *Ferdinando Sanfelice: Napoli e l'Europa,* edited by Alfonso Gambardella, 303–12. Naples.

Pane, Roberto. 1939. *Architettura dell'età barocca in Napoli.* Naples.

———. 1954. *Il Chiostro di Santa Chiara in Napoli.* Naples.

———. 1956. *Ferdinando Fuga.* Naples.

Paquette, Gabriel B. 2008. *Enlightenment, Governance, and Reform in Spain and Its Empire, 1759–1808.* Cambridge.

Parker, Geoffrey. 1996. *The Military Revolution: Military Innovation and the Rise of the West, 1500–1800.* 2nd ed. Cambridge.

Parrino, Domenico Antonio. 1725. *Nuova guida de' forastieri per osservare e godere le curiosità più vaghe e più rare della fedelissima gran Napoli, città antica e nobilissima.* Naples.

Parslow, Christopher Charles. 1998. *Rediscovering Antiquity: Karl Weber and the Excavation of Herculaneum, Pompeii, and Stabiae.* Cambridge.

Pasanisi, Onofrio. 1929. "La costruzione generale delle torri marittime ordinata dalla R. Corte di Napoli nel sec. XVI." In *Studi di storia napoletana in onore di Michelangelo Schipa,* 423–42. Naples.

Pastor, Ludwig von. 1938–61. *The History of the Popes.* Translated by E. F. Peeter. 40 vols. St. Louis.

Patte, Pierre. 1765. *Monuments érigés en France à la gloire de Louis XV.* Paris.

———. 1782. *Essai sur l'architecture théatrale; ou, De l'ordonnance la plus avantage à une salle de spectacles, relativement aux principes de l'optique & de l'architecture.* Paris.

Pedly, Mary Sponberg. 2004. "Scienza e cartografia: Roma nell'Europa dei Lumi." In *Nolli, Vasi, Piranesi: Immagine di Roma antica e moderna,* exh. cat., edited by Mario Bevilacqua, 35–47. Rome.

Pérez de Herrera, Cristóbal. 1975. *Amparo de pobres.* Madrid.

Pérez Samper, María de los Ángeles. 2003. *Isabel de Farnesio.* Barcelona.

Pessolano, Maria. 1980. *Il Palazzo d'Angri: Un'opera napoletana fra tardobarocco e neoclassicismo.* Naples.

———. 1993. "Il porto di Napoli nei secoli XVI–XVIII." In *Sopra i porti del mare,* vol. 2, *Il Regno di Napoli,* edited by Giorgio Simoncini, 67–115. Florence.

Petraccone, Claudia. 1974. *Napoli dal Cinquecento all'Ottocento: Problemi di storia demografica e sociale.* Naples.

Petroni, Giulio. 1864. *Del Reale Ospizio di S. Pietro e Gennaro "extra moenia" in Napoli.* Naples.

Pevsner, Nikolaus. 1976. *A History of Building Types.* Princeton.

Piante e vedute di Napoli dal 1600 al 1699. 2007. Edited by Ermanno Bellucci and Vladimiro Valerio. Naples.

Pinto, John. 1976. "Origins and Development of the Ichnographic City Plan." *Journal of the Society of Architectural Historians* 35:35–50.

———. 1986. *The Trevi Fountain.* New Haven.

———. 1996. "*Forma Urbis Romae:* Fragment and Fantasy." In *Architectural Studies in Memory of Richard Krautheimer,* edited by Cecil L. Striker, 143–46. Mainz.

———. 2000. "Architettura da esportare." In *Storia dell'architettura italiana: Il Settecento,* edited by Giovanna Curcio and Elisabeth Kieven, 1:110–33. Milan.

Pisapia, Paola. 1993. "El Hospital General de Madrid y el Albergo dei Poveri en Nápoles." *Reales sitos* 30:3–10.

Poleggi, Ennio. 2003. "L'urbanistica alla prova dei porti." In *Storia dell'architettura italiana: Il Seicento,* edited by Aurora Scotti Tosini, 1:70–99. Milan.

Poleni, Giovanni. 1748. *Memorie istoriche della gran cupola del tempio Vaticano e de' danni di essa, e de' ristoramenti loro.* Padua.

Pollak, Martha D. 1991. *Turin, 1564–1680.* Chicago.

———. 2010. *Cities at War in Early Modern Europe.* Cambridge.

Porzio, Annalisa. 2008. "Nel regno di Flora: Giuseppe Canart (1713–1791) e il restauro della scultura a Portici." In *Herculanense Museum: Laboratorio sull'antico nella Reggia di Portici,* edited by Renata Cantilena and Annalisa Porzio, 209–46. Naples.

Poumarède, Géraud. 2009. "Élisabeth Farnèse sous le regard de Saint-Simon." In *Elisabetta Farnese, principessa di Parma e regina di Spagna,* edited by Gigliola Fragnito, 91–113. Rome.

Prota-Giurleo, Ulisse. 1927a. "L'orchestra del Teatro San Carlo nel Settecento." *Vita musicale italiana* 14, no. 3:1–4.

———. 1927b. "L'orchestra del Teatro San Carlo nel Settecento." *Vita musicale italiana* 14, no. 4:1–2.

———. 1952. "Breve storia del Teatro di Corte e della musica a Napoli nei secoli XVII–XVIII." In *Il teatro di corte del Palazzo Reale di Napoli,* 17–146. Naples.

———. 2002. *I teatri di Napoli nel secolo XVII.* 2nd ed. Edited by Ermanno Bellucci and Giorgio Mancini. 3 vols. Naples.

Pullan, Brian. 1978. "Poveri, mendicanti, e vagabondi (secoli XIV–XVII)." In *Storia d'Italia: Annali,* vol. 1, *Dal feudalesimo al capitalismo,* edited by Carrado Vivanti and Ruggiero Romano, 981–1041. Turin.

Quantz, Johann Joachim. (1752) 1966. *On Playing the Flute.* Translated by Edward Reilly. Reprint, New York.

Rabelais, François. 1991. *The Complete Works of François Rabelais.* Translated by Donald M. Frame. Berkeley.

Rabreau, Daniel. 1975. "Autour du voyage d'Italie (1750): Soufflot, Cochin et M. De Marigny réformateurs de l'architecture théâtrale française." *Bollettino del centro internazionale di studi di architettura "Andrea Palladio"* 17:213–24.

Ragioni per la Fedelissima, ed Eccellentissima città di Napoli circa l'impedire la Fabbrica delle nuove chiese e l'acquisto, che gl'Ecclesiastici fanno de' beni de' secolari. 1719. Naples.

Rao, Anna Maria. 1992. "Antiche storie e autentiche scritture: Prove di nobiltà a Napoli nel Settecento." In *Signori, patrizi, cavalieri in Italia centro-meridionale nell'età moderna,* edited by Maria Antonietta Visceglia, 279–308. Bari.

———. 1994. "Charles de Bourbon à Naples." In *La règne de Charles III: Le despotisme éclairé en Espagne,* edited by Gérard Chastagnaret and Gérard Dufour, 29–57. Paris.

Rava, Arnaldo. 1953. *I teatri di Roma.* Rome.

Revillas, Diego. 1743. "Dissertazione . . . Sopra l'antico Piede Romano, e sopra alcuni stromenti scolpiti in antico Marmo Sepolcrale." *Saggi di Dissertazioni Accademiche pubblicamente lette nella Nobile Accademia Etrusca dell'antichissima città di Cortona* 1, 2:65–92.

Ricci, Giuliana. 1971. *Teatri d'Italia: Dalla Magna Grecia all'Ottocento.* Milan.

———. 2009. "Fabrizio Carini Motta allievo di Gaspare Vigarani?" In *Gaspare e Carlo Vigarani: Dalla corte degli Este a quella di Luigi XIV,* edited by Walter Baricchi and Jérôme de La Gorce, 284–91. Cinisello Balsamo.

Riccoboni, Luigi. 1738. *Reflexions historiques et critiques sur les différens théâtres de l'Europe.* Paris.

Ritorno al barocco: Da Caravaggio a Vanvitelli. 2009. Exh. cat. Edited by Nicola Spinosa. 2 vols. Naples.

Rizzo, Vincenzo. 1981. "Notizie su Gaspare Traversi ed altri artisti napoletani del '700." *Napoli nobilissima,* ser. 3, 20:19–38.

———. 1982. "Niccolò Tagliacozzi Canale o il trionfo dell'ornato nel Settecento napoletano." In *Settecento napoletano,* edited by Franco Strazzullo, 91–186. Naples.

Roberts, Michael. 1956. *The Military Revolution, 1560–1660.* Belfast.

Robinson, Michael. 1972. *Naples and Neapolitan Opera.* London.

———. 1990. "A Late 18th-Century Account Book of the San Carlo Theatre, Naples." *Early Music* 18:73–81.

Rodríguez Ruiz, Delfín. 1993. "La arquitectura pulcra de Francisco Sabatini." In *Francisco Sabatini, 1721–1797,* exh. cat., edited by Delfín Rodríguez Ruiz, 23–49. Madrid.

Rousseau, François. 1907. *Règne de Charles III d'Espagne, 1759–1788.* 2 vols. Paris.

Rousseau, Jean-Jacques. 1768. *Dictionnaire de musique.* Paris.

Rowland, Ingrid. 1998. *The Culture of the High Renaissance: Ancients and Moderns in Sixteenth-Century Rome.* Cambridge.

Rubbino, Gaetano. 2004. "Mutazioni della forma urbana di Palermo nei primi decenni del Settecento: Il caso della Piazza Imperiale." In *Ferdinando Sanfelice: Napoli e l'Europa,* edited by Alfonso Gambardella, 221–29. Naples.

Rubino, Gregorio. 1975. "La real fabbrica d'armi a Torre Annunziata e l'opera di Sabatini, Vanvitelli e Fuga (1753–1775)." *Napoli nobilissima,* ser. 3, 14:101–18.

Rubino-Mazziotti, Franco. 1931. *L'unità d'Italia raffigurata nel monumento di Dante in Napoli.* Naples.

Ruffo, Vincenzo. 1789. *Saggio sull'abbellimento di cui è capace la città di Napoli.* Naples.

———. ca. 1789. *Rinnovazione de' progetti relativi all'abbellimento, e alla pulizìa della città di Napoli.* Naples.

Rykwert, Joseph. 1980. *The First Moderns: The Architects of the Eighteenth Century.* Cambridge, Mass.

Sabatini, Francesco. 1974. "Decadenza della corte e di altre istituzioni." In *Storia di Napoli,* vol. 4, no. 2, 1–314. Naples.

Sabine, Wallace Clement. 1922. *Collected Papers on Acoustics.* Cambridge, Mass.

Saint-Simon, Louis de Rouvroy, duc de. 2007. *Memoires of the Duc de Saint-Simon, 1715–1723.* Translated and edited by Lucy Norton. Warwick, N.Y.

Salazar y Castro, Luís. 1716. *Índice de las glorias de la casa Farnese.* Madrid.

Salvatori, Gaia. 1985. "Architettura della devozione." In *Le guglie di Napoli: Storia e restauro,* 13–105. Naples.

Sambricio, Carlos. 1982. "L'opera di Francesco Sabatini a Madrid nei primi anni del regno di Carlo III." In *Arti e civiltà del Settecento a Napoli,* edited by Cesare de Seta, 251–70. Bari.

———. 1986. *La arquitectura Española de la Ilustración.* Madrid.

———. 1991. *Territorio y ciudad en la España de la Ilustración.* Madrid.

Sancho, José Luis. 1991. "Ferdinando Fuga, Nicola Salvi y Luigi Vanvitelli: El Palacio Real de Madrid y sus escaleras principales." *Storia dell'arte* 72:199–252.

Sansone Vagni, Lina. 1992. *Raimondo di Sangro, principe di San Severo: Le origini, la tradizione templare, la vita, il periodo storico, il cammino iniziatico del tempio della pietà.* Foggia.

Santiago Paez, Elena. 1967. "Algunas esculturas napolitanas del siglo XVII en España." *Archivo Español de Arte* 40:129–31.

Santoro, Lucio. 1969. "Il Palazzo Reale di Portici." In *Ville vesuviane del Settecento,* edited by Roberto Pane, 193–235. Naples.

Sarnelli, Gennaro Maria. 1739. *Ristretto delle ragioni cattoliche, legali, e politiche in difesa delle repubbliche rovinate dall'insolentito meretricio: Coll'aggiunta delle maniere da restringere, e frenare le meretrici, da conservare le fanciulle pericolanti e mantenere le contrade purgate dalle carnali dissolutezze.* Naples.

Sasso, Camillo Napoleone. 1856. *Storia de' monumenti di Napoli.* 3 vols. Naples.

Sassoli, Mario Gori. 1994. *Della chinea e di altre "Macchine di Gioia": Apparati architettonici per fuochi d'artificio a Roma nel Settecento.* Milan.

Saunders, George. 1790. *A Treatise on Theaters.* London.

Saxe, Maurice de. 1757. *Reveries or memoirs upon the Art of War.* London.

Schipa, Michelangelo. 1902. "Per l'addobbo, l'ingrandimento e le decorazioni della reggia di Napoli alla venuta di Carlo di Borbone." *Napoli nobilissima,* ser. 1, 11:109–11.

———. 1922. "Reali delizie borboniche." *Napoli nobilissima,* ser. 2, 3:146–48.

———. 1923. *Il Regno di Napoli al tempo di Carlo Borbone.* 2 vols. Rome.

Schott, Frans. 1660. *Italy, in its Original Glory, Ruine, and Revival.* Translated by Edmund Warcupp. London.

Scott, John Beldon. 2009. "Fashioning a Capital: The Politics of Urban Space in Early Modern Turin." In *The Politics of Space: European Courts ca. 1500–1750,* edited by Marcello Fantoni, George Gorse, and Malcolm Smuts, 141–70. Rome.

Il Settecento a Roma. 2005. Exh. cat. Edited by Anna Lo Bianco and Angela Negro. Milan.

Sharp, Samuel. 1767. *Letters from Italy.* London.

Sigismondo, Giuseppe. 1788–89. *Descrizione della città di Napoli e suoi borghi.* 3 vols. Naples.

Sitwell, Sacheverell. 1931. *Southern Baroque Art: A Study of Painting, Architecture, and Music in Italy and Spain of the 17th and 18th Centuries.* 3rd ed. London.

Solleysel, Jacques de. 1672. *Le veritable parfait mareschal.* Paris.

Spagnoletti, Angelantonio. 1996. *Principi italiani e Spagna nell'età barocca.* Milan.

Sparti, Barbara. 1989. "Una francese 'napoletano' e il ballo nobile." *La danza italiana* 7:9–29.

Stapelbroek, Koen. 2008. *Love, Self-Deceit, and Money: Commerce and Morality in the Early Neapolitan Enlightenment.* Toronto.

Stargard, William. 1995. "Repression and Catholic Reform: Bernardo Vittone's Commissions for Charitable Institutions." Ph.D. diss., Columbia University.

Starkey, Armstrong. 2003. *War in the Age of Enlightenment (1700–1789).* Westport, Conn.

Stein, Louise K., and José Máximo Leza. 2009. "Opera, Genre, and Context in Spain and Its American Colonies." In *The Cambridge Companion to Eighteenth-Century Opera,* edited by Anthony DelDonna and Pierpaolo Polzonetti, 244–69. Cambridge.

Stein, Stanley J., and Barbara H. Stein. 2003. *Apogee of Empire: Spain and New Spain in the Age of Charles III, 1759–1789.* Baltimore.

Stendhal. 1958. *Rome, Naples, and Florence.* Translated by Richard N. Coe. London.

Sterne, Laurence. 1768. *A Sentimental Journey Through France and Italy by Mr. Yorick.* 2nd ed. London.

Stevenson, Christine. 2000. *Medicine and Magnificence: British Hospital and Asylum Architecture, 1660–1815.* New Haven.

Stoschek, Jeanette. 1998. "Il Caffeaus di Benedetto XIV nei giardini del Quirinale." In *Benedetto XIV e le arti del disegno,* edited by Donatella Biagi Maino, 159–76. Rome.

Stratton, Suzanne L. 1994. *The Immaculate Conception in Spanish Art.* Cambridge.

Strazzullo, Franco. 1968. *Edilizia e urbanistica a Napoli dal '500 al '700.* Naples.

———. 1969. *Architetti e ingegneri napoletani dal '500 al '700.* Naples.

———. 1974. "Documenti d'archivio." *Napoli nobilissima,* ser. 3, 13:151–58.

———. 1979. *Le manifatture d'arte di Carlo di Borbone.* Naples.

———. 1984. "Documenti del Settecento per la storia dell'edilizia e dell'urbanistica nel Regno di Napoli (VII)." *Napoli nobilissima,* ser. 3, 23:161–64.

———. 1991. *Restauri del Duomo di Napoli tra '400 e '800.* Naples.

———. 1997. *Il marchese di Squillace: Leopoldo de Gregorio ministro di Carlo di Borbone.* Naples.

———. 1998. *Alcubierre-Weber-Paderni: Un difficile "tandem" nello scavo di Ercolano-Pompei-Stabia.* Naples.

Strohm, Reinhard. 1997. *Dramma per Musica: Italian Opera Seria of the Eighteenth Century.* New Haven.

Szambien, Werner. 1986. *Symétrie, goût, caractère: Théorie et terminologie de l'architecture à l'âge classique, 1550–1800.* Paris.

Tabacchi, Stefano. 2009. "La Santa Sede, Alberoni e la successione di Parma." In *Elisabetta Farnese, principessa di Parma e regina di Spagna,* edited by Gigliola Fragnito, 207–28. Rome.

Taddei, Emanuelle. 1817. *Del Real Teatro di San Carlo: Cenno storico.* Naples.

Tadgell, Christopher. 1978. *Ange-Jacques Gabriel.* London.

Tamburini, Luciano. 1991. "La cornice." In *L'arcano incanto: Il Teatro Regio di Torino, 1740–1990.* Exh. cat. Edited by Alberto Basso, 31–79. Milan.

Tanucci, Bernardo. 1914. *Lettere a Ferdinando Galiani.* Edited by Fausto Nicolini. 2 vols. Bari.

———. 1980–2003. *Epistolario.* 20 vols. Rome.

Telleria, Raimundo. 1950. *San Alfonso Maria de Ligorio: Fundador, obispo y doctor.* 2 vols. Madrid.

Thomson, David. 1993. *Renaissance Architecture: Critics, Patrons, Luxury.* Manchester.

Tintelnot, Hans. 1939. *Barocktheater und barocke Kunst: Die Entwicklungsgeschichte der Fest- und Theater-Dekoration in ihrem Verhältnis zur barocken Kunst.* Berlin.

Tortora, Simona. 2005. "La nascita di un modello per l'architettura dei teatri partenopei: Il Teatro Nuovo a Montecalvario." In *Domenico Antonio Vaccaro: Sintesi delle arti,* edited by Benedetto Gravagnuolo and Fiammetta Adriani, 251–64. Naples.

Tovar Martín, Virginia. 1995. "Filippo V e l'architettura spagnola della corte nel primo terzo del XVIII secolo." In *Filippo Juvarra: Architetto delle capitali da Torino a Madrid, 1714–1736,* edited by Antonio Bonet Correa and Beatriz Blasco Esquivias, 175–92. Turin.

———. 2000. "Giacomo Bonavia en la Corte española, su obra en La Granja de San Ildefonso." In *El Real Sitio de La Granja de San Ildefonso: Retrato y escena del rey,* edited by Delfín Rodríguez Ruiz, 127–38. Madrid.

Traversier, Mélanie. 2009. *Gouverner l'opéra: Une histoire politique de la musique à Naples, 1767–1815.* Rome.

Tutini, Camillo. 1641. *Dell'origine e fundatione de' seggi di Napoli.* Naples.

Urrea, Jesús. 1989. "Itinerario italiano de un monarca español." In *Itinerario italiano de un monarca español: Carlos III en Italia, 1731–1759,* exh. cat., edited by Jesús Urrea, 23–68. Madrid.

Valenzi, Lucia. 1995. *Poveri, ospizi e potere a Napoli (XVIII–XIX sec.).* Milan.

Valerio, Vladimiro. 1993. *Società, uomini e istituzioni cartografiche nel Mezzogiorno d'Italia.* Florence.

Vanvitelli, Luigi. 1756. *Dichiarazione dei disegni del Reale Palazzo di Caserta.* Naples.

———. 1976–77. *Le lettere di Luigi Vanvitelli della Biblioteca Palatina di Caserta.* Edited by Franco Strazzullo. 3 vols. Galatina.

Vanvitelli, Luigi, Jr. (1823) 1975. *Vita dell'architetto Luigi Vanvitelli.* Reprint, Naples.

Vauban, Sébastien Le Prestre de. 1693. *The New Method of Fortification as practiced by Monsieur Vauban Engineer General of France with an Explication of all Terms appertaining to that Art made English with cuts.* Translated by Abel Swall. 2nd ed. London.

———. 1737. *De l'attaque et de défense des places.* Edited by Pierre Hondt. The Hague.

Vaussard, Maurice. 1962. *Daily Life in Eighteenth Century Italy.* Translated by Michael Heron. London.

Vázquez-Gestal, Pablo. 2008. "Corte, poder y cultura política en el Reino de las Dos Sicilias de Carlos de Borbón (1734–1759)." Ph.D. diss., Universidad Complutense de Madrid.

———. 2009. "'The System of This Court': Elizabeth Farnese, the Count of Santiesteban, and the Monarchy of the Two Sicilies, 1734–1738." *Court Historian* 14:23–47.

Venditti, Arnaldo. 1961. *Architettura neoclassica a Napoli.* Naples.

Venturi, Franco. 1969. *Settecento riformatore.* Vol. 1, *Da Muratori a Beccaria.* Turin.

———. 1972. "Napoli capitale nel pensiero dei riformatori illuministi." In *Storia di Napoli,* vol. 8 no. 2, 1–74. Naples.

———. 1973. "1764: Napoli nell'anno della fame." *Rivista storica italiana* 86:394–472.

Viale Ferrero, Mercedes. 1970. *Filippo Juvarra scenografo e architetto teatrale.* Turin.

Vico, Giambattista. 1982–2004. *Opere di Giambattista Vico.* 12 vols. Naples.

———. 2001. *New Science.* Translated by Thomas Bergin and Max Fisch. 3rd ed. Ithaca.

Villani, Pasquale. 1968. "Il dibattito sulla feudalità nel Regno di Napoli dal Genovesi al Canosa." In *Saggi e ricerche sul Settecento,* 252–331. Naples.

———. 1977. *Mezzogiorno tra riforme e rivoluzione.* Bari.

Villari, Rosario. 1987. *Elogio della dissimulazione: La lotta politica nel Seicento.* Bari.

Villari, Sergio. 1991. "La piazza e i mercati: *Equipement urbano e spazio pubblico a Napoli nel decennio

napoleonico." In *La piazza, la chiesa, il parco,* edited by Manfredo Tafuri, 204–38. Milan.

Virol, Michèle. 2003. *Vauban: De la gloire du roi au service de l'état.* Seyssel.

Vitella, Maurizio. 1999. *Il Real Albergo dei Poveri di Palermo.* Naples.

Vitruvius. 1758. *L'architettura di M. Vitruvio Pollione.* Translated by Bernardo Galiani. Naples.

Vives, Juan de. 1999. *On Assistance to the Poor.* Translated, with commentary, by Alice Torbiner. Toronto.

Voltaire. 1877. *Sémiramis.* In *Oeuvres complètes de Voltaire,* vol. 3. Paris.

Waddy, Patricia. 1990. *Seventeenth-Century Roman Palaces: Use and the Art of the Plan.* Cambridge, Mass.

Wahnbaeck, Til. 2004. *Luxury and Public Happiness: Political Economy in the Italian Enlightenment.* Oxford.

Walling, Pia. 2009. "Vienna e la politica italiana di Elisabetta Farnese." In *Elisabetta Farnese, principessa di Parma e regina di Spagna,* edited by Gigliola Fragnito, 229–43. Rome.

Welch, Evelyn S. 1995. *Art and Authority in Renaissance Milan.* New Haven.

Wilkinson, Catherine. 1975. "The Escorial and the Invention of the Imperial Staircase." *Art Bulletin* 57:65–90.

———. 1985. "Planning a Style for the Escorial: An Architectural Treatise for Philip of Spain." *Journal of the Society of Architectural Historians* 44:37–47.

Wilkinson-Zerner, Catherine. 1993. *Juan de Herrera: Architect to Philip II of Spain.* New Haven.

Wittkower, Rudolf. 1999. *Art and Architecture in Italy, 1600–1750.* Revised by Joseph Connors and Jennifer Montagu. 3 vols. New Haven.

Wittman, Richard. 2007. *Architecture, Print Culture, and the Public Sphere in Eighteenth-Century France.* New York.

Wolff, Christoph. 2000. *Johann Sebastian Bach: The Learned Musician.* New York.

Woodward, David. 1996. *Maps as Prints in the Italian Renaissance: Makers, Distributors, and Consumers.* London.

Worsley, Giles. 2004. *The British Stable.* New Haven.

Zambelli, Paola. 1973. "Il rogo postumo di Paolo Mattia Doria." In *Ricerche sulla cultura dell'Italia moderna,* edited by Paola Zambelli, 149–98. Rome.

Zangheri, Luigi, and Elvira Zorzi. 2000. "Il teatro di via della Pergola: Corte e accademia nella cultura fiorentina." In *Lo "spettacolo maraviglioso": Il Teatro della Pergola; L'opera a Firenze,* edited by Marcello de Angelis, Elivira Garbero Zorsi, Loredana Maccabruni, Pietro Marchi, and Luigi Zangheri, 15–38. Florence.

Zerella, Francesco. 1968. *Padre Rocco correttore popolare.* Naples.

Zilli, Ilaria. 1990. *Carlo di Borbone e la rinascita del Regno di Napoli: Le finanze pubbliche, 1734–1742.* Naples.

Zucco, Claudia. 1977. "Le ipotesi progettuali dell'edificio: Da cavallerizza a museo." In *Da Palazzo degli Studi a Museo Archeologico,* exh. cat., 29–57. Naples.

Vázquez-Gestal, Pablo, 19
Vechione, Luca, 64
Velez y Tassis de Guevara, Iñigo. *See* Oñate, Count of
Verboom, Jorge Próspero de, 26, 98
Vergara, Ignacio, 139, 140
Vernet, Claude-Joseph, 128
Vico, Giambattista, 11, 38, 168
Vittone, Bernardo Antonio, *41,* 42, 51

Vives, Juan de, 46, 49
Voltaire, 11, 43, 50

Waddy, Patricia, 101
War of Austrian Succession, 6, 10, 53, 54, 96, 161
War of Polish Succession, 3
War of Spanish Succession, 1
watchtowers, 93

water supply, for Albergo dei Poveri, 64–65, 68, 78
Wittel, Gaspar van, 108
wood, in Teatro di San Carlo, 28, 30
Worsley, Thomas, 122
Wren, Christopher, 161
Wyngaerde, Anton van den, 162